Digital Media Foundations

This book is a creative and practical introduction to the field of digital media for future designers, artists, and media professionals. It addresses the evolution of the field, its connections with traditional media, up-to-date developments, and possibilities for future directions. Logically organized and thoughtfully illustrated, it provides a welcoming guide to this emerging discipline.

Describing each medium in detail, chapters trace their history, evolution, and potential applications. The book also explains important, relevant technologies—such as digitizing tablets, cloud storage, and 3-D printers—as well as new and emerging media like augmented and virtual reality. With a focus on concepts and creative possibilities, the text's software-neutral exercises provide hands-on experiences with each of the media. The book also examines legal, ethical, and technical issues in digital media, explores career possibilities, and features profiles of pioneers and digital media professionals.

Digital Media Foundations is an ideal resource for students, new professionals, and instructors involved in fields of graphic and visual arts, design, and the history of art and design.

Richard Lewis is Chair of Marist College's Department of Art and Digital Media and the academic coordinator of their branch campus in Florence, Italy. He is also a former Dean of Academic Programs. He is a practicing artist, whose work combines digital and traditional media, and also the author of *The Power of Art* (2019), now in its third revised edition, an art appreciation textbook used in over 300 colleges and universities.

James Luciana is Professor Emeritus of Art at Marist College and a former Chair of their Department of Art and Digital Media. He is an accomplished photographer in both traditional and digital techniques. His work has been extensively exhibited both in the United States and abroad. In addition to teaching at Marist College, he has taught nineteenth-century printing techniques and digital media at the International Center of Photography in New York City. He is the author of *The Art of Enhanced Photography* (1999) and *Black and White Photography: Manifest Visions* (2000).

Digital Media Foundations

An Introduction for Artists
and Designers

Richard Lewis and James Luciana

Routledge
Taylor & Francis Group

NEW YORK AND LONDON

First published 2020
by Routledge
52 Vanderbilt Avenue, New York, NY 10017

and by Routledge
2 Park Square, Milton Park, Abingdon, Oxon, OX14 4RN

Routledge is an imprint of the Taylor & Francis Group, an informa business

© 2020 Taylor & Francis

An earlier version of this book was previously published by: Pearson Education, Inc.

Library of Congress Cataloging-in-Publication Data
A catalog record for this book has been requested

ISBN: 978-0-415-78717-8 (hbk)
ISBN: 978-0-415-78730-7 (pbk)
ISBN: 978-1-315-22612-5 (ebk)

Typeset in Univers
by Apex CoVantage, LLC

For Susan and Robbie,
with love, gratitude, and admiration

–Richard Lewis

For my wife Kathryn,
and in memory of my parents Dominick and Lillian and my father-in-law Robert Hunter.
Love and recognition also go to my mother-in-law Barbara Hunter, who at 91 is still
an inspiration.
With love and appreciation,

–James Luciana

Contents

10 Two-Dimensional Animation: Up and Running

■ Contents

Preface

Digital media is the art of our time. Its impact goes far beyond any exhibition or museum. Digital photography is in the hands of everyone with a smartphone, along with filters and apps that once were only found in expensive professional software. Anything that involves design, whether an ad, webpage, shampoo bottle, or billboard, requires the use of digital media. About 2 billion people regularly play video games. They are an essential part of most childhoods and, as those children grow older, an indispensable part of their social networks, too. Snapchat is luring animators away from Disney to work on three-dimensional (3-D) emojis. Virtual reality (VR) experiences, once the province of industrial researchers, are available at many malls. Instead of telling audiences to turn off their cellphones, some theaters are integrating augmented reality experiences into their productions—mixing avatars and actors. Recently, the art world was shocked when the director of an important museum left his job to join a VR start-up; he explained that "it's exciting" because it was "uncharted" territory.

0.1
Viewers at Venice Biennale, 2019

Today, as in the Renaissance, daring explorers are heading out across unfamiliar seas. Art and technology have joined together to inspire new visions. New ways of working and a new culture are being born—with their own vocabulary, tales, history, and lifestyle. As the artist Laurie Anderson said of our time, "Technology is the campfire around which we tell our stories."

Our goal has been to write a book that captures the energy and enthusiasm that artists and designers, both young and old, feel as they explore digital media. Unfortunately, the books one finds next to the keyboards of most artists and designers are guides to specific software, whose soul is more technical and mathematical than inspiring. After teaching digital media courses for more than 25 years, we have written **Digital Media Foundations** because we believe there is a need for a broader view, one that introduces students to a wide range of different media and approaches.

This book is designed to be a gateway to more focused study in the various media that constitute this new field. Written with the perspectives of artists and designers in mind, it limits jargon and focuses on the possibilities inherent in the new media. We hope it will be useful for students just entering the field, as well as the many self-taught artists who want to broaden their experience beyond the one or two digital media programs they know well.

At Pixar, one of their mottos is "Art challenges technology, technology inspires art." This synergy has driven the story of digital media's progress. The book's first section is a clear explanation of how the hardware that digital media depends on works along with a history of computers and the new media. Readers will also learn about the many components (such as digitizing tablets and 3-D printers) that are found in the contemporary digital media studio, as well as the new tools that are emerging, like augmented and virtual reality.

The heart of the book is the second section, which examines each of the digital media, as well as their evolution and connections with the traditional media they descended from. Each chapter ends with a series of exercises to provide hands-on experience to put the concepts learned into practice. These exercises, like the entire book, are designed to be platform and software neutral, so that they will apply whether one is working on a Mac, PC, or tablet. Each chapter also includes a discussion of the impact emerging technologies may have on digital artists and designers.

All artists, designers, and teachers are painfully aware that software changes quickly and hardware is always improving. Just about any guide in print is outdated the day it is published. The challenge for teachers (and authors) is to find topics that remain important in the midst of constant change. In this book, we have focused on the constants that face any artist, designer, and student. The ultimate goal remains, no matter what the media, to create successful and creative works of art and design.

Therefore, students need to be introduced to more than new tools and special techniques. As exciting as these tools are, there is more than software code behind each of them. In the digital realm, a new medium cannot be truly understood without understanding the concepts and history of the traditional medium that it mirrors. In addition, students should learn the historical evolution of the new medium itself. Unfortunately, most digital media courses today have become the equivalent of an odd beginners' painting course that focuses solely on the construction of brushes and the chemistry of paint. In our book, whenever possible, we connect the new ways of working to the concepts behind their traditional forerunners.

In short, beyond special keyboard shortcuts, there is a great deal to know—like the exciting possibilities in every new tool. In every chapter, we introduce clear, coherent descriptions of common tools and techniques, along with the reasons for their use.

Each medium has also generated new and exciting career paths for artists, whose careers are profiled in special boxes within the text. Other boxes focus on issues like copyright and ethics or clarifying technical issues for each medium with charts and clear explanations.

Ultimately, we hope **Digital Media Foundations** will be a book that readers enjoy learning from and teachers enjoy teaching with. It is meant to open doors to a new and exciting realm for artists and designers, one with extraordinary potential. It is not meant to provide mastery in any one medium, but to provide a sense of the whole range of new media and how they interrelate. Our goal has been to write a clear text, logically organized, with a sense of history. One that bridges the gap between the technical manual and artistic inspiration.

We hope that students, designers, and artists will see that while we are truly in the midst of a new era in art and design, whatever is ahead will be part of a long, marvelous tradition that began thousands of years ago with carving soft stone into rounded forms and scraping charcoal on the walls of caves. Just as stone and charcoal were for the inhabitants of caves, and oil paint and chalk were for the artists of the Renaissance, the digital media are the media of our age.

Acknowledgments

This book is the product of years of teaching and working in digital media. Anyone who works in this field knows no one can do this alone. Many individuals have helped support us and contributed to our understanding of this ever-challenging new realm for artists and designers. This book could never have been written without the assistance of many friends, family members, colleagues, and students, only some of whom are listed below.

We have had the pleasure of working with many talented individuals at Routledge during the production of this book. We want to thank the following for their diligence, thoroughness, and support: our Acquisitions Editors, Judith Newlin and Erica Wetter, whose initial infectious enthusiasm helped make this project a reality; our ever patient and professional Editorial Assistant, Emma Sherriff, and Production Editor Sarah Adams.

During the development of the manuscript, many readers offered perceptive comments that were extremely helpful in the preparation of these pages. We especially appreciate the contributions of Chip Gubera, at the University of Missouri; Ricardo Cortez, previously at San Jose State University; as well as the other manuscript reviewers.

We are honored by the talented artists who were willing to contribute examples of their work to illustrate this book. In particular, we would like to thank the following artists whose work is featured in profiles: Marian Bantjes, Ruud van Empel, Stephanie Lempert, Mike Milano, Nina Paley, Shana and Robert ParkeHarrison, Alexandre Pelletier, Chet Phillips, David Sossella, teamLab, and Clement Valla.

The following colleagues at Marist College and Istituto Lorenzo de'Medici have helped support our work over the years and deserve our thanks: Chris Boehmer, Stefano Casu, Donise English, Matt Frieburghaus, Carlotta Fuhs, Paolo Ghielmetti, Tom Goldpaugh, Fabrizio and Carla Guarducci, Lyn Lepre, Dennis Murray, Vanessa Nichol-Peters, John Peters, Ed Smith, Chris Taylor, Lee Walis, Joey Wall, and Thom Wermuth.

Finally, we must thank our students whose excitement, enthusiasm, and general good humor helped us go on during days when data became corrupted, monitors died, and hard drives crashed. The love for these new media shared by Basel Alnashashibi, Mia Blas, Sarah Carmody, Dan Cerasale, Toni Marie and Rachael and Jessica Chiarella, Derek Cussen, Rich Dachtera, Maria Dos Santos, Lauren Emory, Mo Gorelik, Anya Ioffredo, Baz Murnin, Jenna Obrizok, Caitlin O'Hare, Kalei Perkins, Jennifer Polidore, and many more students like them will always be an inspiration for us.

Richard Lewis and James Luciana

Part I
Introduction

1 The Artist and the Computer

1.1
New tools mean new possibilities for artists and designers

INTRODUCTION

We are at the beginning of a new age for art. While only a few generations of artists have been given the opportunity to pioneer a new medium, this generation has been blessed with many. The arrival of the digital media, the art forms created with computer technology, offers a wealth of new possibilities whose impact is just starting to be felt in the art world.

NEW MEDIA, NEW FREEDOM, NEW REALMS

For many artists and designers, entering the world of digital art and design is liberating and exciting. While most begin with manipulating a photo, they will soon realize their biggest challenge is choosing which of the digital media to investigate next (see Figure 1.1). From still images to animations to websites to immersive environments, the range of forms and possibilities appears limitless.

The tools for digital artists are unlike any before them. Rather than starting a collage by cutting out a picture from a magazine, you can simply copy several with a few clicks and then rearrange them. Or select a part and paste hundreds of them to form a pattern. Instead of erasing and redrawing a line,

you can reshape it with a drag of the mouse or even smudge it with your finger. A color can be changed instantly, and the palette of choices runs into the millions.

The freedom of working in digital media is liberating. When you can undo any experimental action instantly, disaster simply doesn't lurk in quite the same way as in traditional art. Because a digital artist "works with a net," the oil painter's hesitation, fearful about ruining a picture with the next stroke, or the sculptor making too big a chip and ruining a marble statue, are largely things of the past. Even the centuries-old foundations of the art world—its gallery and museum system—can be bypassed entirely since artists can choose to distribute their art electronically around the globe in online galleries, Twitter, or their own websites.

Despite (or because of) its transformative nature, the new media have not been greeted with universal enthusiasm by many of the art world's institutions. Some question how quality can be determined if every artist has his or her own gallery. Where are the gatekeepers? The ability of even children to tamper with images seems to threaten the nature of truth. Abuse of images, doctored or not, can be used to blackmail or even change the shape of an election. Artists, too, worry that control of an image that took them months to create can be lost as quick as a download (see Box 12.4 on "Copyright and Fair Use"). The impact of games on young people (and not so young) has led to fierce debates, causing some to accuse Game Designers of being responsible for mass shootings or the collapse in values of a whole generation. Because of these controversies, society may consider it not unreasonable to ask today's digital media artists, like any superheroes, to use their amazing powers for good.

ARTISTS AND TECHNOLOGY IN THE PAST

Ours is not the first era where artists have embraced new media and technologies in the face of resistance. It is worth remembering that all of what is today called traditional once did not exist. Many of the artist's materials we take for granted, even the most basic of art's tools, had to be invented or discovered. On some morning in prehistory, *someone* had to reach into the cooling embers of a fire and make some marks on a cave's wall with a piece of charcoal for the first time.

A discovery for which we have a bit more documentation was that of graphite in the Cumberland mines of England in the late sixteenth century. This material would transform the nature of drawing and cause the fall of metalpoint as the most favored artist's drawing tool. Just like today, a new medium—in this case, the pencil—was embraced because it offered artists new freedom. Lines were now easily erased. They could vary in thickness from light scratches to bold gestures based on the tilt of a hand and the pressure brought to bear. Two centuries later, the enormous value artists placed in pencils was illustrated during a war between France and England. Because graphite shipments to France had been halted by the war, armed guards were posted around the Cumberland mines after spies heard rumors that desperate French artists were planning a raid.

Art history is filled with examples of a new technology or medium emerging that sent art off in new directions. For centuries, oil paint was considered a poor material for art because of its slow drying time. It took the vision of artists like Leonardo da Vinci to see that this paint's "worst" characteristic was its best. His *Mona Lisa*'s success could never have been achieved if he wasn't able to keep reworking the oil paint for hours at a time and add fresh layers weeks, months, and even years later.

Many other technical innovations have helped change the history of art. The arrival of the printing press ushered in the first age of mechanical reproduction. The invention of metal paint tubes liberated artists from being tied down to the studios where they mixed their paint. For the first time, they could head outdoors and paint directly from nature. This led to the *en plein-air* techniques of French Impressionists like Claude Monet (whose work was called "an assault on beauty" and "wretched daubs

in oil" by critics). The invention of new brighter and more intense pigments led to the wild, colorful pictures of the Fauves and the Expressionists in the early twentieth century.

The assimilation of new materials into art is not just a Western phenomenon. The invention of paper in China around 100 AD was a catalyst for lyrical brush and ink painting. By the 1200s, skill in the "arts of the brush"—calligraphy and brush painting—marked one's membership in the cultivated, elite class. Even emperors labored to become expert in the application of ink to paper.

When European colonists brought nails, screws, and machine parts to the African Kongo lands, artists and *nganga* (ritual leaders) stuck them, along with bits of mirrors and glass, in ceremonial figure sculptures designed to hold magical ingredients (see Figure 1.2). Far from rejecting these alien materials, African artists believed it was the act of hammering these bits and pieces into the wood sculptures that activated their power.

In the 1950s, artists discovered industrial paint made of plastic polymers and re-christened it *acrylic* paint. Fast drying, water-soluble, cheap and available in buckets, it became a favorite material of abstract expressionists like Jackson Pollock and Helen Frankenthaler. Pollock loved to drip long lines of silver paint meant for airplanes with a stick across his revolutionary paintings. Frankenthaler was fascinated by how, when diluted and applied to raw canvas, acrylic paint would soak into the cloth and run—a technique now known as "soak and stain" (see Figure 1.3).

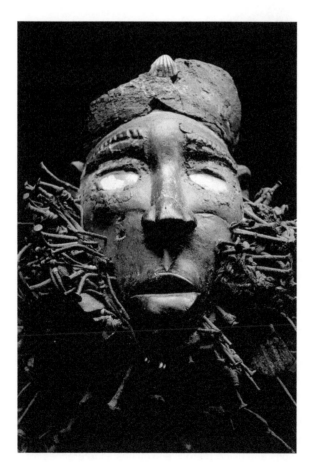

1.2
Kongo ceremonial figure

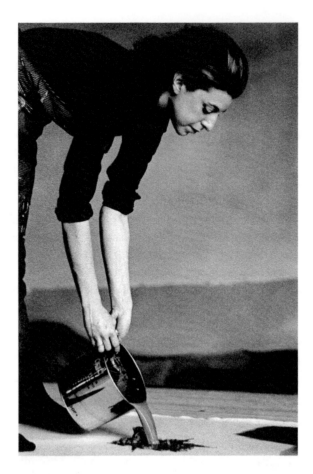

1.3
Helen Frankenthaler pouring paint onto canvas

Probably the closest analogy to the arrival and reception of the digital media in our time is the invention of photography in the nineteenth century. It would eventually change how images were perceived and even how time and history were recorded. It was also met with great resistance from the art world and not generally accepted as a medium for fine art until well into the twentieth century (see Box 1.1).

Box 1.1 The Art World vs. Photography

Like the impact of digital media today, the invention of photography (see Figure 1.4) in the 1830s was a troubling development to the art world of its time. The detailed realism that dominated Western art at the time suddenly had an upstart competitor.

Many visionary artists, like the French Impressionist Edgar Degas, the American Realist Thomas Eakins, and the French Romantic Eugene Delacroix, were excited by this new technology, taking their own photographs and using them like sketches as references for their pictures. But for

1.4
Mid-nineteenth-century portrait photograph by the Matthew Brady studio. The apparently angry subject is George Peter Alexander Healey, a prominent portrait painter

more conventional artists and critics, the new medium was seen as a threat. Some painters, particularly portraitists, worried it endangered their way to earn a living. It did end the careers of many engravers and lithographers, whose income had depended on reproducing art works. Among the most vehement opponents were art critics who felt obliged to defend art against this mechanical threat.

In an attitude we would find familiar today, photography's "purely scientific" approach to image making was said to have "ruined" the fine arts. Rather than promoting progress, it was seen as contributing to its "degeneracy." The great French poet and critic Charles Baudelaire, normally a voice for the avant-garde, wrote: "the disaster is verifiable. . . [photography is] the refuge of every would-be painter, every painter too ill-endowed or too lazy to complete his studies."

Yet almost from its inception the photographic vision changed our view of the world (see Figure 1.5). Because of the camera's ability to record an instant, we gained a new understanding of movement. Composition changed forever after artists had seen the way photographs crop off subjects arbitrarily at the edges of the frame. The beauty of the normally unnoticed alleyway or torn poster, the new perspective from high above a city, the once undocumented atrocities of war and other tragedies, have all affected what might be the proper subjects for artists. Photomontage, the combination of photographic elements, gave artists a new way to play with reality and a better way to picture the rapidly changing nature of modern life.

1.5
A new way of looking at the world: Los Angeles in the nineteenth century from a balloon

It was decades before photography was finally accepted as a unique fine art medium. So it may be for digital media. But as in photography's early days, we can see that the effects on art are already being felt, if not completely understood.

Like the photographer's darkroom, the digital artist works in an environment unlike the studios of the painter and sculptor. The Renaissance workshops and the Romantic's dusty, crowded attic garrets have been exchanged for rooms with desks, metal cases and cables, serenaded with the hum of machinery and MP3 files. Replacing the artists' finely ground pigments and secret recipes for modeling paste are now special software techniques and keystroke shortcuts. Yet, the digital studio is as magical as any loft or darkroom. Within the virtual world seen through a monitor, new visions appear.

THE DIGITAL STUDIO

In reality, the digital studios of most artists and designers are not very antiseptic. Just as in the past, their walls are covered with sketches of ideas and reproductions of works they admire. In addition to postcards and photos, they might have their bookmarks of favorite artist websites and a screensaver of inspiring images. Still prized are the old sculptor's books of anatomy and Muybridge's photographs of figures in motion, particularly for reference by animators. But now the bookcases and objects that have always lined the walls of artists and designers have been joined by the clutter of printouts, sketches, thumb drives, and peripherals (see Figure 1.6A and B).

The rapid miniaturization of computing technology is both amazing and liberating. Sixty years ago, a computer filled a room. Today, much more powerful ones than those can be imbedded in a children's toy. As a result, like the Impressionists once paint tubes were invented, digital artists have been freed from the chains of dangling electrical cords and can leave their studios because of the arrival of handheld tablets and phones. A twenty-first-century digital painter can comfortably sit with tablet and stylus in the same French landscape where Monet painted on his portable easel in the 1890s.

Of course, while there are parallels between the studios of digital artists and their traditional counterparts in the past, there is no question that their tools *are* different.

HARDWARE

At first glance, a desk in today's digital studio appears to be outfitted in a manner not unlike one for a clerk in an accounting office. On it, you'll see the basic elements of a typical computer: a box or *case* with slots and buttons, a monitor (usually separate but sometimes integrated into a single unit), keyboard,

1.6a & b
Artists at work: a nineteenth-century artist's studio and a twenty-first century animator's workplace

mouse, and printer. Looking at the back or sides of the box is even less impressive—just a gaggle of wires plugged into connectors. It is hard to imagine that these are the instruments of visual magic.

What separates a graphics computer from a business one is the quality of the components. Understanding these elements, explained in detail in Chapters 4 and 5, is critical for any digital artist. (These chapters also will help unravel the mysteries of computer advertisements.)

The first apparent difference will be the size of the monitor or **display**—the gallery wall for digital imagery. Digital artists and designers prefer to have large *high-resolution* monitors, ones that can display fine detail and millions of colors on as big a screen as possible. Some artists use two monitors at once, one just for tool bars, menus, and windows, the other devoted to displaying a large, crisp image.

Most of the most significant differences, however, will only be made clear when you understand what is inside the box (see Figure 1.7). The foundation of every computer is the **motherboard**, a long, flat card that looks very much like all electronics boards but is the center of all internal communication

1.7
More than meets the eye: inside a computer

in the computer (see Figure 1.8). At its heart is the **central processing unit** or **CPU**—the true computer, the brain of the whole system. Digital art and design make intense computational demands and require the most powerful and fastest processor an artist or designer can afford. Processing speed is measured today in gigahertz (GHz); thus, a computer will be advertised as having an "Intel Quad Core Xeon 3.0 GHz." A CPU is a miracle of miniaturization, not more than an inch wide, a few millimeters high and containing millions of transistors.

Also attached to the motherboard are thin strips containing random access memory or **RAM**. These memory chips temporarily store your programs and information while the computer is running. While this may sound inconsequential, the amount of RAM has a huge impact on how fast your computer will operate. Information bursts quickly while in RAM and slows down after the RAM's storage capacity is exhausted. For procedures that require complex processing, like applying filters to images or rendering 3-D animations, a click of the mouse on a computer without enough RAM can lead to a screen slowly remaking (or *redrawing*) an image, possibly stalling for minutes or even hours, or worse, crashing. Digital artists and designers will buy as much RAM as they can to avoid these troubles and work smoothly in "real-time."

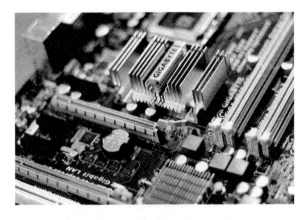

1.8
The motherboard is the foundation of the computer

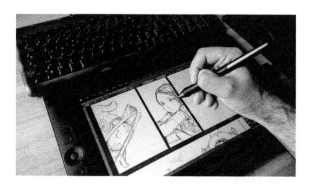

1.9
Artist working on a digitizing tablet with integrated monitor

Inside the computer's case, you'll also see wide, flat cables sprouting off the motherboard and connecting it to other cards and components. One of these is the *video card*, which transforms the digital information generated by the processor into a format that can be displayed on your monitor. Today's high-end video or *graphics cards* have their own memory and processors to speed up these calculations and share the workload of image processing. Graphic artists and animators want video cards with the most memory and fastest processing available in order to move the pixels on their monitor quickly and smoothly. (See Chapter 4 for a more thorough discussion of computer hardware.)

Sound cards function similarly, converting input from the computer itself or from recordings into the analog format understood by speakers. They can also operate in reverse and digitize input, from a microphone for example, so the sound can be edited in the computer.

Input—the information you send into the computer—for decades was the role of the keyboard and then the mouse (see Figure 1.9). While the invention of the mouse was a big step forward in making the computer an artist's tool (see Chapter 3), many artists and designers require a subtler tool to create their work. One such tool is a flat pad, called a **digitizing tablet**, which allows you to draw freely with a pen (or *stylus*) and sends the information directly into the computer (see Chapter 8 for a more comprehensive explanation). The sensors on the tablet are sensitive to the slightest movements of the pen (including its tilt and downward pressure). In recent years, the same technologies were adapted for touch-sensitive screens, so that fingers can be used as art tools, too.

Scanners are designed to **digitize** (convert to a form that a computer can understand) all kinds of materials for use by artists. The most common is the **flatbed scanner**, discussed in Chapter 4, which digitizes flat images, like photographs (see Box 1.2), prints, and drawings. These are relatively inexpensive, unlike 3-D scanners, which, depending on their complexity, can capture an object from all sides or the movements of a dancer in 3-D space.

Artist Profile: Ruud van Empfel—Realism beyond Reality

A young girl stares at the viewer while she floats in an unreal paradise in *World #7* by Dutch artist Ruud van Empel (see Figure 1.10). Each part of the world is crystal clear and seemingly perfect. But nothing is what it appears to be. The vegetation and the pond itself are constructed from photographs that van Empel took during visits to many different landscapes. Like a natu-

1.10
Ruud van Empel, *World #7*, 2005. Digital collage, 43" x 59". Des Moines Art Center, Iowa

ralist collecting insects, his walks are meant to gather images with his camera, raw materials that he can break apart later in his studio and add to his database of nature. With these bits and pieces, he then meticulously pieces together an imaginary seamless environment with the help of image-editing software. When complete, the only clue to its being unreal is its flawlessness. At times, he needs to soften parts to make sure that the illusion of reality is maintained.

Even the staring child is van Empel's creation. While she appears to be an innocent, if intense, young girl, she doesn't actually exist. Like the pond she swims in, she is built from a collection of elements from the faces of many children he has photographed over the years in his studio.

When asked what he is trying to express, van Empel has said,

> To me, both nature and the innocence of children is something beautiful. Children are born innocent into a cruel and dangerous world. I wanted to do something with that idea.

Trained as a graphic designer, he discovered "the new possibilities" of digital photography and collage allowed him to achieve his visions and "create my own reality."

Large works like *Wonder #7* take months to complete. Because of his technique, there is a debate among art critics about whether van Empel is really a photographer or someone who just works with photographic elements. In any case, his painstaking montages are clearly the work of an artist. The results are lovely and mysterious, familiar and unfamiliar at the same time. With the aid of a digital techniques, he is able to "re-create reality in a better way."

While the Web is full of material to be downloaded (see Box 12.4 on "Copyright and Fair Use"), **digital cameras** (whether a dedicated unit or on a phone) are the most common way to introduce your own digital images and videos into the computer. This digital material can easily be moved to the computer for editing by inserting a camera's storage card in a reader, transferring files via Bluetooth, or downloading it from Cloud web storage.

However, your carefully edited sounds, images, or other digital information will disappear forever when the computer is turned off or loses power unless you store them by saving. The computer age has witnessed a whole history of portable media for saving files, from floppy disks, *Zip* disks, CD-ROMs, thumb drives and memory cards, which have continued to evolve and increase in storage capacity since the first personal computers were manufactured. The disc drives, slots, or adapters where you insert these media can be *internal* (built into the case) or *external* (attached by cables to the back or side of it). Cloud storage (files stored in a remote location) is the latest version of external storage but requires an active network connection to retrieve files and can be time-consuming if the connection is slow. However, it will safeguard your files if your computer or phone is lost or damaged.

Hard drives are the computer's own permanent storage. Files stored on a hard drive can be retrieved quicker than any other storage medium and are the best place for editing them with software. Once measured in megabytes or a million bytes of data (MB), today's hard drives have grown by an order of ten into gigabytes (GB) or hundred in terabytes (TB). In an age of ever-increasing complexity in software, the growth of computer storage has been both fortunate and essential—because the hard drive stores not only the files you are working on, but all of a computer's programs.

SOFTWARE

A huge monitor and a computer loaded with RAM, the most powerful processor, and the finest video card, cannot display one marvelous graphic without the software or programs to do so. Software is what makes a computer work and each kind of software determines what you can do with a computer. The most important is the **operating system**. This is what appears when you first turn on a computer. It runs the programs and controls all the components of a computer (see Chapter 4 for a full discussion). The most common operating systems are Microsoft Windows, OS X, and Linux.

Operating systems have become increasingly easier to work with since the first personal computers. Important developments in their history, like the **graphical user interface (GUI)**, are discussed in Chapters 2 and 4. In order to function, programs must be written to work with particular

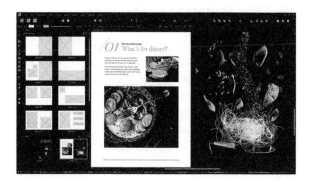

1.11
Digital layout and design software has transformed the graphic design profession

operating systems. For example, a game written for a Macintosh computer may not work in a PC that runs Windows.

Originally the domain of only computer scientists, the new field of digital media really began when graphics programs became both easier to work with and more sophisticated (see Chapter 3 for the evolution of digital art software). Over the last few decades, computer graphics programs have differentiated themselves into several types. Today, while most artists and designers use a mix of software, their specialties can be defined by the kind of software they primarily work with.

For example, **digital layout and design** software (once known as **desktop publishing**) is the primary tool for graphic designers. This graphics software transformed the publishing industry, replacing the old methods of cut and paste for laying out text and pictures in ads, magazines, newspapers, and books. Chapter 6 focuses on how designers accomplish their work with this kind of software (see Figure 1.11).

Photographers use *image-editing* programs that create the computer equivalents of many darkroom techniques, such as dodging and burning. The filters a traditional photographer screws onto a lens for special effects, like one to warm up the colors of a scene, can now be added digitally, with more flexibility and control. More importantly, image-editing programs have expanded the photographer's tools far beyond traditional ones. Many effects and techniques that never existed before have become the staples of the new field of digital photography (see Figure 1.12). The digital darkroom is the subject of Chapter 7.

1.12
Image-editing software has expanded the range of collage techniques (Manuel Camino, *Koi*)

Box 1.2 John Knoll—From Photoshop to *Star Wars*

The birth of Photoshop is not a well-known story, but one that links the history of digital media, animation, and motion pictures. Back in the 1980s, John Knoll was a young camera operator working on special effects at George Lucas' Industrial Light and Magic (ILM). When he toured the labs of ILM's special computer graphics division, he was amazed to discover that this small group of computer scientists and animators had developed software capable of manipulating large images on what they called the "Pixar Image" computer. (This team would later form the nucleus of Pixar Animation—see Chapter 10 for their story.)

After the tour, Knoll tried to write his own image manipulating software; one that didn't require a computer that cost hundreds of thousands of dollars like Pixar's, but could run on his home

Macintosh. Imagine his surprise when during a visit to his brother, a University of Michigan graduate student, he discovered that Thomas was already working on the same thing—as his Ph.D. thesis. Tom gave him a copy of the latest version of his software to try out, which already could find the edge of a shape in a photograph and adjust its brightness. Knoll added new functions and pushed his brother to create more, too.

In the 1980s, digital images were not so easy to come by. Knoll was excited when he saw an early flatbed scanner during a visit to Apple and convinced them to let him borrow it. This gave him a chance to digitize some of his photographs to test out their software.

It was a snapshot of his girlfriend during their vacation in Bora Bora that would make digital media history (see Figure 1.13) by becoming the first ever "Photoshopped" image. The picture of Jennifer—who would later marry Knoll—also ended up being the centerpiece of a presentation he made to prospective financial backers to demonstrate their new software's capabilities. Knoll called the photo "Jennifer in Paradise" and would stun the audience by cloning Jennifer again and again, so the beach would get crowded. As the topping on the cake, he took an island in the background and made a twin appear off in the distance. He did this by copying the island, then shrinking, re-positioning, and making it transparent—all common image-editing techniques today but never seen before. The Knoll brothers initially struggled with a name for their software ("Display" and "ImagePro" were early choices), but in the end settled on *Photoshop*.

After an art director at Adobe (a company that had already revolutionized graphic design with PostScript and Illustrator) saw one of John Knoll's demonstrations, he got the software publisher to not only buy the rights but hire Tom Knoll to develop it further. Adobe Photoshop version 1.0 was released in February 1990. Tom Knoll would go on to help create all the new versions up to CS4.

Meanwhile, John Knoll continued to work at ILM, ultimately becoming Chief Creative Officer and Senior Visual Effects Supervisor. There he has played a key role in the look of some of the most visually impressive television shows and films of the last 30 years. Among them are both the Special Editions of the original *Star Wars* trilogy and the more recent *Star Wars* films, *Avatar*, *Mission: Impossible*, and *Mission to Mars*. He has been nominated for many Academy Awards, winning for Best Visual Effects in 2007 with *Pirates of the Caribbean: Dead Man's Chest*.

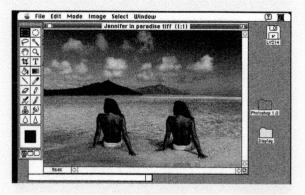

1.13
John Knoll—Jennifer in Paradise, 1987

Knoll, the child of a NASA scientist, says his career goals were shaped by seeing the first *Star Wars* at 14. It made him want to make "really big, innovative visual effects productions" and to win an Academy Award. He got hired after film school by impressing George Lucas' special effects company with his senior thesis—a short film made with his own handmade miniature models and a computer-controlled camera system he designed himself. Once at ILM, he made X-wing battle scenes on his home computer that surpassed the work of the ILM special effects team. He also wrote the software that took the Enterprise to warp speed on *Star Trek: The Next Generation*. His career continues to redefine what is possible in special effects. But what else would you expect from someone who used an early Macintosh to create Photoshop with his brother?

Digital painting software, the subject of Chapter 8, was consciously designed to recreate a traditional painter's tools and palette and, therefore, is also known as a *natural media* program. The digital painter can build up surfaces with digital layers of oil paint, mixing colors by dragging a virtual palette knife across the surface, or combine media that normally couldn't without making a mess—for instance, mixing markers, oil paint, and watercolors (see Figure 1.14).

Illustration software, a unique creation of the computer age, was actually the first of the digital art programs. Its approach to line and shape creation is mathematical and precise, closer to what was once known as mechanical or technical drawing. Yet in the hands of creative graphic artists, it has become a tool for lively, imaginative illustrations (see Figure 1.15). Chapter 9 focuses on the special flexibility and clarity of illustration programs.

Animation has experienced a rebirth with the arrival of new digital techniques (see Figure 1.16). The old methods of **cel animation**, the time-consuming work of drawing every individual frame, has been streamlined by two-dimensional (2-D) animation software (see Chapter 10). Artists can create remarkable animations or cartoons in the manner of Golden Age animators like Chuck Jones (father of the Roadrunner) on their desktop. Most animation software also includes methods of integrating and **synching** soundtracks to the animated action, as well as some special effects.

The tedious techniques of clay animation, once the territory of teams of animators, have been transformed into the uniquely digital techniques of 3-D modeling and animation (see Figures 1.17a and b). Because of the labors of 3-D modelers and animators, game players and moviegoers around the world have traveled to imaginary realms populated by strange, dreamlike creatures. This fascinating but challenging new medium is the subject of Chapter 11.

1.14
A digital painting by Chet Phillips, from his series "The Life of an Imaginary Friend"

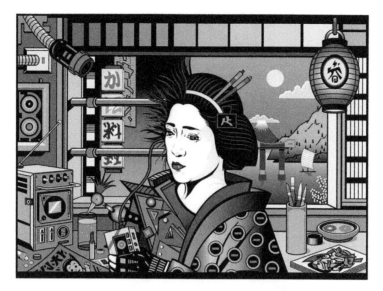

1.15
A digital illustration by Brad Hamann (*Kimona Lisa*, 2010)

1.16
Scenes from a popular web animation series (Adam Phillips, *Brackenwood*)

The arrival of the World Wide Web in the 1990s opened up even more possibilities for digital artists and designers. Since then, it has become a global gallery for the creations of digital illustrators, photographers, painters, and animators. However, designing Web pages (see Chapter 12) is an art in itself, requiring both the skills of the traditional designer along with an understanding of how people interact with this new medium. Specialized programs for web designers have moved the field from the realm of pure programming to one for the visually sophisticated graphic designer (see Figure 1.18). A truly successful series of web pages, however, is rarely the work on one person. Like all multimedia, it requires the efforts of a team (see Box 1.3).

1.17
Three-dimensional modeling and animation software makes it possible to construct and populate imaginary creatures (Basel Alnashashibi, *Blood Elf Warlock and Pet Dragon*)

1.18
With web design software, artists and designers can make the Web their world-wide gallery

Box 1.3 The Multimedia Team

The process of creating any kind of interactive media project requires a variety of skills of very different kinds. Whether the product will be a website, corporate training program, VR experience, or role-playing game, a multimedia team typically includes a minimum of three to five people. Larger teams have the general tasks broken up into subgroups with individual leaders. While the titles for these roles may change from project to project, the roles do not.

The role of a *Project Leader* is similar to a movie director. Clear goals and tasks for the team must be outlined. An understanding of each member's strengths and weaknesses, even his or her way of thinking, is very important. A cooperative and supportive environment must be established so each member will be encouraged to think creatively. On the other hand, the Project Leader also is responsible for ensuring the final product fulfills the original vision and goals. Usually, the Leader's greatest challenge is to orchestrate the team's activities so that the project is completed on time and within the budget.

The *Technical Director* will have a computer science or information technology background. Whatever specialized programming needs to be done is his or her responsibility. This specialist is also responsible for developing the technical plan. The *Technical Specialist* must understand the ins and outs of the team's equipment and software, as well as the target audience's (which may include many different computing environments). That means managing whatever software is being used to integrate the graphics, text, animations, video, and sounds, like a game engine, as well as customized coding.

The *Technical Writer* will develop the concept and the scripts for the multimedia production. The writer designs the structure for the flow of information and makes sure it is logical and easily understood. Clear writing and an understanding of the overall vision is critical for this team member.

The *Creative* or *Art Director* is responsible for anything visual, from individual graphic elements to the style or "look" of the whole project. He or she has to understand what the audience needs to see to enjoy and easily utilize all aspects of the production. In a large company, this artist/designer will either oversee a staff or hire freelance photographers, illustrators, and animators to create specific elements for the project. In a small company, however, all these tasks may fall to one person.

1.19
Multimedia creation requires a team of people with specialized skills.

Depending on the project, other specialists may be needed, such as a *Video Producer*. This team member will have the technical knowledge of video and editing. Beyond producing all the video elements, he or she may also be arranging locations, hiring and directing actors, and setting up lighting and props.

A *Sound Producer* will handle all audio recording (like narration) and editing, and select the background music and sound effects. A UX/UI specialist in interface design and its usability may be brought in who will focus on the logic of the overall design. Will the links or path make sense to a new user?

The possible roles in multimedia production are a catalog of the many jobs in digital media. Special effects designer (or Fx Artist), Concept Artist, character rigger, and lighting technician are just a few of the many people who may be necessary to complete a project.

In the end, the Project Leader must make sure that all the parts are logically integrated. He or she must decide if that Steam Punk look being pushed by the art director is really right for a demonstration on how a nurse should draw blood. As wonderful as it is, will Beethoven's Ninth Symphony be the right soundtrack for a playground scene in a children's game?

From brainstorming to creating the blueprint to production to testing the prototype and the final release, multimedia production is a challenging process for everyone involved. Each member will need to be sensitive to the importance of the contributions of others. Artists who are used to working alone in a studio, where every part is theirs to control, may find the team environment not to their liking. Many compromises have to be made for the sake of the whole project. Nonetheless, after the finish of a successful production, there can be great satisfaction in sharing the excitement with your teammates. That's a pleasure that no solitary artist gets to enjoy.

CONCLUSION: TIME TO BEGIN

Whether someday you will be a member of a multimedia team developing a video game, an animation studio, an advertising firm, an online sports network, or have a career as an independent artist, today you are walking through the first doorway to the newest way of making art and design. This book will provide you with a solid background for your learning; it will help you understand the potential and strengths of digital media and will amplify what you are experiencing as you explore them. We hope you will return to this book time and time again. Some sections may make more sense after you have been working in a particular medium for a while. In every one of the digital media there are years of learning ahead (if not a lifetime or two). Don't worry about ever getting bored. The hardware and software will continue to change, as will your skills, interests, and desires.

For some, this exploration of digital media will only reinforce their conviction that they are still most excited about the traditional media. That will not mean that this investigation of new technologies was a waste of time. Today, even the most traditional of artists needs to not only understand the many forms of social media but also how to produce elements for them in order to promote their work. In any case, it is admirable and sensible to try to understand each of the media available to artists and designers, whether one is just beginning or in the midst of a lifetime in the visual arts. And who can tell what change in perception will result from an exploration, no matter how brief?

On the other hand, if you've always known you were meant for a career in digital media, don't neglect traditional skills such as drawing and sculpting. Mastering them will only enhance the work you can do on a computer (and lack of such skills is one of the most serious limitations of many young artists, according to digital professionals). Don't ignore art history either. It is not just a dusty attic, but a rich resource of ideas and styles. A sense of it will also come in handy when a supervisor or colleague makes a reference to a famous work of art while planning a new project.

Now that you've begun, don't forget that being a beginner is sometimes an advantage. Beginners try things more experienced practitioners never would, and therefore make unexpected discoveries. No baby reads a manual before he or she takes those first steps. Expect many trips and falls. Don't fear them, learn from them. As much as we believe this book will enhance your learning and understanding of digital media, the most important thing is to get started. There is so much to learn.

Projects to Introduce Digital Media

1. Using your favorite search engine, look for digital artists who have online portfolios. List the different kinds of work and approaches you have found.

2. Using your favorite search engine, look for companies that specialize in design. List the different kinds of projects that digital designers are hired to do.

3. Divide a page into three columns. In the first column, make a list of the traditional media that artists and designers have used in the past. In the second column, see if you can find the digital media most comparable to the traditional one. In the third column, list the most common digital media software these artists and designers use to work in these new media. For example, if the traditional media is "Photography," then "Image-editing" might be the digital equivalent, and "Adobe Photoshop" the most common software package.

Part II
Hardware and History

Part II

Hardware and History

2 The History of Computers: From Calculators to the Web

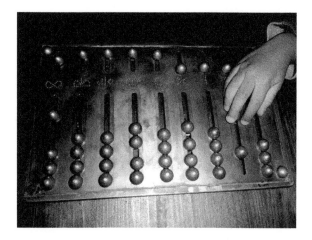

2.1
The abacus was probably the first computing machine. (Reconstruction of Ancient Roman abacus)

INTRODUCTION

Behind every artwork and design, no matter how new and innovative, are the efforts of the past. The digital media are fairly unique in the arts because they are not only influenced by centuries of art, but also the labors of scientists and mathematicians dating back thousands of years. This chapter will help you understand how the primary tool of digital media, the computer, was first conceived, its birth process, and its evolution. It is, of course, a brief history, since whole books have been devoted to this subject. The history of computers is much longer than you might expect—it goes back to nomadic traders roaming the desert.

IMPORTANT FIRST STEPS

The word *computer* has been a part of the English language since the seventeenth century, but until the twentieth century it referred not to a machine but to a clerk in an office who made computations. If one defines a computer as a machine that performs calculations quickly, it has much older, even ancient, ancestors.

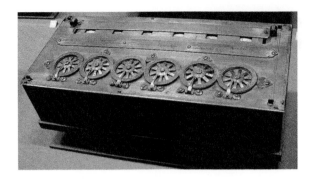

2.2
Blaise Pascal invented the Pascaline to help his father

The Abacus: The First Calculator

Between 3,000 and 5,000 years ago, traveling traders in ancient China and Babylonia began to calculate using an **abacus**; originally large, flat stones covered with sand. To use the ancient abacus, the trader would first draw a series of lines in the sand over a stone, then to make his computations, smaller stones were moved up and down the lines. This early computing machine allowed the trader to add, subtract, multiply, and divide very quickly. Eventually, the abacus developed into a portable system with beads that slid along several strings held in a frame (see Figure 2.1). One string and its beads represented ones, the next tens, the next hundreds, and so on.

Forms of this computer were used throughout the ancient world by the Greeks, Romans, Egyptians, and Chinese. Today, the abacus is still used in the Middle East, Asia, and Russia by merchants and for teaching children basic arithmetic.

The Pascaline

Around 1640, a French teenager, Blaise Pascal, decided to help his father in his rounds as tax collector by creating a calculating machine. Pascal's Wheel Calculator or **Pascaline** (see Figure 2.2) added large sums by rotating eight metal dials linked together by gears in a box. Each dial had ten notches. As one dial finished its revolution at the number ten, a gear would move the next dial up one notch. Because there were eight dials, his father was able to add up sums in the tens of millions. While they rarely reached such figures, Pascalines were still used until the end of the twentieth century—as grocery shopping calculators.

Pascal's Pascaline was an important landmark in the development of mechanical calculators, but even greater fame would come to the ingenious young man as one of the most important philosophers and mathematicians of the seventeenth century.

The Jacquard Loom

Sometimes progress comes from a surprising direction. In the early 1800s, Joseph-Marie Jacquard devised a new kind of labor-saving loom that ended up being vital to the development of computers. Looms have been in use since ancient times and are used to make cloth and other textiles. In the hands of a skilled weaver, very complicated patterns can be created. But before the Jacquard loom (see Figure 2.3), mass production of designs was impossible. Introduced at the 1801 Paris Industrial Exhibition, his loom controlled the patterns being woven mechanically with a set of boards with punched holes. If a rod on the loom met a hole, it passed through and the thread connected to it would not be added there. If there was no hole, the rod was pushed into action and added its thread.

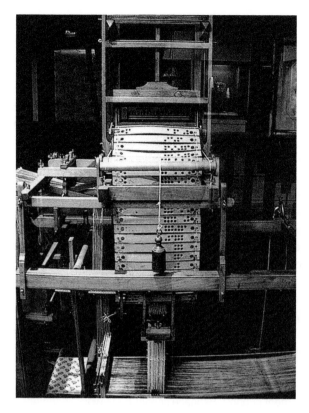

2.3
The patterns produced by a Jacquard loom were controlled by a series of wooden cards with punch holes

Now patterns could be repeated over and over again flawlessly. By varying the color of threads, even cloth with identical patterns but different colors could be offered by merchants.

An unfortunate result of Jacquard's invention was that weavers had the dubious honor of becoming some of the first victims of automation—in the years to come, a worldwide trend for many trades. French silk weavers rioted in protest, smashing the new looms. But as other skilled workers would learn, automation was a force that could not be resisted. By 1812, there were already 11,000 Jacquard looms used in France. In the next few decades, they would spread throughout Europe and transform the textile industry.

By century's end, Jacquard's innovation of using cards with punch holes to control a machine would prove to be just as significant in the development of modern computers. First, because it was one of the first examples of machine memory. Second, because the punched card system permitted only two actions, add the thread or not. This yes or no system is the language that is fundamental to all computers—what we know today as **binary code**.

Charles Babbage's Difference Engine and Analytical Engine

In the 1800s, producing mathematical tables was the tedious task of office workers known as *computers*. Some of these tables, such as navigational and astronomical ones, were of national importance because they were used to chart the courses for England's fleet of merchant ships. Errors were all too common and could be catastrophic not only for a ship's crew and the businessman who owned it, but

also for the national economy. It was said at the time that a table error was like "a sunken rock at sea yet undiscovered, upon which it is impossible to say what wrecks may have taken place." An English mathematician, Charles Babbage, devoted most of his career to creating a machine that could put an end to dangerous human errors by mechanizing computing.

He and his allies in the scientific community were able to convince the Parliament that finding a more scientific way to generate accurate tables was in the national interest of England. As a result, Babbage was given large government grants to develop what he called the **Difference Engine**. This computer would be capable of doing the calculations for mathematical tables mechanically and flawlessly. Babbage also designed his machine to print automatically because he knew that most errors did not come from mistakes in arithmetic but in the process of hand copying numbers.

Unfortunately, designing a mechanical computer is not the same as building one. Babbage worked for decades on the project and was regularly advanced more and more government funds (in just one ten-year span, he was given what today would be nearly a million dollars). A small working model of the Difference Engine was actually finished in 1833. However, it could not print and was not quite capable of making a truly functional table.

Babbage was a mathematician with great imagination and was constantly revising and improving his ideas. Not long after completing its model, he abandoned his Difference Engine project for a grander one, the **Analytical Engine** (see Figure 2.4). This computer, a machine powered by steam engines, was designed to be able to perform many more kinds of calculations. Unfortunately, after already experiencing years of investment with no return, this change of direction was the last straw for the British government. They no longer had faith in Babbage's ability to finish his project and stopped funding his research.

Even without government support, Babbage continued to work on the Analytical Engine for the rest of his life, although he never would complete it. This is not surprising—Babbage's plan called for over 50,000 parts. In old age, his workrooms were filled with bits and pieces of his various engines; each one abandoned for a new and better approach.

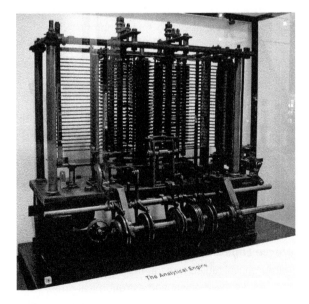

2.4
A model of Charles Babbage's Analytical Engine

While never realized, the Analytical Engine anticipated much of the concepts behind today's computers and, in particular, one technique that would be an essential part of computers through most of the twentieth century. To create a flexible and universal calculator, Babbage had the brilliant notion of borrowing the punch cards of Jacquard's loom to control it. A carefully organized set of punch cards interacted with pins on metal wheels. By allowing or preventing the pins to pass through a card, a prescribed series of mechanical actions would take place. In essence, the punch cards acted as instructions to create formulas for algebraic operations that Babbage named the "Mill," but what we would call today a "program." These cards could be stored for later use in what he called the "Store," what we might call today "memory." Babbage used names to describe his machine that were most familiar to his era, thinking the automatic motions of his machine were like the mechanical process of grinding grain.

Box 2.1 Augusta Ada King, the first female programmer

One of Babbage's colleagues who helped him secure government money for his great project was Augusta Ada King (see Figure 2.5), the only child of the great British Romantic poet, Lord

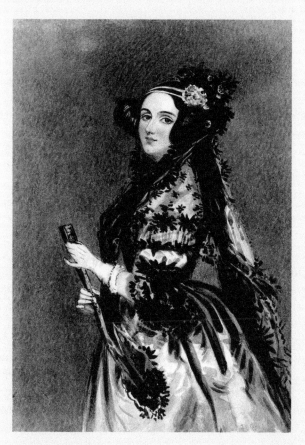

2.5
Augusta Ada King, the Countess of Lovelace

Byron. Abandoned by her father and brought up by her mother, Ada was steered away from poetry and directed towards the sciences. She became a talented mathematician, and after being introduced to Babbage, was entranced by his ideas and began a voluminous correspondence with him.

Ada, later Lady Lovelace, understood the Analytical Engine better than anyone other than Babbage. Her *Sketch of the Analytical Engine* explained the inventor's conception to the scientific community. It was far from simply a technical text because Ada was blessed not only with a superb analytical mind, but also inherited her father's poetic way with words. For example, to describe Babbage's innovative use of Jacquard's cards, she wrote, "We may say aptly that the Analytical Engine weaves algebraic patterns just as the Jacquard loom weaves flowers and leaves." Ada also was a visionary. Her writings predicted that an Analytical Engine and its descendants would be used not only for mathematical and scientific purposes, but also to create art and music.

Today, Lady Lovelace is best known for writing a series of instructions that drove the engine, designed to calculate mathematical functions. Because of this, she is considered the first woman programmer. The programming language ADA, developed by the Department of Defense in 1979, was named in her honor.

To sum up Babbage's truly revolutionary and prophetic vision, the Analytical Engine was designed to act universally rather than do only one simple mathematical operation. In his words, "to solve any equation and to perform the most complex operations of mathematical analysis." Today's computers are just such machines—universal calculators whose actions change depending on which programs or software is used. Thus, by the early 1800s (when John Quincy Adams was U.S. president), Babbage had already envisioned a digital machine that utilized programs stored on punch cards to vary actions and had a printer.

Across the Atlantic, later in the century, Babbage's concept of using punch cards to transmit instructions to the Analytical Engine would be a crucial element of a more successful and powerful computing machine.

The Census of 1890 and Hollerith's Machine

In the United States, the approach of a national census led to an important leap forward in the history of computers. It also set the nation on a course to ultimately become the world's leader in mainframe computing.

A census is more than simply counting all the citizens of the country. This once-a-decade tabulation has the deepest political ramifications. Census numbers determine how political districts are drawn throughout the country and how many representatives each area will have. Much of the government aid the nation distributes is allocated based on census numbers. An undercounting of any region can limit its political influence and prevent its citizens from getting their fair share of resources.

When the U.S. Congress first established the national census in 1790, the nation's population was less than 4 million. By 1880, the population had jumped to 50 million but the census was still primarily being done by hand. The 21,000-page 1880 census report was tabulated from countless handwritten sheets with many columns and rows. The final report took most of the decade to complete. As the 1890 census drew near, it was feared that the task had grown so great that it might not even be

finished before the 1900 census began. A national competition was established to come up with a new approach.

Only three people submitted proposals but one by a young engineer, Herman Hollerith, would change the history of computing. Hollerith proposed to replace the handwritten sheets with a punch card system that could be tabulated by a machine. The punch cards were descendants of Jacquard's and Babbage's innovations and could store 80 variables about an individual on a single card (see Figure 2.6). In a test that used records from the previous census, the **Hollerith Electric Tabulating System** was ten times as fast as its closest competitor.

The 1890 census would be the largest yet seen in history. In June, tens of thousands of census workers visited millions of households. In less than two months, census officials were able to announce the new population of the United States was 25 percent greater than in 1880—nearly 63 million. Unfortunately, the American public's reaction was not what the officials or Hollerith expected. Rather than being thrilled and amazed by the incredible speed of the mechanical tabulation, there was great anger. Most Americans had assumed the nation had grown to 75 million people (a total that would take ten more years to reach). While the Hollerith's punch card system was a significant scientific achievement, the census count ended up as a blow to national pride.

The Tabulating Machine Company Becomes IBM

In 1900, Hollerith's *Tabulating Machine Company* was once again hired to compute the next census. However, once his firm completed it, a new Census Bureau director decided it was time for the government to develop its own devices and stop paying Hollerith's fees. Hollerith was suddenly faced with either bankruptcy or finding new uses for his tabulating machines.

The ingenious inventor simplified them for general office use and renamed them *automatics*. In the Hollerith system, tabulation became an organized three-step process with three different machines: a keypunch, a tabulator, and a sorter. In the next ten years, Hollerith's automatics could be found in all kinds of businesses, from department stores to insurance companies, textile mills to automobile plants and, despite the Census Bureau's rejection, in government agencies at all levels. Because the machines were rented and keypunch cards needed to be restocked regularly, his company had a steady and dependable stream of

2.6
The Hollerith Tabulation System used to tally the 1890 census

revenue. The tabulations generated regular and special reports for sales, manufacturers, and officials efficiently and economically—making monthly reports a normal part of business and government life.

In 1911, Hollerith, in ill health and on the advice of his doctor, sold the Tabulating Machine Company for $2.3 million. The new owner hired a young, ambitious man to run the company—Thomas J. Watson, a name that would become synonymous with the rising computer industry (see Figure 2.7).

Watson, a successful salesman and rising star at the National Cash Register Company (NCR), was well equipped to understand the potential of the tabulating machines. He joined the new company with a small salary but a 5 percent commission on all the profits. Two decades later, Watson was the highest-paid person in America.

Watson applied the successful marketing and sales techniques of NCR to his new company, tripling its income. He opened offices around the world. In 1924, as the company's president, he renamed it the International Business Machines Corporation, or, as the world knows it, IBM.

IBM continued to follow Hollerith's business model, which made it less vulnerable than most companies to business downturns, even catastrophic ones like the Great Depression of 1929. Because most of its machines were rented, there was always a steady income each year even if not a single new machine was sold. In addition, there continued to be substantial earnings from selling punch cards. Even during the Great Depression, IBM was selling 3 billion new cards every year.

Throughout this grim period, Watson stayed loyal to his workforce even though there were very few new contracts. IBM factories continued making new machines to prepare for the return to the better times, which Watson was confident were ahead. As an advisor and friend to Franklin Delano Roosevelt (FDR), Watson's IBM found that prosperity *was* just around the corner. FDR's New Deal unleashed a myriad of government programs, which created a great demand for accounting machines, both in the public and private sectors. IBM, with a ready storehouse filled with new machines, became the biggest office machine producer in the nation. By the end of the Depression, IBM had nearly doubled its sales and had more than 12,000 workers.

As the 1940s began and World War II broke out across Europe and Asia, the urgent need for developing more powerful and sophisticated computing machinery would be a catalyst for the creation of the first modern computers.

2.7
IBM's Thomas Watson Sr. and Thomas Watson Jr.

BIG IRON: THE FIRST TRUE COMPUTERS

Colossus Breaks the Code

The official mathematical tables that so worried Charles Babbage in the early 1800s took on fresh importance during World War II. The navies on the seas, the bombers in the air, and the gunners in the artillery all required the most precise tables to locate and attack the enemy. An inaccurate weather forecast could cripple the best planned of military missions. Computing machines with punch cards were enlisted in the war effort, along with hundreds of civilians to operate them. There was tremendous government support, particularly in the United States and Britain, for developing machines that could work faster and make more complex calculations.

Another task that required new calculating machines was the effort to break Nazi codes. This became the focus of a secret and unconventional team from a variety of fields in Bletchley Park, outside of London. Among them was D.W. Babbage, a relation of Charles Babbage; Ian Fleming, the author of the James Bond novels; and Lewis Powell, a future U.S. Supreme Court Justice. The most brilliant was a mathematician, Alan Turing.

Turing was a visionary genius. He designed what he called the *universal automaton* (now known as a *Turing machine*)—the twentieth-century version of what Charles Babbage had worked so hard to create almost a century earlier. Although it could solve any mathematical problem, the Bletchley team specifically designed it to work on code ciphers. It was fed information via a tape marked in binary code. While much of the work at Bletchley remains a secret, Turing's first functional machine, code named *Bombe*, was able to decipher the German *Enigma* code. The Allies could translate intercepted German messages almost immediately.

Unfortunately, the Germans soon replaced Enigma with a much more complicated cipher, which the British called the *Fish*. To conquer this code, Turing and his colleagues devised a much larger machine, called *Colossus*. It was the first truly programmable computer. Rather than the electronic relays used by earlier computing machines, it was filled with over 1,800 vacuum tubes. Hot, expensive, and ravenous devourers of energy, vacuum tubes were much faster and quieter than relays. Too fast, perhaps, because when run at top speed, the tape fell apart and pieces flew in all directions. Since speed was of the essence in code-breaking, the Bletchley team slowed the processing down but put in five different processors that could work simultaneously, a technique known today as **parallel processing**.

Like Babbage before him, Turing felt it was essential to remove the human element from computing to eliminate errors. So Turing conceived of one of the most important ideas in the development of the computer—the **stored-program concept**. Instead of a machine depending on instructions fed to it with tapes or punch cards, the program was stored in the computer itself and only the data was fed in. Also, Colossus would print out its solutions.

The influence of Colossus as a tool of war was considerable. The Germans never learned of its existence or knew that their new code was regularly being broken. (It was said that Churchill read Hitler's messages before Hitler.) Many Allied lives were saved by the work at Bletchley Park.

However, Colossus' influence on the history of computers was limited. The Colossus computers were destroyed at the end of the war and the details of their existence were kept secret long after the war had ended. It is only in recent years that the visionary work of Alan Turing and his colleagues at Bletchley Park has begun to be understood.

Though only 35 when Germany surrendered, Turing would not live to see the birth of the Information Age he helped conceive. After the war, he devoted himself to realizing his dreams of a universal machine controlled by programming. Unfortunately, before he finished his work, he was arrested on charges of homosexuality (then a crime in Britain). Despite the testimony of his Bletchley colleagues about Turing's

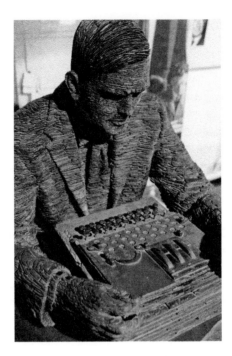

2.8
Alan Turing memorial at Bletchley Park (Stephen Kettle, sculptor)

important contribution to the survival of Britain, he was convicted and later committed suicide at the age of 42 (see Figure 2.8).

The Mark 1—Harvard/IBM

In the 1930s, Howard Aiken, a physics graduate student at Harvard, was tired of doing lengthy, complex calculations for his dissertation (its subject, by coincidence, was vacuum tubes). He wondered if he could make a machine that could do them quickly. When he tried to recruit some colleagues into participating in such a project, none were interested. However, a lab technician, after overhearing Aiken's futile attempts, told him they "already had such a machine and nobody ever used it." Aiken was then shown a dusty old relic—Babbage's calculating engine—one of the few working models he ever created. It had been donated to Harvard by Babbage's son in the late 1800s and promptly forgotten.

Aiken had never heard of Babbage, but found his autobiography in the Harvard library. While reading it, he sensed that "Babbage was addressing him personally from the past" and calling on him to continue his work.

Disappointed with his colleagues, Aiken began approaching business machine companies with his idea. He found an enthusiastic audience at IBM. By 1939, Aiken was working with some of their best engineers on developing the machine of his dreams.

In 1943, the Automatic Sequence Controlled Calculator was completed. A gift to Harvard from IBM, the project's cost had grown from the initial planned $15,000 to $100,000. The machine, which became known as the Mark 1 (see Figure 2.9), had also grown to the size of a room. It weighed five tons, was 51 feet long and eight feet tall, and looked like a huge manufacturing machine. With almost a million parts and hundreds of miles of wire, it could add, subtract, multiply, and divide. Fed information with rolls of paper tape, it was the first truly automatic machine. Once started, it could run for days doing

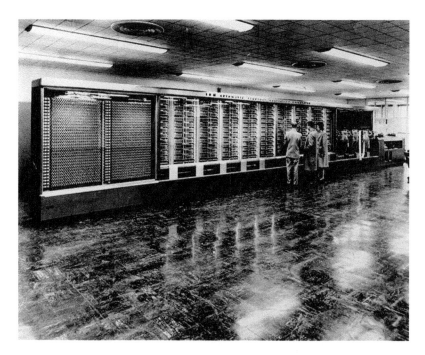

2.9
The Mark 1 computer

calculations. Unlike the Colossus, it did not use vacuum tubes, but the older electronic relays. The sound of the Mark 1 working was likened to "a roomful of ladies knitting."

The public dedication of the Mark 1 in 1944 at Harvard was a huge event. IBM's Thomas Watson commissioned one of the top industrial designers, Norman Bel Geddes, to enclose the machine in a sleek, modern, luminous design of steel and glass. Headlines celebrated the robot brain and, for the first time, the public became fascinated with computers.

Aiken, now in the Navy, put the Mark 1 to work on computing mathematical tables for ship navigation. Twenty-five volumes of tables were ultimately created but little more. Despite its limited achievements, the development of the Mark 1 was an important milestone that ushered in the era of the giant computers. It also was an important training ground for the first generation of computer scientists (see Box 2.2).

Box 2.2 Finding the Bug

Grace Hopper, one of the leading figures in computer programming, was a young Navy lieutenant when she worked on the Mark 1. As its primary programmer, she wrote the first book on digital computing—her manual for the Mark 1. A colorful, quick-thinking, and resourceful scientist, Hopper was able to save the day more than once for her colleagues. For example, during a tour of admirals, the Mark 1 was having many problems—the most obvious being that it shut down every few seconds. Hopper solved the problem by simply leaning on the start button during their entire visit.

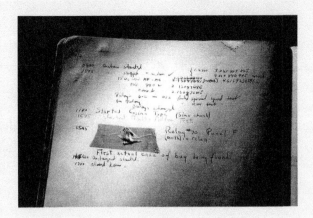

2.10
"The bug" Grace Hopper discovered

Her most famous solution came during the development of the Mark 2. In 1945, on a hot summer day, the Mark 2 shut down suddenly without warning. Hopper went inside the machine searching for the source of the trouble. She found a dead moth in one of the relays and began to remove it (see Figure 2.10). When asked by Aiken what was going on, she told him she was "debugging" the computer. Since then "debugging" software has become part of the job description of every programmer.

ENIAC

At the University of Pennsylvania, another team of engineers under contract with the Army was developing a massive computer that would work much faster than the Mark 1. Called the Electronic Numerical Integrator and Computer or ENIAC (see Figure 2.11), its speed was largely due to replacing old-fashioned mechanical relays with vacuum tubes—almost 18,000 of them. Aiken, who had done his thesis on vacuum tubes, had avoided them in the Mark 1 because he knew that their lifespan was very short and technicians would be replacing them constantly. However, the creators of ENIAC realized that the tubes largely failed during powering up—so they rarely turned it off. A good thing—the ENIAC drew so much power that whenever it was turned on, the lights dimmed across a whole neighborhood in Philadelphia.

When completed in 1945, ENIAC was the fastest calculating machine ever created. It could calculate the trajectory of an artillery shell in less than 30 seconds—quicker than one actually fell. One test showed it could do a complex calculation in two days that would take a person with a desk machine 40 years. One thousand times faster than the Mark 1, ENIAC replaced the earlier machine in the public's fascination.

The unprecedented speed of ENIAC turned out to be a problem. Technicians struggled to feed punch cards and tape fast enough to keep up with its 5,000 operations per second.

UNIVAC—Remington Rand

After World War II, the development of new, huge computers began to switch from military to peacetime applications. Two key engineers on the ENIAC project at the University of Pennsylvania, J. Presper Eckert and John Mauchly, decided to go into business together and design the next generation of huge computers.

2.11
Whenever the ENIAC was turned on, the huge mainframe would dim the lights of a nearby Philadelphia neighborhood

Like Herman Hollerith more than a half-century earlier, in 1946 they proposed to build their new machine for the United States Census Bureau. They called it the Universal Automatic Computer or UNIVAC (see Figure 2.12). Facing the first wave of the post-war Baby Boom, an anxious Census Bureau gave the men $300,000 to begin the project. Unfortunately, Eckert and Mauchly were better engineers than businessmen. Within two years, the men had nearly exhausted their funds.

Their company was saved by being acquired in 1950 by Remington Rand (later Sperry-Rand), a typewriter manufacturer that was expanding into computers. With fresh resources and personnel (including Grace Hopper, the lead programmer of the Mark 1), the team was able to deliver UNIVAC to the Census Bureau in 1951 but at a loss to the company of nearly $1 million. Nevertheless, the new computer was a success and the most technologically advanced computer of its time. UNIVAC's internal stored memory could hold up to 1,000 words, and data was stored not on the old paper tapes but on new magnetic ones. Magnetic tape could be read a hundred times faster than punch cards or paper tape and wasn't as fragile.

Not only was UNIVAC much faster than Eckherd and Mauchly's ENIAC, but, at 352 square feet, less than one-fifth of the old mammoth's size. This significant miniaturization of computer hardware helped establish a trend that continues today. "Smaller and faster" would become the rallying cry for future computer innovations.

Luckily, the government ignored the advice of the once visionary Howard Aiken, whose Mark 1 had begun the era of large computing in America. In a now famous misunderstanding of the need for new technology, he argued that the project should be canceled because the United States simply did

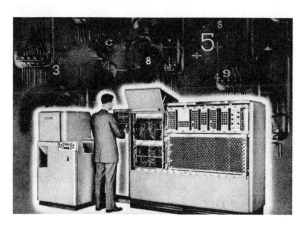

2.12
Illustration from an advertisement for the UNIVAC from the 1950s

not have "enough work for more than just one or two of these computers." In 1952, the government ordered five more UNIVACs. By 1955, more than 15 had been built and huge firms like General Electric began ordering their own UNIVAC computers (see Box 2.3).

Box 2.3 UNIVAC gets a national audience

The commercial success of UNIVAC was made certain by the presidential election of 1952. In an inspired piece of public relations, Sperry-Rand convinced CBS News to allow UNIVAC to be part of their election night coverage (see Figure 2.13). The company announced that their electronic brain would be able to beat the experts in predicting the outcome. On election night, however, viewers never actually saw the real computer in Philadelphia. Instead, a mock wooden one with blinking Christmas lights inside was shown all night behind the anchormen in the New York studios.

As the coverage began, CBS newsmen announced that the contest between Dwight D. Eisenhower and Adlai Stevenson was too close to call. Viewers were told that even UNIVAC was "stumped." This was disappointing but not a surprise since all polls had predicted a close race. What the viewers didn't know was that they were being misled. UNIVAC was far from stumped and early in the evening had already predicted an Eisenhower landslide. Because the computer's prediction was so far from conventional wisdom, the newscasters decided to ignore it. Even UNIVAC's engineers were convinced that something was wrong with their computer and began reworking its programming.

Hours later, however, it became clear that there really was an Eisenhower landslide. UNIVAC's original prediction was finally broadcast. It had been astonishingly accurate, off by only four electoral votes from the final results. The public was enthralled by a machine that appeared smarter than all the experts and commentators. UNIVAC was "seen" by millions on television and became the symbol of a new era. Today, one of the original UNIVACs is housed in the Smithsonian Institution as a landmark of the computer age.

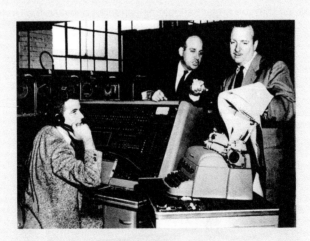

2.13
CBS News' Walter Cronkite at a demonstration of the UNIVAC before the 1952 election

IBM Responds to the Challenge

Under Thomas Watson, IBM had continued focusing on government contracts and did not see the danger represented by the work of Eckert and Mauchly. It was Watson's belief that IBM's dependable punch card accounting machines were a separate and distinct market from the inefficient and expensive colossal computers. But his son, Thomas J. Watson Jr., a veteran of World War II who shared control of the company in the 1950s, understood well the threat UNIVAC posed to IBM's dominance of computing. The popularity of UNIVAC among big commercial accounts was growing and IBM had no competing product to offer. Just as threatening was UNIVAC's use of magnetic tape for data storage. Suddenly, the revenue from millions of punch cards was no longer assured. Probably even more upsetting to Watson Jr. was that Eckert and Mauchly had offered their company to his father before Remington Rand and the elder Watson had turned them down.

After years of trying, Watson Jr. was finally able to convince his father that IBM was being left behind. The company doubled the budget for research and development and hired hundreds of new engineers. IBM moved into what was called, internally, "panic mode" and the result was the IBM 700 series of computers (see Figure 2.14). While their typical system continued to include a cardpunch and reader, it also stored information on magnetic tapes—the beginning of the end of punch card systems, just as Watson Sr. had feared. Capitalizing on a superior salesforce, smart modular design (for the first time each component was made small enough to fit into an elevator), and its reputation for customer service, by 1956 the rental of IBM 700s exceeded UNIVACs. Ultimately, IBM would control 75 percent of the market world-wide.

The First Programming Languages

By the late 1950s, the use of large computers in business, government, and universities was becoming routine. Besides IBM, large computer makers included Sperry-Rand, Honeywell, Control Data, and Burroughs. Each computer company had its own proprietary machine codes, making it difficult for companies to ever change systems or even hire computer programmers trained in other systems. If a company dared to switch computer systems, all its programs had to be rewritten. The need for standard programming languages was becoming more and more apparent.

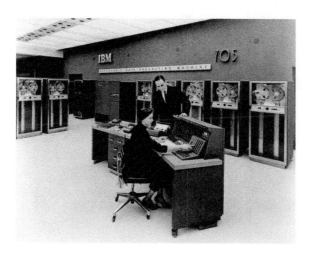

2.14
The IBM 700 series of computers was the first to be designed with modular components

In 1957, a team lead by John Backus at IBM created the first programming language that was hardware-independent. They called it **FORTRAN**, which stood for "formula translation." Upgraded versions of FORTRAN are still in use in today, primarily in the scientific community.

The U.S. government, meanwhile, had directed Grace Hopper, programmer for both the Mark 1 and UNIVAC (see Box 2.2), to lead the movement for a standard language to be used in government and business. In 1959, she developed the Common Business Oriented Language (COBOL) for programmers. Unlike FORTRAN, it was a language that used words rather than numbers. As Hopper described it, "I felt that more people should be able to use the computer and that they should be able to talk to it in plain English." While computer makers resisted giving up their control over profitable proprietary languages like UNIVAC's *Flow-Matic* (which Hopper had designed), in 1960, the government announced it would not use any system that couldn't be programmed with COBOL. That promptly ended the era of proprietary languages, opening the door to future hardware-independent languages like BASIC, Pascal, C, and C++.

THE TRANSISTOR, SILICON, AND SOFTWARE

Transistor Invented at Bell Labs

In 1947, while the UNIVAC was under development, an important invention took place at Bell Telephone Laboratories that would eventually transform not only the young computer industry but also most consumer appliances. The **transistor** (see Figure 2.15), invented by John Bardeen, Walter Brittain, and William Schockley, had many advantages over the vacuum tube it ultimately replaced. It was much smaller, did not need to warm up, required very little electricity to operate, created much less heat, and was much longer lasting. It was called a **solid state** device because all its parts were solid, unlike vacuum tubes.

2.15
The first transistor

Initially, there was little interest in the invention; the vacuum tube was well proven and cost less than a dollar. But a small Japanese company, Tokyo Tsushin Kogyo, took the lead by developing *portable* radios in the mid-1950s. The first portables were a quarter of the size of the smallest vacuum tube radios. As attractive as the new radios were, the company realized that in order to enter the U.S. market, they would need to find a company name that was easier for Americans to pronounce. Basing it on *sonus*—Latin for sound—*Sony* Corporation became the world's leader in utilizing transistors in a broad array of consumer appliances, such as record players, tape recorders, and television sets. In addition, the company's success was critical to the recovery of the Japanese economy after the devastating effects of World War II.

The Birth of Silicon Valley

In 1955, William Shockley, leader of the transistor team at Bell Labs, quit and went across the country to start his own company in the Palo Alto section of California. His Shockley Semiconductor Laboratory (transistors are known as **semiconductors** because they conduct electricity only under special conditions) was the first of many labs to settle in the area around Stanford University.

One of these labs, Fairchild Semiconductor (ironically, formed by defectors from Shockley's new company), would devise a new manufacturing method for transistors, which would lead to the next generation of computers and the region's nickname—*Silicon Valley*.

The first transistors had been wired into circuit boards by hand, limiting both the quantity that could be manufactured and the size of any circuit board to the number of transistors that could be installed with tweezers. Fairchild engineers realized that all parts of a circuit could be made of silicon, not just the transistor itself. By imbedding transistors directly into silicon sandwiches or *chips* with printed metal connections, machines could mass-produce the circuit boards, and the size of transistors could shrink to no more than the size of a flea. This was called an **integrated circuit**.

Intel and Moore's Law

In 1968, three of the founders of Fairchild Semiconductor, Robert Noyce (who had co-invented the integrated circuit), Andrew Grove (who had discovered the best form of silicon for circuits), and Gordon Moore, decided they did not approve of the way Fairchild was going. Together they founded a new company that focused on building special silicon chips designed strictly for storing computer memory. They called their company Integrated Electronics or *Intel*.

Moore was a brilliant scientist, yet his greatest fame came from a graph he drew in 1965 that showed that the power of memory chips would double roughly every year while the cost of producing them would be cut by half. (In 1975, he revised his prediction to every two years.) **Moore's Law**, as it became known, withstood the test of time much better than expected and explains why a computer or smartphone you bought today becomes obsolete in a very short time. It was not until 2019 that Moore himself declared the law had "run out of gas" because "transistors are made of atoms" and could not get smaller. He said, at the time, that he "was amazed that the engineers have been able to keep it moving as long as they have."

In 1971, Moore's Law was more than proven when Intel built a chip with more than 4,000 transistors on it. Intel engineer Ted Hoff utilized this new technology to create the first **microprocessor** (see Figure 2.16). Originally designed for calculators, Hoff's microprocessor combined on one chip all arithmetic and logic circuits necessary to do calculations—a "computer on a chip" as the company's advertising described it. When Hoff's team connected this new chip to Intel's memory chips, they harnessed the processing power of the enormous ENIAC of 1945 in a package less than an inch wide.

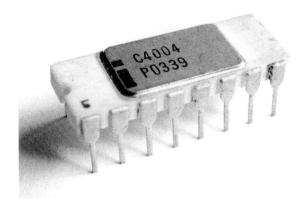

2.16
The Intel 4004, the first microprocessor

The microprocessor's first impact was in the production of low-cost handheld calculators that spread worldwide and immediately made engineer slide rules obsolete. Only ten years later, the microprocessor of a VCR already had more computing power than Eckhert and Mauchly's early colossal 50-ton computer. But unlike ENIAC, which drained enough power to dim a Philadelphia neighborhood, a VCR's chip required less energy than a lightbulb. Today, microprocessors that would have astounded the pioneers of computing can be found in nearly every kind of electronic device and appliance.

The Sovereignty of the Giant Mainframe Comes to an End

The first microprocessor was called the Intel 4004 (the number referring to the number of transistors). While some manufacturers put the chip in toys, its limited computing power restricted its use to fairly simple operations, like those used by handheld calculators.

Meanwhile, IBM became the dominant force in the mainframe world with its System/360 computers. This was a family of computers that all shared accessories and used the same language—a concept called **scalable architecture**. If a customer needed to increase the size of their computers, it could now be done easily without purchasing new software and retraining the entire staff. By the 1970s, the dominance of IBM was so total that competing mainframe companies could only survive if their system ran IBM software.

In the 1960s and 1970s, the lure of computers began attracting a new generation of students to the industry. Computer science became one of the fastest growing majors at colleges and universities across the country (see Figure 2.17). Programming homework required each student to sign up for

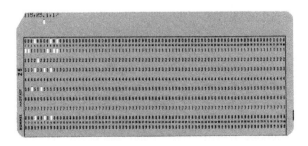

2.17
The bane of 1970s computer science students: a punch card

dedicated computer time, when a large package of computer cards they had carefully punched would be fed into readers wired into the campus mainframe. A successful program would result in long, wide sheets of green paper pouring out of the printer. However, bent punch cards and programming errors were much too common. Phrases like "do not fold, spindle, or mutilate" and "garbage in/garbage out" were born from the frustrations of young student programmers.

Few could see that the little processor in their handheld calculators was opening a door to a whole new approach to computing and the beginning of the next revolution in computers. From the 1940s into the 1970s, computing meant mainframe computing. But like the stone David hurled at Goliath, the tiny chip in the hands of some young visionaries was going to change the world and leave the old giants behind.

THE PERSONAL COMPUTER

Two events mark the beginning of this next era of computing: Intel's release of the 8080 chip in 1974 and an article published in *Popular Electronics* magazine in early 1975. Twenty times more powerful than the 4004, the 8080 had enough capacity to handle about 4,000 characters of memory; more than enough to store not just numbers, letters, but even some simple programming. The chip cost less than $200.

The cover of the January 1975 issue of *Popular Electronics* announced "World's First Minicomputer Kit to Rival Commercial Models" with a picture of a small box with diodes called the *Altair 8800* (see Figure 2.18). It was the machine that inspired a revolution. The kit cost less than $400 and used the

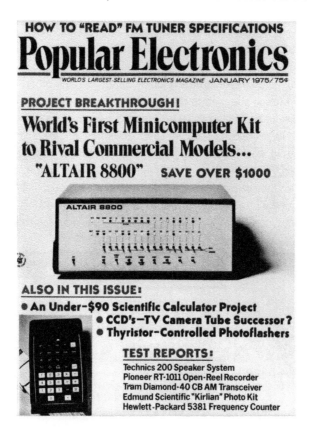

2.18
Inspiration for the revolution: the Altair 8800

2.19
Paul Allen and Bill Gates, the founders of Microsoft, working on a computer in high school

8080 chip as its brain. Young hobbyists swamped the manufacturer, MITS, with orders, and began writing their own programs.

In the state of Washington, two imaginative young friends spent five weeks adapting a simple programming language, **BASIC (Beginners All-purpose Symbolic Instruction Code)**, for the Altair. They were so excited about the future of small, cheap computers that they decided to start their own software company. One, Paul Allen, quit his programming job at Honeywell; the other, Bill Gates, quit Harvard. They first moved to New Mexico and then to Seattle, calling the company *Microsoft* (see Figure 2.19).

Around the same time, just down the coast in California, two other young men were already in business selling "blue boxes," illegal machines that let users make free long-distance calls. Steve Wozniak, a Hewlett-Packard programmer, and Steve Jobs, who would drop out of Reed College, were members of a group of hobbyists called the "Home-brew Computer Club." In Jobs' parent's garage, they built their own microcomputer, which they called the Apple I. Jobs thought he could sell it to the same hobbyists who were so excited about the Altair and soon had his first order of 25. To raise the money to build their machines, Wozniak and Jobs (see Figure 2.20) sold their most prized possessions: a Volkswagen mini-bus

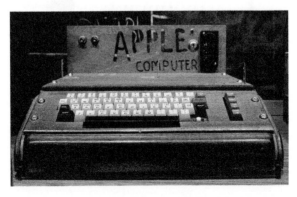

2.20
The first Apple computer. Hobbyists had to build their own cases because it didn't come with one

and a programmable calculator. With the $1,300 they raised, they formed a company called **Apple** and designed a logo that would become famous—an apple with a bite out of it (a pun on the word "byte"). The Apple I cost $666 and they would eventually sell 600.

It was their Apple II in 1977 that truly launched the minicomputer revolution. Not a kit, but an already assembled machine, the Apple II had graphics, sound, and a color monitor. It even had a computer game designed by Wozniak that bounced a ball around the screen with paddles. Jobs recruited programmers to design other applications. One, VisiCalc, was the minicomputer's first budget spreadsheet program and was the program that transformed the market for minicomputers beyond the hobbyists to the business world. The Apple II would eventually generate over $100 million in sales. Another reason for its success was the introduction in 1978 of the first floppy disk drives for consumers, which replaced the cassette tapes that had been used to store information.

While the Apple II would be the top-selling microcomputer for five straight years, as the microcomputer explosion continued, other companies began selling them. Among the competitors were Radio Shack, Atari, Texas Instruments, and Commodore.

The IBM PC

While they continued to control 80 percent of the mainframe market, by 1980 executives at IBM became concerned that they were not participating in what was becoming a significant, fast-growing market in small computers. Never known for quick product development cycles, IBM, acting out of character, authorized an innovative lab director named William Lowe to put together a team of engineers to quickly develop a prototype minicomputer which could be on the market in one year.

The development of what would be called the IBM Personal Computer or "PC" would have lasting effects on the development of the PC industry (see Figure 2.21). Breaking with past practices, IBM decided to sell the PC in retail stores and buy components like the Intel 8088, rather than manufacture them themselves. Even programming the PC's operating system and software would be contracted out. This was the beginning of the concept of **open architecture**.

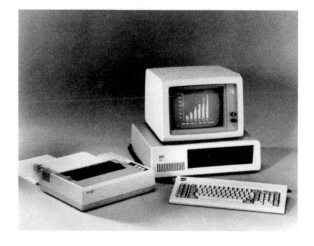

2.21
The original IBM PC

In Seattle, Bill Gates and Paul Allen already had a growing business selling versions of BASIC for the various microcomputers being developed. When IBM approached Microsoft for a version to be used in their new computer, Gates proposed that his company design the PC's operating system, too. Microsoft quietly bought the rights to an operating system called QDOS (or "quick and dirty operating system") from another company, hired its chief engineer, redesigned it, and called it PC-DOS. Microsoft offered it to IBM for a low, one-time fee that allowed IBM to use it on as many computers as it wanted. In return, IBM agreed to let Microsoft retain the licensing rights, allowing the small company to sell it to other companies (under the name MS-DOS).

In August 1981, almost exactly a year after the project began, IBM began selling the IBM Personal Computer at retail outlets, like Sears. Primitive by today's standards, the IBM PC had only 64K of RAM and one floppy disk drive. A color graphics card was optional. It cost $2800 (not including the monitor) and was a huge hit. In four months, 35,000 were sold. Small microcomputer companies soon found it difficult, if not impossible, to compete with the huge IBM sales and marketing teams.

With the success of the PC came many innovative software packages. While the original PC came with its own version of VisiCalc, Mitch Kapor designed spreadsheet software called *Lotus 1–2–3*, which would become the PC's "killer-app." Word processing packages like *WordStar* and *WordPerfect* helped make not only the IBM PC a success but also Microsoft's DOS, which was necessary to run them. Within three years, no competing minicomputer company, other than Apple, would use any other operating system. Those that had unique software systems and hardware simply went out of business. A few, like Commodore, survived by migrating their businesses into computer game machines (see Chapter 3).

In their place, an IBM-compatible or "clone" industry arose, led by Compaq, Texas Instruments, and Toshiba. A college student, Michael Dell, started selling mail order computers from his dorm room.

IBM kept ahead of these rivals by releasing new machines (though they would soon be cloned). In 1983, it released the PC-XT with a 10 MB hard drive. Its **AT** with an 80286 (or "286") processor was three times faster than the original PC and would lead to IBM's controlling 70 percent of PC sales in 1985.

Still, all these systems were text- and code-dependent. Users constantly had to refer to thick manuals to make the programs work. To simply copy a file from one drive to another, one had to type, "COPY A:\BOOK.TXT B:\BACKUP\BOOK.TXT." If a letter or space was wrong, it wouldn't work and one had to type the whole line over. In addition, while they all worked with DOS, each program had its own interface and codes for users to remember. While in the early 1980s, artists had begun exploring the computer as a new medium, PC graphics were remarkably simple and limited to 256 colors. For most artists, the programming necessary to simply draw a circle on the screen was not worth the trouble.

The Graphical Age Begins

A revolution in personal computers was announced in one of the most famous commercials of the 1980s. Shown only once, during the 1984 Super Bowl, viewers saw a runner in full color run past crowds of gray, bland workers. She then hurled a heavy hammer against a giant screen showing Big Brother, an image from George Orwell's *1984*. As the screen shattered, the voiceover said simply, "On January 24, Apple Computer will introduce the Macintosh. And you'll see why 1984 won't be like 1984."

The look of the Apple Macintosh computer (see Figure 2.22) was part of what made it extraordinary. It was simple with clean, curved lines and a monitor built into the same box as the CPU. But what made it stand out from the PC and its clones was what one saw on the screen. All of its software, including the operating system, was graphical. Microsoft collaborated with Apple in designing the first graphical word processing program, *Word*, and spreadsheet, *Excel*. A graphical user interface (or GUI—pronounced

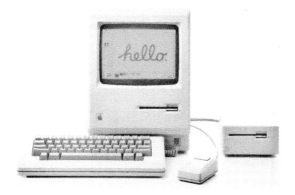

2.22
Apple's Macintosh computer became immediately famous for being user-friendly

"gooey") had been on earlier machines but it was the widely marketed Macintosh that was the first to be known as "user-friendly" (see Chapter 3).

The Mac's GUI could be understood and used with a little experimentation and without a manual. It had windows, icons, and pull-down menus that were controlled, not by a keyboard, but by moving and clicking a mouse. Using the desktop as a metaphor, files could be dropped into folders that were easy to label. A file could be copied into another drive by simply clicking and dragging it to the icon for the drive.

Still, business users did not embrace the Macintosh, due to IBM's established reputation in the business community and the wider array of business software on the PC platform. But because it was a graphics-based machine, the Mac was immediately accepted as *the* computer for artists. A wide array of digital art programs was written for it and it even came with fun *MacDraw* and *MacPaint* software. The Macintosh's ease of use made it popular in homes and in schools, too. In addition, combined with the Apple LaserWriter printer and new design software by Adobe, the Macintosh became the favorite of the design and publishing industries. It introduced desktop publishing (see Chapter 6) and a world of variety in typefaces and styles. A creative person could write, edit, design, illustrate, and lay out a whole book—all on one small computer.

The arrival of the Mac solidified the divide between PC and Apple computing: PC users were seen as straitlaced, serious, and old-fashioned, Mac users as creative, spontaneous, and youthful.

Windows Comes to the PC

A year later, GUI came to the PC in Microsoft *Windows*. Bill Gates had begun its design back in 1981 when he first saw what Apple was working on. Despite imitating the Macintosh interface, Windows was far from popular in this first version. It had two significant handicaps. First, the market required that DOS remain the main operating system so old DOS software could still be used. This made Windows in essence a second operating system sitting on top of another. Second, it ran very slowly, frustrating users and comparing badly with the Apple Macintosh (see Figure 2.23).

It wasn't until five years later, with the release of Windows 3.0 in 1990, that Microsoft really created a GUI environment that worked as well as the first Apple Macintosh. Its windows could be resized, and several software packages could be open at the same time. Microsoft's software designers rewrote their other software to complement the new environment, creating its Office suite of Word, Excel, and PowerPoint. The once-dominant competing products, like WordPerfect and Lotus 1–2–3, now found themselves turned into secondary players. Even before the release of Windows 3.0, Microsoft had

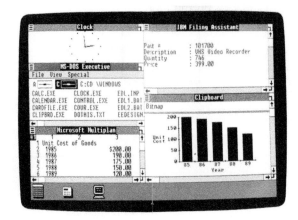

2.23
An early version of Microsoft Windows

become the largest software company in the world. In the early 1990s, it seemed that by the end of the decade, Microsoft was going to have few competitors other than Apple.

The Arrival of the Clones

One factor that made Windows 3.0 successful was the arrival of faster processors. Since the beginning of the 1980s, Intel had steadily released faster and cheaper microprocessors, proving the law of their founder Gordon Moore. These new chips could not only handle the new, more demanding programs, but also ran earlier software faster, too. By the mid-1980s, Intel dominated the chip industry much as Microsoft dominated software. However, the personal computer industry was shifting.

New industry leaders whose focus was on mail order sales, like Gateway and Dell, took the lead in developing the fastest, most sophisticated PCs. With lower prices than the older manufacturers, they began to dominate the market. When the first Intel Pentium chips were released in 1993, PC-clone manufacturers beat IBM in the race to release the first machines with the latest chips.

A shocked IBM and Apple began to lose ground in the personal computer market. With the success of Microsoft's Windows 95 and the proliferation of low-cost, powerful PCs, many experts predicted that Apple would not survive to the end of the decade. While loyalty to Apple among graphics and multimedia users remained strong, by the mid-1990s, it was not unusual to see some PCs next to Apple computers in former strongholds of Mac computing.

THE BIRTH OF THE INTERNET

In the 1990s, another revolution was brewing that caught almost all the technology experts by surprise and once again created a change in direction for the entire computer industry. The first sign for most computer users was the growth in the use of email at their offices and schools—the first popular application of the **Internet**.

The Internet had been born nearly 30 years earlier as **ARPANET**, begun by the U.S. Defense Department in 1969. It was designed to network huge computer systems together to store information, share computing power, and help researchers at their many military sites around the world communicate with each other. When research scientists at universities began to use this system, the Internet's use began to expand rapidly (see Chapter 12 for a fuller discussion of the development of the Internet).

Today, the Internet is billions of computers around the world communicating together. Its success can be traced to the fact that its content is *distributed*. The Internet is a huge worldwide shared database, containing far more information than can be stored on any one computer.

The World Wide Web: Internet Goes GUI

The original Internet was only in text, with screens displaying on black or green backgrounds with white or yellow characters. The World Wide Web is a relatively recent development of the Internet. It began in 1989 at **CERN (Conseil Europeen pour la Recherche Nucleaire)** in Geneva, Switzerland as an aid to easier collaborations between physicists and engineers working on different systems. Its goal was "universal readership." Like the Internet, the Web's development and impact has expanded far beyond what the originators first envisioned (see Box 2.4).

Box 2.4 Tim Berners-Lee: The Father of the Web

In 1990, the British engineer Tim Berners-Lee was a researcher at CERN, based in Switzerland. On his own initiative, he wrote a program that originally was designed to store and link documents by the many CERN scientists across their worldwide computer network. He soon saw that it had a far broader application—as a way to help organize information across the Internet. His program assigned addresses to all the documents on the Internet, which allowed users to quickly travel from one computer in the system to another.

Berners-Lee envisioned a global network of linked information, which he called "the World Wide Web." While his proposal was initially ignored by the scientific community, Berners-Lee, with encouragement by his supervisors at CERN, got to work on creating the tools necessary to implement it. By 1992, he had designed the first World Wide Web **browser**, distributed it for free, and ran the first Web server from his desk (see Figure 2.24).

While this network soon began to grow, in the first year there were less than 30 Web servers in the world. The user's experience was quite different from the Web today. Initially, it was a com-

2.24
The computer that Tim Berners-Lee used to create the World Wide Web at CERN. (Sticker reads "This machine is a server. DO NOT POWER IT DOWN!")

pletely text-based environment—there were no pictures and no buttons. Still, you could easily link from one page to another.

Ultimately, with the help of many other scientists and programmers, Berners-Lee's vision of documents linked across the globe utilizing hypertext would triumph, transforming computing and the world. Today, he continues his work as the director of the non-profit World Wide Web Consortium, which manages the Web and approves any new changes and standards. In 2018, he established the World Wide Web Foundation, an organization that campaigns for a Web that expands access, is safe, and will always remain free and open for everyone.

It required the imagination of a group of computer science students at the University of Illinois, led by Marc Andreessen, to change the Web from a tool for elite computer scientists to one that captured the imagination of people around the world. They devised **Mosaic**, the first true web browser, in 1993, and made it available to the public for free. Mosaic changed the Internet from a text-based environment to an interactive, multimedia one, much like the change from the command-driven DOS to the graphic user interface of the first Macintosh, a decade earlier.

The first Web browsers had several features that led to its immense popularity. First, they were *interactive* and utilized **hypertext** and multimedia. Instead of getting information in a linear way (like a book or magazine), users clicked on a topic and went directly to more information on it. A series of links could lead to "deeper" information or related topics. Documents were no longer limited to text but could contain colors, images, sounds, animations, and video.

Like today, the early Web's information was both *searchable* and *dynamic*. Websites with *search engines* then scanned hundreds (vs. hundreds of millions today) of websites for relevant information. The first Web search engines, like WebCrawler, AltaVista, and Yahoo, were critical to its success.

Most importantly, the Web was **platform independent**. It didn't matter what kind of computer and operating system you were using, any computer with a browser and Internet connection was able to access the Web's information.

When Marc Andreessen graduated from the University of Illinois, he was surprised when the school told him it owned Mosaic. In response, he formed a new company called *Netscape* in 1994. Netscape's *Navigator* was a more sophisticated browser that supported email and plug-ins, and also expanded the kinds of media browsers could display. Easy to use and free to the general public, millions of people first experienced the Web through a Netscape browser. They and many organizations, and businesses also began developing their own websites. By 1996, there were more than 16 million different websites.

Today, the World Wide Web is managed by the World Wide Web Consortium (W3C) (CERN turned authority over to it in 1994). Led by Tim Berners-Lee, the Consortium's nearly 500 international members are responsible for establishing the standards for all web applications, such as those for addresses and updates to language of the Web, **HTML** (see Chapter 12). Its mission is to maintain universal access and promote the evolution of the Web.

CONCLUSION

When Charles Babbage imagined a universal calculator, able "to solve any equation and to perform the most complex operations of mathematical analysis" more than a century and half ago, he was truly a visionary. Yet, the results of this vision are far more universal than anyone could have imagined and

continue to unfold. His colleague, Lady Lovelace, was the first to perceive that artists might see this universal calculator as a new medium for creativity. We are still at the pioneering edge of this vision.

As discussed in the first chapter, technology has long been an important catalyst for artistic innovation. In the nineteenth century, the invention of tubes for oil paint liberated painters from their studios and led to Impressionism. The discovery of new pigments by German chemists at the beginning of the twentieth century led to the wild, imaginative colors of Modern Art. By the end of that century, computers that were hundreds of times more powerful and fit in a briefcase easily surpassed huge computers that once filled a room.

It is a cliché but nonetheless true that in our time the only constant is change. How today's artists and designers will respond to rapid changes and utilize the new tools that have been put in their hands is unfolding before our eyes. It is both a blessing and a challenge to live in a time when an important chapter in the history of the collaboration of art and technology is being written.

Projects: The History of Computers

1. Interview your family members about their first encounters with computers. Find out when they first heard about them and what they were like then. Ask when they first purchased a computer and to describe it.

2. Visit the websites of two major computer manufacturers (for example, Apple and IBM) and write a report on their histories, comparing them.

3. Write an essay on the impact of computing in your life. Consider how pervasive computing is today. Try to identify how many appliances you own that have computer chips in them. Then consider how the manufacturing processes of other items you own require computer technology.

4. Which five major events in the history of computing do you consider most important? Explain and defend your choices. If you could extend the list to ten, which five would you add? Why?

3 The Pioneers of Digital Art

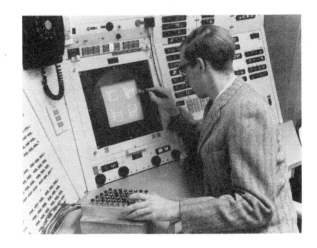

3.1
Ivan Sutherland's Sketchpad, the first computer graphics system

INTRODUCTION

The story of digital media is still in its early stages. This chapter focuses on key moments between 1960 and 2000 when the new tools for art and design were being established. Because of the extraordinary costs and complexity of computer machinery before the arrival of personal computers in the 1980s, the beginning of the history of digital media was not be written by artists. Progress in the early years was largely the work of imaginative engineers who had a fascination with art and access to big, expensive hardware. While Andy Warhol may have said "I want to be a machine," artists with an interest in technology in this period were quite rare. However, it ultimately would be the uneasy alliance of these two groups that gave birth to the field as we know it today.

ART OR SCIENCE?

In the 1960s, there were really only a few ways to make "computer art" and they were all very time-consuming. Results were limited to linear, geometric forms, though often in quite intricate patterns. These would be printed by **plotters** (large printers with rolls of paper, the marks being made by moving pens). Programmer-artists defined the parameters of a design using mathematical formulas. These were fed into the computers with tape or punch cards. The program might have to run for an hour before the printing process could even begin. Once started, one image would take hours to print. The "creative"

part of the process involved the naming of the variables and coordinates, which would determine the results. The complexity and limitations of this kind of art-making illustrates why few artists at this time were interested in computer graphics as a creative medium and why it remained largely the domain of engineers and scientists in the early years.

It would be an engineer at Boeing, William Fetter, who first used the words **computer graphics** in 1960. A pioneer in the development of computer-aided design (CAD) for manufacturing, he wrote algorithms to create 3-D wireframe drawings of a cockpit and even a digital model of a person to help design it ergonomically (see Figure 3.2).

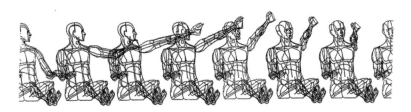

3.2
William Fetter's three-dimensional wireframe drawings for Boeing in the early 1960s were aids for designing cockpits

Sketchpad

In 1962, Ivan Sutherland (see Box 9.1), a graduate student at the Massachusetts Institute of Technology, created **Sketchpad** (see Figure 3.1) as his doctoral thesis, which he called "a man-machine graphical communication system." Many historians and researchers mark this development as the true beginning of computer graphics, because for the first time images were created by the hand of an artist, not by mathematical programs, and could be seen as the artist was working on them (not only in a print made hours later). Using a light pen combined with his own software for drawing, Sutherland could draw directly on a 9" monitor (or cathode ray tube, as it was more commonly known at the time). Simple patterns of lines and curves could be created on the screen and manipulated. Keyboard commands could change the patterns, for example into a series of parallel lines, or could erase lines. There were dials below the screen for zooming in or out.

Due to his groundbreaking work, Sutherland is considered one of the founding fathers of digital media. The remarkable features of his drawing program would influence the development of many later computer graphics programs. Sketchpad utilized a vector system where points are placed on the screen and the software creates the lines between them, the basis of all future vector drawing programs. In addition, an image could be made of parts, which could then be moved into a variety of positions. Each part could also be individually resized independently from the rest of the image. Shapes could be shrunk to the size of a dot, copied over and over again to make a pattern, and then enlarged again, so you could see a field of the same shapes clearly defined. The software was also able to save the images created on the screen for later use. Many of the pioneers of digital media technology were inspired by Sutherland's Sketchpad, particularly by the concept that a computer could be designed for the use of ordinary people, rather than remain the domain of a select group of technology experts.

The Mouse Is Born

In 1963, Douglas Engelbart, an engineer at the Stanford Research Institute, was looking to find ways to use the computer to allow people to solve complex problems. Frustrated with the available methods to interact with information displayed on a screen, he began to think about ways to point and create input

3.3
The first mouse built by Douglas Engelbart in 1963

more quickly and efficiently. He felt one way to cut down on wasted motion was to eliminate the need to lift the input device off the desk. With a fellow engineer, Bill English, he designed a small box with a cord in the front and two perpendicular disks on the bottom that tracked its motion. The "X-Y Position Indicator," as it was called (see Figure 3.3), was first used only to draw straight lines but testing showed it outperformed keyboards, light pens, and joysticks in a variety of tasks. When the cord was moved to the back end, it wasn't long before someone in Engelbart's lab noticed it looked like a mouse with a tail—gaining the name it has to this day.

Engelbart went on to become one of the key visionaries in the history of computing. At a computer conference in 1968, he presented what has become known as "the mother of all demos." In it, the mouse was unveiled, but only as one part of a much larger "Online System," or NLS. Engelbart's vision of NLS was a networked environment which supported collaboration between people using computers over long distances (see Chapter 12). The goal of this Internet-like idea was to "find much better ways for people to work together to make this world a better place." Remarkably, in the same presentation, he also introduced several other key concepts that would prove to be essential in the development of computers and the communication industry: computers with a windows-like interface, hypertext, email, word processing, and videoconferencing—more than a decade before they arrived.

ARTISTS AND ENGINEERS (FINALLY) UNITE

In 1965, the first fruit of the exploration of computer graphics was exhibited in galleries (to a mixed reception). The very first exhibition was held at a gallery in Stuttgart, Germany (Technische Hochschule) and displayed the work of three mathematicians. Later that year, "programmer art" was featured at New York City's Howard Wise Gallery, the first exhibition in the United States. Most artists, along with the other members of the art world, turned a cold shoulder to the work. One reviewer compared the art to "the notch patterns on IBM [punch] cards."

Despite this reception, exhibitions continued during the 1960s, eventually at major museums. In 1968, *Cybernetic Serendipity*, curated by Jasia Reichardt, opened at the Institute of Contemporary Art in London. This was an important retrospective of the state of computer graphics at the time and demonstrated that the medium had begun moving beyond formulas and plotter pictures.

One new approach was what became known as **ASCII art**, images composed of letters and symbols. After analyzing the tonal levels of a photograph, patterns of pre-determined letters and symbols

3.4
Ken Knowlton's *Studies in Perception #1* from 1966, one of the earliest examples of ASCII art

would be used to recreate the image. Much like the dots in a newspaper photo, an image could emerge like the nude in Ken Knowlton's *Studies in Perception #1*, a mural-sized work from 1966 (see Figure 3.4).

Cybernetic Serendipity also included examples of art and design inspired, not just created, by computers. Spanning the wide variety of visual and performing arts, the exhibition mixed paintings and sculptures about computers with choreography and music designed with computers, poems generated by computer, computer films, and robots. Reichardt acknowledged that largely the show dealt "with possibilities, rather than achievements" and was "prematurely optimistic." But she also wrote: "Seen with all the prejudices of tradition and time, one cannot deny that the computer demonstrates a radical extension in art media and techniques."

Despite the negative reactions of most in the artworld, *Cybernetic Serendipity* demonstrated that there was a growing number of artists intrigued by the possibilities of new technologies. In 1966, the artist Robert Rauschenberg and the electronic engineer Billy Kluver founded E.A.T. (Experiments in Art and Technology).

Kluver and Rauschenberg shared the belief that since technology was now part of life, it should be part of art, too. In 1967, E.A.T. collaborated with a MOMA curator for a portion of the museum's upcoming exhibition, *The Machine as Seen at the End of the Mechanical Age*. E.A.T. sponsored a contest for artists combining art and science, which generated a huge response. When the museum only selected ten of the entries, E.A.T. arranged for a simultaneous exhibition at the Brooklyn Museum of over a hundred of the remaining entries called *Some More Beginnings:* **Experiments in Art and Technology**.

Box 3.1 E.A.T. in Osaka

At Expo '70 in Osaka, Japan, the collaboration of artists and engineers was given its first world stage. Pepsi-Cola commissioned a unique organization, E.A.T. (Experiments in Art and Technology), to design and build its pavilion as a demonstration of how contemporary art and science were opening new frontiers. E.A.T. had been founded in 1966 by the artist Robert Rauschenberg and the Bell Laboratory scientist Billy Kluver, an expert in laser light and sound. Their goal was to bring together artists, choreographers, musicians, scientists, and engineers to imagine new forms of art, which combined performance art with technology.

Visitors approaching the Pepsi-Cola pavilion saw a deeply angled, geometric dome shrouded in mist created by sprayers and lit by huge spotlights—a cloud sculpture (see Figure 3.5). Surrounding

the building were slow-moving, six-foot-tall pod-shaped sculptures that made sounds, like a whale singing or a truck's engine. The pods changed direction whenever they bumped into an obstacle.

Viewers were ushered into the pavilion through a dark tunnel. Once inside, they saw the E.A.T.-designed interior—a large dome whose surface was covered with a huge, spherical mirror (at that time, the largest ever created). This was the elaborate backdrop for interactive performance pieces that used programmed multicolored laser lights. Artists and dancers moved freely among lights of all colors and sizes, the mirrored walls reflecting in many directions, creating new shapes and forms (see Figure 3.6). In many performance pieces, viewers were invited to

3.5
The exterior of the Pepsi-Cola pavilion at Expo '70 in Osaka, Japan. A cloud vapor sculpture covered the roof

3.6
The mirror dome of the interior of the Pepsi-Cola pavilion at Expo '70 reflects a performance

participate. Speakers hidden behind the dome's mirror created imaginative and changing sound experiences. Visitors also carried handsets that picked up different sounds depending on where they were walking, transmitted from the floor. Each performance became a unique experience that combined artists, scientists, and the public.

The optimism and ambition of E.A.T. had been enormous, but unfortunately so was the cost of their project. The project went far over budget, much to the distress of the corporate sponsors. Disputes also broke out over who would control the building's events. Pepsi-Cola wanted to use the building for rock bands, E.A.T. had already arranged for artists, music, and poetry readings. In the end, the building was finished but E.A.T. was removed from control over the programming.

Nam June Paik, the video art pioneer (see Artist's Work: Nam June Paik in Chapter 4), had always been enthusiastic about exploring art through technology, once claiming that "the cathode ray tube will replace canvas." One of the first artists to use portable video cameras, he later integrated video and other technologies into sculptures, installations, happenings, and even a bra. So it is not surprising that, with the arrival of digital technologies, he began integrating them in his work as well (see Figure 3.7). The Paik/Abe Synthesizer was able to interfere with and manipulate video images on a monitor, creating unusual forms, colors, and patterns (much like his earlier work with a large magnet affected images on a television screen).

Despite the works of these and many other artists at the time, the collaboration of artists and engineers continued to face much hostility. The 1971 exhibition at the Los Angeles County Museum, "Art and Technology," curated by Maurice Tuchman, opened to the almost unanimous disapproval of critics. It was a huge, expensive project, five years in development. Twenty-two artists were contracted with corporations who promised to finance the substantial costs of technical assistance, fabrication, and maintenance. Even though many of the artists, like Rauschenberg, Andy Warhol, Richard Serra, and Roy Lichtenstein, were already well known and respected, this approach was seen as nefarious by the critics and gave birth to a new term of derision—*corporate art*.

3.7
Nam June Paik at work in 1982

RESEARCH CENTERS—HEAVY IRON ON CAMPUS

Unfortunately, because of the high costs involved, few artists before the 1980s could afford to produce computer graphics without such "unholy" alliances. This need flew in the face of a widespread sense during the 1960s and 1970s that many of the ills of contemporary society were due to the destructiveness of money and technology. Unfortunately, this would mean that very few artists participated in the development of the tools of digital media during its birth process.

Access to the giant computer systems and funds necessary for research would remain located in three locations: the military, industry, and research universities. Among those universities, the University of Utah and Ohio State University would emerge as the most influential and significant in the history of computer graphics.

University of Utah

In 1965, Dr. David Evans founded the University of Utah's computer science department and focused its attention on the new field of graphics. A native of Utah, he had previously led the team that worked for the Defense Department's Advanced Research Project Agency (ARPA) at the University of California at Berkeley. Evans was not just a successful researcher but an influential teacher and superb recruiter of faculty. In 1968, he convinced Ivan Sutherland to join the department. After his work on Sketchpad at MIT, Sutherland had headed ARPA, then went to Harvard where he had created a head-mounted display screen. By projecting a separate wireframe image for each eye, it was able to create a 3-D effect. The headset became known as the "Sword of Damocles" because of its great weight, but it was only one part of a complex system needed to create the first VR simulation (see Figure 3.8).

In addition to their work together at Utah, Evans and Sutherland also founded the first computer graphics company in 1968. Bearing their names, it would create powerful custom graphics hardware and software first for the military, then commercial animation companies.

The list of David Evans and Ivan Sutherland's students at the University of Utah is a Who's Who of computer pioneers. Among them are Alan Kay, a leading researcher at Xerox PARC (see page 60) who is responsible for many of the key concepts behind personal computers, Nolan Kay Bushnell, the founder of Atari (page 68), and Ed Catmull (page 64), co-founder of Pixar, as well as others who helped create Adobe, Netscape, and WordPerfect.

Talented graduate students at the University of Utah created most of today's methods for realistically shading 3-D objects (for a fuller discussion of these methods, see Chapter 11). Ed Catmull's Ph.D. dissertation developed the concept of **texture mapping**, which wraps a photo-realistic image of a texture

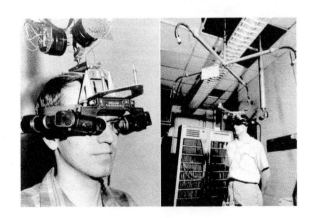

3.8
Ivan Sutherland was already exploring virtual reality in the 1960s

around a wireframe form. In 1971, Henri Gouraud conceived **Gouraud shading**, where by blurring the facets of a polygon, an object can appear to be smoothly shaded. In 1974, Phong Bui-Toung created **Phong shading**, creating realistic highlights on shaded objects. In 1976, Martin Newell worked with his teaching assistant, Jim Blinn, to help him develop *reflection mapping*, where objects are shaded with reflections from their environment. Blinn then developed the technique of **bump mapping** while at Utah, allowing shading of irregular surfaces. More than 40 years later, these methods still dominate the rendering of 3-D images in animations and computer games.

Ohio State

A rarity in the early history of computer graphics, Charles Csuri was an art professor at Ohio State University in the early 1960s who played an important role in the development of the new field. A renaissance man, he was an All-American football player and trained as both a painter and an engineer. Csuri was one of the few early computer artists who created representational images with the new technology. Working with programmers, he would scan pencil drawings and then transform them on the computer. One of his most famous digital artworks was a series of drawings that showed a young woman slowly changing into an old one.

This forerunner of morphing naturally led Csuri to animated films. In 1967, he created *Hummingbird II*, a playful transformation of a hummingbird in flight. Using 30,000 scanned drawings, Csuri was able to make a ten-minute film, which broke the bird into floating geometric forms and then reconstituted it again (see Figure 3.9). Today, this landmark film is in the permanent collection of the Museum of Modern Art in New York.

In 1969, Csuri founded the Computer Graphics Research Group (CGRG) (later the Advanced Computing Center for Arts and Design [ACCAD]) at Ohio State, which brought together faculty and students from a wide range of disciplines. With grants from the government, military, and industry, the CGRG focused on advancing research in computer animation. New and important animation languages, modeling, motion, and character animation systems were developed there, as well as award-winning animated short films.

One of their first projects was to develop a real-time animation system, which they unveiled at IBM's showroom in Manhattan. Csuri showed how he could pull up images from the computer's memory and animate them on the screen with a light pen. Salvador Dalí was among the many impressed visitors.

3.9
An early computer-animated film: *Hummingbird II*

XEROX PARC

The founding of Xerox Corporation's Palo Alto Research Center (PARC) in 1970 would prove to be one of the most important developments not only in the history of digital media, but of computing itself. The

young, talented scientists assembled there were given the mission of developing "the architecture of information" in ten years—and would succeed beyond anyone's imagination. More than any one group, they pioneered the foundations of computing.

Alan Kay was one of those researchers and is credited with the slogan, "The easiest way to predict the future is to invent it." Before joining Xerox, he was a graduate student at the University of Utah, who studied with Ivan Sutherland and experimented with Sutherland's Sketchpad program. At PARC, he changed the idea of what computing could be. Rather than a world of huge computers run by experts, he imagined computers as small as a book that could be used by anyone, even children. By observing how children worked, he devised a new programming language that was *object-oriented* (rather than text based) called "Smalltalk," since children worked best with images and sounds, rather than words. Inspired by this success, Kay led a team of PARC researchers to develop an experimental system that predominantly used graphics and animation, rather than text. He believed that using graphics to represent computing actions not only make them easier to use, but would stimulate learning and creativity.

In 1968, he proposed "Dynabook," a notebook-sized computer, which would be so easy to use that his mother could take it shopping. It would be a true multimedia computer, integrating images, animation, sound, and text. While this project never received funding from Xerox, four years later, Kay was part of a team that developed a computer that included many of these ideas. It was called "Alto"—and it revolutionized computing.

Until the Alto, a computer was always a huge, expensive machine housed in a central facility. Users were programmers or researchers who competed for mainframe time and were given printouts of results later in the day. Alto, however, was a small computer that sat on a desk and was designed for one user—in essence, the first personal computer. It had its own keyboard and used Douglas Engelbart's mouse for input. Its monitor was the size of a typical page. It even had removable disks for storage.

Equally revolutionary was the Alto's utilization of Kay's concept of a graphically designed system of interacting with the computer—the first of what would become known as a graphical user interface (GUI) (see Figure 3.10). Kay's approach would be quite familiar to today's computer users. Each element on the screen was a picture, or *icon*. The icons were designed with an office metaphor; so information was put into files, files into folders. Clicking the mouse while over an icon could start a program. The interface even allowed for multiple windows and pop-up menus.

By using bitmapping (where every pixel on the screen can be used to describe forms) rather than text or shapes composed of vectors, what one saw on screen was quite close to what was printed. This new approach became known as "what you see is what you get" or **WYSIWYG** (pronounced "wizzy-wig").

Despite the visionary innovations of the Alto, Xerox never marketed it successfully. In fact, the shortsightedness of Xerox management in the 1970s has become legendary in the history of computing. They mismanaged a tremendous lead in a host of technologies. Among other PARC innovations that would be developed more successfully somewhere else are Ethernet, laser printing, and the first page description language. All of the key researchers who created these and many other breakthroughs would eventually leave PARC, forming their own successful companies or working elsewhere.

In December 1979, the company made its most infamous blunder. Despite protests by their own researchers, management ordered them to show the Alto and its GUI interface to a young computer maker, Steve Jobs, in return for an opportunity to buy $1 million of his company's stock.

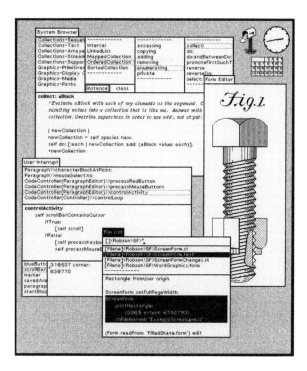

3.10
The Alto computer developed at Xerox PARC had a graphical interface designed by Alan Kay that could be controlled by a mouse

APPLE AND THE ARRIVAL OF THE MACINTOSH

Jobs' small computer company was Apple. Following up on the success of their Apple I and II, the company was in the process of designing their new Lisa at the time Jobs visited the Xerox facility. Jobs was amazed by what he saw at PARC and had his engineers integrate the mouse and GUI interface into the Lisa, adding some important innovations. Files could be clicked and dragged, pop-up windows with scroll bars at the sides overlapped rather than tiled, and there was a menu bar with pull-down menus. Apple engineers also simplified the PARC three-button mouse to one button and made it smaller, to fit more comfortably in one's hand. Lisa's software included features familiar today: Cut, Copy, and Paste, the Clipboard and Wastebasket. It also included a simple page layout program. But the cost of the Lisa—$10,000—and its slowness hurt its acceptance by the public. Luckily for Apple, they already had another computer in development.

The most important milestone in the history of digital media was the release of the Apple Macintosh computer in 1984. Its impact on the history of computer technology has been compared to the first flight of the Wright Brothers in aviation or Edison's light bulb in the electric industry.

Faster than the Lisa and designed to be small, simple, and affordable for not just thousands but hundreds of thousands of people, the Mac was a tremendous success. The Mac came with the first 3 1/2" floppy disk drives, storing 25 percent more than the then common 5 1/4" floppy while being smaller and sturdier. Most importantly, ease of use was the overriding philosophy in the Macintosh's design. Even the packaging of the computer was done simply and clearly, with easy to read manuals that made unpacking and setting up a Mac a pleasure. Within two years, 500,000 Macintoshes had been sold.

One reason for the success of the Macintosh was that it was a graphics-based machine from the beginning. Its makers assumed that users wanted to do more than type or program. Painting software, called *MacPaint*, came with the machine, as well as *Hypercard*, so users could create interactive multimedia. Compared to Lisa's GUI interface, the Mac workspace was clearer and cleaner. Another innovation was that, unlike previous small computers, the Mac abandoned the old approach of character generation for text and replaced it with typefaces that were bitmapped. This gave users much more flexibility for varying fonts, styles, and sizes—and would play a crucial role in ushering in a new era in layout and design.

The Beginning of Electronic Printing

As with many other revolutionary technologies, it was not just the release of the Macintosh but the simultaneous arrival of several breakthroughs that would lead to what became known as the "desktop publishing revolution." The first step towards a new world of electronic printing was made with the arrival of a new light. In 1960, Theodore Maimon, a researcher at Hughes Research in Malibu, California, invented the first practical way to generate laser beams. This technology would, of course, have many ramifications beyond the world of art and design, but also was an important first step in developing laser printing (for a detailed discussion, see Chapter 4). Laser light could be used to expose very fine dots, permitting both crisp type and the detailed reproduction of images in halftones. The first laser printers, however, would not arrive until the early 1970s and, even then, only in the form of large commercial machines dedicated to typesetting.

What would become known as desktop publishing didn't truly emerge until the 1980s. To the surprise of most professional designers and printers who treated the new technology with contempt (calling it more appropriate for a church newsletter than a professional publication), electronic publishing became the industry's standard before the decade was over (see Chapter 6).

What was needed for this to occur was the arrival of relatively inexpensive and easy-to-use computers and methods of printing, along with digital methods of defining typefaces and pages. These seemingly huge challenges were overcome in just a few years.

In the early 1980s, *Bitstream* was founded, the first company dedicated to developing digital typefaces. In 1983, another new company called *Adobe*, founded by John Warnock of the University of Utah and Charles Geshchke, developed a language for describing page layout called PostScript. Adobe PostScript makes the printed page an image where every pixel has been arranged to form the graphics and text clearly. The same year Canon developed a laser printing engine that could print cheaply at 300 dpi. Combined, they would be the foundation for the Apple LaserWriter, the first laser printer for the general public.

The final piece in the puzzle was released in 1985—Aldus Corporation's *PageMaker* page layout software (see Figure 3.11). Designed for the new Apple Macintosh, it allowed users to easily combine and manipulate text and graphics. Users could choose from hundreds of typefaces, in a variety of styles and sizes. Suddenly, an electronic publishing system (see Chapter 6) that cost less than $10,000 was available to designers at both large and small firms. An individual could control design, fonts, and printing from their desktop.

The days of cutting and pasting waxed pieces of paper onto boards to make mechanicals were over, and a new way of understanding the words "cut" and "paste" had begun. For many designers and typesetters, the career impact was like that on actors in silent films after the arrival of sound for motion pictures.

For others, it was as if one small computer opened up a whole new world. The result has been a continuing loyalty among artists and designers to Apple computers that transcends mere

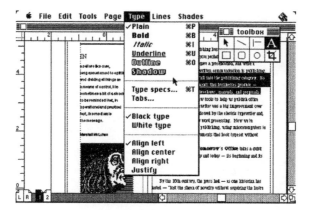

3.11
Aldus PageMaker, the pioneer desktop publishing program, 1985

technology or software. To this day, Macintoshes dominate the worlds of graphic design, multimedia, and education.

PIONEERS OF COMPUTER GRAPHICS AND ANIMATION

As sophisticated as it was, the original Macintosh was only available with a black and white display. It took three years, with the arrival of the Mac II, before Apple users could work in color graphics in digital imaging. But pioneer work had already begun a decade earlier.

As in personal computing, Xerox PARC was a leader in the development of digital painting software. In the early 1970s, researchers Richard Shoup and Alvy Ray Smith worked on a painting program that would allow artists to paint on a computer the way they painted on a canvas. It was called *SuperPaint*, the prototype for all future bitmap painting software. It included a palette where one could select up to 256 colors from 16.7 million choices. Brush sizes could be varied and a user could apply colors and shapes with a tablet and stylus. Yet once again, Xerox management failed to capitalize on their advanced technology. Soon after SuperPaint's release, Xerox decided to focus on black and white projects, rather than color. Shoup and Smith soon left PARC.

The Jet Propulsion Laboratories

As Xerox's imagination and funding began to dwindle, its top researchers began to search for institutions with greater resources. One new home was the Jet Propulsion Laboratories (JPL) in Pasadena, California, part of a U.S. space program at the height of its funding and busy hiring the next trail blazing generation of developers.

Jim Blinn arrived directly from the University of Utah where he had developed new techniques for reflection and bump mapping as his Ph.D. dissertation. His first important project at JPL was to create simulations of the upcoming Jupiter and Saturn planetary flybys. Unlike previous simulations, they would be not just for planning purposes, but to interest the public in the mission.

Due to Blinn's groundbreaking animations, viewers were able to follow Voyager I in its travels (see Figure 3.12) as it approached the huge planets. Distributed to the media, the simulations received worldwide attention from both the computer graphics community and the general public. While only two to three minutes each, they had a degree of realism never seen before (in fact some television stations

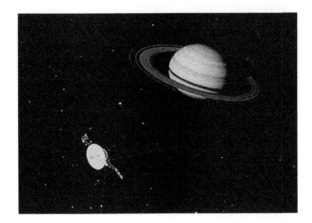

3.12
Scene from Jim Blinn's animated simulation of the Voyager I flyby for the Jet Propulsion Laboratories

described them as actual footage of the mission). While scientifically accurate and great technical achievements, a sense of drama is what makes these truly remarkable. The planets come towards the viewer at an angle, growing larger and larger as the gravitational pull draws the space probes in. Then we appear to whip past the planets and out into space. Blinn explained that he had studied traditional animation techniques, like those of the Disney animators (see Chapter 10). Blinn's cinematography, as well as his animation software, shaped the appearance of most subsequent space sequences in television and films.

New York Institute of Technology

In the 1970s, like many other disillusioned colleagues, Alvy Ray Smith left PARC. He joined a new research center in New York, the New York Institute of Technology (NYIT), which he described as a place with "plenty of money" where researchers would get "whatever was needed." At NYIT, wealthy entrepreneur Alexander Schure was funding a new Computer Graphics Laboratory and outfitting it with the best hardware, software, and scientists. By 1977, Smith developed the first 24-bit painting software, *Paint3*, with 16.7 million colors. It also introduced many of the tools digital artists use today: digital airbrushing, selecting colors from any part of an image with an eyedropper, compositing images, and making paintbrushes of any shape or size.

Smith had been recruited by NYIT's head of the Computer Graphics Laboratory, Ed Catmull, whose Ph.D. dissertation at the University of Utah developed the concept of texture mapping. One of the important early applications of *Paint3* was creating richly detailed textures to map on 3-D forms. NYIT's Lab became a center of research in 3-D modeling and animation, attracting scientists who would be leaders in computer animation for decades to come. Among the firsts developed there were: video editing with a computer, the **alpha channel** (named by Smith), tweening (which creates the in-between frames from one drawing to another in an animation), a complete 2-D animation system, and morphing software.

TOYS AND MONSTERS: THE COMPUTER GRAPHICS INDUSTRY

A new era in the development of graphics and animation tools began in 1979, when George Lucas convinced Ed Catmull and Alvy Ray Smith to leave NYIT and start a computer graphics unit at Lucasfilm.

High-end applications were now less likely to be created in university research centers but as proprietary systems at commercial computer graphics studios for use in mainstream films, commercials, and especially television.

Digital media went on view for the first time by the general public in the late 1970s when computer graphics began appearing on television news and sports broadcasts in the forms of backgrounds, charts, and flying logos. Not long after, commercials featured 3-D animations of dancing candy and gyrating fuel pumps.

New companies were being formed, like Digital Effects, R/Greenberg (later R/GA), and Pacific Data Images, as special effects firms housed in small apartments. In just a few years, they would grow to fill entire buildings, producing commercials, television graphics, and occasionally astonishing sequences in full-length films, like *The Last Starfighter* and *Tron*.

Initially, commercial computer graphics was produced primarily for television because it could use lower resolution effects compared to movies. Filmmakers were not open to including what they saw as expensive, low quality imagery in their motion pictures. However, in 1982, the computer graphics division of Lucasfilm created one of the landmark sequences in 3-D animation history—the Genesis effect for *Star Trek II: The Wrath of Khan* (see Figure 3.13).

The original screenplay had called for a small special effect—a rock would turn green and glow after being shot by the Genesis machine. It was Alvy Ray Smith who suggested the idea of demonstrating the Genesis effect with a computer simulation, showing a dead planet coming to life. To accomplish this, new software was especially developed, including some of the first commercial applications of particle systems (for flames and explosions) (see Chapter 11). While it lasted for only a minute, the sequence was so impressive and successful that it was used in the next three *Star Trek* films and used in commercials for many years.

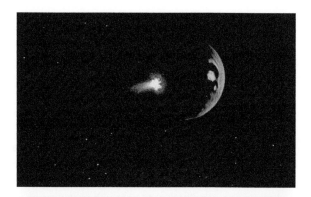

3.13
The first moments of the Genesis effect, created by Lucasfilms for *Star Trek II: The Wrath of Khan*

3.13
The first moments of the Genesis effect, created by Lucasfilms for *Star Trek II: The Wrath of Khan* (Continued)

In addition to particle systems, the computer graphics unit at Lucasfilm created important tools for 3-D animation, such as advanced ray tracing and motion blur effects. Despite their successes, the staff remained frustrated. Even at a visionary company like Lucasfilm, there remained little support for going beyond short special effect sequences and developing independent computer animation projects.

In 1985, George Lucas decided to let the unit become independent and allowed his employees to look for investors. The next year, with their purchase by Steve Jobs (recently fired by Apple) it became an independent company led by Catmull, Smith, Bill Reeves, and John Lasseter (see Chapter 11). The new company was named *Pixar*, while what remained became the special effects giant, *Industrial Light and Magic*.

Together and separately these companies would help define the range and promise of commercial 3-D animation and special effects, in such films as *Terminator 2*, *Jurassic Park*, and *Toy Story*. By the 1990s, even the venerable traditional animation company, Disney, began integrating more and more computer-animated sequences, like the ballroom in *Beauty and the Beast*, into its films—with a system devised by Pixar. Even traditional films like *Forrest Gump* routinely had computer-animated sequences (hint—the floating feather). At the end of the decade, following *Star Wars Episode I*'s successful inclusion of over 60 digital characters, George Lucas decided to film *Episode II* as a completely digital production.

Box 3.2 Commodore: A Computer for the Masses

In the 1970s, Commodore led the push to create a very affordable computer for consumers. Its PET of 1977, with a built-in monitor, cost less than $1,000. The *VIC-20* of 1981 cost less than $300. The next year, they released the *Commodore 64* (see Figure 3.14), one of the most successful computers in history, selling about 20 million computers. Besides word processing, the Commodore 64 introduced computer painting to the general public. With a wax printer attached, artists could make their first affordable color prints. Now a machine that cost only a few hundred dollars, could be used not only make pictures but also music with the first built-in synthesizer chip.

In 1985, Commodore leapt far beyond the rest of the young industry with their introduction of the *Amiga*. Designed from the start as a graphics machine and costing only $1200, this was the first truly affordable multimedia computer. It integrated graphics, sound, and even video and animation. While competitors were proudly announcing machines with 16 colors, the Amiga displayed more than 4,000.

Combined with the *Video Toaster*, a video editing board designed by Tim Jenison's NewTek, the Amiga became a machine that is still astounding. For an additional $1,600, users could add a board that could input video from camcorders, VCRs, or directly from a TV and add special effects, characters, and animation. Also included with the board was a paint program with a palette of 16.8 million colors and a 3-D modeling program. In the early 1990s, Amigas with Video Toasters were used for special effects on television shows like *Star Trek: The Next Generation* and by musicians like Todd Rundgren, as well as many early digital animation and video artists. Even Andy Warhol had an Amiga in his studio and colorized photographs of celebrities as he had on canvas in the 1960s and 1970s.

Commodore and NewTek shared a dream of multimedia computers being a democratizing force, allowing any creative person to produce professional quality art, animation, and video in their homes and broadcasting their work for free on public access television stations. Unfortunately, a series of poor financial decisions led to their bankruptcy and the end of Amiga production (though there remained a loyal underground of Amiga users for another decade). Ironically, only a few years later their dream would be revived in a format they had not imagined—the World Wide Web.

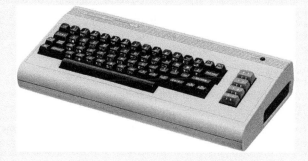

3.14
In 1982, the Commodore 64 cost only $595 and became the best-selling computer in history

The Games: From the Arcade to Your Home

An argument can be made that after the military, the single most important driving force behind the development of computers has been video games. Many of the essential elements of digital media, high-end graphics, 3-D modeling and animation, and interactivity, can be traced back to the ever-increasing demands of gamers (see Chapter 13, which focuses on game art and design).

Today's multibillion-dollar industry began with the simplest of forms bouncing across a screen. In 1961, Steve Russell, a computer programming student at MIT, secretly created the first video game. He called it *Spacewar* and it ran on the Institute's huge $120,000 DEC mainframe. With a crude joystick, one could maneuver a spacecraft (a rotating triangle) and fire space torpedoes (white dots) at an enemy ship (another triangle). A community of underground gamers was born. Enthusiastic programmers around the country secretly circulated copies with others who worked at the large universities or at companies with rented DEC mainframes. Surprisingly, when DEC management finally discovered the game, rather than blocking it, they recognized its popularity and embraced it. *Spacewar* was used to test new mainframes and the DEC sales staff used the game as an impressive demo for prospective customers.

Five years later, Ralph Baer of Sanders Associates designed *Odyssey*, a simple computer game where players moved lights around the screen. Licensed by Magnavox, it became the first consumer computer game. But it was Nolan Kay Bushnell, a University of Utah graduate, who truly created the computer game industry. In 1969, he designed the first video arcade game—*Computer Space*. In 1972, he founded a company whose sole focus was video games—*Atari*. That same year they released Bushnell's Pong, a simple black and white form of table tennis that captured the enthusiasm of young programmers around the world. Among the classic Atari games released in the next few years were *Asteroids*, *Breakout*, *Centipede*, and *Missile Command*. In 1977, Atari unveiled a home video game console, the Atari 2600. When they included a home version of the hot arcade game *Space Invaders*, demand for the consoles overwhelmed the company, captured the attention of the news media, and a new industry had been born. Six years later, in 1983, the first Nintendo game console was released. Over 30 million machines would be sold (see Artist Profile on Shigeru Miyamoto).

Artist Profile: The journey of Mario's legendary father—Shigeru Miyamoto

Around 1960, a small boy who liked to explore nature without a map was wandering in the forest near his village. He was frightened when he accidentally discovered the entrance to a cave in the woods. Later, he got up the courage to return alone from his house with a lantern. His decision to explore the cave's passageways would take on greater meaning in the years to come.

The boy was Shigeru Miyamoto and he grew up to be one of the founding fathers of electronic game design. As a young man, he wanted to be a manga artist and went to college for art and design. After graduation, his father got him an interview at an old Japanese company that specialized in playing cards, but had begun to expand its offerings into electronic toys—*Nintendo*. Miyamoto brought children's clothes hangers in the shape of animals that he had designed and convinced the company to hire its first artist.

A couple of years later, motivated by the huge success of video arcades, Nintendo built their own version of *Space Invaders* that failed dismally. Stuck with two thousand unsold arcade units, they turned to their artist and asked if he could come up with a better game. At this time,

3.15
Shigeru Miyamoto and his original version of Mario

video arcades games, while popular, were little more than shapes shooting and attacking other shapes. But in 1982 that all changed when Nintendo released Miyamoto's *Donkey Kong*. Donkey Kong was the first arcade game with a story and characters—a gorilla, the girl he kidnapped but loved, and a hero—a carpenter known in this game as "Mr. Video," later "Jumpman," and finally, "Mario." Miyamoto had been inspired by the characters in the Popeye cartoons (Bluto, Olive, and Popeye). Nintendo even tried to license those characters for the game but were turned down. Forced to come up with his own characters, Miyamoto mixed Popeye's classic plot structure of a villain in love, a damsel in distress, and the hero who could save her with the story of King Kong.

In that era of video arcade games, to create something resembling a character required ingenuity. With the handful of pixels available, Miyamoto gave Mario a red hat so you could see his head and a mustache so it could define his nose (see Figure 3.15).

As video game technology improved, Miyamoto was able to increase not only the complexity of character designs (allowing Mario to become a plumber), but the games themselves. While movements in Donkey Kong tend to be up and down, when Mario got his own game it introduced scrolling horizontally, based on the way traditional Japanese paint scrolls tell stories. Even in his early days as a Game Designer, Miyamoto thought a great deal about how

to introduce a player to the rules of a new game naturally. For example, in *Super Mario Brothers*, we first see Mario on the left side of the screen, with the right side wide open. This hints to the player to move him to the right. In all later screens, Mario appears at the center. Barriers appear early in the first level, forcing you to find a way to jump and bump into blocks overhead. Players quickly learn how Mario gets stronger.

In 1986, Nintendo moved beyond the arcade and introduced their first home system—in Japan, the Family Computer, but in the West, the NES or Nintendo Entertainment System. Their timing couldn't have been worse. The home video game console industry was collapsing. While there had been huge demand, too many console companies and too many buggy games had led to a dramatic drop in sales. The leader, Atari, was on the verge of bankruptcy.

The Japanese version of the NES console came with a new game called *The Legend of Zelda* which single-handedly saved the console market and introduced a whole new vision of what a game could be. Like the young boy who once explored a cave, Zelda's hero, Link, goes on a quest that can take him down many paths. His journey is one of imagination and established what became known as the "massive exploration adventure." It also was the first game with a memory chip that could save your place in the game when you left it.

Later versions of the Zelda (see Figure 3.16) and Mario franchises introduced many technological innovations to electronic games, like a 3-D universe. But Miyamoto is not excited by the ability to increase realism or making video games that resemble movies. "I am not convinced that being more realistic makes better games. . . . We have to pursue something that movies cannot do." In addition to the games themselves, he has played a leading role in the design of consoles and controllers. For the Wii, the first wireless motion-capture system, he said, "Our goal was to come up with a machine moms would want."

Miyamoto's philosophy has remained remarkably consistent—"The most important thing is for games to be fun." His games are ones that anyone can play. So in a Mario game, "simply put, you run, you jump, you fall, you bump into things. Things that all people do." In the end, Miyamoto

3.16
Scene from "Legend of Zelda: Twilight Princess," 2005

believes that all players should finish with a sense of accomplishment. He wants each player to be a hero. His journeys are ones of imagination, rather than through killing fields. Adventures should not only immerse their players in fantastic environments but allow them to stray from the mission and, as he did as a boy entering a cave, simply explore.

Miyamoto is proud that he creates trends and is not influenced by them. It is no wonder that when the Academy of Interactive Arts and Sciences created its Hall of Fame, the first person inducted was Shigeru Miyamoto. The Academy's citation states simply that his peers describe him as "the greatest video game designer in the world."

It was about this same time that the first personal computers came on the market. The first computer games for personal computers were no match for the game consoles. They were completely text based with no images. A popular game called *Zork* began with these words on a black screen: "You are standing in an open field west of a white house" and the user would type on the keyboard, "walk east." But over the next decade, images, animation, and video would be integrated into increasingly powerful personal computers with the arrival of new storage media and multimedia peripherals like CD-ROMs, sound and video cards and new formats like MIDI and Quicktime.

During the early 1990s, games on the PC finally became the equal of those on dedicated game machines. Living Book's *Just Grandma and Me*, released in 1992, ushered in a new era in children's interactive and educational software. In 1993, the Zork-like exotic adventure puzzle, Rand and Robyn Miller's *Myst* (see Figure 3.17), became the most successful CD-ROM game of the decade. Its direction, sophisticated, textured graphics and sound, and imaginative approach truly took advantage of the potential of the new medium. Id software's *Wolfenstein* along with the later *Doom* (released in 1994) established a whole new genre, the first-person shooter, which dominates gaming to this day. *Doom* became the second most popular game in terms of sales, but those sales figures do not take into account the millions of players who downloaded it as shareware from a new outlet for games and artists—the Internet.

3.17
A scene from *Myst,* 1993

The World Wide Web: Another Campus Revolution

Researchers in computer graphics were among the first to utilize the early stages of the Internet. In addition to information, images, graphics software and wire-framed models were shared on Internet bulletin board systems, newsgroups, and archives. In 1987, CompuServe created the Graphics Interchange Format, or GIF, that compressed images for quicker downloading. In 1991, the JPEG was introduced by the Joint Photographic Experts Group.

In 1992, Marc Andreessen and other fellow graduate students at the University of Illinois Champaign-Urbana learned of Tim Berners-Lee's concept of a hyperlinked and graphic Web and decided to see if they could build the first graphical browser (see Chapter 12 for a fuller discussion). They worked for 18 hours a day, over three months. In the development process, there was some debate over whether to allow large graphics, whose file sizes might threaten to choke computer networks. Andreessen insisted there was no need to limit the size of images, since few would want to include anything larger than small icons to identify links.

The success of their free browser, **Mosaic**, in 1993, was beyond anything they imagined (see Figure 3.18). Andreessen later recalled, "We introduced Mosaic to three people at the beginning of 1993, and by the end there were one million people using it." By transforming the Internet into a visual environment, they had made the Internet easy to use and hugely popular. In the first year after its release, the traffic on the Internet increased by 350,000 percent. As feared, almost immediately, large-scale images flooded and overwhelmed the networks. Confronted with this by one of his co-workers, Andreessen is reputed to have laughed and said he knew it would happen all along.

Recognizing the World Wide Web's potential, many artists were among the first users. In fact, within two years, they accounted for nearly 10 percent of all websites. What excited many artists was the way the Web offered an escape from the narrow confines of a commercial gallery system devoted to profit. This concept was in tune with earlier art movements of the 1960s and 1970s, such as happenings

3.18
The opening screen of Mosaic, 1993

and mail art. Now, artists for little cost could directly reach a world-wide public. Many celebrated the arrival of a new era where all information and ideas were free and art accessible to all.

Among the early users of the Web as an environment for art was Jenny Holzer, an electronic artist. In 1995, she was among a group of artists who created "ada'web," one of the first sites for web-specific art, named for the early programmer Ada Byron, the Countess of Lovelace (see Chapter 2). Like her giant Diamond Vision message boards, "Please Change Beliefs" is an interactive display of Holzer's mottoes on politics, power, religion, and fear and meant to communicate directly to the public. Among the truisms are "YOU ARE A VICTIM OF THE RULES YOU LIVE BY" and "LACK OF CHARISMA CAN BE FATAL." When ada'web ceased operations in 1998, the Walker Art Institute acquired it as the first Web art in their collection. They continue to host it so even today visitors can write their own aphorisms, edit Holzer's, and vote for their favorites.

Virtual Reality

The concept of *VR* is far from new. The military began supporting research in this area in the 1960s for its application in flight simulations. In the 1980s, building on Sutherland's "Sword of Damocles," Scott Fisher of the NASA Ames Research Center in California (who had worked previously with Alan Kay at Atari Research) updated Sutherland's work by creating a stereoscopic headset with headphones for sound and a microphone. Participants wore a **dataglove** which allowed them to touch and manipulate objects in the virtual environment.

The dataglove was developed with the visionary computer scientist and musician Jaron Lanier, who is also credited with coining the term *virtual reality*. In 1983, Lanier founded VPL (Visual Programming Language) Research, the first company to sell VR products such as headsets, datagloves, and datasuits. These not only had an impact on innovative commercial, educational, and medical ventures, but also allowed visionary artists to turn their attention to a new arena—virtual worlds (see Figure 3.19). Lanier, an artist himself, also led pioneering research in a wide variety of VR applications, including *avatars*, the representations of visitors in 3-D worlds, and real-time virtual surgery.

In the 1990s, Carolina Cruz-Neira, Daniel J. Sandin, and Thomas A. DeFanti of the University of Illinois, Chicago's Electronic Visualization Laboratory created the Cave Automatic Virtual Environment or *CAVE* (see Figure 3.20). This was a small room with images projected on the walls and floor along

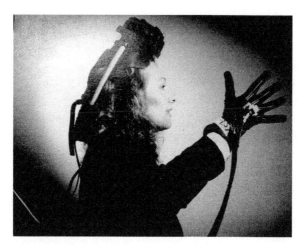

3.19
Artist Nicole Stenger in VPL VR equipment designed by Jaron Lanier, c. 1989

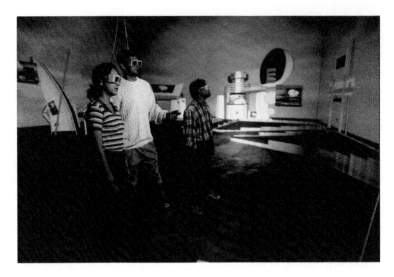

3.20
Students in CAVE—an early virtual reality room—1999

with a complex audio system. Once inside, one was thrust into a virtual world that responded to one's movements with images and sounds. Visitors also carried wands so they could move virtual objects and navigate in the environment.

Unlike many other VR systems, CAVE dwellers did not need to wear helmets to experience VR. Instead, they put on lightweight stereo glasses and walked around inside the CAVE. This meant they could see not only the projections but also fellow visitors—making the VR a shared experience. CAVEs were later installed around the world and research continues to this day on what is called the CAVE2 hybrid-reality environment.

CONCLUSION

Beginning in the 1950s, a group of visionary engineers developed the hardware and software to create digital media in all its myriad forms. Because of their high cost and complexity, few artists participated in the early stages of development. Today, however, the needs of artists are driving further developments of many of these tools. Digital media and software have become sufficiently mature so that artists and designers rarely require the collaboration of a team of technical advisors. In the 1980s, costs dropped as well, so digital artists and designers were finally able to afford their own tools and could shift their focus from gaining access to equipment to what they want to create.

We have entered an important moment in the history of digital media because as necessary as the visionary engineers were, it was just as necessary for digital artists to move out of their shadow. For digital media to become truly art media, artists needed to become independent of the programmers and engineers to make their art.

But the need for collaboration is far from over. Multimedia, animation, game design, VR, and interactive art, by their very nature, are meant to be produced by teams with a variety of backgrounds. The era of new technologies and media is also far from over. As others emerge and develop, like dynamic immersive virtual environments, the exciting teamwork of technology experts, researchers, writers, and artists and designers will still be necessary. In the years ahead, we will continue to see remarkable new creations born from the marriage of art and science.

As the history of digital media is written in the coming years, we will most likely see a blurring of categories, along with a fusion of artistic forms. As in many of the arts, it is already difficult to neatly categorize the work of many digital artists. Just as computers have become an essential part of our lives, many artists utilize computers as a normal part of the production of their work.

In the following chapters, we will discuss in much more detail the broad range of digital media and their capabilities. For those beginning their study of digital media, the information is meant to provide a solid background to begin your understanding of a field with exciting potential. The subdivisions reflect as much as possible current usage of its tools but are meant only to organize this book, not limit the possibilities. Those are truly endless.

Projects in the History of Digital Media

1. Using images found on the Web, create a visual history that traces the developments of one hardware component found in a typical digital media studio (for example, a mouse or monitor). Below each image, add captions with dates that explain the changes from the hardware's first appearance to today.

2. Choose five examples that trace the history of video games from Pong to the present. Explain the technical advances that took place (for example, the arrival of 24-bit color) and their relevance to digital media.

3. Using the Web as a resource, write a report on the history of one of the key digital media software manufacturers that no longer exist (for example, *Macromedia*). Explain how their software developed over time and what it meant to digital artists and designers.

4 Inside the Box: The Computer

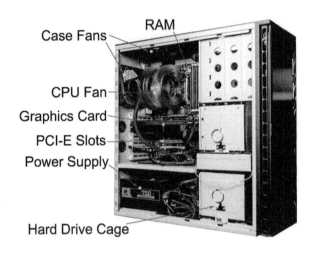

4.1
Basic computer case with major components noted

INTRODUCTION

Never before, not even during the Renaissance, have artists and scientists been so closely allied as they are in the new field of digital media. Because technology is the medium, it is important that artists and designers understand not only how their new tools evolved (as described in this chapter and Chapter 2), but also how their new tools are constructed and operate. This is not entirely unprecedented. For centuries, artists needed to be able to understand the chemistry of pigments and binders in order to grind good paint. Book designers who didn't understand the capabilities and mechanics of the printing process were doomed to failure.

INSIDE THE BOX

This chapter takes us on a tour of the inner workings of the computer itself. We will learn its various parts, how they operate, and why they are important. Unlike a tube of paint that leaks, computers are a major investment and cannot be discarded with little thought. Part of the challenge of being a digital artist or designer is handling the frustrating malfunctions—some minor, some major—during the process of creating art. A better understanding of the interaction of the various parts of a computer will

help us overcome the occasional roadblock and even promote better use of this incredible new medium for artists and designers.

A computer, while it can be stylish, isn't much to look at—even when you open it up and look inside. Nothing moves except for fans. While lights might be seen blinking, nothing buzzes, clanks, or clatters. Unlike the marvelous and massive computing machines described in the last chapter, today's computers do their job quietly and rather uneventfully to the human eye. Fundamentally, computers simply translate information from one medium to another—from analog to digital. They accomplish this task by converting information into a series of on/off, yes/no commands that are then interpreted and translated into what you see on the computer screen. When you type a command into the computer, you are actually using an interpreter—a program—that then tells the computer, in a language it can understand, what you want to do.

When we think of a computer, we think of a box, with a monitor, keyboard, and mouse, though in many cases today the monitor and the inner workings of the "box" are combined into a single discrete unit. In the case of notebooks, laptops, and tablets, all of these elements are combined into one portable device. While it is not difficult to understand the function of a keyboard or a monitor or even a mouse, the box and its contents, which we know are really the true computer, often remain somewhat more mysterious.

PC COMPONENTS

The Box Itself

The box, or *case*, that houses most of the parts of "the computer" is an important element in and of itself. In addition to protecting various internal mechanisms, it provides the frame for the pieces that make up a computer: the motherboard, CPU, mechanical hard drives or SSDs (solid state drives) for long-term storage, random access memory (RAM), and the video and sound cards (see Figure 4.1).

Computer cases come in many forms and sizes, from the ubiquitous desktop to the mini-tower, to large full tower models. The larger the size of the case, the larger the number of internal and external bays capable of housing hard drives, CD and DVD-ROMS, and a variety of other peripherals. In recent years however, the trend has been towards smaller, more easily portable forms.

A good case will not only provide reliable power and a stable working environment. It will also allow easy access to inner workings and adequate space for any additional optional components. Cases are often judged by their use of materials and organization in terms of component placement and airflow (which is important in order to keep the internal workings from overheating). Even compact computer systems such as Apple's iMac, notebook computers and tablets, have a case that must provide many of these functions.

The Power Supply

The power supply, an indispensable part of the computer that is incorporated into each and every case, takes regular household electricity (AC alternating current) and adapts it to a form of power the computer actually uses (DC direct current). It also contains a fan for cooling computer components and directing airflow in and around the various cards and cables within the box. Today's power supplies use a switcher technology to not only convert AC voltage to DC voltage but provide plugs for a variety of digital circuits to power disk drives, fans, video cards, and even the motherboard itself.

There are many different levels and wattages of power supplies available today, and given the power-hungry nature of many video cards it is important to understand the level of power you need to

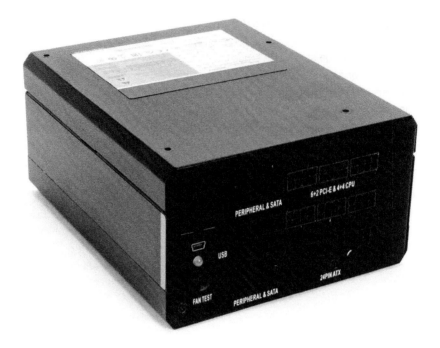

4.2
This modular power supply allows you to use only the power cables you need in order to keep clutter in your case to a minimum

safely run the equipment in your PC. In addition, the quality of the power is critical. If you have a power source that is subject to surges and spikes (short-term voltage increases) and line noise distortion produced by EMI (Electromagnetic Interference) and RFI (Radio Frequency Interference), without some way to correct for them, computer difficulties will follow. Some line noise is inevitable and while not always harmful, it can cause damage to electronic circuits that results in data corruption. It can even affect system components (see Figure 4.2).

Many people think an inexpensive surge suppressor will protect their computer from electrical problems, and this is true only to a degree. In a best-case scenario, a power surge or spike will trip a sensor in the surge suppressor and turn off power before it can damage the PC plugged in to it. Unfortunately, suddenly turning off power to a computer, instead of using the regular shut down process, can lose and/or corrupt important files. To get better power protection, and handle a power outage, an *uninterruptible power supply* (*UPS*) comes with a built-in battery capable of running your system for a short period of time—enough to allow you to shut your computer down correctly. A quality UPS will also filter and modify power so whatever device plugged into it receives a steady stream of clean power.

The Motherboard
The motherboard, or primary circuit board, is the nerve center of the machine. It connects to the power supply and distributes electricity to all components connected directly to it (see Figure 4.3). It is also where many of the most critical elements of a computer are located. The motherboard contains several openings or sockets where computer chips are installed. Among the chips housed on the motherboard is the most important one, the CPU. There are also expansion slots for attaching a variety of special circuit boards or cards (like a video card or sound card) directly into the

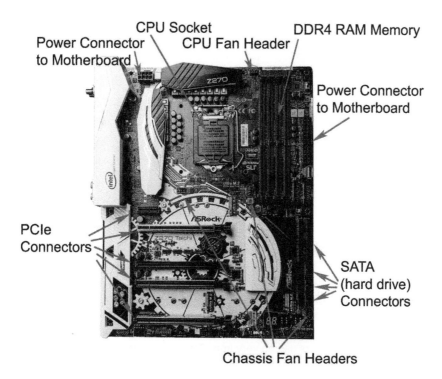

Power Connector to Motherboard
CPU Socket
CPU Fan Header
DDR4 RAM Memory
Power Connector to Motherboard
PCIe Connectors
SATA (hard drive) Connectors
Chassis Fan Headers

4.3

A basic PC motherboard usually contains PCIe slots for expansion cards (video cards for example), DIMM slots for RAM, a processor socket, and SATA connectors for hard drives. There are also connectors to provide power from the PSU and fan headers (3 or 4 pin connectors) to power fans to help cool the system

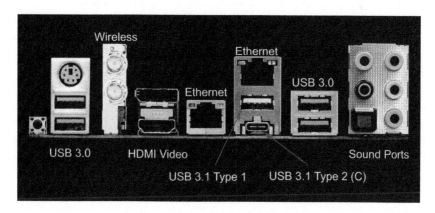

Wireless
Ethernet
Ethernet
USB 3.0
USB 3.0
HDMI Video
Sound Ports
USB 3.1 Type 1
USB 3.1 Type 2 (C)

4.4a

Ports at the rear of a PC to connect peripheral devices

motherboard. At its back end, the motherboard also has ports—places to plug in peripheral devices (see Figures 4.4a and 4.4b). As CPU design has evolved, the socket it uses to plug into the motherboard has also changed. This affects everything from the internal bus that allows the CPU to communicate directly with the system's RAM (central memory) to the type of fan that will fit on the CPU and the way in which it is attached.

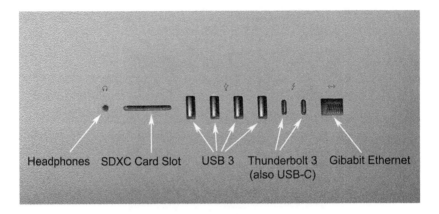

4.4b
Ports at the rear of an iMac computer to connect peripheral devices

Central Processing Unit (CPU): The Brain on the Motherboard

The brain that runs everything inside your computer is a microprocessor called the **central processing unit**. Everything a computer does, from word processing to digital imaging, is executed by this microprocessor. While other components can be very important to the overall performance of your system, the CPU is, without a doubt, the single most important one. As personal computers have evolved since 1981, the CPU has taken huge leaps in terms of processing power. Initially limited to a single processor on a single chip, today's processors are more often multiple CPUs combined on a single chip, capable of dramatically increasing processing power. This allows multiple tasks to be completed simultaneously, thus increasing the overall speed of the computer itself.

When we look at the microprocessor, what we are really seeing is the housing for the CPU chip. In fact, what we often see on the motherboard is the heat-dissipating *sink*, which is capped with a fan to keep the CPU cool while it is working. The CPU itself is less than 1 mm thick and only one-third of an inch square in size. Contained in this fragile wafer are millions of embedded transistors created by a photolithographic process in which the physical map of the CPU design is layered onto the chip. When the chip is complete, hundreds of connections are made to the larger housing, which is then inserted into the motherboard.

A key element of the microprocessor is the *control unit* (CU). The control unit interprets a program's instruction and then launches the action that will carry it out. It does this in four steps: first, it has to get the instruction; second, it must decode the instruction; third, it executes the instruction; and fourth, it writes the result to temporary memory. The time it takes to get the instruction and execute the instruction is referred to as a **machine cycle**.

The CPU depends on the **system clock** to coordinate a computer's operations. The **system clock** times the activities of the chips on the motherboard and makes sure that all processing activities are discharged according to the **clock tick** (the speed with which the CPU can execute instructions) of the system. The more clock ticks per second, the faster the CPU is able to execute instructions.

A CPU's speed is normally measured in megahertz. One megahertz (MHz) is equal to 1,000,000 clock ticks (cycles) per second. The early 8088 processor used in the one of the first desktop IBM computers of the 1980s ran at 4.77 MHz or 4,770,000 ticks per second. In comparison, a 3.5 GHz processor of today can process 3.5 billion clock ticks per second, or more than 700 times more per second. Generally, the CPU's megahertz rating is the most important indication of how fast the processor is. But other factors, like extra instructions written into the code of the chip, can affect its speed. For

example, to speed up the handling of multimedia data, a special instruction set called MMX (Multimedia Extensions) was introduced in 1997 and has become standard in all Intel processors. Equivalent instruction sets have also become standard in the chips of Intel's competitors and continue to be expanded and extended since then.

Early CPUs executed instructions one at a time. As processors developed, different ways of increasing the speed at which the processor could execute instructions advanced dramatically. In 1989, a five-stage pipeline allowed the processor to *pipeline* instructions. This allowed the processor to start a second cycle before the first one was complete. Without having to wait for an entire cycle to finish, three additional cycles could be started before the first one was finished. Some CPUs, known as **super-scalar**, could run two or even more pipelines that rapidly processed many instructions at the same time.

Today's processors have multiple cores combined onto a single chip. This is similar to installing two, four, or even six or more processors, each of which can process instruction sets along multiple threads on each core, increasing processor speed exponentially. Multiple threads dramatically increase the number of transactions that can be processed simultaneously.

MEMORY ON THE MOTHERBOARD

ROM Memory

There are several different types of memory used in computers, and they differ in significant ways. **Read-only memory**, or **ROM**, is relatively slow and can only be read, not written to (changed). ROM memory is relatively permanent and far more secure for certain types of small programs. A good example of this is the BIOS (Basic Input/Output System) ROM that begins the start-up or **boot** process for the computer. The BIOS ROM is a permanent part of the system and can even be removed from a computer and later returned without losing the information inside.

The BIOS, while offering options to set certain parameters for your system, including overclocking to make your PC run faster, is essentially responsible for initializing and testing system hardware components (the POST or power on-self test), initiating the operating system from a hard drive, DVD, or flash drive and providing support for interaction with your keyboard and display. Once the BIOS completes its work, your operating system takes over and controls all elements and operations of the computer.

Electrically Erasable Programmable ROM or **EEPROM** is the type of ROM that is used most often in motherboards. It allows the user to "flash" or upgrade the BIOS to take advantage of processor improvements or errors found in earlier releases of the BIOS ROM.

UEFI (Unified Extensible Firmware Interface) Firmware

Starting with the Windows 8 operating system, the traditional BIOS began to be replaced with UEFI firmware, the same system used by Apple computers. UEFI does have a legacy BIOS compatibility mode that provides backward compatibility when necessary, such as running older operating systems. While older BIOS-based systems were limited to 16-bit processes and 1 MB of memory, UEFI systems can work in both 32- and 64-bit mode, address more RAM and make it easier to adjust system settings. It also offers more boot options, has more sophisticated network booting possibilities, and can address booting from larger hard drives. It will also, thankfully, boot much faster than BIOS.

RAM Memory

Random access memory, or **RAM**, is what most users think of when discussing computer memory. This fast, *short-term* memory is used by a computer for holding data and programs as you work. RAM

is much faster than your computer's hard drives and sends information to the computer's CPU at high speed, so it shortens the time the processor must wait for it, resulting in faster operations. Unlike ROM which can only be read from (not written to) and does not lose information when the power is turned off, RAM can be both read from and allows information to be written to it but loses all its data once the power is turned off.

However, there is a price to be paid for this speed. The reason you can lose work when your computer suddenly crashes is because RAM, unlike ROM, is a very temporary storage medium. It only stores information while the computer is running. When RAM stops receiving power, everything contained in the RAM is lost. So, unless the data is written to a more permanent storage medium or *saved* to a more permanent medium (like a hard drive or thumb drive), whatever was contained in the RAM will simply vanish when the power is turned off.

Usually the more RAM you have, the faster the data it contains can be accessed by the CPU. This becomes especially important when you are working with larger files—like digital images or 3-D animations. The amount of RAM a computer can use is determined by its motherboard's chipset and architecture. The operating system is also very important as a 32-bit operating system can only access 4 gigabytes of RAM, while a 64-bit system can access considerably more. In addition, RAM consistently changes (DDR2, DDR3, DDR4) as motherboards evolve.

Buses and Ports on the Motherboard

Buses are essentially a series of pathways that connect components of a computer and transfer data between the CPU and peripherals. Just as Greyhound buses can travel at different speeds depending upon their agreed upon route, how wide and easy the road is to travel, and the number of stops they must make, computer buses also convey data at different speeds depending upon the width of their path and the distance the information must travel. By reducing the number of pathways needed to communicate between devices, the primary bus (for example, PCI Express) allows for synchronization between different components. Bottlenecks are prevented by having the system prioritize data and by giving each device its own dedicated connection to the controlling switch.

The motherboard also contains **expansion slots** that connect to a bus to allow users to add different kinds of cards that control peripherals. For a long time, the PCI (Peripheral Component Interconnect) bus provided slots that allowed a user to add different peripheral cards (sound cards, video cards, etc.) to upgrade their computer or replace broken components. However, its limitation to a fixed width of 32 bits and the inability to handle more than five devices at a time led to its replacement by a 64-bit PCI-X bus and then with the newer and far more sophisticated PCI Express (PCIe) bus. PCI Express behaves more like a network and instead of devices having to share a pathway as they did with older bus systems, this new bus has a switch that allows each device to have its own connection without sharing bandwidth.

Universal Serial Bus (USB)

The **universal serial bus** provides an excellent system for installing devices outside the computer. All USB ports on the exterior of the case connect to this universal serial bus, which then connects to the PCIe bus on the motherboard. External devices such as keyboards, mice, CD-ROM's, scanners, printers, and other peripherals can be plugged directly into a USB port on the back and/or front of the computer. External hard drives and digital cameras benefited greatly, especially with the newer and much faster USB 3.0 connections, which were introduced in 2008.

In the past, each computer had many specialized ports. A dedicated parallel port would be used for a printer. There were also a serial port and special ports for a keyboard and a mouse. This more recent USB bus system provides a standardized method of connecting up to 127 devices to your computer.

We can find USB connections on the computer itself, on extension cards, even built into monitors. It is clear to see why this bus system has replaced the far slower 1-bit serial bus, and now obsolete keyboard, mouse, and parallel ports. In addition, due to the nature of USB, it is far more "plug and play" than the older bus systems.

A USB cable can be up to 15 feet in length. A USB 2.0 cable has two wires for power and data is carried via a single twisted pair of wires in one direction only. USB 3.0 has four additional wires for data transmission and can send information upstream and down simultaneously. The increased speed of USB 3 made using external hard drives much faster and more productive. While each of these protocols is fully backward and forward compatible with the other, keep in mind a USB 3 device will only run at the speed of a USB 2 device when plugged into a USB 2 port. Likewise, a USB 2 device will not run faster when plugged into a USB 3 port.

In 2013, an even faster USB 3.1 was introduced. There are two types of USB 3.1—Generation 1 and Generation 2. USB 3.1, Generation 1 is essentially the same as USB 3.0 but with the addition of all the changes and upgrades made to USB 3.0 since its introduction. They both transfer data at 5.0 Gbps and use the same connecting cables. USB 3.1 Generation 2 is quite different, both in terms of speed and connectors. USB Generation 2 can transfer data at 10 Mbps (twice that of USB 3.0) and has a different connector entirely. USB Generation 2, Type C uses the same connector as Thunderbolt 3 (see Figure 4.5).

Thunderbolt

Thunderbolt is a bus connection championed by Apple in its computers with far faster speeds for external devices. This is of particular importance for iMacs where the computer components are built into the monitor, and no provisions are made for installing add-on cards. Thunderbolt allows a seamless integration of a variety of different devices. With simple adapters you can connect to older Firewire (high-speed serial bus) peripherals, USB devices, and even Ethernet networks. You can also *daisy chain* or connect computer devices and peripherals one after another in sequence, as long as they have two Thunderbolt ports (one in and one out) for up to seven devices.

Introduced	Version	Identifier	Speed / Mbps
1998	USB 1.1	Full Speed (FS)	12 Mbps
2000	USB 2.0	High Speed (HS)	480 Mbps
2008	USB 3.0	SuperSpeed (SS)	5 Gbps
2013	USB 3.1 VERSION 1		
2013	USB 3.1 VERSION 2 (Type C)	SuperSpeedPlus (SSP)	10 Gbps
2011	Thunderbolt 1	(uses Thunderbolt Mini DisplayPort Connector)	10 Gbps
2013	Thunderbolt 2	(uses Thunderbolt Mini DisplayPort Connector)	20 Gbps
2015	Thunderbolt 3	(uses USB C Port Connector)	40 Gbps with active cable 20 Gbps with passive cable

4.5
Speed identification chart

In terms of speed, Thunderbolt is twice as fast as USB 3.0, clocking in at 10 Gbps. Thunderbolt 2 doubles that to 20 Gbps and Thunderbolt 3 again doubles that speed to an astonishing 40 Gbps (8 times the speed of USB 3) and provides connection to just about any device you can imagine. What's more, a single Thunderbolt 3 cable can provide four times as much data while also supplying power. As Thunderbolt is often used to connect to monitors, it also can double the video bandwidth of other cables and easily provide 4K (Retina and other High Definition) monitor support. Compared to a monitor that provides a resolution of 1920 x 1080 resolution, a 4K monitor has four times as many pixels and requires faster and wider video bandwidth.

Hard Drives

In 1956, IBM invented the first computer disk storage system, which was called RAMAC (Random Access Method of Accounting and Control). This disk storage system could store a then astounding five **megabytes** of data on 50 24" diameter disks. Today, hard drives commonly range in size from 750 **gigabytes** (a gigabyte is 1,000 megabytes) to several **terabytes** (a terabyte is 1,024 gigabytes) and larger in capacity, and typical mechanical desktop hard drives are usually only 4" x 6" x 1" in size. Just to place this in context, a one terabyte drive can hold 472 hours of broadcast-quality video or 150 hours of hi-definition recording or 2,000 hours of CD-quality recording. For the average user this is an astonishing amount of storage space, but for digital artists it is not nearly as impressive. Depending on its use, one digital image might require between 50 megabytes to even a gigabyte of storage. Three-dimensional animation, which requires displaying 24 images per second, obviously will create even larger files.

Traditionally, mechanical hard drives store information in a series of tracks and sectors on a series of platters that are stacked together and spin in unison (see Figure 4.6). A read/write head for each platter floats, ready to read a specific area of the disk. This is similar to a conventional vinyl record and needle playback head. However, the data on a hard drive platter is arranged in concentric circles rather than the spirals of a vinyl record. The density of the platters and the fact that many can be stacked together give the hard drive tremendous storage capacity.

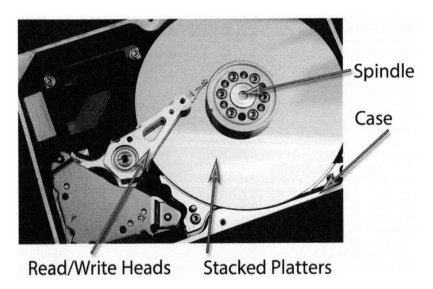

4.6
Internal view of hard drive showing a storage platter and read head

The faster a hard drive spins, the more quickly it can retrieve data. Most current hard disk drives spin at 5,400, 7,200, or 10,000 RPM (revolutions per minute) with more expensive 15,000 RPM drives also available. The platters themselves are made from glass or ceramic to avoid the problems created by the heat they generate as they spin.

Solid State Drives and Flash Drives

As processor speeds have increased exponentially, traditional, mechanical hard drive speeds have been hard pressed to keep up. One of the problems with traditional hard drives is that it can take 15 milliseconds (1 million nanoseconds) to find and then provide data to the processor. The problem is that processor speeds are in nanoseconds so hard drives are, by comparison, excruciatingly slow. Solid state drives work very differently, and are faster than a mechanical hard drive, though still slow in comparison to a processor. But they have other significant advantages.

To begin with, a solid state drive has no moving parts and unlike traditional RAM, retains its charge state even when turned off. Because they have no moving parts, they are less vulnerable to failure than conventional hard drives, and by using flash memory that does not require power to retain data, solid state drives can start up instantaneously instead of needing time to spin up to speed. Random access time is also much faster than mechanical drives as data can be retrieved directly from a specific location instead of having to wait for data to move under the mechanical read/write head of a traditional hard drive. Because an SSD drive can read data directly from any location instead of having to seek information from various locations on a mechanical disk, a pronounced increase in the speed of various processes is evident. Fragmented files (parts of a file stored in different sections of a disk instead of next to one another) are far more of a problem for a mechanical drive than an SSD drive. In addition, a solid state drive (unlike mechanical hard drives) creates no noise and has no heat issues.

However, SSD drives are not a perfect solution to increased speeds. They have their own issues. While they read and write faster than a traditional drive, in time their read performance can suffer as NAND (nonvolatile memory that maintains data even after power is turned off) cells degrade. NAND flash memory cannot be overwritten and needs to be written to unused space on the drive. When you delete information from an SSD drive, the operating system simply marks that space as "not in use." When you write information to an SSD drive, it must first erase that marked space before it can write new data to it. SSD drives have resolved this by using a TRIM command that not only marks a space as "not in use" but also wipes that space clean, making it possible for an SSD to write data directly to that space without having to erase it first. This allows an SSD drive to continue to work at full speed for a longer period of time. TRIM is a crucial part of SSD use and should always be enabled.

Despite the pros and cons, there will be a noticeable increase in speed when using a computer with an SSD drive. They are generally smaller in terms of storage size and more expensive than mechanical drives, although that is changing. Many users select SSD drives as their boot drives and for installing programs while using larger and slower mechanical drives for storing data.

Video Adapters: What You See

All information sent to a video monitor is broken down into **pixels** or picture elements, an individual point of light on the screen. Video cards and their ability to display color is related directly to how many bits of information they use to compose each pixel. Different color depths result from a graphics card's ability to display finer distinctions of color variation (more bits per pixel) and send those descriptions of each pixel to the monitor. This is also affected by the monitor's ability to display those more finely tuned colors.

Most video cards allow you to choose the color depth by selecting the number of colors you wish to display on screen. Four-bit color results in no more than 16 colors, while 8 bit gives you 256 colors.

Most digital artists want all the color they can get and so work at 24-bit depth (8 bits or 256 colors per channel), which allows them 16.7 million colors to work with. Many digital cameras today can photograph images at 16 bits per channel (16 bits or 1,024 colors per channel), which gives a much fuller and smoother gradation of color, using billions instead of millions of colors. We will be discussing this in more detail in Chapter 5.

While older video cards didn't need built-in memory to do an adequate job, today's requirements of increased resolution and color depth demand dedicated memory on the video card itself. As monitors grow ever larger and pixel density brings us high definition screens (Apple's 4K and 5K Retina for example), there are simply a greater number of pixels that must be moved. Video games, for example, rely on a video card's GPU (*graphics processing unit*) and built-in RAM, along with additional power (wattage) to run smoothly. In addition, newer 3-D technologies and faster bus speeds have resulted in a need not only for more, but faster memory. The earliest form of this faster RAM was known as *VideoRAM*, or *VRAM*, and was introduced in the late 1980s. *Graphics RAM*, or *GRAM*, is much faster and was designed for graphics-intensive applications. It also synchronizes with the bus clock of the CPU in order to increase speed.

Today's video cards are more accurately called **graphics accelerators**. Besides RAM, they have a dedicated GPU to boost performance beyond that of a simple video card. Newer and faster chip sets handle everything from decoding MPEG movies to special features of 3-D graphics and games. This relieves the CPU from working at this task and frees it to devote its time to what it was designed for— performing complex executions of data.

Video adapters are often built right into the processor/motherboard of your computer with a port to allow you to plug in a monitor. These *integrated* GPUs can help lower the cost of a computer, as they are much less expensive to implement than a *dedicated* GPU. Unfortunately, they use slower system memory instead of a dedicated video card's GPU and faster, built-in graphics memory. However, they also run cooler and use less power, which makes them a good match for a notebook computer or tablet. For those whose graphics needs are not very high then this card should be all you need. However, for most digital artists and designers, many built-in video cards are not powerful enough to run the software necessary for more demanding programs, especially 3-D rendering, multimedia, high-end photo editing, and others. In this case, a dedicated video card can offer you increased speed and power.

Dedicated video cards have their own dedicated amount of memory. If your graphics card has 2 or 4 gigabytes of memory built directly into the card, that memory is separate from the RAM memory used by your computer. These cards also contain their own processor and as a result are more powerful and a much better match for power-hungry digital design programs. On many machines, with cases that can be opened, they can also be "upgraded" or replaced with an even more powerful card as they are released. While dedicated cards containing a specific GPU and faster dedicated memory are costlier, they are a good investment for anyone pursuing digital media as a career.

Some systems today even have both an integrated and dedicated video card, allowing the user to determine which sorts of activities are best for each card. This can be particularly helpful for notebook users who need to get the best balance of power and battery life, since a dedicated video card uses more power.

JUST OUTSIDE THE BOX: THE MONITOR

It is difficult for most people to visualize a computer without its primary output device—the *monitor*. This is what we see and often what we judge a computer by. It is the face for all the computer's information.

In the past, computer monitors implemented a relatively old technology originally used in television sets, the cathode ray tube. CRT technology shoots a beam of electrons from the back of the screen to the front of a "picture tube." A phosphor coating on the back of the screen lights up a pixel when hit by an electron beam. It is the mix of electrons fired by three color guns—red, green, and blue—hitting the back of the screen, and their relative strength, that determines the colors we see. As the strength of the electron hitting a particular phosphor determines how much light it will emit, the intensity of the electron beams is varied to control how individual colors will appear on screen.

Liquid Crystal Display (LCD)

Today's computers typically rely on some form of liquid crystal display (LCD) monitor. These flat panel LCD displays are much lighter and require far less room than conventional CRT displays. They also require less energy. Initially there were two main forms of this technology, passive and active matrix LCD. While both worked, the passive matrix screens were slow in terms of response times. Things that moved quickly—video game elements or mouse movements—caused an after image or "ghosting" that interrupted the flow of information seen on the screen.

Box 4.1 Gaming and Video Issues: Refresh Rate and Frames Per Second

While most LCD monitors have a standard refresh rate of 60 Hz (the number of times each second a monitor can redraw the entire screen), a video card controls the FPS (frames per second) that can be produced. Your monitor's refresh rate essentially sets a cap for FPS as a monitor will not be able to display more FPS than the refresh rate. The solution to this, especially for gaming and software requiring fast frame rates, are monitors with a faster refresh rate. However, even if you purchase a monitor with a refresh rate of 120 Hz or higher, and a video card capable of producing 90 FPS in your game or application, your computer's ports might still impose limitations. If you connect your computer to a monitor using an HDMI port, you will still be limited to 60 Hz. However, if you use DisplayPort you can take full advantage of your monitor's faster refresh rates.

While a higher frame rate is what we pay for when purchasing an expensive video card, it will still be limited by the monitor you connect it to. If the frame rate of your video card is higher or lower than the monitor's refresh rate, an issue known as "tearing" can occur where information from multiple frames is shown as a single frame. While this causes no damage, it can become bothersome. Enabling a feature known as *vertical synchronization*, or *VSync*, allows you to synchronize the GPU's frame rate to the monitor's refresh rate.

Many monitors today are also capable of faster refresh rates (120 and above) and have a technology that allows it to communicate directly with the video card to in order to vary its refresh rate to match the frame rate of the video card, resulting in fluid movement without artifacts or tears.

A *TFT* (or *thin film transistor*) display screen is known as *active matrix* because the LCD panel has an extra matrix of transistors, with a transistor assigned to each pixel—one transistor each for red, green, and blue. *Active matrix* technology does not have the ghosting problems associated with older types of passive LCD screens. Because each pixel is turned on and off by a transistor in active matrix LCDs, refresh rates are no longer an issue, screens are bright and colorful, and they respond quickly to changes. This improves the ability to control color and image characteristics.

There are two primary forms of LCD technology available today, TN (Twisted Nematic) and IPS (in-plane switching). Each has strengths and weaknesses. TN is the less expensive and the older technology of the two. Its displays provide quick response times and with LED backlighting offer bright, crisp colors. Their Pixel Response Rate, the time it takes for one pixel to change from black to white, is very fast. Gamers usually prefer these monitors for their bright colors and quick response times. However, one of the major drawbacks to TN monitors is that color will fade and change depending on your viewing angle. If you are looking straight on there is usually no problem. But if you view from slightly too low or high an angle, or from the side, color shifts and density changes will occur. In addition, TN monitors are essentially 6-bit monitors and so are only able to display about 70 percent of 16.7 million colors offered by video cards.

IPS (in-plane switching) monitors offer far better color reproduction (8-bit true color offering 16.7 million colors), eliminate the viewing angle issue, and provide consistent color from even extreme angles of view. When they were first manufactured, they were far more expensive with response times that could not compete with TN displays. They also had difficulties in reproducing dark values, resulting in contrast issues. Most of this has been resolved today and IPS displays are the monitor of choice for design and photography professionals. They are easier to calibrate (see Chapter 6) for professional use, have great dynamic range, and reproduce a broader range of color (in the 90 percent range) than a TN monitor. Newer Super IPS technology is also available but it is limited to improving legibility outdoors. It works great for phones and tablets but uses battery power more quickly.

Artist Profile: Nam June Paik

The Korean artist Nam June Paik (see Figures 4.7, 4.8, 4.9, and 4.10) is often referred to as the artist who invented video art. This can be interpreted quite literally, as he often used multiples of old televisions as his medium of choice, bringing together piles of TVs in a kind of organized chaos. By using video displays as his raw material, sometimes as many as 300 at a time, he was

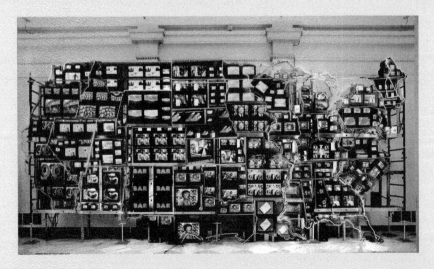

4.7
Nam June Paik, *Electronic Superhighway: Continental U.S., Alaska, Hawaii*, 1995, 51 channel video installation (including one closed-circuit television feed), custom electronics, neon lighting, steel and wood; color, sound

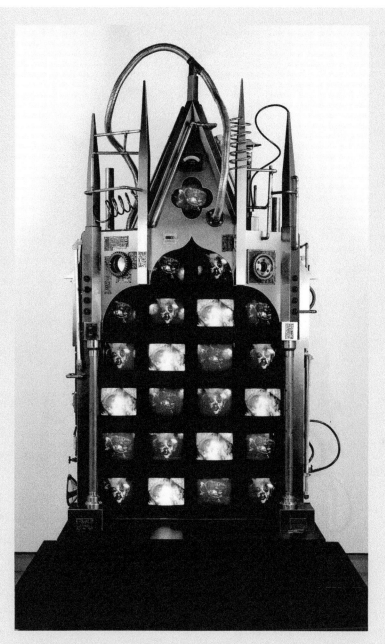

4.8
Nam June Paik, *Technology*, 1991

able to shape concepts that redefined the nature of reality and how we perceive it. In addition, his collaborations with some of the world's leading avant-garde artists (like composer John Cage) opened his work to new directions.

Although technology as art was central to his work (he was particularly known for his television robots), it was often humanized as he opened the opportunity for viewers to engage in his work

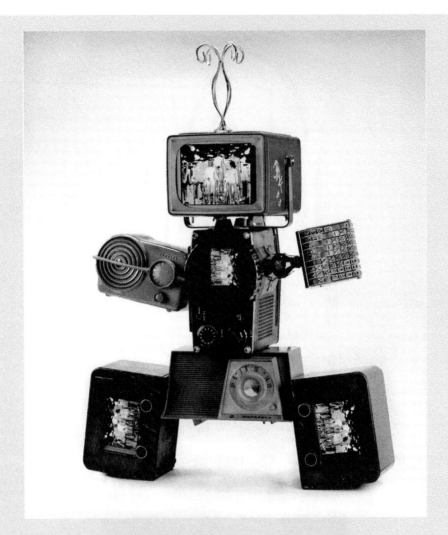

4.9
Nam June Paik, Paik, *Untitled (robot)*, 2005, single-channel video in robot-shaped assemblage of televisions, radio parts, library stamp, and metal hardware, with additions in paint; color, silent

rather than view it passively. His work presaged the development of many of today's advances in technology. He once wondered how soon it would be until artists had their own TV channels and people would watch in their homes on flat screens. This was 40 years before the advent of flat screen technology. His later work in the 1990s made him a leader in the combination of video art and new technologies.

At his death in 2006, the entire archive of Paik's work was given to the Smithsonian American Art Museum—everything from his early writings to his collaborations with other artists and the complete collection of televisions, radios, and videos used in his artwork. Due to the antiquated technology Paik used, his work is very difficult for conservationists to recreate.

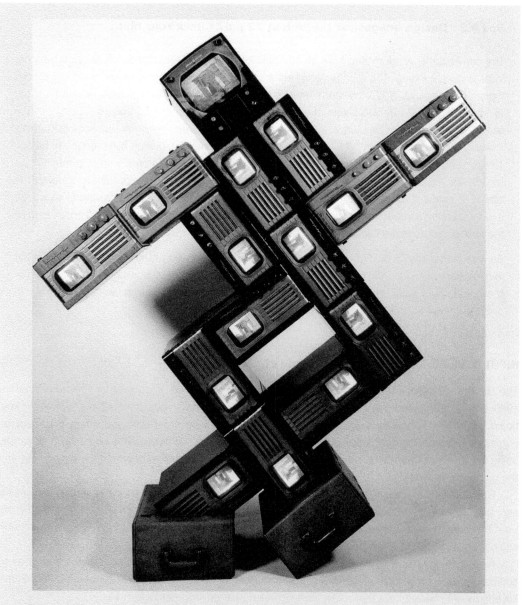

4.10
Nam June Paik, *Untitled (robot)*, 1992, single-channel video in robot-shaped assemblage of televisions, radio and stereo-system parts, and metal hardware, with additions in paint; color, silent

Retina Display

In 2012, Apple started to call their IPS monitors incorporating the high-resolution screen technology introduced on the iPhone 4, a Retina display. The term Retina simply refers to a display where the human eye cannot distinguish individual pixels. Many place this at a pixel count above 163 pixels per inch, although Apple's Retina displays are in the neighborhood of 300 ppi. The name Retina proved to be a very successful marketing strategy.

Box 4.2 Design Images for the Web at 72 ppi? Check Your Math

The conventional wisdom that says all monitors have a screen resolution of 72 ppi (pixels per inch) is simply wrong. The number of pixels a screen actually accommodates is almost always higher. For example, a 17" monitor screen is usually 12.5" wide. If the screen resolution is set for the typical 1,024 by 768 pixels, the actual screen resolution is 1,024 pixels divided by 12.5 or 82.24. If the screen resolution is lowered to 800 by 600 ppi, when one divides 800 pixels (horizontal measurement) by 12.5" we discover that the screen resolution has dropped to 64 ppi. Things now appear coarser. Because the pixels present at any resolution are finite (a monitor set for 1,024 x 768 will have exactly 1,024 pixels horizontally) it is far more important to consider the size of an image in pixels rather than resolution in terms of dpi or ppi in order to control how large it will appear on screen. It really doesn't matter whether the image is 72 ppi or 300 ppi as long as the pixel dimensions are suitable for the size screen for which you are designing.

So where does the 72 ppi figure come from? Apple released its first Macintosh computer in 1984 and it came with a built-in 9" screen that happened to have a resolution of 72 ppi. Somehow the 72 ppi figure stuck, and even after more than 30 years is still confusing new users. Design in pixels but leave 72 ppi in the dustbin of history where it belongs.

INPUT DEVICES: KEYBOARD/MOUSE/TABLET

The computer's keyboard is perhaps the most familiar input device, especially for those born before 1980. For all intents and purposes, it serves the same function as your grandfather's typewriter keyboard, but with additional keys for specific computer functions. On larger keyboards there is a dedicated numeric keypad on the right side, which makes entering numerical data quite a bit easier than simply using the top row of numbers. Navigational cursor keys are also available between the typing keys and the numerical keyboard.

Function keys (or F-keys) are usually located along the top or left side of the keyboard and are for shortcuts specially programmed to issue commands. In many cases they can be programmed by the user. The F-keys can also be used in combination with the shift, control, and alt keys (or shift, command and option keys for MAC) for greater flexibility of function.

As technology has evolved, particularly the Internet, keyboards have added features dedicated to additional tasks. Some keyboards have specific controls for sound, or shortcuts for web surfing. Some keyboards offer backlit keys that make working in a darker environment much easier.

No matter what type of keyboard you use with a traditional desktop computer, they all plug into a USB port either at the back of the computer case or in a USB extension console. Special software is only necessary for those keyboards with enhanced functions and wireless capability. Other devices, like tablets and phones, can connect keyboards using Bluetooth (a wireless, automatic standard using low-power radio waves) or a dedicated SMART connector to provide a data and power connection to connect keyboards to devices like the iPad Pro.

Mouse

The computer mouse is an astonishingly intuitive pointing device that moves a cursor around the computer screen. In word processing or email, it is most often used instead of the keyboard navigational

keys to position the insertion point in a document. In a graphics-oriented program, however, with just a click, it can take on an extraordinary variety of roles—from an airbrush to a selection tool to a paint can to an eraser.

The **mechanical** *mouse* (see Chapter 5) initially introduced contained a small ball that moved against sensors as you rolled it (see Figure 4.11). The sensors translated the move-

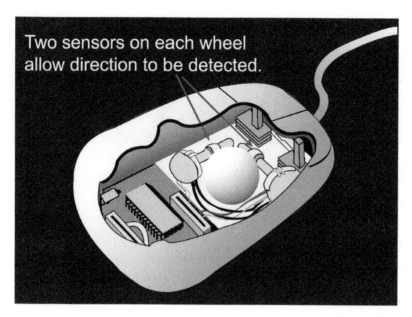

4.11
The mechanical mouse has been replaced by the far more technically advanced optical and laser mouse

ment of the ball to movement on the screen. Like today's mice, they also contained one, two, or three buttons that controlled various functions within programs. There are many variations beyond the simple mechanical mouse including optical and infrared mice. A **trackball** device is actually an upside-down mouse with a larger ball that can be rolled between your fingers or under your palm.

Today, mice have become quite a bit more sophisticated. Introduced by Microsoft in 1999, the *optical mouse* utilizes light-emitting diodes (LED) or laser track movement. Using a miniscule low-resolution camera to take thousands of pictures each second, the mouse sensor sends signals to a digital signal processor (DSP) that analyzes each image for changes, determines distance moved, and sends that information to the computer. The cursor is then moved relative to perceived changes. Of course, this happens hundreds of times a second, so the movement is very smooth. A laser mouse is similar in operation but uses laser light to detect the movement of the mouse. Laser mice are more accurate than the standard optical mouse and can provide up to 20 times greater accuracy.

4.12
An optical mouse uses light-emitting diodes or lasers to track movement

Graphics Tablets

For digital media, a mouse can sometimes be a relatively clumsy tool for input. A graphics or digitizing tablet is far more sophisticated than a mouse in terms of function and sensitivity. Ranging in size from a small notepad to as large as a tabletop, artists can draw directly on the tablet with a special stylus that has a small, spring-loaded plastic tip. The tablet is extremely sensitive to the movement of the stylus. It can sense not only where a line has been drawn, but how hard the artist has pressed down, as well as at what angle the stylus was held. Some styluses can be even be turned over to act like a pencil's eraser. Using a graphics or digitizing tablet with image-editing or painting software is much closer to drawing directly onto and into a computer. In fact, more recent developments in advanced tablets have a flat screen monitor built in (Wacom's Cintiq[R] for example) so users can work directly on their images. The ability of a graphics tablet, when used with specific software, to mimic natural art media is surprising and rewarding (see Chapter 8).

Sound

Most computer users' first experience of sound on a computer was the musical score that played when the operating system became active or closed a program or announced an error. However, for digital artists, sound has become an integral part of most multimedia productions.

In addition to speaker output, sound cards also have external connectors for a microphone and stereo components. Increasingly sophisticated sound cards have been created to respond to the demands of music listeners, game players, and creative artists. Sound recording and playback is one of many features sound cards can offer in addition to simply playing back prerecorded sound. Sound is essentially analog—a rippling flow of sound waves that we encounter continuously. Just as a flat image will need to be digitized, in order for a computer to make sense of analog sound waves it must first convert that information into a digital form. To convert analog to digital sound, the computer *samples*

the original analog sound and converts that information to a format (zeroes and ones) it understands. A sound sample is a quick picture of a sound wave. The more samples the computer takes per second, the finer the image of the sound wave, and the higher the quality of the digitized sound. Most computers have the ability to sample sound from 8,000 to 44,100 times each second. Analog sound sampled at 11 kHz is only one-quarter of the quality of sound sampled at 44 kHz (CD quality). As one might expect, the higher the quality of the digital sound recording, the larger the file necessary to store that information.

CONCLUSION

In this chapter, we have examined the basic nature of hardware components, as they related to computing. With new plans for computer chips with ever smaller components and faster speeds; web connectivity increasing in both speed and breadth of service; and VR being used more and more in science and medicine, training, and, of course, gaming, the integration of computers in our lives is expanding at breakneck speed. Knowing the individual components that make up a computer is one important element in knowing what to look for when purchasing a new computer, upgrading, or troubleshooting an existing one.

Projects: Inside the Box

1. *Make a list of the components* (type of video card, RAM, hard drive, CPU, and so on) in your computer, either by looking at the documentation that came with the computer, researching your computer on the Internet, or by contacting the manufacturer.

2. *Build your "dream computer."* What parts would create the very best computer for digital media production? List all parts of the system it would be necessary to purchase and their current prices.

3. *Compare the major* **operating systems** for personal computers. Visit the websites of Microsoft, Apple, and review sites featuring Linux. Make a list of their similarities and differences.

5 Outside the Box

5.1
This photo of an archaic daisy wheel print assembly shows the individual letters that will print when the head spins to the correct location on the wheel

INTRODUCTION

As the computer has become a consumer appliance for everything, from information processing to game playing to use as an artist's creative medium, it has redefined the world in which we live and has opened new visions of what that world can become. It has crept into our cars and home appliances and communication systems and has become a transparent and accepted force in our lives. At the beginning of the computer revolution, analysts predicted that users would soon communicate directly with others exclusively through the computer. This would lead to a "paperless society." Yet, as computers have become more powerful and printers more sophisticated, the promise of a paperless society has met the reality of a world where the quantity of printed documents to cross the world's desks has grown astronomically, creating small mountains of paper everywhere.

This phenomenon began long before personal computers. It was the typewriter that was the world's first desktop mechanical printer. It eliminated the difficulty of reading handwriting and created a document that conveyed a sense of formality suitable for business. As the computer industry evolved, it realized very early that there remained a need for *output*, or hard copy. In the early years of the computer as a consumer appliance, this was accomplished with impact character printers.

A BRIEF HISTORY OF COMPUTER PRINTING

Impact Character Printers
By the early 1980s there were a variety of printers available for home computers. However, sales were limited because even the most basic printer cost over $1,000. As expensive as they were, the majority of these printers could only print the standard, universal ASCII (American Standard Code for Information Interchange) text set of 96 characters. This code read the combination of data bits from the computer and assigned a letter (usually only uppercase), number, punctuation marks, and even mechanical functions like carriage returns and line feed. A few higher-end printers could print *both* upper and lowercase characters and could even be programmed to change the typeface or font.

Daisy Wheel Letter Quality Printer
Daisy wheel printers contained an assembly that resembled a conventional typewriter, but unlike the typewriter prongs ending in a type character, it had a spoked **daisy** wheel, with the characters positioned at the end of each spoke (see Figure 5.1). A print hammer would strike the key and push it into an inked ribbon, which would then strike the paper to create a text character. These printers were capable of producing text that was indistinguishable from a conventional typewriter and they soon became known as *letter quality* printers. Daisy wheel printers cost up to $2,000 when they were initially introduced and were usually purchased by businesses. Unfortunately, they were relatively slow and soon fell from favor as new, speedier, less costly but lower quality printers arrived.

The Dot Matrix Printer
The dot matrix printer was a less expensive alternative to the daisy wheel or letter quality printer. It was also an impact printer, but instead of using actual type letters like a typewriter, small hammers pushed pins against an ink-coated ribbon, which in turn transferred ink dots onto the paper to form letters (see Figure 5.2). Dot matrix printers used either nine-pin or 24-pin dot arrangements—*the matrix*—to

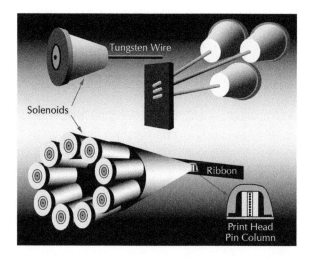

5.2
Dot matrix print head assemblies drive a pin into an inked ribbon, creating a dot on the paper underneath. Most pin assemblies were either 9 or 24 pins. More pins meant finer and less obvious dots. These are still in use for certain applications today

create the letters used to make up documents. Compared to the clarity of letters created by even a simple typewriter, dot matrix documents were relatively coarse, with heads containing 24 pins capable of improved letter formation. The printers with 24-pin capability were sometimes called "near letter quality" printers because they placed the dots close enough together to minimize the broken, dot like nature of the letter form.

In this era of printers, speed was not measured in the number of pages per minute but the number of characters per second (cps) it could produce. By 1977, dot matrix printers for mainframe computers could average approximately 50 cps and cost well over $1,000. As with most technologies, speed and quality rose, even as prices dropped. By the 1980s, cheaper dot matrix printers could easily produce between 100 to 200 cps.

Despite quality that was lower than a traditional typewriter, users found it exciting to use a computer and dot matrix printer to produce a document that could easily be revised without completely re-typing the entire composition. The tradeoff between high-quality "typed" output and convenience made the inexpensive dot matrix printer a popular addition to any computer system in the 1980s.

With dot matrix printers clearly established as the printer of choice, other alternative printing technologies were evolving. One company, Trendcom, created a different kind of dot matrix-like printer that was originally sold with the Apple II. Rather than use a mechanical device to drive the pins as in conventional dot matrix printers, they used a thermal technology that used special heat-sensitive paper (a method that survives in electronic cash registers today) to create the dots that made up the letters. One advantage of this method was that, unlike their noisy cousins, the dot matrix printers, these printers were very quiet. In June of 1979, Apple released a version of this printer under the Apple logo as the "Apple Silentype" for half the cost of a conventional dot matrix printer. These printers had more control over where each dot would be printed and so were better suited to print the high-resolution graphics that were becoming associated with the Apple II computer.

Even though the dot matrix printer remains lower in quality than other forms of printers, it is still used today by older applications for printing forms and reports that require a carbon-like duplicate, which is only possible with impact printers. It can also print connected (*continuous-feed*) sheets of paper. By the late 1980s, even as newer printing technologies emerged, the dot matrix printer remained the most popular printer for home computer users. Its price had dropped to only $200 and was widely accepted as the inexpensive and easy-to-maintain printer for consumers.

Why would we ever want to change?

The Change

In 1984, while most of the computing world hammered along the impact road of dot matrix printers, one of the most important computers the world had yet seen was being introduced. The Apple Macintosh, with its 32-bit Motorola 68000 processor, larger random access memory capability, relatively large hard drive for storage, and, most importantly, a graphical user interface complete with a mouse, opened the way for programs that incorporated graphic elements as part of their function. Programmers could now create programs that allowed the user to easily draw images on the screen (see Chapters 2 and 8).

Apple released the *Apple Laserwriter* in 1985 and ushered in what we now know as the birth of the desktop publishing (digital layout and design) industry. It was based on the first desktop *laser* printer developed by Hewlett-Packard in 1984 (initially costing as much as an average car of that time period) (see Chapter 6). Even at its initial price of $7,000 (about $15,500 in today's dollars), the new technology gave designers the ability to print an entire page at one time, instead of character by character, and dramatically changed the way in which the world defined quality output for computers.

Box 5.1 Xerox: The Father of Laser Printers

Chester F. Carlson completed his Bachelor of Science degree in Physics at the California Institute of Technology in 1930. He first worked for Bell Laboratories as a research engineer but was soon laid off, like so many others during the Great Depression. Unable to find a job in his field, he accepted a job at P.R. Mallory, an electronics firm famous for making batteries. At night, he went to law school to become a patent lawyer. As he studied, he found that copies of patents were scarce, and to make a copy of a patent, one had to either laboriously hand copy the original or send it out to be photographed. Either way, it was time-consuming and expensive. He became determined to find a better way.

Carlson spent months studying scientific articles at the New York Public Library. He eliminated photography as an answer, feeling that it had already been studied without result. Eventually he came across the relatively new field of *photo-conductivity*, which recognized that the conductivity of certain materials increased when struck by light. He realized that if an image were projected onto a photo-conductive surface, current would flow in the areas hit by light. The dark areas, those not hit by light, would have no current flowing over them. He applied for his first patent in 1937.

Working first in his kitchen and then in the back room of his mother-in-law's beauty salon in Astoria, Queens, he continued his experiments. He hired Otto Kornei, an unemployed German physicist, to help him work more quickly and it was Kornei who first took a zinc plate, covered it with sulfur (which conducts a small amount of electrical energy when exposed to light), rubbed it to give it an electrical charge, and placed a microscope slide on top of it. The slide had the words "10–22–38 Astoria" written on it in India ink and was exposed under a bright light for a few seconds (see Figure 5.3). After the slide was removed, the sulfur surface was covered with lycopodium powder (created from fungus spores). When the excess powder was removed, some remained adhered to the words exposed through the slide. To preserve the image, Carlson heated wax paper over the powder forming the words. It coated the powder, preserving it.

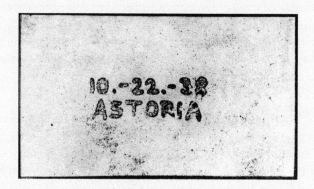

5.3
The first ever "Xerox" copy

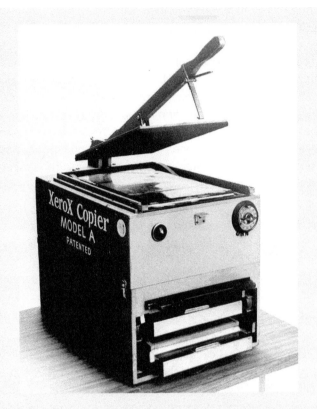

5.4
Model A Xerox Copier

During the next four years, until 1944, Carlson's research was ignored by some of the most prestigious companies in the world including IBM, Kodak, and General Electric. It wasn't until one of Carlson's business trips for Mallory took him to Battelle Memorial Institute in 1944 that someone expressed an interest. Battelle was a non-profit organization that invested in technological research. They signed a royalty agreement with Carlson and began work on the technical areas that needed to be resolved before the process would become commercially feasible. The Battelle staff developed three important improvements: a new photo-conductive plate using selenium (a better conductor than sulfur), a *corona* wire to apply a charge to the plate and also transfer powder from the plate to the paper, and a better dry ink. Their ink was composed of an iron powder, ammonium chloride salt, and plastic. The plastic melted when it got hot and fused the iron to the paper (see Figure 5.4).

When the process, then called **Electro-Photography**, was first introduced in 1948, it took 14 steps and 45 seconds to make a copy. The name of the process was later changed to *xerography* (Greek for "dry writing") and then finally to *Xerox*. In 1959, the first easy-to-use machine that could handle 9" x 14" legal size paper, known as the Model 914, became a huge success. By 1965, the Xerox Corporation had revenues of over $500 million dollars.]

From Xerox to Laser

The Xerox process itself works its magic in a complex series of steps (see Figure 5.5). A photo-conductive (sensitive) drum receives a positive charge of electrons. An image is then reflected from a piece of paper (by mirror) onto the positively charged photosensitive drum. The white, non-image areas become more conductive and their charge dissipates. A negatively magnetically charged black powder known as *toner* is spread on the drum and is attracted to the drum's positively charged areas (those corresponding to the darker parts of the image). A piece of positively charged paper is then placed on the drum. The paper attracts the negatively charged powder (toner). The charged ink (in the dark areas) is then fused to the paper by heat and pressure. This complicated process has made possible the untold number of copies that have flooded the world since its invention.

By the early 1970s, computers and programs were already becoming capable of doing more than simply creating text. However, printers could not accurately depict images and graphics. Xerox researchers, working to create an image on the drum itself directly from the computer, invented the laser printer.

Instead of an image being reflected onto a drum, as in the case of the Xerox machine, a laser printer writes an image onto the drum with a high-intensity laser. Ten thousand times brighter than a reflected image, the laser is spread over the drum by mirrors and lenses that spin at an incredibly high rate in order to synchronize with the laser switching on and off to write the information on the drum.

Wherever the laser light hits the drum (which has a coating that allows it to hold an electrostatic charge), it places points of positive charge onto the surface. These points will print as black in the output image. As the drum rotates, it records one line at a time. To build a high-resolution image, the drum must move in smaller rotations. If a drum moves 1/600th of an inch, a 600 dpi vertical resolution will result. The faster the laser beam switches on and off, the higher the horizontal resolution.

As the drum is exposed, it rolls through a tray of negatively charged toner, which adheres to the positively charged portions of the drum. As this is being done, a piece of paper passes underneath an

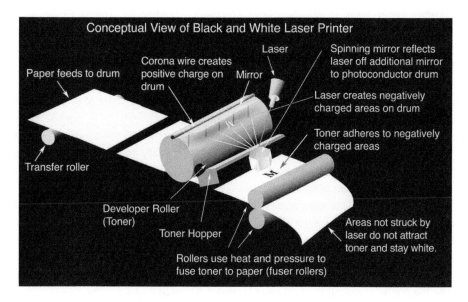

Conceptual View of Black and White Laser Printer

Laser

Corona wire creates positive charge on drum

Mirror

Spinning mirror reflects laser off additional mirror to photoconductor drum

Paper feeds to drum

Laser creates negatively charged areas on drum

Toner adheres to negatively charged areas

Transfer roller

Developer Roller (Toner)

Toner Hopper

Areas not struck by laser do not attract toner and stay white.

Rollers use heat and pressure to fuse toner to paper (fuser rollers)

5.5
Inner workings of a black and white desktop laser printer.

electrically charged wire and receives a negative charge. When the sheet of paper passes over the drum, the toner is transferred from the drum to the paper and forms the image. Parts of the drum that hold a negative charge do not affect the negatively charged paper and so result in white areas.

Once the toner is transferred to the paper a fusing system applies heat and pressure and permanently adheres the toner to the paper. It is wax, just as in Carlson's first attempts (see Box 5.1), rather than the plastic placed in the original toner developed for the Xerox machine by Batelle engineers, that makes it easier to fuse the image to the paper.

Laser Resolution

Perhaps the most important defining characteristic of a laser printer is the resolution it is capable of achieving, defined by how many dots per inch the printer is capable of placing on the paper. Early laser printers were limited to 300 dots per inch by the *print engine*, which controls the action of the drum and laser. As print engines have become more sophisticated, this has increased to 600 dpi and most recently 1,200 dpi. Some lasers also include special resolution enhancement techniques that can vary the size of the dots in order to make the appearance of curved edges smoother. The advantage to more dots per inch is a reduction in the jagged quality of curved lines.

Lasers and Fonts

While laser printers are capable of printing whatever fonts one chooses to use, many laser printers also have a basic font set stored internally. These resident or internal fonts are built into the hardware of the printer and reduce the time it takes to print documents containing these fonts. In some cases, cartridges containing additional "hard" fonts can be inserted into the printer to extend the printer's font storage capacity. Resident fonts will print quickly and cleanly.

Printers also have the ability to download "soft" fonts from your computer's hard drive into the printer's RAM memory. However, this causes a small delay in print time and also uses more of a printer's memory to make a print. Today, this rarely creates a problem in printing documents. However, if it does, the RAM memory of most laser printers can be increased to handle additional fonts and graphics.

Controlling Laser Printer Output

Because laser printers are "page printers" that must process an entire page of information before that page can be printed, **page description languages** (**PDL**s) are important. There often is more about the document to be printed than appears on the computer screen. Standard 8.5 x 11 letter stock paper can hold over 8 million dots at 300 dpi. At 600 dpi this can increase to over 33 million dots. A laser printer's ability to interpret information about the page being printed is critically important to the speed at which it prints and the ultimate quality of the finished document. There are two standard languages that most printers adhere to in order to accomplish this.

The first commonly used standard was Hewlett-Packard's printer control language (PCL). Originally intended for dot matrix printers, the HP's first PCL language supported only simple printing tasks. In later versions, HP added support for graphics, scalable fonts, vector printing descriptions, and bidirectional printing. Today, printer control languages offer an object-oriented control made specifically for graphics and WYSIWYG (what you see is what you get) capability. Unfortunately, it also increases the time it takes the printer to output the first page by about 30 percent.

The second standard is **PostScript**, which was included in the first Apple LaserWriter and is actually a programming language (see Chapter 6). Due to its higher quality, it quietly became the professional choice for anyone involved with digital layout and design or those with a need for more sophisticated output. A printer that supports the more expensive PostScript option will also support PCL.

Unlike Hewlett-Packard's early PCL language, PostScript was always a **vector** or *object-oriented language* (see Chapter 9) that treats images and fonts as geometric objects rather than **bitmap** images that are created by a series of dots. Because of this, PostScript fonts are fully scalable, always smooth edged and can be resized using PostScript commands rather than being recreated as bitmaps or **raster** images.

Color Laser

Color laser printers work exactly like their black and white counterparts, but make four passes through the process, usually building the four-color image on a transfer drum with cyan, yellow, magenta, and black toners (see Figure 5.6). The toners are then fused to the paper using heat or a combination of heat and pressure. Color laser prints are very durable. The toners are chemically inert and are fused onto the paper's surface instead of being absorbed into the paper's fibers. Because of this, color lasers can print onto almost any paper stock, or even transparent materials.

Color lasers are more expensive to operate than black and white lasers. Not only do they have four separate toner cartridges with a limited life expectancy, but the surface of the print drum can wear out, needing to be replaced periodically. In addition, the developer unit and fuser unit also have to be

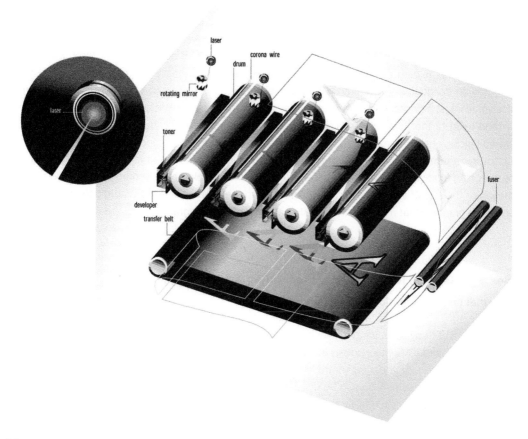

5.6
Color laser printers print with four separate toner cartridges (cyan, magenta, yellow, and black) in order to create the illusion of a full-color print

replaced whenever the printer reaches certain page counts. Newer technology has helped to limit these maintenance costs by combining the drum with the toner cartridge so that when the cartridge is replaced, there is no need to be concerned about the drum wear.

INKJET

A popular choice today for consumers and professionals, **inkjet** printers are far less expensive color printers than lasers. Available in the mid-1980s first as a low-cost monochrome alternative to the laser printer, today's inkjet printers have made rapid improvements in quality, based on improvements in technology, starting with the move from three-color to four-color printing. Early inkjet printers required the user to choose between a black or color ink cartridge. To print in color, the black cartridge had to first be removed and then replaced with the CMY (cyan, magenta, yellow) cartridge. Today's inkjet printers allow the use of both cartridges at the same time and use black even when printing in color in order to improve the depth and crispness of shadow areas and extend the range of tonal values. Not only have inkjets have become more popular, they have continued to improve in quality as they drop in price.

Inkjets are not impact printers like the dot matrix printer, nor are they page printers like the laser. Instead they spray ink from nozzles as the nozzles pass over the paper. Mechanically, a motor moves a print head containing ink nozzles back and forth over the paper in a series of horizontal bands. In coordination with this, another motor moves the paper in vertical increments as the inkjet nozzles drop the ink that builds the letters or images being printed. The page is printed one strip at a time as the print head drops a row of pixels every time it passes over the paper.

As inkjet printers have evolved, we have seen the inclusion of additional colors to the ink set in order to increase the gamut or range of tones visible in the prints. Initially this included a light magenta and light cyan in addition to the standard cyan, yellow, and magenta and black cartridges. On larger, professional inkjet printers, this has expanded to include these colors and an orange and green in order to extend even further the range of colors the printer is capable of producing. In addition, there are now two blacks, one for printing on a matte paper and one for a glossy paper. And finally, in addition to the black ink, there is now a light black and light, light black ink. The result is printers that are capable of reproducing a range of colors that would have been unthinkable only a short time ago. Add to this a reduction of the size of the dot of ink placed on the paper and you have an extraordinary ability to print images and graphics that rival anything traditional darkroom photography could produce.

Box 5.2 Getting Technical Inkjet Technologies: HP vs Epson

Thermal Inkjet Technology: HP Drop on Demand

Invented in 1979 by John Vaught, while at Hewlett-Packard, *thermal inkjet technology* (TIJ) is a **drop on demand** (DOD) technology in which small drops of ink, triggered by heat, squirt onto the paper through hair-thin nozzles controlled by a printer's software (see Figure 5.7). The software determines how much ink should be dropped, where it should be dropped, and when it should be dropped. The heat applied to the ink creates a tiny bubble, which is forced to burst under pressure onto the paper. As the heating element cools it creates a vacuum that pulls ink from the ink reservoir to replace the ink that has been discharged. The average thermal inkjet has between 300 and 600 nozzles. Each hair-thin nozzle delivers an almost microscopic ink dot with

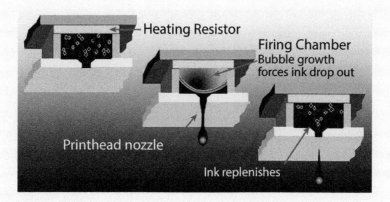

5.7

Thermal inkjet nozzles depend on heat expansion to drive ink from the ink cartridge

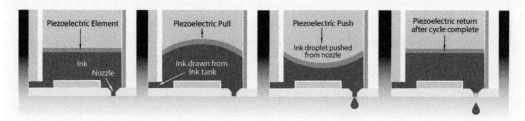

5.8

Piezo inkjet print head assemblies use an electrical current to flex a plate to drive ink from the ink cartridge

a diameter of only 50 microns. Variable dot sizes can be created by combining several color ink drops to create larger dots and additional colors. Black ink requires a larger inkjet nozzle and is kept in a separate cartridge.

Epson Piezoelectric Inkjet Technology

Known for their ability to produce stunning color reproduction of photographs and complex graphics, Epson **Piezoelectric** inkjet printers are the strongest competitor to Hewlett-Packard's approach to inkjet printing. Their special technology uses a *piezo* crystal (a thin section of a crystal that oscillates when voltage is applied) behind the ink reservoir (see Figure 5.8). Instead of heat being applied when an ink droplet is needed, electrical current is applied to the piezo crystal, which then flexes, forcing ink out of the nozzle.

Piezo technology allows for more precise control over the size and shape of the ink drop and, as a result, more nozzles can be used to drop the ink onto the paper. This increases control of ink drop size and placement. Unlike thermal technology, the ink does not need to withstand heat and so can be formulated in ways unavailable to thermal inkjet printers. Epson inks are solvent based and dry very quickly. Therefore, rather than hitting the paper and spreading out into the paper fibers, they maintain their shape and individuality, creating sharp, highly detailed prints without bleeding into one another.

Permanence

For artists, the increasing level of detail in inkjet printing, along with a corresponding decrease in the visibility of the dots of ink as they have become smaller, has been very important. But the issue of permanence has been of equal concern. While not every print for every function needs to last for a long time, for the fine arts this is an important issue.

In the twentieth century, most inkjet prints could only last from six months to a year—perhaps two if stored properly and not kept in strong light. Dye-based ink was notoriously fugitive (quick to fade or change color) and like traditional photography after its introduction in 1839, creating an image that would not change further when exposed to additional light was important to its maturation as a fine arts medium. For artists it was difficult to defend selling images that would only last a few years at best. The addition of pigment ink sets to dye-based ink sets (see Box 5.2) offered far greater stability and longer lasting prints. Epson's response to this was the development of pigment in addition to dye-based inks. A pigment ink set extends the permanence of a print beyond a hundred years (even over 200 years depending on paper choice) if stored properly. This opened a fine arts printing market for Epson inkjet printers, and was soon followed by other manufacturers.

Box 5.3 Getting Technical: Dye vs. Pigment-Based Inks

Basically, dye inks are composed of a water-soluble colorant that is fully dissolved in water whereas pigment inks are composed of an insoluble pigment encapsulated in a synthetic resin and suspended in a liquid. While dye-based inks are less likely to clog a print head, pigment particles are still 200–300 times smaller than a print head opening so clogging is also not a major issue.

Although the differences between dye- and pigment-based inks have lessened in recent years, there are differences that are generally agreed upon.

Advantages of Dye-based Ink

- Greater color vibrancy and saturation than pigmented inks (optical compounds added ink to enhance color)
- Excellent image detail
- Wide color gamut (range of values)
- Higher Dmax (black density) than pigment inks
- Lower metamerism (color appearing to change when viewed under different light sources)
- Fade resistance improved over the years (up to 32 years on certain papers)
- Lower cost than pigment inks

Disadvantages of Dye-based Ink

- Dye inks more likely to smear (longer drying time)
- More susceptible to moisture damage (a single drop of water can ruin a print)
- Lower resistance to light than pigment ink (fading can be a problem for dye-based prints, especially if they will be exposed to light) so is a problem for signs and banners or even exhibition prints for galleries

Advantages of Pigment-based Ink

- Fast drying, less likely to smear
- Not water soluble

- Far better longevity and better resistance to light—best for prints that will be exhibited in one form or another
- Color stability—over 200 years when paired with certain papers
- Gamut has been increased significantly with the addition of HD and HDR (*high dynamic range*) pigment inks

Disadvantages of Pigment-based Ink

- Still can be some shifting of color under different color temperature lights as compared to dye-based ink
- More expensive than dye inks
- Earlier pigment ink sets don't have the brightness and broad color range (gamut) that dye inks have

Inkjet Papers

In addition to the ink set an inkjet printer uses, the type of paper or *substrate* used is also important to the longevity of an inkjet print. Further, since traditional paper simply soaks up ink and allows the individual ink dots to spread into one another, inkjet papers must be coated to prevent ink from soaking into the paper fibers below. The type of paper, along with the type of coating technology used, has a great deal to do with the quality of an inkjet print as well as how long it lasts.

Generally, glossy papers and those with optical brighteners tend to have a shorter print life than those without them. Unfortunately, optical brighteners are often added to many papers, and even laundry detergents, in order to make whites appear whiter and cleaner.

Papers without the addition optical brighteners will last longer but might not appear as bright as those with added brighteners. (If you have a "black light," shining it on your printing paper will reveal the amount of optical brightening taking place as they will fluoresce strongly under ultraviolet light.)

TYPES OF INKJET PAPERS AND THE SCIENCE BEHIND THEM

The special inkjet coatings applied to different types of paper influence the way in which ink is absorbed by the media. Coatings have a variety of technical functions but also have an impact on the aesthetics of a print and determine the way in which paper absorbs the ink, image resolution (crispness of dot placement), color gamut, dry time, stability, and resistance to damage.

Swellable Papers

This coated inkjet paper swells when in contact with the moisture of the ink, which allows the ink to penetrate the top layer of the coating. Swellable papers have a protective top layer, a layer that holds the ink droplets where they are placed by the print head, and finally an absorption layer for any additional ink components. The protective top layer encapsulates the ink and minimizes the negative effect of ozone and other atmospheric pollutants. Unfortunately, pigment inks do not work as well with swellable paper as the pigment particles are too large to be absorbed.

Porous Paper (Microporous/Nanoporous)

Porous paper is coated with microscopic particles held together with a chemical binder that creates small spaces in which ink can be deposited. When the ink is deposited into the cavities, the print feels

immediately dry to the touch and can be handled without smudging. When pigment inks are used with this type of paper, the porous coating provides stability in terms of water protection and fade resistance. However, there is no protective layer to protect the print from contaminants as there is in swellable paper. Fortunately, pigment-based inks are inherently less prone to damage than dye-based ones.

Cotton Rag/Fine Art Papers

Primarily used for fine art printing, cotton fiber papers are acid-free. Cotton rag papers are made with cotton fibers rather than wood pulp and provide exceptional image quality and, when used with the proper pigment ink sets, unsurpassed longevity. These papers are most often offered in matte or textured surfaces and have an inkjet receptive coating to prevent ink from soaking too deeply into the fibers. In addition, they are available both with and without optical brighteners for even greater longevity.

Inkjet Resolution and Photographic Quality

When discussing inkjet printer resolution, whether it is generated by thermal or piezo means, quality is determined by a combination of two elements. The more dots per inch the printer can deliver, the crisper the image has the potential to be. This is especially important when printing hard-edged items like text and business graphics. However, it is the number of levels of gradations per dot that determines how close to photographic image quality the printer can achieve.

The ability of a printer to create a grid of **halftone** cels—groups of dots positioned closer together or further apart to create what appears to be a continuous tone—is one of the things that determines its ability to mimic photographic quality. By mixing halftone patterns of color dots, the **process colors** of cyan, yellow, magenta, and black can be intermixed to create the illusion of many more colors because the human eye mixes them together. The greater the number of dots that can be overlapped, the better the illusion of continuous tone. As mentioned earlier, six-color inkjet printers have been developed, which add a light cyan and light magenta in order to produce more overlap and subsequently an even better representation of color tonal values.

Many printer manufacturers have opted for increasing the number of colors that can be overlapped on an individual dot rather than increasing the number of dots in an inch. In 1996, a good inkjet printer could print four drops of ink on a single dot. More recently, by decreasing the size of the dot, that number had increased to 29 drops of ink per dot. The real key though was the development of printers that could vary the size of the ink drop when printing. This ability to fine-tune ink coverage creates smoother gradations and tonalities along with sharper text.

Dye Sublimation Printers

Though no longer quite as prevalent as they once were, **dye-sublimation printers** are capable of producing prints indistinguishable from those produced in a traditional photographic darkroom. They do this by vaporizing inks, turning solid colors into a gas, which then solidifies or *sublimates* on the paper. Instead of reservoirs of ink, **dye-sub** printers use a plastic transfer ribbon, which holds a series of panels with cyan, magenta, yellow, and black colors in sequence (see Figure 5.9). A single roll can hold many sets of colors. As an image is printed, a thermal print head with thousands of heating elements moves across the transfer ribbon, vaporizing the appropriate portions of the ribbon and allowing the color to diffuse onto specially coated paper. The hotter the heating element in a particular location, the more dye is vaporized and diffused onto the paper's surface. Varying color densities can be achieved through precise temperature variations. This provides a true continuous tone, photographic quality image without visible dots or halftone screens of any kind.

5.9
Dye sublimation printers print in register from a special ribbon. This printer vaporizes parts of the ribbon in relationship to the density and color values of the image. This material then settles onto the paper receiver sheet to create continuous tone images without visible dots of any kind

The dye-sublimation process, while producing truly photographic quality images, is the most expensive printing technology used by artists. An entire set of color panels is used for each print, regardless of color coverage. A single letter would take as much ribbon as an image that fills the page.

Three-Dimensional Printers

The arrival of 3-D printers seems to have brought science fiction to life. From basic raw materials, we can now print 3-D objects that exist in time and space. Whether creating 3-D sculptures or prototyping industrial parts, we have a fast, easy way in which to create objects that can be held in the hand or displayed.

Three-dimensional printers create 3-D objects using thin slices or cross-sections of an object printed one upon another until the object takes its final form. Printable objects can be produced from any computer-aided design (CAD) or modeling program, through the use of a 3-D scanner or by software that uses complex algorithms to plot points and represent 2-D images for 3-D printing. Additional information on this transformative new medium can be found in Chapter 11.

DIGITAL CAMERAS

How They Work

Digital cameras work in much the same fashion as traditional film cameras. A camera, in its most basic form, has a light tight box (camera body), a hole that lets light into the camera (aperture), something to

control the duration of time light enters the camera (shutter) and a place that light will be focused (film plane, where the light-sensitive material is). There are many different forms of cameras, from "point and shoot" to more sophisticated cameras that can use interchangeable lenses and even the camera on a cell phone, but they all share these characteristics. In the world of digital cameras, instead of using a light-sensitive film material, an electronic sensor has been substituted. However, many of the actual workings of the cameras are the same as your grandfather's Kodak.

Box 5.4 Getting Technical: Digital Sensors

Digital sensors can be constructed of charge-coupled devices (CCD) or complementary metal oxide semiconductors (CMOS). Both technologies translate light into an electric charge, which is then processed into electronic signals. While CCDs have been around longer, they consume about 100 times more power than CMOS sensors of the same size because they record pixels on the chip and then send them one by one through the analog to digital converter to create the image. Due to this, and the fact that CCDs can fit more individual pixels on the sensor, they create a very clean image with less noise than a CMOS sensor. However, the process is slower than CMOS and uses more battery power.

In a CMOS sensor, surprisingly less expensive than CCDs, there is special circuitry at each photo sensor so pixels can be read at the same time and transmitted directly as digital information. This, along with a variety of other circuitry like amplifiers and noise correction, creates a larger sensor and as a result, fewer pixels can fit on a sensor compared to CCD. This results in faster speed but potentially more noise (visual distortion that looks similar to grain found in high ISO film photographs) and less resolution. However, CMOS sensors drive most of the sophisticated, professional cameras in use today. Why? You only need look to your mobile phone and other devices that have incorporated a camera as part of their feature set. Due to its low power consumption and low construction costs, "camera-on-a-chip" has become a reality driven by CMOS sensors. As CMOS engineers concentrated on developing chips for mobile phones (largest user of image sensors today), research and development made vast improvements in the technology. These improvements were directly adapted by the CMOS sensors we have in our cameras today.

Sensor Size and Grainy Images

The size of a camera's sensor is important to the overall quality of an image. A larger photosite (light-sensitive pixel) can record more information than a smaller one. The closer photosites are to one another, the more heat they generate. That results in "noise," which we perceive as "grain." If you have a compact camera with a small 1/1.7" (7.6 mm x 5.7 mm) sensor, and that sensor has enough photosites to provide 16 megapixels of data, how would those individual photosites compare to a camera with a full frame sensor (24 mm x 36 mm) containing the same 16 megapixels (see Figure 5.10)? Given the same number of photosites on each sensor, the ones on the full frame sensor will be considerably larger and further apart, resulting in superior data (better dynamic range, far better low light performance, and greater per pixel sharpness) and less noise.

The number of megapixels a camera has is not as important as the size of the sensor. With the improvement in overall quality a larger sensor provides, professionals will choose a larger sensor with

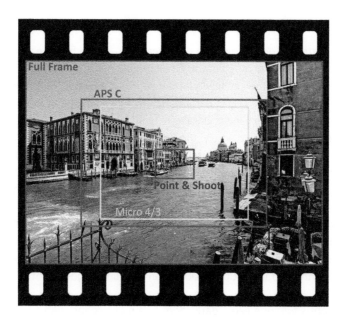

5.10
Larger sensor areas contain larger photosites that are capable of recording a greater range of tonalities and colors than smaller sensor cameras

fewer pixels over a smaller sensor with more pixels. The problem with most cellphone cameras is that in order to fit a camera into the phone, the sensor must be very small. The photos may look great on your phone or computer screen, but even with an 8-megapixel sensor, cellphone images will break apart when enlarged to any great degree. However, there is always a price for quality. As sensors get larger, so do the cameras that hold them. If you want a camera that will fit in your pocket, you will be forced to use a small sensor.

More Megapixels?

Everyone wants more megapixels. What a great reason to buy a new camera. Unfortunately, those additional megapixels will not mean a great deal to most people, despite what the manufacturers would like you to believe. They tend to leave out a few important elements like lens quality, sensor size, camera software and firmware, and much more. If you have a 36-megapixel camera, you need better and more expensive lenses that can take advantage of its ability to capture more information. In addition, you must be prepared to store images that will be at least 200 MB each and have enough computer power to work with them.

The key reason for wanting additional megapixels is so that you can either crop smaller sections out of an image or make large-scale prints. For example, the 36-megapixel sensor on a professional camera can create a 7,360 x 4,912 pixel image. This can be used to make a print of 24" x 36" at a bit over 200 dpi (an acceptable resolution if you need large prints). A 16-megapixel camera will yield an image of 4,928 pixels x 3,264 pixels. If you try to make a 24 x 36" print, your resolution will only be around 136 dpi, which is too low for a good print. But, how often do you really need to print 24" x 36"? How large you normally print should dictate the number of megapixels you need. If you only photograph for the Web or small 4" x 6" prints, a camera phone should be adequate.

ISO (INTERNATIONAL STANDARDS ORGANIZATION) AND LIGHT SENSITIVITY

There are many elements that go into using a digital camera—white balance, choice of aperture and shutter speed, exposure mode and much more. Of all the elements available to us, ISO is one of the most important. ISO establishes the sensitivity of the sensor. Generally, the higher the ISO, the more sensitive the sensor will be to light. This is particularly helpful in darker situations where there is little light. However, there is a cost. The fundamental reality is, for any given camera, the higher the ISO, the more noise there will be, and conversely, the lower the ISO, the less noise there will be and the smoother the tones will become. Think of it as turning up the sound on an old radio. As you turn up the sound, the volume increases but once it gets too high, the sounds become distorted. In much the same way, "turning up the volume" on the ISO increase the sensitivity of the sensor to light but also increases distortion in the form of noise.

Unfortunately, many people leave their camera on the auto ISO setting without even thinking about it. Most camera manufacturers are more concerned with users getting sharp images and so when light begins to fall, the auto ISO feature increases the ISO dramatically. It makes more sense to take control of this yourself and set the ISO low (100 or 200) when shooting in good light, and then increasing it when necessary.

To handle low light situations like a dark room or a night scene, use a tripod, leave your ISO low, and expose for longer times. Additionally, if you leave your camera on aperture priority mode, where you get to choose the aperture and the camera automatically selects the correct shutter speed for the amount of light available, you accomplish two things. First, you get to choose the aperture you want to control depth of field and second, the camera will set the correct shutter speed.

Aperture and Depth of Field

Your camera has a series of **apertures** (openings that let light into the camera) in order to control, along with the shutter speed, the amount of light entering the camera during an exposure (see Figure 5.11). Apertures also affect depth of field (DoF). Depth of field refers to the range of distance that appears sharp directly in front of and behind what is physically focused upon. The larger the aperture at any given distance, the shallower (less) the depth of field will be. Conversely, the smaller the aperture at any given distance, the deeper (greater) the depth of field will be.

Many cameras have landscape and portrait settings. In a landscape setting the camera will choose a smaller aperture to make sure more information will be in focus from foreground to background. In

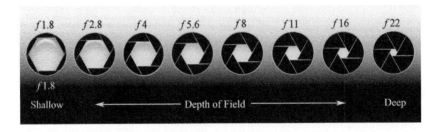

5.11
Apertures not only control the amount of light that enters your camera, they also control depth of field

portrait mode, the camera will choose a larger aperture to allow what you focus on to be sharp while blurring the background. However, as mentioned earlier, it makes more sense to control this yourself, using an aperture priority mode for exposure.

Shutter Speed

Shutter speed controls the amount of time light is allowed to enter the camera. Exposure is determined by a combination of the shutter speed and aperture chosen. However, shutter speed can also control the appearance of motion (slow shutter speeds) and stop action (fast shutter speeds). If you choose a slow shutter speed, the camera shutter will stay open longer and the chance of a blurred image can result. This usually happens when a shutter speed of longer than 1/60th of a second is used, depending on your camera and lens. One of the most important reasons for using a higher ISO as mentioned is so that you can shoot at faster shutter speeds and so avoid blurring an image. Nevertheless, sometimes we may want to create blur deliberately in order to use a slow shutter speed in a creative way. Panning (moving the camera to match the speed of a moving object while using a slow shutter speed) will allow you to freeze a moving object while blurring the background. An example of this might be a race car that is in focus while the background behind it is blurred, giving the sense of something moving very fast.

Using a fast shutter speed, on the other hand, can stop motion. If a shutter opens and closes very quickly, a moving object can essentially be frozen in time and space. Someone in the act of catching a ball just before it hits their glove is one example of this.

JPEG AND RAW FILES

While most point and shoot cameras are limited to JPEG images, many of the more sophisticated cameras also can record images in RAW mode. JPEG images depend on a camera's built-in algorithms (self-contained sequence of actions) to establish color saturation and sharpness, as well as how the colors interact with one another. There may be one color range for landscapes, emphasizing blues and greens, and another for portraits, emphasizing warmer colors. Outside of choosing a particular algorithm, and perhaps low, medium, and high sharpening, there is very little we can do to control the final result.

Camera RAW, on the other hand, records an image with no presets or sharpening applied. When you open a RAW file (Camera RAW is part of Adobe Photoshop, and many camera manufacturers provide their own RAW programs) it will open a separate program where you can emphasize highlights, midrange, shadows, saturation, and also control the amount of sharpness and noise reduction that is applied (see Figure 5.12). Controls also allow you to correct for chromatic aberrations and distortions for whatever lens you are using. You can correct and/or change the white balance of an image, which allows you to correct for initial faulty white balance control. RAW files record a much larger range of tones and allow you to recover detail in highlights and shadows that would be obscured in JPEG images. Photographing in RAW creates images that allow a more finely tuned tonal/color range, greater detail and sharpness, and a more personal interpretation of what was photographed. Enhancing an image in its RAW format is so profound, it is almost like giving yourself the opportunity to go back and re-photograph the image all over again to correct for problems with exposure, white balance, contrast, and so on.

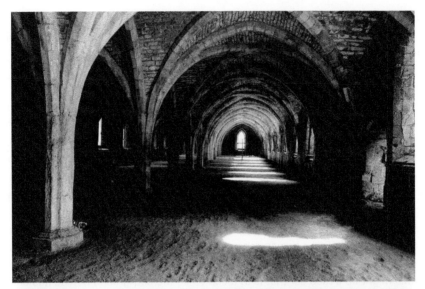

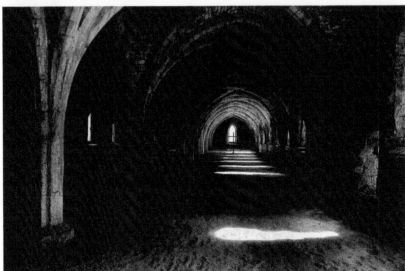

5.12
Correction of a raw file where the color temperature has been recorded incorrectly by the camera. The bottom image has been processed in Adobe Camera Raw to shift the color from blue towards yellow (raising the color temperature) and then shifting the tint from the magenta towards green

Scanner Overview

The most common scanners do the important work of converting flat artwork, such as photographs and drawings, into digital information. Once digitized, scanned imagery can be manipulated and developed in various digital media software programs. The human eye responds to light quite differently than scanners do. We tend to be more sensitive to shadow detail and variations in color and value changes when we view an image. Scanners, on the other hand, have a linear response to light—essentially a one-to-one ratio between the light they read and the outgoing signal they send. Therefore, a scanner often doesn't differentiate the subtlety of values to the degree that we do when we look at an image. Scanners vary considerably in their ability to record the full extent of values in an image and tonal/color correction is often necessary, even with the best of scans. There are three things that can help determine the quality of a scan—available optical resolution (sample rate), bit depth, and dynamic range.

Sample Rate

Initially, the most important consideration when scanning is to determine is the sample rate, or **spi**, at which you should scan an image. This will be determined by the intended use of the scan. Generally, a 200-spi scan can capture all the detail contained by a traditional, machine-made color photograph. Scanning at a higher resolution will allow you to resize it so a larger print can be made, but it won't provide additional detail. Scanning at 300 spi is certainly a good safety margin for most purposes. If you are starting with a small image that you know will be enlarged, then scanning at a higher sample rate is absolutely necessary so that you can resize it safely without losing detail and resolution.

Bit Depth

Another important element that affects the appearance of a digital image is "bit depth." It is bit depth that determines how much color information can be used to define the pixel itself and is a measurement of the number of bits of information stored in each pixel. The greater the bit depth, the more subtle and accurate the color will be. A pixel with a bit depth of 1 is either black or white. If the bit depth increases to 8, then 256 values are possible. When the bit depth increases to 24 bits per pixel (8 bits each for R, G, and B), then over 16 million possible colors become available. This is referred to as "true" color. Many scanners today have the capability of scanning at 30, 36 and even 42-bit depths. This allows them to separate more subtle tonal values—into the billions of colors. Several small variations of a color that a 24-bit scan might read as the same color will be seen as slightly different shades at a higher bit depth. This represents more detail, especially in the shadow areas.

Dynamic Range

Often referred to as a scanner's *D-MAX*, dynamic range indicates the scanner's ability to correctly interpret the full tonal scale of a particular film or artwork. In traditional photography, this measurement is accomplished by using a densitometer to measure the lightest area of a film image and then the darkest area. By subtracting the density of the lightest area from the darkest area, we get the range of values in the film itself. In a similar way, the scanner's *D-MIN* (lightest values the scanner can represent) are subtracted from the scanner's *D-MAX* (darkest values the scanner can represent) to arrive at the scanner's dynamic range. Having a scanner that is capable of capturing the true range of tones of the material being scanned is very important. The higher the dynamic range of the scanner, the better will be its ability to distinguish subtle tonal and color variations as well as its ability to separate values in difficult to read shadow areas.

Scanner Types

There are a wide range of scanners, varying both in quality and cost. **Flatbed scanners** (see Figure 5.13) are the most common form of scanner. They use a series of charge-coupled devices, or CCDs, to convert an analog image to digital signals. Flatbed scanners incorporate three separate light sources as the scanning mechanism passes beneath the original, reading an image in a series of horizontal passes. Light is reflected from the image to the CCD which translates the color from analog to digital. In addition, many flatbed scanners also have attachments that allow transparencies such as slides and negatives to be scanned. Unfortunately, these devices, in all but the most expensive flatbed scanners, don't have the dynamic range (from light to dark values) to do much more from transparencies than provide scans for web use or other low-end output.

The **drum scanner** is considered to be the zenith of scanning devices, and provides scans of unsurpassed quality and tonal differentiation. Expensive (as much as $100,000) and too difficult to operate for the occasional user, a drum scanner uses a stationary photomultiplier tube or **PMT** to read an image vertically, line by line as the drum spins with an image inside it past the PMT. This line by line reading gives the drum scanner the ability to scan at extremely high resolutions and **dynamic range**, a measure of a scanner's ability to differentiate differences in tones from light to dark (see Box 3.1).

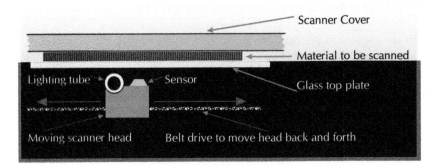

5.13 Basic flatbed scanner

Dedicated *film scanners*, on the other hand, can provide very good scans from slides and negatives. While their quality is not as high as a drum scanner, they can provide satisfactory scans from film materials for nearly any purpose. Unfortunately, with the evolution of digital cameras, film scanners have become almost obsolete and many major manufacturers, like Nikon, no longer produce them.

Three-Dimensional Scanners

The purpose of a 3-D scanner is usually to create a *point cloud* (a set of data points defined by X, Y, and Z coordinates used to represent the external surface of an object). The points are then used to extrapolate the shape of the object being scanned—a process known as reconstruction.

Three-dimensional scanners, like traditional cameras, can only collect information visible to them. They primarily collect information about distance from each point measured during the scan. Sometimes an object can be placed on a turntable so the scan can record an object from multiple sides. If not using a turntable scanner, multiple scans from different directions and points of view are necessary to obtain the required information that can later be merged into a complete 3-D model. (See Chapter 11 for more information about 3-D scanners.)

Artist Profile: Stephanie Lempert

Stephanie Lempert's work bridges the gap between mementos and the childhood memories and associations that make them special. Lempert, long curious about what invests an object with meaning, feels that personal remembrances, associations, and connections to the past help an item transcend its initial purpose to become a meaningful object for the viewer. After photographing the object, and the handwritten story of the individual connected to it, she scans both image and text into 3-D modeling software. Using 3-D prototypes, she prints sculptures of the objects that are literally composed of the handwritten characters that created the story.

Integrating family narratives with a particular object and then weaving the handwritten narrative throughout the piece, both symbolically and through the production process, Lempert offers a level of communication that allows the viewer to, quite literally, read the story as they view the physical object representing it.

5.14
Fly Away? 2011

5.15
Black to Move, 2011

5.16
Sweet Vanilla Scent, 2011

5.17
Drama Queen, 2011

Box 5.5 A Brief Note on CD-ROM/DVD

CD-ROMs (Compact Disc Read-Only Memory) and DVDs (Digital Versatile Disc) store data as pits (recessed surface areas) and lands (raised surface areas). A *land* represents a one and a *pit* represents a zero. A laser reads the disk by distinguishing a pit and a land by the shift in position of the reflected laser light that occurs when the beam hits the surface (see Figure 5.18).

While once standard, many computers no longer provide CD/DVD drives. In the past they were used as the primary way in which to install programs and device drivers on a PC. Today, most software and drivers are downloadable from the Web. It appears that the CD/DVD drives are in the process of joining the venerable "floppy drive" in the "Museum of Obsolete Computer Stuff."

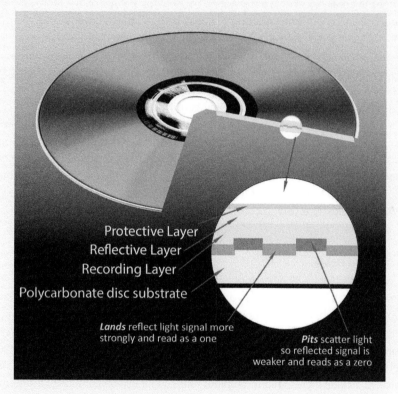

5.18
Recordable disk showing basic structural elements

Thumb Drives

Today, a USB flash drive or "thumb drive" has replaced floppy disks and CD/DVDs for most people as their portable storage medium. As a data storage device including flash memory with a built-in USB interface, it is one of the easiest portable storage devices to use. They are small, fast (as in the case of USB 3.0 and 3.1 drives, see Chapter 4), have no moving parts, and can be rewritten to multiple times. In fact,

most thumb drives today have up to 100,000 write/erase cycles and/or a ten-year shelf life before fail-
ure. Because they use the USB mass storage device class standard they are supported by all modern
operating systems as well as many BIOS boot ROMs. They can also be used in gaming consoles and
even television sets with USB inputs.

Introduced by IBM as DiskOnKey and Trek Technology under the brand name "ThumbDrive," the
first thumb (flash) drives were commercially available in 2000 and held 8 MB (not GB) of memory. While
it might not sound like much today, it was five times the capacity of the common floppy disk that was
prevalent at that time. It has been consistently upgraded from USB 1 to USB 2 and USB 3 and most
recently USB 3.1. You can review the differential in speed in Chapter 3.

As speed increased, so did capacity. What started out as an 8 MB drive has grown to thumb drives
that can hold up to one terabyte of information.

Cloud Storage

The "Cloud" does not really exist. It is essentially a concept for storage on a remote server that can be
accessed through the Internet from wherever you may be through whatever device you may be using.
Essentially you are storing your data on someone else's massive hard drive. While it is not a true backup
service, it can perform a similar service by allowing you to keep important files off site, protected from
loss if your own system or hard drive fails. In almost all cases data is encrypted, managed and main-
tained and so is a safe way to store information.

There are many storage providers and many companies automatically offer free cloud storage
(usually with a storage limit) when you purchase one of their products or services (Apple for example
has its iCloud service). In addition to professionally maintained cloud storage, it is also possible for
individuals to set up their own cloud, with similar kinds of access through the Internet. However, even
with professional, paid services, things can go wrong. With a paid service though, the chances of this
are greatly reduced due to their efforts at redundancy, which keeps your data in multiple locations. As
always, it is wise to make sure your important data is backed up and kept in more than one location,
with one of them preferably off site.

Broadband: DSL and Cable

In the era of web publishing, a significant proportion of artists' creations are not meant for hard copy
or distribution on DVDs but, instead, for an online audience. Transmission of this work is through the
Internet or World Wide Web, which for most users is accessed through broadband connections.

In the past, *high-speed* Internet service was expensive and limited to business, universities and
other larger organizations. Today however, broadband access has become almost universally available
for home users. DSL (digital subscriber line) technology allows carriers to use already installed copper
telephone wires to provide high-speed throughput. Although it can be confusing, the term digital sub-
scriber line does not signify an actual line. A pair of DSL modems—one at the consumer's computer
and one at the service provider's station—connected by a regular telephone line, are the only things
required for a digital subscriber line. DSL accomplishes its connection by using the high-frequency part
of the same phone lines that once only transmitted phone calls. A DSL line is always open and always
on. You can surf the Web while talking on the phone—all on the same line at the same time.

Cable Modems

DSL service was made possible, in part, by the realization that the copper phone lines that carry voice
messages do so at a very low frequency and use only a very small part of the phone line's capacity.
This was coupled with the discovery that the same lines could carry data at very high frequencies

without interfering with voice transmissions on the same line. Similarly, cable companies realized that the same cables that carry television transmissions to a viewer's home could, at the same time, carry data to that viewer's computer.

However, cable systems were designed to send information downstream (downloads) only—and very quickly. While information sent upstream (uploaded) through a cable system will be slower than downloads, it is still far faster than most other systems.

In order for a cable modem to be installed, a splitter is used to separate the cable coming into your home into two separate lines. One line continues to be used for your television and the second line is run from the splitter to the cable modem.

In most cases, cable modems connect to computers through an Ethernet port or wirelessly. Today, a local provider can offer a range of download and upload speeds (often over 200 Mbps download) to fit most budgets.

Satellite Systems

Satellite systems are connected to computers by coaxial cable linked to a satellite dish mounted outside the home. (The satellite dish, satellite modem, and all connections are included as part of a standard package.) In order to connect to a particular webpage, a request for a URL is sent directly through a satellite modem, through the dish to a satellite approximately 20,000 miles in space in geosynchronous (orbiting while matching the Earth's speed as it turns so that it stays in place over a single location) orbit. The satellite then contacts the service provider which locates the website you need. At this point the ISP sends the information back to the NOC (network management center), then to the satellite and finally to your computer through your satellite dish and modem. There may be a slight delay, known as latency, but most users will not notice it. Download and upload speeds are not as fast as cable or DSL (perhaps as fast as 20 Gbps download), but if you are in a rural area not serviced by other forms of broadband, this is a good option. Prices are based on data packages much like a cellphone. Speed can also be determined by the package you purchase.

Security and Hackers

DSL, cable, and satellite systems are always online. Unfortunately, this makes your computer more accessible to those who may wish to "hack" (illegally enter) your system or even harm it. Most broad-band connections have *static* (permanent) IP addresses. This means that your computer is sitting at the same address on the Internet for as long as you leave the system connected. This makes it easier for someone to find you and enter your system if they choose to do so.

One of the recommended steps to protect your system, if you have a cable or DSL modem, is to install **firewall** software. Many routers (separately or as part of your cable modem) automatically provide this feature. This software examines incoming and outgoing information and stops any transmissions that don't meet preset standards. In addition, you can turn off all file-sharing options so that outside users who gain access to your system will be limited as to what they might find.

Cable modems have even more security problems than DSL modems. In addition to the issues raised so far, cable systems have a shared-wire design. Unfortunately, this means that the information that leaves your computer is open and available to those individuals that share your cable line. It is conceivable that someone on your cable line could monitor your connection and find out what Internet sites you visit as well as read your email. However, if this is a concern, then data encryption software is available. Cable companies are always working on improving security. Most cable modem companies already encrypt all traffic from the cable modem termination system (CMTS), located at the local cable operator's network hub, to the home or business cable modem.

CONCLUSION

As we have seen, when artists first began to create computer graphics, output choices were limited and crude. Today there is a wealth of possibilities from photographic quality prints to online experiences through fast broadband capability. The next chapter provides an introduction and brief history of the evolution of digital art and the role it has played in the development of new technologies. We will find that it is often the way in which artists approach things and the questions they ask that push the boundaries of the technologies they encounter and inspire scientists and engineers to create new ones.

Projects: Outside the Box

1. ISO COMPARISON
 Take the same photograph at an ISO of 100, 800 and the highest ISO your camera is capable. Open the images in an image-editing program and view them at 100 percent. Compare the shadows. Compare the detail in the midrange area. What are the major differences?

2. PRINTER COMPARISON
 Make a print of one of your best images on a color laser printer. Make a print of the same image on an inkjet printer using regular copy paper. Now make a print of the image on a coated inkjet paper. Make sure your DPI is at least 200. Compare the prints. Where does the largest increase in quality take place?

3. BANDWIDTH
 Find a website that tests modem bandwidth (speedtest.net, for example). Test your own Internet connection for speed. What factors other than speed might affect your web-viewing experience? Compare your download and upload speeds along with your "ping."

4. IMPACT OF CPU/GPU
 Research on the Web and find out what factors impact gameplay the most. Then find what factors impact creative content creation (Photoshop for example) the most. How does this affect your computer purchasing considerations?

6 Digital Layout and Design: A Change in Attitude

6.1
Gutenberg examining a print in his "press room"

Digital layout and design using a computer has truly revolutionized the graphic design profession. In its most basic form, page layout programs bring type, graphics, and photographs together in a single document. As long as the information is in a file format the program recognizes, it can be used in the design.

The principal element that distinguishes a digital layout and design program from a sophisticated word processing program is the way in which it handles type. Unlike a word processing program that processes type in rows of letters, digital layout and design programs see type as blocks of information that can be picked up and moved around. This is similar to how designers before the mid-1980s would physically pick up and move around cut pieces of printed typography and paste them to boards (the source of the phrase "cut and paste"). In many professional digital layout and design programs text can also be wrapped around a curved line or shape, distorted, skewed and otherwise offer extensive capabilities for manipulating type and layout.

Graphic design was once the exclusive province of trained professionals with access to professional equipment not readily available to the average person. Today, many programs contain templates

including typestyle information and layouts for a variety of standard design functions, like newsletters or business cards. While not appropriate for the professional designer, this is especially helpful to the many users of digital layout and design programs who do not have extensive training in design, but who, with these new tools, are able to design competent documents on their own. Whatever the skills of the user, the ultimate goal of digital layout and design is the production of printed materials, whether a business card, brochure, or poster. Digital layout programs are particularly important when designing a lengthy multipage document like a pamphlet or book.

A BRIEF HISTORY OF PRINT

The Paper Revolution

Hundreds of years before we in the West were scraping hides to make parchment and painstakingly copying documents one at a time, the Chinese discovered that a fibrous material like cotton could be mixed with water and heated until it became soft and pliable. Pouring the mixture over fine bamboo screens allowed the water to escape, leaving the cotton fibers nesting together on the surface. This primitive paper was pliable and held ink well. Traditionally, the invention of paper is attributed to Cai Lun, who lived during the Eastern Han Dynasty, and presented the new writing surface to Emperor He Di in AD 105. However, it is very likely that this primitive form of papermaking was used several hundred years before that date.

Paper would play a critical role in the history of publishing for two reasons. It was less expensive than silk, an earlier Chinese writing surface, or any of the other materials used around the world. It was also firm enough to stay on the surface of carved, inked, wooden blocks. Long before its invention in the West, the Chinese discovered that individual blocks of wood or clay could be carved into various symbols, organized together and used to print copies of documents. As early as AD 740, China had its first printed newspaper, and by 1041 the Chinese had developed their own form of movable type.

During the Renaissance a variety of products, inventions, and technologies began making their way from the East to Europe as a result of trading. Although the Chinese had been guarding the secret of manufacturing paper, in AD 751 when the T'ang Army was defeated by the Ottoman Turks, a number of papermakers were captured along with the Chinese soldiers. Consequently, papermaking spread to the Arab world. Four centuries later, as a result of the Crusades, papermaking made its way from the Middle East and Northern Africa to Spain.

The Print Revolution

By the fourteenth century, inexpensive paper was readily available across Europe. Fine art printmaking was already in full bloom. Still, it wasn't until Johann Gutenberg's printing press in 1440 that true multiple copies of books became a reality.

Gutenberg's printing press was actually a modified wine press. On it he assembled rows of type, which were locked into place and inked (see Figure 6.1). Dampened paper was positioned over the inked type and the **platen**, a kind of pressure plate, was screwed down on top of the paper and type. A lever was used in order to further increase pressure, resulting in firm and even contact between the paper and type. After the impression was made, the press was opened and the paper hung to dry. It was in this manner that Gutenberg's forty-two-line Bible was published in Germany (see Figure 6.2).

This process, while excruciatingly slow by today's standards, was dramatically faster than copying books one at a time by hand and changed the way in which information was disseminated. It was a revolution in every sense of the word, paving the way for sharing culture and knowledge with the general populace instead of limiting it to the ruling classes. It also helped spreading word of new scientific

6.2
Gutenberg Bible, Lenox Copy, New York Public Library

developments and ideas during the Renaissance much easier. By 1499, more than 250 cities around Europe were printing documents using some form of Gutenberg's invention and at least half a million books, ranging from the classical texts to more contemporary accounts like Columbus' description of the New World, were being circulated throughout Europe.

Gutenberg's most important contribution to publishing was not, however, the printing press. It was actually **type founding**, the mechanical production of cast type, which made the printing of books possible. By casting the face and body of the type in one operation, Gutenberg was able to cast multiples of the separate types in metal molds. His movable type (see Figure 6.3) was designed so that it could be aligned in the manuscript he was printing to form a flow from letter to letter and word to word. This mimicked the hand quality of letterforms used up until that point. While movable type was first used in China some 400 years before Gutenberg's printing press, Chinese type was far less durable, being made of clay or wood rather than metal.

As presses became more sophisticated and faster, newspapers became possible along with works of fiction that could be circulated around the world. During the Industrial Revolution (beginning around 1760) numerous advances to the printing industry were developed (see Figure 6.4). In 1790, the rotary press was patented and was capable of making up to 1,000 impressions per hour as compared to Guttenberg's 200–300 impressions per day. In 1886, the Linotype machine, a form of automatic typesetter, replaced the tedious job of hand setting type one character at a time, line by line (see Figure 6.5). Using molds of type, it was able to drop a mold of each letter into place using a keyboard to type the letters. The type was then cast line by line instead of character by character.

The evolution of print technology was not only a series of mechanical advances, but aesthetic ones as well. Type forms and type foundries developed along with the technology, creating different typefaces as the technology evolved. We still recognize the genius of many of this era's type designers. Names like Garamond (1480–1561), Caslon (1692–1766), Baskerville (1706–1775), Bodoni (1740–1813), and Goudy (1865–1947) live on in the names of the fonts they designed.

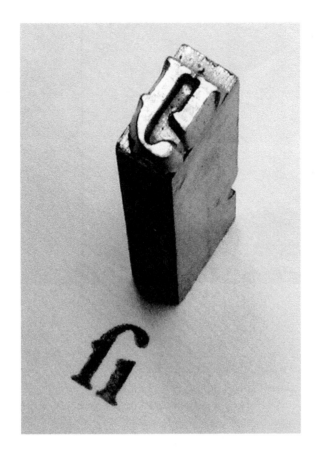

6.3
Representation of Gutenberg's cast type

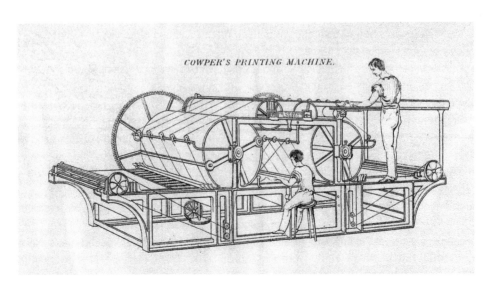

6.4
Rotary presses produced multiple prints at a greatly increased rate

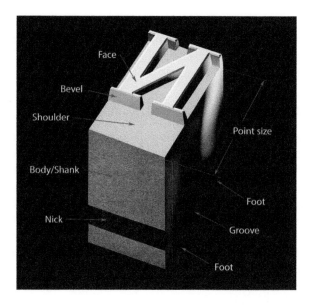

6.5
Handset lead type required skill and care. "Minding your p's and q's" was important because the letter forms were backward prior to printing and were very similar

The Desktop Revolution

When the first printed books appeared in the middle of the fifteenth century, they were usually print versions of manuscripts like Bibles and prayer books. In the sixteenth and seventeenth centuries, printed books began to contain information that moved beyond religious tracts to include non-secular subjects like science, poetry and drama. As a result, they began to have a powerful impact on European society. Martin Luther, for example, used the invention of the printing press to make his writings against what he perceived as the suppression of the Church widely available. Before the advent of the printing press it is likely that his voice would have gone unnoticed, but with almost one-third of all German books written by him and distributed throughout Europe, it became impossible for the Church to silence him. As a result, by the middle of the sixteenth century almost half of Germany and its territories had seceded from the Catholic Church. By the eighteenth century, independent printers like Benjamin Franklin helped foment revolutions in Europe and America.

In the last 200 years, an enormous number of books, periodicals, newspapers, and other forms of publications have been printed on ever widening subjects. Technology evolved to the point where millions of copies of a particular book or other publication could be printed in a matter of days. Distribution of those books, as well as the change from private subscription to public libraries, guaranteed access to anyone who wished to read. One thing, however, remained constant from the days of ancient imperial China—book publishing remained in the hands of those controlling the technology, or those wealthy enough to purchase access to that technology. That all changed in the 1980s with the beginning of the personal computer revolution.

Digital layout and design—the ability to combine text and image together within a computer in preparation for printing—has brought the power of publishing within the reach of anyone who owns a computer. In addition, digital layout and design has forever changed the face of the design world and the publishing industry. Non-professionals who wish to create designs, newsletters, forms, advertisements, catalogs, and similar kinds of printed matter, can now do that on a personal computer with readily available software. While this has been applauded by many, it was initially scorned by professionals who saw the quantity of publications designed by amateurs rising at the expense of design excellence. They

scoffed that an amateur creating a layout using simple software was adequate for a church newsletter but not for truly professional work. Of course, learning a computer program is not the same as having the background and art training necessary to create coherent, visually appealing designs. Nevertheless, the design world was about to change dramatically.

DESIGNERS AND PUBLISHING BEFORE THE DIGITAL REVOLUTION

Prior to the advent of today's digital layout and design programs, the training that went into developing someone capable of working in the design/publishing field was far more rigorous in terms of practical, hands-on skill development. The roles for creating a publication were separated into those of graphic/ production artists and graphic designers.

Graphic Arts professionals were responsible for the various forms of print production. Being a "graphic artist" meant someone who might run the press itself or hold any one of a number of other jobs relating directly to the production of a printed piece. Their training was more vocational in nature and might include developing copy camera skills, *stripping film* (positioning and assembling negatives from the copy camera or typesetter in their proper placement, orientation, and registration), identifying paper types and their printing characteristics, inking and running large offset presses, running the bindery, setting type, and much more.

Graphic designers, however, were and remain primarily involved with designing the material to be printed. The graphic designer had to be familiar with the skills of the graphic artist but be more concerned with specifying how the material to be printed should look.

Training a Graphic Designer

Before the 1980s, students entering a college or university to study graphic design or publication design took a series of foundation courses shared by all art majors. Courses in 2- and 3-D design, drawing and painting, and photography were usually taken as students began their art and design training. Courses in lettering were then taken in order to understand the structure and development of the letterform itself— the differences between sans-serif (like Helvetica) and serif (like Times Roman) typefaces (see Figure 6.6)

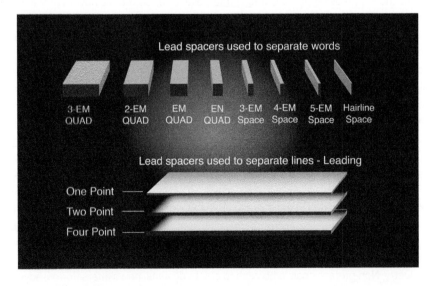

6.6
Letter spacing using lead type was accomplished by using blank spacers of varying widths between letters and words (kerning). Spaces between lines of type (leading, pronounced ledding) were similarly handled by using lead bars of different widths between lines of type

and how that affected the way in which they would communicate. Students created letter forms by hand, drawing them until they could clearly visualize the way in which they would affect the space around them, understanding their rhythm and balance and appreciating the differences between them.

During this time, documents were prepared for publication using traditional and mechanical cut and paste techniques. Images were prepared separately, while text was sent out to a professional typesetter using a typesetting machine that could space the text according to the designer's specifications. It would then be sent to an **imagesetter**, a machine that would print the text at high resolution. The sheets of printed type, or **galleys**, were cut apart and pasted onto cardboard layout panels by the graphic designer along with various graphics or photographs. This **camera-ready art** would then be sent to the graphic artist (production specialist) to be photographed, stripped, made into plates and then run on an offset lithography press to create the final printed piece.

To function professionally, students were required to learn what might become the most important skill of all—the ability to specify, or *spec*, type. After their design was finished, they had to be able to communicate to the typesetter which typeface to use, just how large the type should be, the spacing of the type on the page, and even the spacing between the letters themselves. Without the ability to spec type, their design work would not translate to the printed page.

Students were also trained in the mechanics of **paste-up** *and mechanicals*, as noted, where text spec'd by the designer and produced as galleys would be cut up and pasted down (using rubber cement or hot wax) on a piece of white mounting board (see Figure 6.7) that would finally go to the printer to be photographed and plates made. All of this would evolve into an understanding of how a variety of visual elements could all come together to create a coherent and visually appealing publication. This was often considered an entry-level job in a professional design firm.

Today's design students still take foundation courses in a variety of art studio-related areas, but much of the work in studying letterforms and typography has been integrated into other courses connected to digital design. Even if a course is still called typography, its study enlists the computer in working through the complexities of type and how it can be used creatively. The goal is still to gain a more sophisticated understanding of the different typefaces available, how they evolved and how they are used creatively in design. Students will still study the "color" of type, not in terms of hue but in terms of type density and how that affects the aesthetic quality of the document they are designing. Studying the history of type and its development through the ages gives them an appreciation of various typefaces and how type foundries evolved. Differences between classic and contemporary typefaces and their relationship to changing printing technologies are also studied. However, because they can

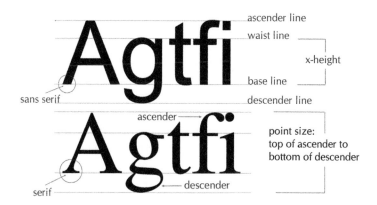

6.7
As these examples of sans-serif and serif letter forms show, type is clearly defined as to its structure

see on screen what will be printed when using digital layout and design programs, designers can make changes directly instead of specifying work to be done by others (like typesetters).

As the description of the training of design students indicates, much of the work in graphic design and publication design prior to 1984 was done by hand—and we may liken this to the type of manual effort that was required prior to the printing press and movable type. The digital revolution in design and publishing has been no less extraordinary than Gutenberg's invention was to publishing during the middle of the fifteenth century. While much of the training described in this section remains a fundamental part of the training of graphic designers, some skills, like producing paste-ups and mechanicals, have been relegated to the "dustbin" of history, much like the calligraphers who hand-copied manuscripts in the Middle Ages.

THE BIRTH OF DIGITAL LAYOUT AND DESIGN

The digital revolution in publishing can be traced to the mid-1980s with the release by Aldus Corporation of a new software program called PageMaker. Developed for the recently introduced Apple Macintosh computer (see Chapter 2), it fully utilized the Mac's revolutionary graphical user interface to create an extraordinary new tool for designers. The PageMaker program was able to combine text and graphics in the same document. The combination of the Macintosh and desktop publishing software would allow designers to see pages on the computer screen as they would look when printed. This WYSIWYG (or "what you see is what you get") capability changed the face of Graphic Design.

At the same time, computer printed output took a huge step towards professional quality with the first laser printers (see Chapter 5). Unlike the then-conventional dot matrix printers, where text and images were composed of large, quite apparent dots, Apple's LaserWriter printed much sharper and clearer text.

With the arrival of digital layout and design programs, a new graphic design environment was born. Type and text could be brought together and combined in the computer. Text styles, the text font, size, and spacing could all be seen on the screen and problems corrected or changed. The relationship of the type to graphics or photos could be adjusted almost endlessly. Changes in composition or content could be completed by the designer without having to send out new specifications to a professional printer or typesetter, eliminating the often-costly loss in time and money.

DIGITAL LAYOUT AND DESIGN: NOT JUST FOR AMATEURS

The accessibility of publishing software and equipment that a user could work with at home, on their own desktop, gave rise to the term desktop publishing. Initially this short-lived term was applied to the home user or amateur wanting to save money and do many of the design tasks that would normally have been the province of the professional designer. As smaller companies and businesses began to handle publishing activities that would normally have been "hired out to professionals," the concept of desktop publishing expanded beyond self-publishing to include professionally prepared and printed documents. Professional tools were suddenly at the disposal of anyone who wished to use them, whether trained as a designer or not—on their desktop computer.

Today professionals also use the tools of digital layout and design. The training that the professional has received, coupled with the tools of digital layout and design, give designers the opportunity to produce publications with a variety and flexibility that would have been difficult to imagine just a few decades ago. Even in magazines, newspapers, and advertising agencies, the era of paste-ups and mechanicals has long been over and digital layout and design, tuned to the requirements of the job, is the order of the day. The offset lithographic presses with their roots going back to the fifteenth century have, for the most part, given way to fully digital printing methods. Designers are finding they can work more quickly and with greater accuracy using digital tools. More variations of a single design can be

explored and shown to a client. Changes can be made less expensively and more quickly. So, while digital layout and design has, perhaps for the first time, made the tools of publishing available to the masses, professionals have also benefited and found their work expanding in new ways because of it.

DIGITAL LAYOUT AND DESIGN: THE EQUIPMENT

Although digital layout and design software was originally produced for the Apple Macintosh computer, the PC has long since caught up with the technology necessary for digital layout and design. Whatever operating system you choose to use, the programs will have a sophisticated graphical user interface and hardware that meshes seamlessly with the software. Other important hardware components for a designer's studio include a scanner for digitizing artwork and a printer for proofing output (see Chapter 4). An image-editing program (see Chapter 7) will be necessary for correcting or modifying images to be placed in a publication and some form of word processing software can be useful in preparing text for long documents. A vector-based illustration program (see Chapter 9) is also useful for designers and allows for work to be scaled to any size without a loss in quality.

Of course, the publishing software itself is of prime importance. Although PageMaker introduced the world to digital layout and design many years ago, other software producers quickly entered the field. Currently, Adobe InDesign and QuarkXPress are two of many choices for the professional designer. Each program offers its own workspace, interface, and depth of features. Still, all digital layout and design software has similar sets of tools to combine text and graphics on screen to represent a draft of document pages.

Inside a Digital Layout and Design Program

When you first open a digital layout and design program you will be asked questions about the size of your document, the number of pages you wish to start with, the size of the margins, and other information about your document. After setting those parameters, you will see something that appears to be a sheet of paper on a desktop. Items, whether graphics, photographs, or type, can be placed either in the document or on the desktop for future use. This is referred to as a pasteboard or layout table, a reference to the old tools and workplace of a traditional designer.

The basic structure of a digital layout and design program should seem familiar. As in most digital media programs, drop down menus will run along the top of the screen, with various program functions nested inside. A floating toolbar will appear on the desktop with the most often used tools for your program, and floating palettes (visual shortcuts for accessing various functions of the program) are available for many of the nested functions in the menu bar at the top of the screen. Often palettes can be modified to reflect the way in which you work. Palettes can be toggled on or off, usually from the Window or View menu depending on your program. If all the tools suddenly disappear, they can easily be brought back on screen from one of these menus.

Rulers and Guidelines

Unlike a word processing program, the rulers at the top and left side of the screen do more than give you an idea of the size of your document. By clicking your mouse inside the ruler and then dragging outward while the mouse button is held down, a guideline can be dragged onto the document. This guideline can be easily moved, and you can drag as many guidelines as you wish into the document (see Figure 6.8).

Guidelines, while visible on the page, do not print with the document. They are similar to the nonphoto "blue pencil" once used to mark guides on a page in traditional cut and paste design to help the artist align different visual elements. When the design was photographed, the blue pencil marks became invisible. Guidelines can also be made to allow design elements to automatically align with a guide by choosing "Snap to Guides."

6.8
This basic layout shows the pasteboard or layout area with a double page spread, open tab groups, a photo on the desktop and guidelines

The rulers can be set to display the measurement system you wish to use (such as inches or picas—a traditional measurement used in typesetting), and whether the horizontal ruler should cover a page or *spread* (two facing pages) depending on the type of document you are working on.

THE BASIC TOOLS

The tool bar or box allows you to select the individual tool you want to use. It is necessary to activate a tool by clicking on its function. For example, before you can add text into your document, you must first click on the text tool before typing. In most cases, you will need to drag a text box with your mouse in order to enter text into the program. This will allow you to move your text freely, as it would any other image or object. Various tools on the tool bar have other tools nested within them. By clicking and holding down the right mouse button on a tool, you can see if additional variations of the tool are available. While actual tools may vary from program to program, the functions they provide will be very similar. We have chosen to detail a few of the tools related to text as an example of how fluid these elements have become.

The Pointer/Select Item Tool
The pointer or select item tool, usually a solid black arrow, is used to select and then move an item from one place on the page to another. It can also be used to resize or reshape items including text boxes, text paths, and wraparound text. By holding down the shift key and clicking on several items to select them, you can temporarily group together. A menu command will allow you to more permanently group or ungroup the selected items. This is helpful when moving or duplicating large collections of elements.

Text and Text Blocks
The text tool is used to enter text directly into a digital layout and design program. As noted earlier, a **text block** is a rectangular space drawn by the user in which text is entered. Once the text has been entered inside it with the text tool, the text block can be moved anywhere in the composition as though it were a graphic element. The text block itself can be pulled or pushed to make it longer or shorter, rotated

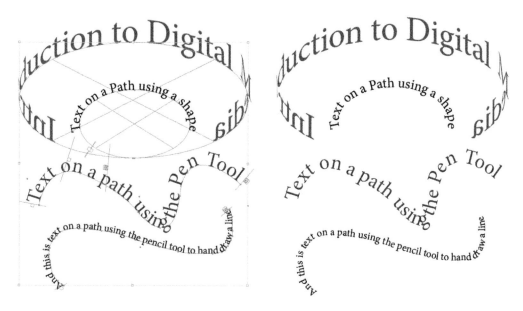

6.9
Examples of text following a path created by a shape, the pen tool and a free-form pencil tool

or flipped horizontally or vertically. The color and transparency of the text can be adjusted as well. The flexibility of moving and organizing text as a series of movable units is a crucial feature of digital layout and design programs.

Another variation of the text tool is the text path tool. This tool allows you to create a **path**, a curved line drawn between connecting points, and then add text, which will flow along the path. A freehand text path tool allows you to draw any line you wish and then type text that will flow along that line. These lines have special anchor points that can be adjusted so that the path can be further corrected or altered. There are even options that allow you to choose how the text will behave when it flows along the path (see Figure 6.9).

BASIC TEXT CONTROL

The ability to adjust and control the way text looks on a page is what really sets digital layout and design programs apart from word processing programs. While the kind of typeface you use, its size and style (bold, italic, and so on), are all tools available in a word processing program, they are only the beginning for digital layout and design programs. Digital layout and design programs are capable of making both global document changes throughout a document and minute adjustments to individual groups of words or even letters. There are a variety of controls to accomplish this.

One should not underestimate the importance of selecting a font as well as its size, typestyle, and color. Certain typefaces are much easier to read in an extensive text (body type) while others are better suited for headlines (display type). Text typefaces don't stand out, read more easily, and are designed to work best between the sizes of 6 and 14 points (a measurement for text size). The size of the text can have a profound impact on your document. Digital layout and design programs allow you to adjust the size of your text in the same way as a word processing program but with much finer control. The typestyle menu allows you to select how the font is to be displayed. Within the typestyle menu are the typical choices of bold, italic, and underline. There are also the options of selecting a word and changing it to all capitals or small capitals or even striking a line through the word so that it appears as though it

were crossed out. In addition, text can be selected and the color of the text changed. Not only can the color of the text be changed to whatever you wish, the value or **shade** of the text can be changed to a percent value to make it appear lighter or darker on the page. It can even be made to appear transparent in varying degrees. These basic text controls give you enormous creative freedom when it comes to simple text modifications (see Figure 6.10).

Other options for type modification include the ability to change the *horizontal or vertical scale* of selected text, stretching the letters wider and fatter or taller and thinner. *Reversing* text creates white text on whatever color background you are using. This can be especially useful when working on a dark background color where black or color text is inappropriate.

Finally, text can be aligned with the borders of the page, as in many word processing programs. The options are **flush left**, which aligns text with the left side of the text block; **flush right**, which aligns text with the right side of the text block; **centered**, which centers text between the left and right edges of the text block; **justified**, which aligns text with the left and right sides of the text block; and finally **forced justification**, in which all lines, including the last line (which may be shorter), are aligned with the left and right edges of the text block.

Times New Roman

Regular Bold Italic

Gradient Tint Stroke

Horizontal Scale

Vertical Scale

6.10
Various simple text treatments of a letter

ADVANCED TEXT CONTROL

Beyond the relatively simple text controls already listed, digital layout and design programs also allow you to make fine adjustments to the spacing of letters and lines of text. This will have a profound impact on your design and the proper use of these controls often separates professionals from amateurs.

Often with **proportionally spaced text**, where the space each letter occupies is different, spacing needs to be adjusted. Monospaced fonts, like Courier, are designed so that each letter takes up exactly the same amount of space. Adjusting the amount of space between two type characters is called **kerning** (see Figure 6.11). The Kern command displays the Character Attributes dialog box, which allows a value to be entered in the highlighted kern amount field. Adding positive values will increase space between characters while negative values will decrease the space.

In most programs you can make these adjustments in the menus at the top or use a type palette with many shortcuts. On the type palette, you can click a triangular arrow in the kern amount field to adjust the kerning. This allows you to see the letters getting closer together or further apart so you can make adjustments visually rather than by setting a pre-determined amount in a menu's dialog box. Optical kerning analyzes the shapes of the characters themselves and then applies kerning to properly space the characters automatically.

The spacing of text and its density (how close together it is) will create different tonal values or what is known as **type color**. In discussing type color, it is not the color of the ink under discussion but the overall tone of the text on the page. The size and style of the typeface, the amount of space around the characters, and the space between the lines all affect typographic color.

If an entire word, sentence, or paragraph need adjusting, **tracking** or letter spacing can be changed instead of using kerning. Tracking sets the amount of space between letters and words and can appear to lighten or darken a page as overall tracking or spacing is loosened or tightened (see Figure 6.12). In the tracking menu, a specific value can be set (again, positive expands the spaces between the letters while negative values contract the spaces) to change the spacing between letters. If using the visual shortcuts in the type palette, you have the option of selecting the words or sentences you wish

Kerning
Kerning

6.11
Kerning allows you to shift the spaces between individual letters

If an entire word, sentence or paragraph needs adjusting, tracking or letter spacing can be changed instead of using kerning. Tracking sets the amount of space between letters and words and can appear to lighten or darken a page as overall tracking or spacing is loosened or tightened. In the tracking menu, a specific value can be set (again, positive expands the spaces between the letters while negative values contracts the spaces) to change the spacing between letters. If using the visual shortcuts in the type palette, you have the option of selecting the words or sentences you wish to change. You can then adjust them visually by clicking on either the negative or positive control. By watching the words expand or contract as you click the appropriate the box you can judge when you have achieved the spacing needed.

If an entire word, sentence or paragraph needs adjusting, tracking or letter spacing can be changed instead of using kerning. Tracking sets the amount of space between letters and words and can appear to lighten or darken a page as overall tracking or spacing is loosened or tightened. In the tracking menu, a specific value can be set (again, positive expands the spaces between the letters while negative values contracts the spaces) to change the spacing between letters. If using the visual shortcuts in the type palette, you have the option of selecting the words or sentences you wish to change. You can then adjust them visually by clicking on either the negative or positive control. By watching the words expand or contract as you click the appropriate the box you can judge when you have achieved the spacing needed.

6.12
Tight tracking on top and loose tracking on bottom. Tracking can affect "type color" by its changing density

to change. You can then adjust them visually by clicking on either the negative or positive control. By watching the words expand or contract as you click the appropriate box you can judge when you have achieved the spacing needed.

Leading (pronounced "ledding") refers to the space between lines of type. In a word processing program, a simple form of leading might be to choose between single or double spacing. Leading is an archaic term and it describes the way in which a typesetter, during the days of hand-set type, would add narrow strips of lead between lines of type in order to maintain the proper spacing. In a digital layout and design program, leading can be adjusted in minute amounts so that type will fit into the space you want. **Baseline shifting**, however, allows you to select and then move individual characters above or below their **baselines**, the imaginary line upon which all letters would normally sit, by minute amounts. This is accomplished without affecting the leading of the overall sentence or paragraph. As with kerning, positive values shift characters up and negative values shift characters down.

However, typographic color is not the only way in which character spacing plays an important role. In addition to the flow of the text, **copyfitting** (the adjustment of type to fit into a given space or number of pages) can be adjusted to accommodate **widows** *and* **orphans**. Widows and orphans are words or short lines of text that become separated from other lines in a paragraph and can be

confusing to a reader. Widows occur at the bottom of a paragraph while orphans occur at the top of a page. Using the many type adjustment tools in a desktop publishing program can eliminate problems like these.

Artist Profile: Marian Bantjes

Canadian artist Marian Bantjes is a designer, typographer, illustrator, and writer who currently specializes in lettering and typography as she works with extremely detailed letterforms and ornaments. Her award-winning work (see Figures 6.13–6.16) has been published extensively and is in the permanent collection of the Cooper-Hewitt National Design Museum.

Having worked as a book typesetter (1984–1994) and a graphic designer (1994–2003), she now works in a wide variety of graphic media including fabric design, wallpaper, wrapping paper, and temporary tattoos. From her incredibly detailed vector art to her hand work specializing in pattern and ornamentation, her work has a structure and formality that sets apart

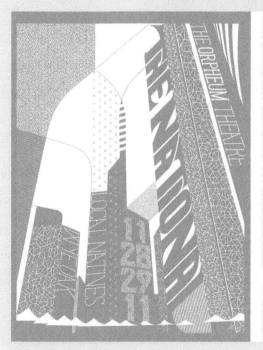

6.13
Marian Bantjes, 2011

6.14
Cover, 2015 PRINT Regional Design Annual

6.15
Cover, GQ Italia's 10th anniversary issue

6.16
Poster for the "National Book Festival," 2019

its organic nature. Widely published, her work has been celebrated around the world. Her reinterpretation of what typography can be has bridged the gap from traditional typographic design to fine art.

Master Pages or Style Sheets

Creating master pages, especially for long documents, will not only save time but ensures that the finished product will be more consistent in terms of layout and design. Should you have a publication already designed but wish to change the document to reflect a new design, new master pages can be applied to all or part of an existing document. This flexibility allows for a variety of design solutions to be created and compared.

Master pages are essentially templates created for documents in which you can set a series of preferences and parameters, which dictate any design element you want to appear on every page, from the number of columns to the way in which the pages will be numbered. Almost everything we have discussed so far can be adjusted and set in a master page template. You have the option of creating master pages from scratch or you can use an existing document that you have modified in order to create a master. Numerous masters can be created and applied as necessary throughout your document.

If creating a two-page master spread, you can also specify the **gutter** (the space you want between pages) in the spread. You can also set different attributes for the left and right pages. This shortcut device will prove invaluable, especially in the production of lengthy documents.

IMAGES

One of the most important elements of digital layout and design programs is the ability to add photographs or other graphic elements to your page layout. The file format most often used for photographs that are to be imported or placed in the document is either a TIFF (tagged image file format) file or PSD (PhotoShop document). These 24-bit raster images have the size and resolution you need for printed materials (vs. lower resolution JPEG images) and can be made the size and resolution you need (see Chapter 7). Graphics (charts, simple designs) are most often brought in as GIF (Graphic Interchange Format) or PNG (portable network graphic) files.

Once placed, text can be made to flow around the image in a variety of ways or even over an image. Text can even be made to flow around irregular shapes. Once a photograph or other graphic is placed in the document, it can be resized (proportionally or not), rotated, cropped, and otherwise modified. Images should be formatted as needed before they are imported since the ability of a digital layout and design program to modify an image is limited compared to that of a dedicated image-editing program.

Image Limitations

One of the limitations of images incorporated into digital layout and design programs is their lack of transparency (see Figure 6.17). In an image-editing program, the use of layers allows an image to have all or part of it transparent. In the not too distant past, when images containing transparent areas were brought into a digital layout and design document, they lost their transparency and became opaque images once again. The only image formats that allow for a transparent section of an image to be truly transparent in a digital layout and design program are PNG, GIF, and higher quality PSD or TIF files. As long as you save your image as a TIFF or PSD file, your image will maintain its transparency and allow

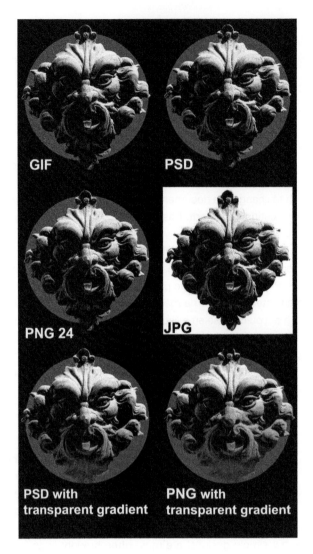

6.17
Numerous file formats now allow you to bring images into a digital layout and design program with transparent sections intact. The two images on the bottom also have a transparent gradient. However, JPEG images do not work for this purpose

other parts of the design to show through. This also holds true for partially transparent areas, perhaps created with a gradient on a layer mask (see Chapter 7).

COLOR AND DIGITAL LAYOUT AND DESIGN

The production of a final printed piece requires a shift from the RGB (red, green, blue) system as seen on the computer screen to a CMYK (cyan, yellow, magenta, and black) ink system used on a printing press or color laser printer. One will immediately see a change in the design because of the difference in the way these two color systems work. In short, colors appear brighter on screen than

when printed because the range of colors or *color gamut* that can be displayed or printed is less in CMYK than in RGB (see Chapter 4). Another way of thinking about this is that a computer monitor can display more than 16 million colors while a printed piece might only reproduce the equivalent of tens of thousands.

The difference in color from what you see on a computer monitor to what can be printed has sparked the pursuit of new systems of color reproduction that might better match the images on your computer screen. However, in order to get a closer match between your monitor and print, your monitor should be calibrated so that colors will appear in their true values. This is a very serious and challenging issue. For example, in a room full of identical computers showing the same image, one can see vivid differences between one display and another. Some are brighter, some have more or less contrast and some may even have different representations of color.

Monitor Calibration

Hardware-based calibration of your monitor is the best way to adjust color, lightness/darkness, and contrast. The many tools that are sold for this purpose are not terribly expensive and pay for themselves in gained productivity. In most, once software is loaded, a small puck (similar to a mouse) is placed on the monitor and a series of steps are followed allowing the puck to read the color, light/dark, and contrast values directly from the screen and make adjustments in order to produce repeatable and accurate color. At the end of this process, an ICC profile will be created (see next section) that will be referenced by your programs to make sure colors are being represented properly. It is important, once this is done, not to change the light/dark values on your monitor. Since monitors do color shift over time, to remain in calibration, these steps need to be repeated regularly.

Fortunately, in both Windows and Mac operating systems there is a very basic calibration tool that is part of the operating system and will at least bring your monitor closer to objective calibration. If you are using a Windows computer, go to the Control Panel and then select Display. From the display panel, select Color Correction and follow the steps they outline.

If you are working on a Mac operating system, go to System Preferences, select Displays, then the Color tab and then click Calibrate. While these are not as accurate as a hardware-based calibration, they will at least provide more accurate color.

[Note: No matter which method you choose for calibration, it is important to let your monitor warm up for at least 30 minutes prior to calibration.]

ICC Profiles

When you move from printing work on your own desktop to working with a professional printer, the level of complexity increases dramatically. Whether sending work out to be printed on an offset lithography press, a digital press, or even a desktop inkjet printer, it is often difficult to get a print to match what you see on your computer monitor. In order to control as much of the transition from screen to print as possible, the use of **ICC (International Color Consortium)** *profiles* can help greatly in maintaining color fidelity. An *ICC profile* is a data set that defines a color space (gamut) of a device and translates that data from one color space to another (see Box 6.1, Getting Technical). Many times this information will be available on a publisher's website in order to assist you in preparing documents that will print accurately on their equipment. Once you have the ICC profile, you can install it to your system and then convert your image to that particular profile. You can then evaluate the converted image and make further adjustments to the image, if necessary, before using it in your document.

Box 6.1 Getting Technical: Color Profiles and Working With a Professional Printer

Color images often have an sRGB color profile. Many cameras also record in Adobe RGB profile, which has a greater range of color than sRGB. No matter which one of these two you have, a profile will be created that helps define the range of colors within the image and how they relate to one another. As already noted, when we print professionally (offset or digital press), an image is printed with four colors: cyan, magenta, yellow, and black. This means that an RGB image will be converted to CMYK when printed. For the greatest control over the quality of the printed image, it makes sense to convert the image from RGB to CMYK yourself and then modify the color as needed. In an image-editing program there are several ways to do this. By selecting MODE, then CMYK, the image will be changed to a "U.S. Web Coated (SWOP) v2" profile. Although this might work, today this is rarely the actual profile the printer will be using. The best approach is to contact the printer and ask them for an ICC profile for the CMYK transition that will work best for the printer and process they are using. Many times this information will be available on a publisher's website as well. Once you have the ICC profile, you can install it to your system and then convert your image to CMYK using that particular profile. The specific ICC profile provided for the CMYK transition will provide a data set that defines the color space (gamut) more exactly and allow for a more exact transition from RGB to CMYK. After the conversion, you can make further adjustments to the image and then use it in your document.

What this means is that once you send your work to a printer for a book, brochure, or even a simple print, the images in your document will have been adjusted to work best with the particular printer and paper that will be used. The ICC profile provided by the printer will allow you to target the conversion from RGB to a CYMK profile that will match the printer's specifications. This will convert your image from RGB to CMYK and change the tonal values so that when printed, the result will more accurately match what you see on your monitor.

Spot Color

Individual colors can be selected and printed in addition to the process colors (CMYK) as noted. **Spot colors** are special premixed solid colors used in addition to the process colors or independently to emphasize or create a point of interest on the page. This adds to the expense of a printing project because each spot color requires its own printing plate when the publication is printed on press. The clearest way to communicate the exact color you want is to select a color from a **Pantone** sample book that contains actual color chips. Each Pantone color has a specific CMYK mixture equivalent. The Pantone color system is only one of many similar systems for choosing spot colors. It can typically be found in the color library section of your digital layout and design program.

POSTSCRIPT

After completing your document in a digital layout and design program, it is important to be sure that the work you send to a professional printer will translate to the system on which it will be printed. For example, sending them your design files without the proper font information will result in your entire document printing with the wrong typeface. If you don't include your image or graphics files,

the quality will suffer greatly. Much of this can be avoided by *packaging* your document (if using Adobe InDesign). When you package your file, it will create a master folder containing not only your design file, but also separate folders for the fonts and images used in the design. It also creates a PDF (Portable Document Format) file for review (as follows). When the file is packaged, there will be a number of choices concerning what files should be included and, most importantly, which PDF preset to use. Very often, a digital publisher will provide a specific preset for the PDF file to match their production requirements. By using their preset, the resulting print job will be as accurate as possible.

PostScript Basics

The language of the computer and the language of printed output are quite different. **PostScript**, a page description language introduced by Adobe in 1985, is a method of communication that links the two together. With this standard format, what you save through the PostScript driver on your computer is what will be decoded and finally printed. (Fortunately, most digital layout and design programs install PostScript drivers for you automatically when you install their software.)

The nature of PostScript, and a key to its success, is that it is device independent. It doesn't matter what sort of computer was used to save the document or what PostScript printer driver was used to create it. Once saved, the file can be printed on any PostScript printer, from desktop laser to professional digital press. Because it can encode everything from vector graphics to photographs and text, PostScript has become the standard in the professional printing world.

When you *print to a file* using a PostScript driver, a PostScript description of the page you have designed is created as a file. That file contains all color, font description, image, and layout information needed to print an accurate representation of your document. It is essentially a description of the page in the language of a printer.

PDF (Portable Document Format)

The Adobe PDF (portable document format) is one way artists and designers are dealing with the complexities of PostScript production. When you save a file as a PDF, your entire design, including typography, fonts, layout information, graphics, and photographs is created as a single file that can be viewed and proofed on a computer screen using Adobe's free Acrobat Reader program.

Using PDF files with Acrobat software allows the person viewing the file to do so without needing to own or know how to operate the software that created the original file or to have the actual fonts that were used to create the document installed on their computer. For example, a file created in InDesign can be viewed by virtually anyone with the free Adobe Acrobat Reader program installed on their computer, and the complete layout will be intact exactly as the designer intended. Fonts will not be substituted and the layout will not be altered if the size or resolution of the monitor it is being viewed on changes. In addition, PDF documents will always appear exactly the same whether viewed on a Macintosh, PC, or Unix operating system.

The ability of a PDF file to be hardware independent, operating system independent, font independent, and even application software independent makes it an excellent choice for publishing on the Internet, publishing digitally, or even for use in multimedia CDs and DVDs.

In the publishing industry, the qualities outlined have made it easier for documents to be prepared for printing, even to non-PostScript printers. Because a PDF file is essentially a description of a page and maintains the integrity of that page's layout, typography, vector, and raster information, it can provide many of the positive elements of PostScript printing to non-PostScript printers and has essentially become the de facto standard.

CONCLUSION

In digital layout and design, the once clear line between the production artist and the graphic designer has blurred. Due to the capabilities of digital layout and design programs, what used to be the exclusive province of the graphic artist or production staff has become at least the partial responsibility of the designer. It is important to keep in mind that what may be an easy trial and error process for printing at home becomes a costly transaction once it moves outside of your control to other working professionals. For this reason, further study should include not only mastery of the specific program you have chosen to work with but also more detailed information concerning pre-press preparation and printing technologies.

Producing work for publication is an art in itself, and one that requires an awareness of what happens when the piece you produce on your desktop goes into production. It is the understanding and ability to deal with the complexity of these issues and many others that separates the professional designer from the desktop enthusiast.

Projects: Digital Layout and Design

1. POSTAGE STAMP
 Design a mock-up for a new postage stamp, celebrating a native animal from a particular nation, to be submitted to their postal service. Scan an image, then size and crop it to fill a 2″ × 3″ rectangle. Label the image in italics, add the country's name in normal style, and write the value of the stamp in bold style.

2. CORPORATE IDENTITY
 Using type and objects, design a two-color logo for a digital design firm that is at least 4″ in one dimension. Then, resize and utilize the logo in a 3 1/2″ × 2″ business card, 8 1/2″ × 11″ letterhead, and a business-size (4 1/8″ × 9 1/2″) envelope, with typical text information.

3. DIGITAL DOLLAR: NEW CURRENCY DESIGN
 In a 6″×3″ format with a 1/4″ border, design a new world currency for the United Nations. Both front and reverse should include images that symbolize international unity and progress. Invent a new monetary denomination and be sure to make it easy for users to see the amount quickly.

4. GALLERY ANNOUNCEMENT
 Create an announcement for an exhibition of a past artist. Your approach to design and typography should try to evoke the era of the artist, whether he or she is from the Renaissance or the 1960s. Create a two-page spread, totaling 14″× 7″ overall, with 1/2″ borders all around and a 1″ gutter. Divide one of the pages into two columns.

5. TRAVEL POSTER
 Choose a famous city or exotic locale and create a poster of 11″ × 17″ that encourages tourists to fly to that location. Combine several images of various sizes and shapes with typography that not only grabs the attention of readers but evokes the tourist site. Use colors and tints that harmonize with the images. Wrap text around the images and include a box with reverse lettering.

7 Image Editing

7.1a
RGB additive color model

INTRODUCTION

The words *image-editing* seem rather mundane compared to the wide range of exciting techniques and approaches that fall under this heading. While the term might mean simply correcting the tonal value of an image, removing dust spots and cropping the composition, or correcting the color of an image prior to printing, it includes all of this and much more. Various filters can be used to enhance the image or even radically change its appearance. For many digital artists it means image compositing, where several images are combined to create a greater imaginative whole. This chapter will examine the various ways in which an image can be corrected, adjusted, and manipulated to enhance its ability to communicate the artist's vision.

The traditional techniques of photography are reflected in all image-editing programs. Most programs have a range of tools that mimic those used in a conventional darkroom. For example, if an area of an image is too light, it can be selectively darkened. If one were working in a traditional darkroom,

one would *burn-in*, or add additional exposure to that portion of the image. If an area needs to be lightened, one might *dodge-out* that part of the image, blocking the light from hitting the area that was too dark for a certain amount of the overall exposure time. Digitally, this can be done with "burning" and "dodging" tools, which can be used like a brush to darken and lighten an area of the image. As in the darkroom, the effect is cumulative. Since it is easy to overburn or overdodge if one isn't careful, setting the opacity of the tool low and working gradually is the safest way to work.

Box 7.1 Getting Technical: spi, dpi, or ppi

We often use the term **dpi** to refer to the overall quality of a digitized image. However, this is not the only way to define image resolution as it relates to the process of image editing. When we scan an image, we are sampling a number of points using an x–y series of coordinates. Each point represents a single pixel making up the image. The more samples per inch (spi), the higher the resolution will be. By sampling more points we obtain more information to use in representing the image. The image resolution, coupled with the image's physical size, determines the file size, which is usually measured in megabytes. Screen resolution is measured in pixels per inch (ppi) and print resolution is measured in dots per inch (dpi). Image resolution must contain sufficient information to allow the printer to fully utilize its ability to deposit ink or toner to the areas described in the print. If an image's resolution is too low, softness and a lack of sharp detail will result.]

Color Models

Most image-editing programs allow you to choose the color mode you wish to work in. Digital artists generally work in RGB mode—the default in most image-editing programs—or Adobe RGB, which many digital cameras use. As noted in Chapter 4, scanners sample images using red, green, and blue filters to create an RGB image, and computer monitors create color by emitting light through a screen containing red, green, and blue phosphors, or in the case of an LCD monitor (see Chapter 4) tiny transistors and capacitors arranged in a thin film matrix. As a particular pixel is turned on, the capacitor of that particular pixel receives a charge, which is held until the next refresh cycle. In RGB mode, the visual spectrum is created by projected light, mixing the three visual primary colors. When all three colors of equal value and intensity overlap, white is the result. This is called an **additive color model** (see Figure 7.1a).

The CMYK color model is rooted in the way in which images are printed on a press. When printing, cyan, magenta, yellow, and black inks are printed one after the other to create full-color images. Unlike RGB, CMYK utilizes a subtractive model based on the reflected light of inks rather than projected light. As light strikes the ink, a portion of that light is absorbed. The light that isn't absorbed is reflected back to the eye. CMYK model image files are about one-third larger than RGB files due to the extra color (black) channel. Most artists edit their images in RGB mode and, if planning to print, convert to the CMYK model after all image editing is finished (see Figure 7.1b).

While RGB and CMYK are the most common models used, image-editing programs usually provide artists with other options. Artists often define a color by hue, value, and intensity, with hue being the color itself, value representing the lightness or darkness of a color, and intensity identifying the chromatic purity of the color. In image-editing programs, this is called the HSB (hue, saturation, brightness) model of color.

7.1b
CMYK subtractive color model

Box 7.2 Getting Technical: Gamut

Gamut describes the range of colors available in a certain color space that can be displayed on a monitor or printed. The RGB gamut contains the colors that can be accurately viewed on a color monitor. The CMYK model has the smallest gamut, and represents colors that can be printed with cyan, magenta, yellow, and black process inks.

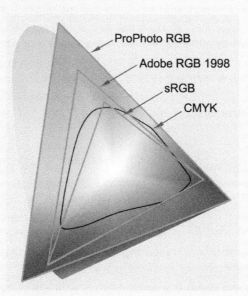

7.2
Visual approximation of color gamut

Out-of-gamut colors are colors that can be approximated on a computer screen but not printed accurately using the CMYK color ink set. There are some colors that are present in the RGB gamut that are not available in the CMYK gamut and some that are available in CMYK that are not available in RGB. In addition, even in inkjet printing, which has the potential to represent a wide gamut, different papers are limited by their inherent ability to reproduce color (Figure 7.2 Color Gamut). Part of preparing an image for print is the process of "correcting" out-of-gamut colors, usually by reducing their intensity or contrast.

GLOBAL CHANGES

Making Images Larger and Smaller

Image-editing programs give you the opportunity to make images larger or smaller after scanning or photographing. This is sometimes confusing due to the options provided. Making an image larger or smaller while maintaining its file size is known as **resizing**. Changing the size of an image by eliminating or adding pixels is known as **resampling** and allows the computer to make an image larger or smaller by adding or deleting pixels. Added pixels are computer generated and created by comparing pixels in an image and then averaging them together to create new ones. This changes the file size accordingly. Generally, it is wise to avoid this approach, known as interpolation, which can degrade image quality.

Resizing

The physical dimensions of an image are determined differently for the monitor screen than they are for the printer. Once the number of pixels in an image are fixed (after being determined by a digital camera's sensor for example or the spi of a scanner), we can only change the printed size of an image by spreading out or bringing closer together the number of pixels per inch. Let's use the example of a 6" x 6" image that has been scanned at 300 spi (samples per inch). If we *resize* that image to be larger, such as 12" x 12", we will find that the pixels have spread further apart in order to do so. The number of pixels per inch will drop from 300 to 150 ppi although the file size will remain the same. Making the 6" x 6" image (300 ppi) smaller, such as a 3" x 3" image by resizing, will move the pixels closer together and make it a 600 ppi image. Again, the file size remains the same although the print size changes.

Resampling

Resampling, also known as interpolation, takes place when attempting to increase or decrease the number of pixels in an image without changing the physical size of the image. When a program resamples an image up to increase the print size without changing the pixels per inch, additional pixels must be created in to do so. This is not the same as simply resizing an image. Creating new pixels by comparing existing pixels really means that the computer is making up new information. This often results in diminishing the sharpness and overall quality of the image because the new pixels are created by comparing existing pixels to average them together to create new information.

Resampling (interpolation) is not only used when resampling images in order to make them larger. When we make an image smaller or **downsample**, we delete information from the image. It is important to note that this information cannot be recovered if we change our mind later and decide to make the image larger. In addition, every time we resample an image larger or smaller, rotate an

image, resize a layer, or use any special effects that change the size or dimension of an image, new color values are created for added pixels. This continued process of interpolation takes its toll on the quality of an image.

Hint:

It is wiser to work on a copy of your image rather than the original itself. In that way, if something goes wrong, you can go back to the archived digital camera image or scan to start again. Once an image is resampled and saved, or edited in the ways described below, the changes cannot be undone.

Value and Contrast

One of the most powerful features of image-editing programs lies in their ability to make changes that affect an entire image. The global tools designed to affect an image's tonal values do similar things with varying degrees of sophistication. Brightness/Contrast controls, Levels, and Curves all have the capability to **remap** or shift values within an image to correct for poor contrast, or an image that is too light or dark. As digital artists become familiar with any digital media program, they soon see there are many different but related ways to accomplish the same objective.

Brightness and Contrast

In a traditional darkroom, a photographer can change from one contrast of photographic paper to another to correct an image that is too "flat" (lacking in contrast) or too "harsh" (having too much contrast). The digital artist, when faced with an image lacking in contrast or an image that is too dark or light, can correct the image by using a program's brightness and contrast controls. The brightness control lightens or darkens an image and the contrast control increases or decreases the number of tonal values in an image. While this is the simplest way to adjust an image's brightness and contrast, it adjusts highlights, midtones, and shadows all at the same time. It does not allow the artist to select specific areas in which to change tonal values, and it doesn't allow for adjustment to individual value ranges.

Levels and the Histogram

Most programs can shift tonal values by adjusting an image's **histogram**. The Levels command is an easy and powerful tool to use for this purpose. The Levels dialog box (see Figure 7.3) builds on the visual nature of the histogram and provides a series of movable controls, which allows one to redistribute an image's tonal values by changing highlight, midtone, and shadow values separately.

A high-quality image has a histogram that is spread out from one end of the scale to another. An image with blank space at either end of the histogram indicates an image that might need further examination in terms of too much or too little contrast. This can be corrected by moving the sliders at the bottom of the histogram (Levels) control. The slider on the left controls the dark values while the slider on the right controls the light values. The slider in the middle controls the midrange or **gamma** of the image.

By moving the sliders on the left and right to the beginnings of the histogram on each side, one can shift the range of tonal values in the image and correct for an initial lack of contrast—or even for too much contrast. The center slider or **gamma** (midrange) control allows one to shift the midrange of an image to make it darker or lighter. An important advantage of this approach is that you are merely shifting tonal relationships—reassigning values, not eliminating them. By correcting for each channel individually, an image can be color corrected with some precision.

The eyedropper tools in both Levels and Curves are shortcuts to adjust tonal range and color. See the explanation in Curves for more information.

Levels Histogram Control

As the far left (black) and far right (white) sliders move towards
each other, contrast increases and tonal range decreases.

Far left slider sets the black
point in the image. Everything
to the left of the slider becomes
black.

Far right slider sets the white
point in the image. Everthing
to the right of the slider becomes
white.

Middle slider allows remapping
of midrange values (lighter to the
left and darker to the right) without
changing highlights and shadows.

Clicking on a corresponding part
of an image with one of the eye-
droppers will set a white, gray or
black point and change tonal and
color ranges accordingly.

Black Output Level:
As the slider moves to the
right, maximum black values
are set at lighter levels, which
can open detail in shadow areas.

White Output Level:
As the slider moves to the
left, maximum highlight values
are set at darker levels making
white areas grayer.

Moving the black and white output levels towards each
other results in a lowering of apparent contrast.

7.3
Histogram control (Levels) with parts labeled

Curves

The Curves dialog box in most image-editing programs allows you to selectively raise or lower values in specific areas of an image. In the initial dialog box one will see a straight line running on a diagonal which represents the current value "ramp" of the image. The Curves adjustment allows for far more precise control of values than the Levels tool. Along the Curves' initial straight line are specific areas that relate to highlight values (white), quarter-tone values (25 percent gray), midtone values (50 percent gray), three-quarter-tone values (75 percent gray), and shadow values (black). You can even use the eyedropper to click on the area of an image you wish to adjust and see its corresponding point on the curves line (see Figure 7.4A). That point can then be adjusted by dragging it up or down to raise or lower the value. Sophisticated users of the Curves tool actually read the numerical values of the areas they wish to adjust and shift their numbers to represent their target reproduction values.

Nevertheless, even simply clicking on the midrange area and dragging it upward or downward will show you the Curve tool's ability to shift tonal values dramatically. Shifting just one point is very similar to using the Levels tool. However, the Curve tool's ability to target a specific range of tones in a print while others are left unchanged demonstrates its flexibility (see Figure 7.4B). Where the Levels control gives you the opportunity to shift three points—shadow (left), midtones (center), and highlight (right)—to correct tonality or color, the Curves adjustment tool gives you more control over additional points. Very often, for simple color correction, one only has to choose the black, gray, or white eyedropper tool and then click in an area of similar value in an image to reset color values (see Figure 7.4C).

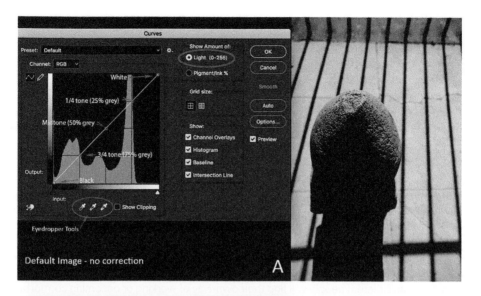

A — Default Image - no correction

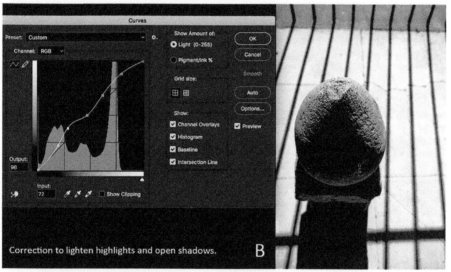

B — Correction to lighten highlights and open shadows.

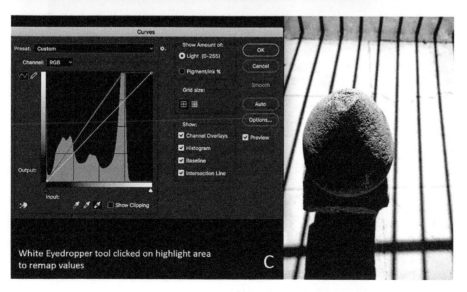

C — White Eyedropper tool clicked on highlight area to remap values

7.4
Curves adjustments using points (in sample B) and white eyedropper between bars (in sample C)

WORKING WITH COLOR BALANCE CONTROLS

Channels and Color Balance

An RGB image has three 8-bit channels (separate 8-bit images) that the computer mixes together to create a full-color, 24-bit image. Each of these independent 8-bit images (representing the tonal values for red, green, and blue) is available for editing as a separate channel. Color correction in CMYK, or any of the other color modes already discussed, is also possible.

As with traditional color darkroom filters, each color channel you adjust makes a change not only to that color but to its complement as well. The red channel controls red and cyan, the green channel controls green and magenta, and the blue channel controls blue and yellow. Each color model will work in a similar fashion and you will find that the complements are the same whether you are working in RGB or CMYK (see Figure 7.5).

Like most of the other options in image-editing programs, there are many ways to balance color. Very often, it will take several options together to arrive at the final color balance you wish to see. There is no one best option. Different people will find their own way of working or becoming comfortable with their favorite tools. Levels, Curves, Color Balance, and Hue/Saturation controls are the most common interfaces for color modification. No matter which tool you choose, it will do essentially the same thing through a different interface with varying degrees of sophistication. Each allows individual color channels to be selected and adjusted to change color relationships.

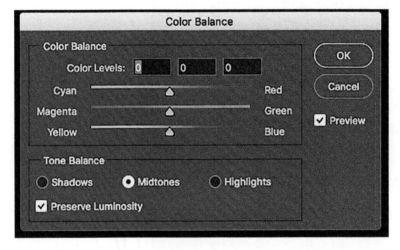

7.5
The Color Balance controls demonstrate the concept of complements that can be adjusted to increase or decrease a particular color. This is exactly the same for RGB and CMYK and allows you to target Shadows, Midtones, and Highlights separately

Simple Color Balance

There are two basic approaches to editing an image in RGB color mode. First, you can decrease a color by adding its complement, and second, you can increase the two colors that mix together to make the color's complement. While this might sound complex, once you try it things become considerably easier. Most programs will provide a simple dialog with each channel represented, allowing you to simply slide a color from one complement towards another. For example, to remove red from an image, you can either increase the amount of cyan (red and cyan are complements), which decreases the amount of red, or increase the amount of green and blue (which make cyan). Either of these adjustments result in an image that will contain less red. This tool is useful for tweaking slight overall color bias but is not as good as others for more complex color correction.

Color Balance Using Levels

The Levels control also allows you to select each color channel independently (see Figure 7.6) so that separate adjustments can be made to each color's highlight, midtone, and shadow areas. As a starting

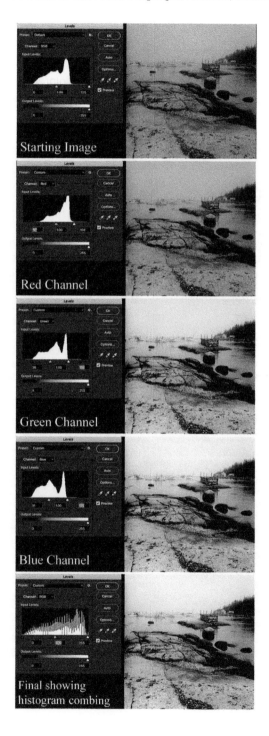

7.6

Basic color correction using levels separately on each channel. In the last image we can see the histogram is now spread out across the full range. The vertical lines are called "combing" and are the result of the tonal adjustments

point, adjustments can be made to bring the sliders for each channel to the beginning and end of the visible histogram. Once this is complete, fine-tuning can be finished using further modification in Levels or in any of the other controls as listed.

Hue/Saturation Controls

The **Hue/Saturation** control brings up a dialog box in which both the **hue** (color) of an image along with its **saturation** (intensity) can either be shifted or changed (see Figure 7.7a). The hue or color control allows one to shift the entire spectrum of color in an image but also provides the option of selecting a particular part of the color spectrum to move (see Figure 7.7b). This is

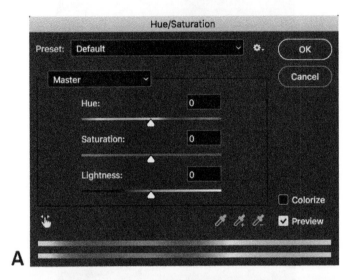

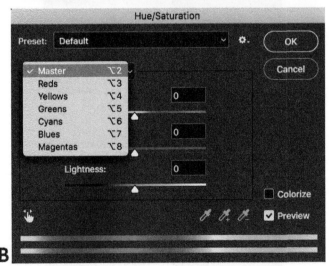

7.7a
Hue/Saturations allows you to target and shift color and saturation for a specific range of color

accomplished by using the eyedropper tool to sample a specific color to shift and then, by moving sliders, shift the original color to another part of the spectrum. All similar colors in an image will then change to the new selection. You can use this same method to increase or decrease saturation to an entire image or to a specific hue within the image. Very often simply decreasing part of an image's saturation will correct what appears to be a very difficult image. Whichever tool you use, recognizing the color you are attempting to shift and knowing its complement will help you modify the image accurately.

FILTERS: MODIFICATION AND ENHANCEMENT

All image-editing programs have sets of filters which will allow you to apply different effects to your image. You can change a photograph into what looks like a pen-and-ink drawing or a watercolor or create a multitude of other effects. Beyond what is included in the software, there are companies that specialize in creating special filters for image-editing programs.

Filters are simple to experiment with and use. The challenge for many students is to use filters both creatively and wisely. It is far too common to allow filters to create interesting effects unrelated to the content of the image or the context in which an image is to be used. Filters might seem new and interesting to the novice, but the effects will appear obvious and clichéd to the more sophisticated viewer. The selective application of filters to portions of an image is generally a more effective use.

Filter sets are classified by the function they perform. One group of filters mimic other art media. These include filters to create watercolor and other painting effects, pen-and-ink drawing effects, charcoal-and-pastel drawing effects, and many more. These filters usually provide dialog boxes that allow the user to control the impact of a filter by adjusting its strength, brush size, or opacity.

In addition to the strong, visually transformative filters, there are also filters that are targeted to specific objectives. These filters are often used not to change an image so much as to enhance or correct an image. The Unsharp Mask filter for example (see Box 7.3) has been a staple of image sharpening since the inception of digital imaging programs and is used to restore sharpness to an image after scanning (see Chapter 4) or to a camera image that seems a bit soft. (Almost all scanned or digital camera images can benefit from judicious sharpening.) Other filters allow you to correct for camera lens issues like *geometric distortion* (for example, where a wide angle lens makes an image appear to bow out at the edges) and *chromatic aberration* (which creates colors, often blue or purple, surrounding darker areas in high contrast situations—like tree branches against the sky) as well as other common problems many cameras have. There are filters to create lighting effects, high contrast, clouds, and much more. In addition, new filters can be downloaded from the Internet so new approaches are constantly possible. You will even find a Camera RAW filter that gives you great control over raw images produced by many cameras (see Chapter 4 for information on digital cameras and RAW files). It is sometimes very difficult to move beyond the easily applied filters available to digital imaging and begin to see them as just one more tool in your repertoire.

Box 7.3 Getting Technical: The Unsharp Mask

Most images require some form of sharpening after scanning or at the completion of various forms of manipulation. Every time your program resamples, rotates, or completes an operation affecting the file size of an image, there is some form of interpolation that can degrade its sharpness. Additionally, scanners, regardless of their resolution, tend to soften the contents of an image.

The *Unsharp Mask* filter takes its name from a traditional photographic technique used when making color separations for image reproduction. A piece of frosted mylar (coated plastic) was used as a photographic mask through which separate negatives for the cyan, magenta, yellow, and black values were exposed. This process created an increase in contrast that appeared as an increase in sharpness. In digital imaging the Unsharp Mask filter increases contrast between light and dark pixels and thereby creates the illusion of greater sharpness.

When using this filter there are three adjustments that can control the amount of sharpening that takes place. *Amount* (which ranges from 1 to 500 percent) controls the strength of the sharpening effect—somewhere near 100 percent works well for most images. *Radius* controls the number of adjacent pixels that will be sharpened. This can range from .1 to 99.99 pixels, although a setting of 1 to 2 pixels for scanned images and less (.9 for example) for images created by digital cameras creates appropriate contrast for most images. The higher the value selected, the more pixels will be affected by the sharpening. If too high a value is set, over-sharpening might occur, and the resulting image will appear grainy and halos might appear around items in an image. The *Threshold* command, with a range of 0 to 255, is essentially a mask that protects certain portions of the image from being sharpened. It determines how different pixels must be before they are selected and sharpened by the filter. The larger the number entered here, the more pixels in an image are protected from being sharpened. An amount of 0 sharpens the entire image. Choosing the appropriate Threshold settings is dependent upon the nature of the image being sharpened. If one wishes to maintain subtle differences and variations, a low setting is best; to emphasize only the edges of objects in an image (larger variations in pixel value) and increase edge contrast, then a higher threshold setting may be needed. Generally, the larger the image, the more sharpening it can use. A smaller image with a lesser dpi would require less sharpening.

Image-Editing Tools and Selections

All the effects already described—the global changes and tools that can be applied to an entire image—can also be applied to smaller areas of an image. In order to accomplish this, parts of an image must be selected to separate them from the rest of the image and allow the artist to make changes to only those areas while leaving the remainder of the image intact.

Selection Tools

To be successful in image editing, it is very important to master the basic selection tools and their modifying palettes. Whether selecting part of an image to lighten or darken or selecting part of an image to copy

in order to move it into another image, the quality of the selection process is critical to the final result. A selection is complete when you see flashing dotted lines surrounding the area you have selected.

Traditional selection tools usually include a *lasso* tool for freehand selections, a *rubber-band* tool which allows selections to be made in a series of straight lines much like snapping a band from point to point, *rectangle* and *oval* selection tools, and a *magic wand* tool that selects pixels of similar values and colors depending on the sensitivity you set in that tool's dialog box. Some programs also have *magnetic* free-form tools that follow along pixels of dissimilar values to make a selection easier. This is used in a similar fashion to the lasso tool but clings to the edges of pixels that are different from one another, usually the edges of objects in a picture.

Common controls available for most selection tools are **feathering** and **anti-aliasing**, along with modifiers for adding or subtracting from a selection. Feathering allows the selection of a certain number of pixels with which to soften the edge of the selection or mask. This is helpful when selected areas need to be blended in with their surroundings at some point in the editing process. Anti-aliasing will smooth the edge of a selection but will not soften it as extensively as feathering. Curved selections will benefit the most from anti-aliasing.

For conventional geometric shapes, the rectangle and oval (ellipse) selection tools are the easiest to use. After clicking in a corner of the area to be selected, the rectangle or oval tool is simply dragged to make it larger or smaller until the desired area is enclosed. While keyboard commands, like the shift key, will constrain the selection to a square or circle, or start the selection from the center instead of the edges, the dialog boxes for these tools provide even greater flexibility. After an initial selection is complete, it can be modified by keyboard commands that allow you to add to or subtract from the selection. This is true for all selections.

The lasso tool is used to select areas that are irregular in shape. There are many variations of this free-form section tool. While holding down a mouse button, the tool is dragged around areas to be selected. When it returns to the beginning point, the selection is complete.

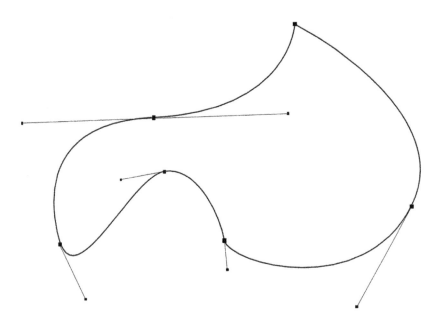

7.8
Pen tool selections can be very exact, crisp, and easy to convert to traditional selections

The Polygon Lasso or rubber-band selection tool creates a series of straight line segments. When you click the mouse, move to a new location, and click again, a selection is stretched between the two points. This can be useful for selections that are more geometric in nature, although curves can be selected with a series of short lines that follow an arc. As with the lasso tool, when it returns to the beginning point, the selection is complete.

By clicking on an area with the magic wand selection tool, pixels of similar tone and value will be selected. The magic wand selection tool has greater flexibility and additional control settings than the other selection tools. In addition to the choice of anti-aliasing, the magic wand also allows the choice of tolerance, which allows you to select the number of pixels that will be affected (from 0 to 255). The lower the number, the fewer the pixels that will be affected by the selection. There is also an option, depending on your program, of making the selection contiguous. A contiguous setting only allows similar pixels that are touching one another and within tolerance to be selected. If this box is unchecked, then all similar pixels (within tolerance) throughout an image will be selected when you use the magic wand.

Many image-editing programs also include *magnetic selection* tools that follow the edges created by tonal or color differences. By clicking the tool at the beginning of your selection and then floating the tool along the area to be selected without holding the mouse button down, the tool will follow along the edge while laying down points to fasten it to the selected area. The dialog box for this tool will display some form of options for the lasso width, which will determine the width of the area in which the tool will look for edge information. The smaller the width, the greater the eye-hand coordination required. In addition, frequency and edge-contrast settings are available. Frequency determines how often a fastening point is established as the selection is made and edge contrast determines the amount of contrast the tool looks for in establishing an edge. The more complex the selection to be made, the greater the frequency should be. For images with a lot of contrast between the object being selected and its surroundings, a high edge-contrast setting can be selected. Images with little contrast require a lower setting.

The *pen* tool utilizes a vector approach (see Chapter 9) to provide a more exact way of selecting portions of an image for masking or later manipulation. Clicking with the mouse sets anchor points that are connected by a visible line or path. The shape of the path is adjusted by dragging handles on the anchor points to control the direction of the curve (see Figure 7.8).

This creates a series of path segments. Additional pen tools allow you to modify path directions, add or remove points from a segment, or change from curved segments to straight line segments or vice versa. In addition, because of its vector properties, a selection using a path will be crisp and smooth with no jagged areas. Paths have many advantages, including the fact that they can be stored in their own native vector format, which requires very little memory. They can also be converted to traditional selections at any time or activated as paths and edited at will. Most programs related to digital imaging, whether vector or raster, will have the pen tool available so it is a good idea to master it. More information on these tools can be found in Chapter 9.

Saving Selections and the Channels Palette

When using a selection tool to capture part of an image, it makes sense to save the selection, especially if it is complex and takes a lot of time to complete. When a selection is saved, it will be seen as a Mask in the **Channels** palette box. The Channels palette box shows the individual channels for each of the colors in the color mode being used. A stored selection is also called an *alpha* channel and does not affect the color of an image. The alpha channel **mask** can be reloaded at any time to bring the selec-

tion back into the image for further editing (see Figure 7.9). There are many methods that can be used to save a selection. Perhaps the simplest is to go to the Selection Menu and click on Save Selection. This will create the alpha channel mentioned. Activating the Channels palette will allow you to see the selection as a Mask. By Control or Command clicking on the channel, the selection will instantly appear in your image. Once something has been selected, it can be used as a Mask to single out the selected area for further changes. For example, if you wished to change the color of someone's shirt, you could select the shirt and then use any of the color controls already mentioned to change the color of the shirt in just that targeted (selected) area. By reversing (or inversing in Adobe Photoshop), the selection will be the opposite of what was originally selected.

Some programs also provide special selection-editing modes. For example, in Photoshop, a feature called *QuickMask* (see Figure 7.10) places a red mask around selected areas. This can be changed to any color and level of transparency you wish for ease of viewing. You can start with a relatively rough

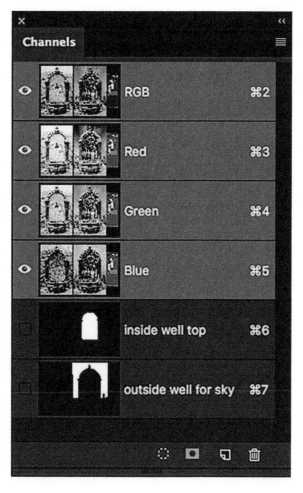

7.9
In the Channels palette you can see the separate channels for Red, Green, and Blue. Directly below are the alpha channels showing saved selections

7.10
Column after selection, while still in QuickMask. Clicking on the QuickMask icon again will change this into a traditional selection with the column selected

selection, turn on QuickMask and then add to the selection by painting areas using any of the paint tools and the color black in the foreground or remove parts of the selection by painting with any of the brush tools and the color white in the foreground. Once you have cleaned up your image with the painting tools, you can click on the QuickMask icon once again (bottom of the toolbar to the left in Photoshop), and your mask will convert back to a selection complete with the flashing dotted lines that define the selection. Many people find it easier to use the brush tools to make selections on the alpha channel or in QuickMask mode due to their larger size and ease of handling.

If you are interested only in correcting an image's tonal or color flaws, selecting parts of an image for localized modification can be very important. If you are interested in image compositing or combining several images together to create a new reality, the selection tools will become a key component of the creative process.

Hint:

Sometimes it is easier to modify a selection if you create a separate layer from the selection. A simple Edit>Copy, Edit>Paste command would work, as would (for Photoshop) the Control or Command J shortcut depending on your operating system.

LOCAL CONTROLS

Local controls allow for small changes to portions of an image without the need for masking or selecting areas first. These controls include tools that allow the user to *Blur, Sharpen,* or even *Smear* portions of an image with a brush. In addition, similar local controls can be used to *Saturate, Desaturate,* and *Burn and Dodge* (or even Color Burn and Color Dodge) areas of an image. Setting the opacity in the dialog box for these tools allows you to control the degree of change that takes place.

Paint Tools

The paint tools in an image-editing program are relatively basic. Almost all include a brush tool, pencil tool, and some form of airbrush tool. Often a palette will allow you to choose the size of the brush and whether it has a sharp or soft edge. In addition, the rate at which the brush repeats can also be changed so that the space between individual brushstrokes can be made larger or smaller. This results in everything from a smooth flowing brushstroke to a staccato-like repetition of the brush character. The basic brush tool is circular but, in many cases, can be changed to an oval or even a flat brush and then rotated in any direction. The color and opacity of the brush can also be changed. Most programs offer several different ways of selecting the color of a brush. A box representing the color model you have selected can be used to make any color needed by moving sliders back and forth under each of the hues represented. The color the brush will apply will show up on the toolbar as the foreground color.

An eyedropper tool can also be used to select a color already in an image. The color clicked on with the eyedropper tool will then show up as the foreground color. A box containing pre-determined color swatches can also be used for color selection. Finally, clicking on the foreground color in the toolbar will often bring up a more sophisticated color selection utility, allowing the choice of hue, value, and intensity.

Choosing the opacity of the brush will allow control of the relative opacity or transparency of a color. With the conventional brush tool, once the set opacity is reached, further build-up of the color stops unless you stop and start again. The airbrush tool, however, can be set to a lower pressure, but will build color opacity or density as long as the mouse button is held down. Other than that, the airbrush tool is very similar to a regular brush tool.

The pencil tool is also similar to the regular brush tool except that it always has a crisp, hard edge through the full range of sizes. The orientation of the pencil can be changed from round to chisel point, but it is always hard edged.

Gradient tools are very useful for filling sections of an image with a range of color that changes smoothly from one hue to another. While most programs have at least one straight gradient option allowing for the selection of colors to run in a linear fashion, many programs also provide a selection of different types of gradients (for example, a radial gradient) along with numerous preset gradient colors. Most useful are the tools that allow you to edit gradients and select the points at which gradients blend colors. Many programs even allow you to create your own gradients

The Rubber Stamp/Clone Tool

The **Rubber Stamp** or Clone tool is in a category all its own. This tool is designed for duplicating portions of an image from one location to another (see Figure 7.11).

One starts by setting the beginning of the clone point (the sample point) and then moving to another portion of an image and clicking a destination point. Information from the sample point is copied to the destination point and thus "cloned." The size of the clone tool is determined by selecting a brush size from the brush palette. Options include setting the opacity of the newly cloned or rubber-stamped area, and whether or not the area is *aligned*. If you do not select aligned, then each time you re-click the mouse, a new clone image will begin.

In addition to its creative uses, this tool is especially useful for correcting dust and other imperfections in an image. By starting the clone point outside the image defect, those pixels can be copied over the defective ones and so eliminate them. By constantly resetting your beginning clone point, new, "good" information is copied over bad.

7.11
The clone tool was used to copy the background area over the statue, in effect removing it. The original image is on the left

BASIC IMAGE MANIPULATION

Layers
Layers are like sheets of clear plastic upon which new information is added. Any image opened in an image-editing program is automatically opened as the first or background layer. Then new layers can be added to include new image elements. A new layer will be created automatically whenever you paste an image or part of an image into a document. Each layer is independent of other layers and can be set to varying opacities so that an image on one layer may show through another. In addition, the order of the layers in the layer palette can be changed so that the corresponding layer in your image can be placed over or under whatever layer you choose—much like shuffling images on pieces of clear plastic.

The independence of layers is one of their greatest assets in image editing. Once a layer is active, anything you do to the image will take place only on that layer and will not affect any of the other layers in the image. Any of the image modification tools we discussed in this chapter can be applied to the document but they will now only affect the active layer. Layers can also be duplicated, deleted, and merged together. This is important as the more layers an image has, the larger the file size will become.

In order to save an image with layers, and to keep those layers intact for additional editing sessions, the image must be saved in the program's native format (such as PSD), or as TIF files. Saving an image in a file format that does not support layers, such as a JPEG, will automatically flatten all layers into a single background layer. This should only be done with a copy of the file (simply use Save As and give it a different name) or when you are sure no further editing or compositing needs to be done.

Artist Profile: Robert and Shana ParkeHarrison

As a sample of how an artist's imagination can be kindled by the many tools available, the work of Robert and Shana ParkeHarrison illustrates how images can be created that both defy and draw us in to the reality they create. Magical and metaphorical, they engage us in a poetic search to understand our world.

Artist's Statement: "We create works in response to the ever-bleakening relationship linking humans, technology, and nature. These works feature an ambiguous narrative that offers insight into the dilemma posed by science and technology's failed promise to fix our problems, provide explanations, and furnish certainty pertaining to the human condition. Strange scenes of hybridizing forces, swarming elements, and bleeding overabundance portray Nature unleashed by technology and the human hand.

Rich colors and surrealistic imagery merge to reveal the poetic roots of the works on display. The use of color is intentional but abstract; proportion and space are compositional rather than natural; movement is blurred; objects and people juxtaposed as if by chance in a visual improvisation that unfolds choreographically. At once formally arresting and immeasurably loaded with sensations—this work attempts to provide powerful impact both visually and viscerally."

Throughout this evolution of media, the core aesthetic of the work is not only consistent but almost overpowering in its ability to surprise and call into question the very nature of reality.

7.12
From the *Precipice* series, 2015

7.13
Sojourn, 2015

7.14
Logic of Spring, 2015

7.15
Downpour, 2015

The Layer Mask

One of the most powerful and flexible features of Layers is the *layer mask*. The layer mask tool allows you to literally mask portions of a layer to reveal the layer underneath (see Figure 7.16). This works in a similar fashion to the QuickMask tool but it is an invisible addition to a layer. When the layer mask is activated, you can paint on it using the brush, pencil, airbrush, gradient tool and just about anything else from the tool bar. Choosing *black* to use on an area of the layer mask will cover up or appear to erase the image, thus revealing what is underneath. Choosing *white* to use on an area of the layer mask will restore the image on a layer and reveal what is underneath. You can even choose the Gradient tool (black to transparent with black as the foreground color) to allow the image to slowly fade out wherever you apply the gradient. Reversing this (white to transparent) will restore the image. Unlike the eraser tool which permanently deletes whatever you erase, the layer mask is much more flexible. The modifications you make are made on the layer mask itself and do not affect the original image.

Rotate and Transform with Layers

If an image is to be turned or rotated, then a program's general rotate command will bring up a dialog box which will typically allow choices of 180 degrees, 90 degrees CW (clockwise), 90 degrees CCW

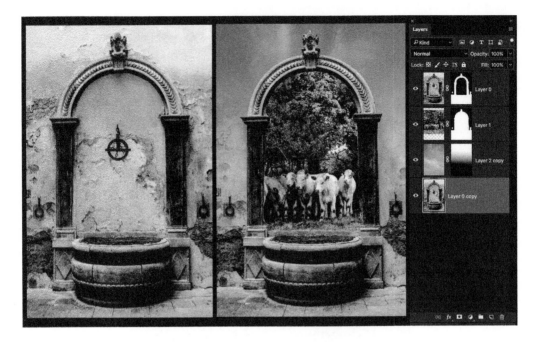

7.16
The original image of a well in a small Italian town is on the left. The image on the right uses layer masks to reveal images below each layer. The layer palette shows how the layer mask shows up when used

(counterclockwise), arbitrary, flip horizontal, and flip vertical. These commands will affect the entire image, not a single layer. In order to make the same changes to a single layer, the edit/transform or layers/transform dialog box must be accessed. Information on layers can also be scaled to be made larger or smaller, rotated in a freehand method that will allow you to spin them incrementally, distorted into strange polygonal shapes (great for shadows), or even skewed and shifted in a "natural" perspective. This is very useful for creative artists combining several images into composites. These transformation commands can be applied directly to selections as well as layers.

The Undo and History
Most image-editing programs allow the artist to undo the last action undertaken in the editing process. However, where a mistake is made but discovered later, several options are available. If a snapshot, checkpoint, or other command is used frequently which allows an image to be temporarily saved at that stage of the editing process, it is a simple matter to go back to the last point at which that was done. If an error is made that does not allow the temporary save to resolve the problem, then it is possible to revert to the last fully saved version. Some programs also provide the option of multiple undo in the form of a History panel that allows you to click backwards on each step to undo as many things as are necessary. The number of undo steps stored as you work on an image can be set in an options box for this feature.

CONCLUSION

We have only scratched the surface in our discussion of image-editing. Image-editing programs today can overwhelm a user with the rich variety of their features, some immediately apparent and some

that you might not discover for some time. Many digital artists work almost entirely in image editing and enhancement and find it completely satisfying enough for a lifetime of work. Still, it is important to remember that image editing is only one segment of the digital media world.

As image-editing programs became more and more sophisticated, they began to integrate components usually associated with other types of programs. Sometimes the division between a raster-based image-editing program and vector-based illustration program become blurred as an image-editing program's text handling becomes more advanced, or its vector-based pen tool evolves into a more sophisticated element of the program. Nevertheless, at the heart of image editing is the ability to work seamlessly with images—especially photographs—of all kinds. Digitizing, correcting, balancing, integrating, and compositing new realities that stretch the imagination are part and parcel of these exciting programs.

Projects: Image Editing

1. THE NINE-SEGMENT PROJECT: INTRODUCTION TO LAYERS AND FILTERS
 Select a single image. Use guidelines to initially break the image into nine relatively equal parts. Select one of the nine segments and cut or copy it to a new document. You may want to use the rectangle selection tool for this. Do this for each of the nine segments. Once you have each of the nine segments saved as an individual document, create a new, separate document the same size and resolution as your original image. Reposition the layers so that they recreate the original image. You will have to activate each layer before you can move it by clicking on it in the layers palette. Apply a different filter or effect to each one of the nine individual layers that now compose your image. Experiment. If you don't like what has happened to an individual section, discard it and replace it with the original saved section so you can start again.

2. IMAGE CONVERSION: COLORIZE A BLACK AND WHITE IMAGE
 Starting with a grayscale image, convert it to RGB. Select parts of your image, and feather them to soften the edges (experiment with the amount). Create a separate layer from your selection, protect the transparent portions of the image (in the layer palette) and then use any of the tools that can change color to "colorize" that portion of the image. Try color balance, hue/saturation, or curves. Avoid using the paintbrush tool.

3. IMAGE COMPOSITE: OLD MASTER PAINTING
 Start with a scan of an Old Master painting. Add elements to redefine it and change the context of the image. Would Whistler's Mother really be watching TV? Copying and pasting new elements from one image into a painting background offers you an opportunity to try matching color values and even adding shadows to complete the illusion.

4. PLAYING CARD: EXPLORING SYMMETRY AND TEXT
 Scan an image you feel might make a good jack, queen, or king playing card. Take a look at a conventional playing card to identify the major characteristics playing cards should have. Are they symmetrical? Symmetrical but flipped over? How can you "blend" the two images together using the layer mask tool? Add text elements to identify the playing card. The final image should be 4"× 6" at 300 dpi.

5. SCANNER AS CAMERA
 The scanner is a great camera. See what happens when you scan natural objects like crumpled paper, feathers, and bubble wrap. What happens when something moves while being scanned? Can you create a still life in the scanner or afterwards in an image-editing program?

8 Digital Painting

Digital Painting

Image Editing

Digital Illustration

8.1
The triumvirate of image making

INTRODUCTION

Like most software, digital media programs continue to increase in power and range. Some have become quite complex, even muscle-bound, by adding features of very different kinds of art programs with the goal of becoming a comprehensive "solution." Despite the impressive depth of today's digital media software, most digital artists and designers continue to use more than one program to create their works. The particular software an artist or designer chooses to use at any moment depends on the effect he or she is looking for. Experienced artists and designers know each type of software's unique strengths and when to use them.

This chapter focuses on one of the very important and distinct approaches to the creation of 2-D images: bitmap painting software. Along with the subject of the previous chapter, image editing, and the next, vector illustration, it forms one side of the triumvirate (see Figure 8.1) of 2-D digital imaging.

Bitmap painting software is the ideal choice for the many artists whose goal is to create digital pictures that have the look and range of traditional painting, as well as other artist materials. Like bit-mapped images, discussed in the last chapter, evocative, soft forms and naturalism are its strengths. But painting software can also be used to create rich, dramatic abstractions (see Figure 8.2).

8.2
Detail of a digital painting

Traditional and Digital Tools

All of today's painting programs are direct descendants of the first—*SuperPaint*, created by Richard Shoup and Alvy Ray Smith at Xerox PARC in the 1970s (see Chapter 3). While Shoup and Smith were true pioneers, their inspiration came from looking to the past. According to Smith, their goal was the "digital simulation of classic painting with a brush on a canvas." More than four decades later, while bitmap painting software has certainly developed in depth and complexity, it has retained Shoup and Smith's philosophy and remains the most closely connected of the digital media to the tools of the traditional artist.

BITMAP PAINTING

Basic Concepts and Tools

As in image editing, when working with bitmap painting software, you are redrawing each pixel on the screen. But the focus of the tools is quite different. Their primary goal is to recreate traditional drawing and painting tools, like pencils, chalk, crayons, watercolor, and oil paint. That is why bitmap painting programs are also called **natural media software**.

What many artists find particularly exciting is that they can create art that does not look like it was made with a computer. Since every pixel on the screen is described in terms of color, value, and transparency, natural media brushes can paint the very subtle shades and complex color transitions in both convincing landscapes and vividly expressionistic abstract paintings. In addition, digital painting allows one to combine media in ways that would not work in the real world (for example, you can wash watercolor on top of oil paint).

For artists who have worked previously only in traditional media, bitmap painting can ease the transition to the digital world. Working with a stylus on a digitizing tablet or touch screen, bitmap painting software feels more natural and direct than any of the other digital media (see Box 8.1).

Box 8.1　The Digitizing Tablet and Its Mobile Offspring

More than any of the other digital media programs, bitmap painting software is designed to take advantage of the features of a graphics or digitizing tablet (see Figure 8.3)—though most other software can take advantage of them. Digitizing tablets are pressure-sensitive input devices for artists. Rather than moving a mouse, the artist holds a pen-shaped stylus and draws directly on a tablet. A wire grid inside the tablet reads the position of the stylus. This information is sent to the computer as x and y coordinates of a location on the screen. Unlike a mouse's approach to location, these are absolute coordinates—each spot on the tablet corresponds to a specific place on the screen. So you do not have to roll over to a spot as you do with a mouse. You can just pick up the stylus and start making a mark in another location.

For a hand-drawn look, a tablet is essential. It works almost as easily as a pen and paper. The effects you are able to create can range from exuberant to subtle. The tablet is very sensitive to the pressure of the stroke being made and its angle (this is done automatically by modifying the strength of a stylus' signal). As one increases the pressure of the stylus against the tablet, a line on the screen thickens and gets darker. Working with a tablet and the calligraphy pen tool from your painting software, you can smoothly change the angles of your hand-drawn script from wide to narrow and then back again. Without a tablet, effects like this are nearly impossible.

Tablets include software to personalize them to the user's preferences. You can adjust the feel of the pen and its response to pressure (some have more than 8,000 different levels of pressure sensitivity). Buttons on a tablet can be set to trigger frequently used commands like copy and paste—and the indispensable *undo*. Tablets today also integrate the use of hand gestures typically found in mobile computing so digital artists can use them to spin a canvas or swipe to make adjustments.

In 2000, the tablet maker Wacom took tablets to the next level with the introduction of ones with an LCD screen imbedded. Now digital artists and designers could use a stylus to draw directly on their images. Much more expensive than a conventional tablet but often replacing the monitor, these are favored by many studio professionals, such as illustrators and concept and graphic novel artists.

8.3
Digitizing tablets are more sensitive and responsive to hand movements than a mouse

However, there is a newer and less costly approach for artists and designers who want to draw directly on a screen. Tablet computers like the iPad Pro and specialized mobile phones have inspired the development of new, low-cost digital painting applications (see page 183). With a stylus like the Apple Pencil, brushes, charcoal, pastels, and pencils of all sizes and shapes respond naturally to your hand's movements. Even more revolutionary is their portability. Because a lightweight tablet or phone does not require being attached to a more powerful desktop computer, mobile computing has truly arrived and digital painters have finally been liberated from the studio. They can work anywhere, like an Impressionist in a wheat field or a portrait painter in a palace.

The Workplace

When first opening a bitmap painting program, you will see much in common with other digital media software. The screen's work area includes menus at the top, a tool bar with the typical buttons found in art programs, like zoom and the paint bucket, and a large window where the new image will be created, called the **canvas**.

The strength of digital painting programs can be found in their unique palettes. One houses an extensive collection of natural media brushes. There is also a separate control palette for modifying each brush's attributes. Other palettes are for selecting colors, gradients, and patterns. Like other art programs, the palettes can be hidden so you can see your work without distractions.

The Brushes

The heart of any natural media software is in its imaginative collection of brushes. The brushes are organized into categories based on traditional media, but within each one you can explore a wide assortment of variations. Think of each media category as a box for tools of that kind. For example, the pen box includes pens of all sorts, from calligraphy to a leaky one. A chalk box may contain soft and sharp chalks, dry pastels, and oil pastels.

Since the brushes are meant to respond like their traditional models, each has its own unique characteristics (see Figure 8.4). Some of the brushes work cumulatively, allowing you to build up areas with successive strokes. Others make transparent washes that appear to soak into the canvas. One brush may lay its paint independently of what is already there, while another will pick up nearby paint and smear it into the new stroke.

When using a stylus and digitizing tablet or sensitive screen, you can make strokes that fade in and out as you vary the pressure of your marks. For example if you are going to draw a shaded object, you might first trace its form lightly with a hard pencil, then begin shading with a sharp chalk held at a slant. To finish, you could aggressively deepen the shadows with thick, soft charcoal. The materials respond to the surface of your drawing as they do in real life. For example, when using chalks or charcoal with textured papers, the grain of the paper can be seen (see "Paper Textures" on page 178).

While the number of brushes at first seem to provide an overwhelming number of choices, eventually most artists find they want to adjust them to their own preferences. A separate control panel allows you to change the size of the marks made, their opacity, and the amount of grain from the paper that is revealed. Even more subtle variants can be created, from the shape of the brush, its angle, the ways color bleeds from it, even the number of bristles. Advanced digital painting software allows you to create your own variations and save them as new or *custom* brushes. Other customized sets can be downloaded from the Web.

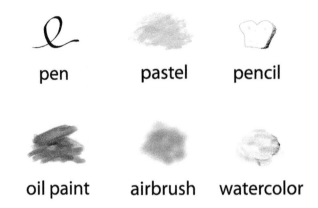

8.4
Marks from a variety of natural media brushes

Color

The combination of color and brushes has excited artists for centuries and made painting one of the most popular of all the arts. In digital painting, while you can certainly create an impressive, finished drawing in black and white, adding color can make an image blossom (see Artist Profile on Chet Phillips).

Artist Profile: Chet Phillips, Digital Painter

Chet Phillips is an Austin, Texas-based artist and illustrator who works predominantly in natural media software. Before his discovery of digital media in 1992, he used the traditional tools of an illustrator: colored pencils, scratchboard, and airbrush. Today, his work utilizes the digital versions of those media and combines them in new ways. His clients include newspapers, magazines, airlines, department stores, and movie production companies.

"Frankenscan" (see Figure 8.5) was created for a service bureau that specializes in making high-quality scans. Animals are characters in much of Phillips' work, in this case a mad cat scientist. Like many digital artists, he begins his work just like traditional ones—by making a pencil sketch. After the sketch is approved by his client, the drawing is scanned into his computer and opened in his natural media software.

By placing a black layer above a white one, Phillips was able to recreate the process of scratch-boarding (similar to carving a woodcut panel) by erasing the black areas until all the details emerge. The tracing paper function of his software allows him to use the original sketch as a reference while he scrapes away the black areas.

Once the scratchboard image is finished, a new layer is added below it so he can add colors, but not cover up his drawing. His use of color adds richness and depth to the picture. In *Frankenscan*, Phillips used the pastel tool, rubbing in soft colors that heighten the drama of the dark night and the flashes of lightning. The final act was the placement of the client's logo on top in a new layer.

Phillips' digital scratchboard technique caught the attention of Warner Brothers when they were filming the first of their Harry Potter movies. They asked him to develop a series of images to be used

8.5
Chet Phillips mixed traditional and digital techniques in this illustration for an advertisement

8.6a
Chet Phillips, *A Fox in the Henhouse*

8.6b
Chet Phillips, *Flying Monkey Squadron*

for promotion and Harry Potter products. One of his favorite moments from this commission, according to Phillips, was when he received a fax from J.K. Rowling herself with suggestions on how to modify his initial drawing of the sorting hat. Another highlight was when he saw "tables and racks full of items" that he helped create at a Warner Brothers store in his local mall.

In addition to his work for clients, Phillips regularly exhibits his own personal work in galleries and on the Web (see Figure 8.6a and Figure 8.6b). Another example, from the series *The Life of an Imaginary Friend*, can be seen in Chapter 1.

Three variables shape color in bitmap painting: hue, value, and saturation. The hue is the name of the basic color, as in "red" or "purple." Once the hue is selected, you can choose from the range of values, how dark (**shade**) or light (**tint**) the color should be. You also choose how intense or *saturated* it is.

Colors are placed on your brush in a two-step process. There are two large, colored shapes in the color palette (see Figure 8.7). One has the color spectrum, where you select the hue. The color you've chosen will then appear in the other shape, as a range of intensities and values. There you can choose how saturated the color will be and how light or dark it will appear.

Most painting software has alternative ways to select colors. You can choose to work in an optional RGB palette with variable sliders for the red, green, and blue components of projected color. Like most digital media programs, you can select a color already in your image by clicking on or **sampling** it with the eyedropper tool. This is particularly useful in digital painting, where it is often difficult, after much smearing and layering, to recreate how an existing color was created. In addition, there are sets of pre-selected colors in libraries, like Pantone color sets. You can also create your own sets.

8.7
One kind of color palette: hues in an outer circle and values in the center triangle

More Than One Color and Gradients

With natural media software, you can paint with two or more colors at once. Unlike most other art programs, the two small rectangles or circles at the bottom of the toolbar and color palette are not foreground and background colors, but the primary and secondary ones. There will be painting brushes designed to use both at the same time. For example, oil brushes can combine the two to create a more convincing recreation of painting in oils. There may also be specialized oil brushes with multiple colors that recreate the brushstrokes of famous artists like van Gogh. You can make your own multiple color brushes by adjusting the amount of color variability in a custom brush, adding a range of values, intensities, or colors for each stroke.

The use of **gradients**, a gradual blend of a range of colors, is a more common way to apply multiple colors in digital media software, perhaps in a background to create a sense of depth or in an object to evoke lighting. Depending on your choices, these smooth blends can give a clean and professional or atmospheric and natural look to your images. Most bitmap painting programs have a large collection of gradients in a special palette, with even more in separate libraries. Custom gradients can be created by editing a preset gradient, for example, by adjusting its angle or by adding more colors to it. You can also start new ones from scratch and save them.

As in most digital media programs, gradients can be linear or radial (sometimes called circular). They can be left to right or right to left, doubled or mirrored, or a combination of these. With so many fascinating choices and possibilities, the danger is you'll forget to work on your painting. Gradients are usually applied to shapes or selections with the paint bucket tool, but some digital painting programs let you create interesting effects by using the brushes to paint directly with gradients.

8.8
This detail of pastel brush marks reveals the grain of the paper

Paper Textures

The simulation of paper textures is one of the most impressive ways digital painting software recreates traditional media. In most digital media programs, a new file is simply an empty white field. At most you can change the background color. In bitmap painting, while a new file may look empty and white when you begin, it has texture, like a fresh sheet of artist's paper or a stretched canvas. You can see this, for example, as soon as you use any of the tools that normally show the grain of a paper, like charcoal.

There are many textures available that simulate a variety of art materials, like canvas and expensive watercolor papers. In additional downloadable libraries, you may also find strange, unique ones, with names like "window frost" and "spider on caffeine." The size of the grain of each texture is adjustable. You can also modify most brushes to increase the visible effect of a paper's texture (see Figure 8.8).

Cloning and Tracing

Cloning, as in image-editing software, allows you to paint with a part of another picture or another part of the one you are working on. It is an excellent way to combine images with more control and subtlety than simply cutting and pasting. In digital painting, your clones can easily take on a painterly look even if your source is a photograph. Special cloning brushes transform your selection as you brush with them. For example, if your source is a color photograph of a tree and you draw in a new file with the chalk clone tool, the tree will appear in your new picture as if it was originally in pastels (see Figure 8.9).

Tracing is another way of retaining a natural look for your art while working from photographs as a source. Some digital painting programs will place a pale clone of an entire image on a separate bottom layer, making it appear as if it is below a sheet of tracing paper. You can then trace over it with natural media tools. Just by clicking a button, you can turn the pale image on and off to check your progress. The pale tracing paper image is only a source; it will not be part of the final image or print.

8.9
Using the watercolor cloning brush transforms a photograph into a creative original

Layers

Layers, as seen in the last chapter, allow you to keep elements of your picture in separate levels, so you can work on them independently. Layers can be added, merged, hidden, or deleted, their order can be rearranged, and opacity modified. Filters and other changes can be isolated to affect only one layer. The background of any layer other than the canvas will remain transparent until paint is applied to it.

More powerful painting programs utilize layers much like image-editing software but add some special features. For example, Corel Painter has specialized layers for wet media, like watercolor painting. When the "dry" command is applied to a wet layer, it will become unified with the canvas but until then it will remain wet for as long as you want it. In addition, Painter permits you to break down the barrier between two layers by changing a layer's property so you can blend colors with another layer's while painting.

Selecting and Masking

The goal of making a selection is to isolate one part of your image from the rest of the picture. However, that simple act is a gateway to a whole range of operations that give you increased control over specific parts of your picture. An artist's skill in creating selections can have a big impact on whether a final work looks crude and clumsy or seamless and polished.

The basic selection tools in bitmap painting programs (arrow, lasso, marquee, and magic wand) are usually identical to those in image-editing. Selections are used in three basic ways: to limit the area you can work on, to protect that area (or **mask** it), or to choose it for cutting, copying, or moving. While selected, the area will "float" above the canvas in a temporary layer, separated from the rest of the picture. You can paint wildly across it, rotate or resize it, change its opacity, apply a special effect (explained next), like embossing, or all of the above, and not affect any other part of your image. Some programs allow you to save a selection for later use.

As in image-editing, masks protect an area and prevent you from accidentally changing it. Masks are made in two basic ways. One is making a selection and transforming it into a **mask**. Another is to paint a new mask using brushes. This painterly approach is often more in keeping with the style of a digital painting. As in image-editing software, by painting your mask with a semi-transparent color, rather than an opaque one, you can allow changes but limit their impact.

8.10
Special effects filters in digital painting software work much the same as in image-editing (Original, Sketch, Woodcut, and Surface Texture filters)

Corel's Painter includes, in addition, quick-masking buttons, which allow you to choose to draw only outside or only inside a selection (known as **stenciling**). By clicking the "draw anywhere" button, the selection is released and you return to being able to work all over the canvas.

Special Effects

Like image-editing software, digital painting programs include filters and plug-ins that create special effects. A wide range of exciting changes can be made quickly, such as transforming the whole image into a mosaic. The Glass Distortion filter will make your picture look like it is being seen through the glass of a shower door. These changes can be applied to an entire picture or limited to a selection, masked area, or layer (see Figure 8.10).

Filters can also add texture to a whole image by selecting from different paper types and using the *apply surface texture* command. Your picture can appear more 3-D by applying filters that can either add a subtle sense of depth to your brushstrokes or make your whole image appear as if it was embossed in plastic.

Special lighting effects are another way to make your picture seem more 3-D. They can also be used to unify a picture with a simple wash of light across the surface, or create a sense of drama, with a focused spotlight in a field of darkness. There are many preset lighting effects to choose from, as well as custom settings that affect where a light is aimed, its color, brightness, angle, and "distance" from your image. You can have one light source or add several.

As in all digital media, experimenting with filters presents the danger of losing track of what your aesthetic goals were. They may give your picture an artificial or computer-made look. To make sure you and not the software is in control, it is often better to rework your picture with brushstrokes after you finish applying filters.

The fade filter, on the other hand, is an excellent way to maintain control of your image. If your last brushstroke's effect was stronger than you had expected, you can reduce its strength. While looking at a preview window, you can use sliders to adjust the effect of the brushstroke and make sure it fits well with the rest of the picture. Fading adds transparency to the stroke and is in essence, an "undo" of variable strength (see Figure 8.11).

Working With Type

Because digital painting, like all bitmap software, breaks up shapes into fine dots, it is not a good choice when laying out large amounts of small text that needs to be crisp and legible. That's the strength of digital layout and design software (see Chapter 6) or vector illustration (see Chapter 9). But if you are designing large display text, digital painting software has superb tools for creating imaginative and dynamic type for logos, signs, headings for a web page, or film titles.

All painting programs include the basic tools of type manipulation. After the text is typed in, it floats above the canvas in its own layer. Text can then be rotated, scaled, and repositioned. Spaces between the letters can be adjusted throughout the entire phrase (tracking) or between individual letters (kerning). Type can also be made transparent. Drop shadows can be added as a special effect.

More advanced software with multiple layers allows you to apply a wider range of special effects. Text can be filled with gradients and patterns. The letters can be blurred or given textured edges. By applying lighting effects, letters can glow like neon or appear embossed in the paper. Working carefully with selections and masks, you can zoom in and airbrush directly onto your letterforms to shape and bevel them (see Figure 8.12).

Of course, you can create letters without using the text tool at all. With the control you have with a stylus, along with the many kinds of pens and brushes, lighting, and texture effects, you can hand-letter

8.11
The fading window can be very helpful in toning down a new brush stroke

8.12
Type after special effects have been applied

your own exciting text. Rather than typing, why not use the creative freedom of painting software to create liquid metal chrome nameplates or furry spotted signatures?

PRINTING AND EXPORTING

Printing is the moment of truth for many digital painters. The fidelity and quality of color printers, even those for home use, have improved to astonishing capabilities compared to the early years of the first color thermal inkjet printers (see Chapter 5). Nevertheless, all digital painters should prepare to be disappointed or at best, surprised, when seeing the first trial print of a newly finished image.

What is seen on the screen is rarely what appears printed on paper because they are very different ways of displaying images. The colors from the projected light seen on a monitor are often more luminous and saturated compared to those that appear on a printed page. Color management software (see

Chapter 6) will calibrate the colors between your monitor and printer to minimize these differences, but you should still expect to spend some time adjusting an image so it prints to your satisfaction. Because these adjustments are often quite subtle, many artists prefer to export their paintings into an image-editing program to have more control over how an image is going to print.

Nonetheless, personal printers have become much more capable for fine art printing than in the early years of digital media. One of the most important advantages of printing an image yourself (besides cost savings) is it remains under your control and your studio computer can be calibrated directly to your printer. Another advantage of personal printing is the ability to see results immediately and to make necessary adjustments. Previously, only professional printers could produce archival prints. Today, archival inks and papers are now available for personal printers that have a life span far beyond typical color prints.

In the hands of many artists, personal printers have also become a medium for creating experimental prints. Some like to combine media, printing a digital image on fine papers and then reworking it with traditional media like watercolors or pastels. Others collage small digital prints into larger works. Unusual papers fed into the printer by hand can create imaginative variations of screen images.

Even with the expanded capabilities of personal printers, many artists still prefer to use a professional printer (sometimes called a "service bureau") to create a unique copy or edition of their digital paintings. The advantage of this approach is access to the finest quality printing equipment, far beyond the financial capacity of most artists. You can also have your image printed directly to unique media like a large-format transparency or with unusual inks, like fluorescent ones. They can print much larger sizes than the largest personal printers and on a greater variety of materials (for example, canvas). Some professional printing companies even have the equipment to print high-resolution images on vinyl that are large enough to cover a bus.

PAINTING FOR THE WEB

Of course, some digital paintings will never be printed. Designed from their inception to be displayed online, they could be illustrations for a website, part of a multimedia experience, or featured in a personal blog's gallery. Whatever the purpose, one benefit of this approach is they will retain their original luminosity, unlike printed versions. Combined with typical mobile applications, digital painters find it is easy to share their work today with others through social media.

Today's digital painting software makes saving files for online use easy. Besides saving files in a bitmap painting software's own native format, you can compress images in the formats most commonly found on the Web: GIF, JPEG, and PNG (see Chapter 12). While these tools are very helpful, it is wise, as in image-editing, to save your paintings first as uncompressed TIFFs or PSDs before compressing them. That will ensure your ability to open these files later not just in digital painting software, but also in a dedicated Web image processing or image-editing program for more sophisticated fine-tuning.

DIGITAL PAINTING AND MOBILE APPLICATIONS

The next revolution in digital painting has arrived. Tablet computing and smartphones with pressure-sensitive screens, as noted in the box on page 172, have liberated digital painters from working tethered to a desktop or even a laptop computer. Now digital painters can leave their studios with their lightweight "easel and paints" in hand, much like the nineteenth-century painters who first ventured into the landscape to paint directly from nature after the invention of paint packed in tubes.

8.13
Procreate app on iPad Pro

Along with easily portable hardware, new and lower cost (even free) painting applications (see Figure 8.13) have appeared that, while not as powerful as their desktop cousins, easily surpass the early versions of digital painting software from only a decade ago. While designed to be used with special pressure-sensitive styluses, you can also paint with your fingers or simply modify any marks you make with them to create truly painterly effects. For example, if you are sketching animals at the zoo, you can sketch a charcoal line, then gently smudge it with the tip of your finger to add shading. An added bonus—unlike drawing with real charcoal, you never need to worry about accidentally getting your clothes dirty.

CONCLUSION

In the 1970s, Richard Shoup and Alvy Ray Smith's *SuperPaint* first took computer graphics beyond a fascination with geometry and recreated "classic painting" techniques. Their vision and dedication made it possible for today's digital studio to be a place where the techniques of the Old Masters can be combined with ones from a new age.

Natural media software's hand-drawn look and its ability to simulate traditional painting techniques have drawn many artists to this new media. If you already love the way colors can smear together in unexpected ways in an oil painting or how an evocatively drawn line can bend, disappear, and re-emerge, then you will find bitmap painting programs to be a satisfying and exciting method of creating digital works. Whether you are preparing an archival print to be displayed in a New York City gallery or images for your own online one, digital painting software provides the tools for a wide variety of painterly approaches to image making.

Projects in Digital Painting

1. Working in a non-representational manner, paint a 5" x 7" image on the theme of "Storm." Experiment with a variety of brushes to capture the feeling of being in the midst of a violent storm.

2. Paint a pair of 5" x 5" abstract images on the themes of "Calm" and "Anxiety." Use a different color scheme and brushes to increase the contrast between your two paintings. Experiment with contrasting paper textures as well.

3. Using the tracing feature of digital painting software, begin a picture with a tracing of a landscape photograph that you have scanned. The goal is not to create a photo-realistic painting, but to use the photograph as a source of inspiration only. By the time you are finished, no trace of the original image should be apparent. Experiment with lighting to increase the mood of the scene.

4. Create an 8" x 10" illustration based on a favorite line of poetry or song lyric. Utilize the type tools in the painting software to integrate the words into your picture in a way that makes visual sense.

9 Vector Drawing and Illustration

INTRODUCTION

From the beginning, painting software was consciously designed to mimic a traditional painter's tools and palette. Image-editing programs include digital equivalents of many darkroom techniques, such as dodging and burning. Vector drawing, however, had no equivalent because it simply did not exist until the era of computers. As discussed in Chapter 3, Ivan Sutherland's **Sketchpad**, the first interactive art software, invented this new mathematical approach to line and shape creation. Vector illustration is, in other words, the firstborn of the digital media (see Box 9.1).

Box 9.1 Father Ivan

If vector drawing is the firstborn of the digital media, it's no wonder that many people call Ivan Sutherland the father of computer graphics (see Figures 9.1a and 9.1b). So much of what would come to define the field can be traced to his innovations, starting with **Sketchpad** (see Figure 3.1).

Born in Hastings, Nebraska, in 1938, he was probably the only high school student in the 1950s who had a computer to play with. The SIMON, a relay-based mechanical computer, was lent to his father, an engineer. SIMON was so "powerful" that it was capable of adding all the way up

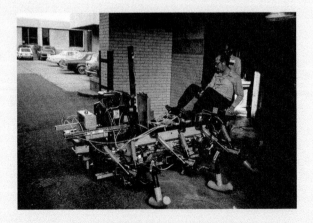

9.1a
Ivan Sutherland testing his six-legged crawler (the "Trojan Cockroach"), 1983

to 15. It could, however, be programmed—by punching holes into paper tape and then feeding it into a tape reader. Young Ivan's first program "taught" SIMON to divide and required an eight-foot-long roll of tape.

As a graduate student in engineering at MIT, Sutherland once again was one of the few young people in the nation to have a computer available for his research. And this one was much more powerful than SIMON. MIT's TX-2 was built for the Air Force to demonstrate that transistors could be the basis of a computer. One of the fastest machines of its day (320 K of memory!), it had Xerox's first computer printer, one of the first display screens (9" in width), and a lightpen.

It was at MIT that he wrote Sketchpad, a graphics program, as his doctoral thesis. Sutherland utilized vectors based on geometry to create forms that could be rescaled and zoomed in on. His graphics were the first capable of being stored in computer memory and the first that could be changed by redrawing on the screen.

Interestingly, Sutherland created the first interactive drawing software not for art's sake, but with the goal of simplifying the exchange of information between people and machines. This goal, and the design of his program, are why many also consider him the grandfather of the graphical user interface or GUI (the father being Alan Kay, one of Sutherland's students). The width of the TX-2's small screen was treated by Sutherland's program as a "window," so when one zoomed in on a form its outer parts would go beyond the edges of the screen. His program even allowed him to copy parts of his objects, move them, and delete them.

While Sketchpad was a 2-D program, later versions utilized 3-D wireframes, the forerunner of modern CAD systems. Sketchpad 3 even included the division of the screen into four views, now standard in all 3-D software (above, side, front, and in perspective). Sutherland utilized this kind of software in another innovation. As a professor at Harvard, he developed a head-mounted display inside a helmet to project an immersive 3-D graphics environment. The movements of the wearer's eyes or bodies were tracked and the perspective of the image would make corresponding changes—in short, it was the first VR display (see Figure 3.10).

At the University of Utah and at a company he co-founded with Dave Evans, Sutherland continued his research in computer graphics. This research helped lay the foundation for the simulators

9.1b
Ivan Sutherland in his office

used to train pilots and 3-D computer modeling. Their company's hardware and software systems were among the first graphics systems made available to the public. Both men extended their influence even further as teachers. As discussed in Chapter 3, their students at the University of Utah would make many of the most important contributions to 3-D modeling and animation.

In the 1970s, he joined the faculty at California Institute of Technology and shifted his research and teaching away from graphics to integrated circuit design—helping to create the foundation for the modern computer chip industry and Silicon Valley. In the 1980s, he formed a new company which was later sold to and became an important part of Sun Microsystems. Today, he is still exploring new technologies as a self-described, "Engineer, Entrepreneur, Capitalist, Professor."

BASIC CONCEPTS AND TOOLS

Vector illustration, or *object-oriented* software, utilizes a very different approach to image making compared to bitmap software like digital painting or image-editing. A simple explanation of the difference is that vector drawing is geometry based, while the other two are pixel based. Images are made up of geometric descriptions of points, lines, and shapes and their relative positions, rather than a large collection of pixels.

While this mathematical approach can put off many artists, it also means you can have remarkable amount of control over an image. Placement is precise and editing is specific.

Every line and shape is created by placing end or **anchor points**. The software then calculates the **path** or connection between the points, creating forms that are always sharp and clear (see Figure 9.2).

Since outlines of shapes are created by points and the lines between them, rather than many pixels, the results are smooth and geometrical. This is also why type in vector programs is always crisper and cleaner than in bitmap ones (see Figure 9.3). This makes illustration programs excellent choices for logos and other creative typography, as well as line art.

Another benefit of the mathematical approach to image making is that elements can also be rotated, skewed, and re-colored quickly. More significantly, when images are resized, there is no change in the clarity of the forms. No matter how much vector images are enlarged, their edges will remain

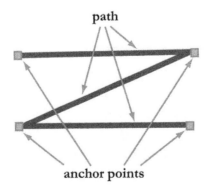

9.2
Vector drawings are made of anchor points and the paths between them

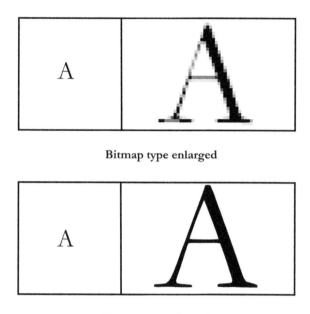

Bitmap type enlarged

Vector type enlarged

9.3
Type created in vector programs retains its sharpness and clarity even when enlarged significantly

smooth and distinct, because the change is made mathematically. This is why they are also known as **resolution-independent graphics**. You can even rescale an image many times, either larger or smaller (and back again), and it will not suffer from the blurring or "the jaggies" common to over-enlarged bit-mapped images.

Resolution independence also means that no matter if a vector object is seen on a high-end large screen monitor or a small mobile phone, it will remain smooth and clear.

Perhaps the most exciting difference for those who normally work in imaging or painting software is the difference in file sizes. Unlike a bitmapped image, a vector file does not need to include information on every pixel on the screen. A vector file is composed of equations storing data on placement, size, color, and width; much less information is stored. File sizes in vector art, therefore, are considerably smaller than bitmapped images, sometimes astonishingly so. It is not unusual for a vector drawing to be one-tenth the size of a comparable image created with pixels.

The Workplace

On first look, the workplace of vector drawing and illustration programs resembles those in other digital media software. The basic commands are retained, as well as the layout of menus, toolboxes, palettes, and windows. As in bitmap painting, the canvas or drawing area is generally kept at the center, with the toolboxes and palettes in the working space surrounding it. Usually, the canvas will have blue, non-printing, guides near the edges that show what part of the page is in the printable area.

A closer look at the toolbox will reveal the unique aspects of vector drawing and illustration. Some drawing tools will be unfamiliar; there are more shape tools than in bitmap software, and *two* selection arrows. Beyond the toolbox, there is a window with precise X-, Y-, and Z-axis locations and a menu called "Object."

Path, Stroke, and Fill

The vocabulary of vector graphics contains terms that are distinctly different from those that describe bitmapped images. As previously mentioned, all vector forms are made up of paths, the connection between two points. There are two kinds of paths: **open** and **closed**. Open paths have endpoints that are not connected. A line, whether it is curved or straight, is an example of an open path. Closed paths are like outlines; they begin and end at the same point and describe a shape. A rectangle or circle are examples of closed paths (see Figure 9.4). More complex forms can be made from connecting a collection of paths.

In vector drawing, shapes are made of **strokes** and **fills**. The stroke is the linear portion of the path and its characteristics. In an open path, it is the line itself. In a closed path, it is the outline around a shape. A line or outline's width, color, and style (like straight or with dashes) are all part of its stroke. For example, a stroke might be a violet dotted line, 4 points wide. The appearance of a stroke can be modified in other ways. A collection of arrowheads and tails can be applied to a stroke, dashes can be customized, and you can choose what kind of corners are used when the stroke outlines a shape.

The fill is applied to the open area inside a closed path. A fill might be a color, gradient, or pattern. While an outline is necessary for any closed shape, a fill can appear to stand alone without an apparent outline. By setting the width or color of its stroke to "0" or "none," the outline, although still there, will become invisible. A sphere composed of only a smooth radial gradient could be created this way. Most illustration programs also include a variety of custom patterns to use as fills, from checkerboard patterns to blades of grass.

Open paths

Closed paths

9.4
Open and closed paths

Creating Simple Shapes

While any shape can be drawn by placing points (see "Drawing with the Pen tool" section later in this chapter), vector illustration software includes tools for basic, common forms to simplify the process. These are a good place to start when first exploring an illustration program. On the tool bar, you will find rectangle, ellipse, polygon, spiral, and star tools. These shapes are made by clicking on the drawing area and dragging until they reach the desired size. Combined with the shift key, you can **constrain** (force) a rectangle to be a square or an ellipse to be a circle. By opening a special window, you can modify more

complex shapes like polygons, spirals, and stars. For example, you can select the number of sides to a polygon or the number of points on a star.

Selecting and Transforming Shapes

Of all the digital media, vector illustration is perhaps the most dependent on the process of selection and modification. Because of this, vector programs contain both standard and special selection tools. The basic selection tool (a black arrow) operates very much as it does in most digital media software. After selecting an object, you can move it or manipulate it in many ways, either through commands in the menu or with special transformation tools in the tool bar. Among the many transformations possible are **scaling** (resizing), rotating, stretching, and skewing.

As in most digital media programs, multiple objects can be selected by holding down the shift key while clicking on them. Another common approach is to use the arrow to draw a marquee box over two or more objects. Once several objects are selected, they can be moved as a temporary group. To make a group permanent, choose the *group* command.

Objects can also be selected in a freehand way by the lasso tool. In some programs, simply by drawing a selection over part of one or more paths, each entire path is selected. In others, the lasso tool can also select just parts of an object or path.

One of the most important editing tools in illustration software is the **direct selection** tool (a white arrow). Designed specifically for selecting parts of a path and individual anchor points, it is used for making precise modifications to open and closed paths. With it, you can reshape any form by selecting its individual parts (see Figure 9.5).

After clicking on a straight line or edge with the direct selection arrow, its anchor points and segment will be selected and visible, and ready for modification. By selecting just one of a straight line's

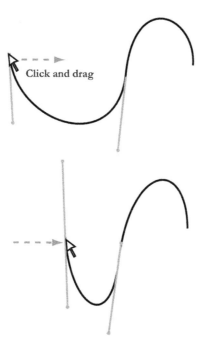

9.5
Direct selection in action

anchor points, you can reposition the point and reshape the form (for example, skewing one side of a rectangle). Any path can be split with the *scissor* or *knife* tool, by clicking in its middle. The knife tool can also be used to cut curves through closed paths, making two new closed paths. By pulling on one of the parts with the direct selection tool, you can separate the two paths.

Editing Curves

It is after clicking on a curve with the direct selection tool that vector graphic's most unique (and often frustrating for new users) aspects are revealed. Along with a curve's anchor points, its **direction lines** are made visible (see Figure 9.6). As with a straight line, the direct selection tool can simply reshape a form by moving individual anchor points. However, much more comprehensive and complex changes to curves are possible when you modify the direction lines.

Direction lines are connected to every curve's two anchor points. These lines control a curve's height and slope. An anchor point between two curved segments will have two going off in two directions. Anchor points, located where a curve and a straight segment meet, have only one direction line. At the end of each direction line is a small control point, which can be clicked on and dragged to edit a curve (see Figure 9.7).

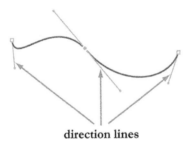

direction lines

9.6
Direction lines of a curve

two curve segments

curve and straight segments

9.7
Direction lines for curved and straight segments

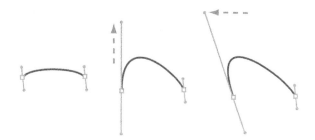

9.8
Effects on curves when direction lines are modified

As you click and drag on a control point, the curve will quickly reshape, so it is best to move slowly. If you drag the control point further away from the anchor point, the direction line will get longer and the curve will bulge more and more. If the direction line connected to the anchor point at the other end of the curve is shorter than the one you just edited, the curve will lean towards the higher direction line (see Figure 9.8). If both direction lines are equal in height and placed symmetrically, the curve will be uniform and balanced. By dragging a direction line away from the curve at an angle, you can increase the lean of a curve in one direction.

Even with illustrations, it is not easy to describe how dragging a direction line's control point redraws a curve. It is best to experiment in order to become familiar with how to edit vector curves.

Working With Type

Illustration software is ideal for handling type. Unlike bitmapped type forms, type created with vectors will remain crisp and sharp even after being rescaled and manipulated many times. In addition, the type tools in vector illustration programs are the most sophisticated of all the digital media. In fact, for short documents, like an ad or brochure, many designers prefer them to layout and design software. (For a longer document, like a book, it makes sense to use a layout program's specialized page handling tools.)

Because you are working in a vector program, type can be rescaled, skewed, and rotated easily. But the strength of illustration software in handling type goes far beyond this. In many other programs, to go beyond simple horizontal text boxes and layout type in an imaginative way, you have to cut and paste letters or experiment with spacing keys. In vector software, type can be placed vertically, along curving paths, and inside any shape, by just clicking on a special tool in the tool bar. These paths and shapes are editable with the direct selection tool. You can even slide type along a curving path to reposition it. In Adobe Illustrator, type can be made to take the shape of simple objects, such as a sphere or chevron, by using the envelope distort command.

Along with these specialized tools are the standard page layout ones: kerning (the spacing between two letters), leading (the spacing between lines of text), and tracking (the spacing between groups of letters). Text can be wrapped around graphics or scaled as a group. These tools allow many designers to forgo the use of layout software on many projects.

By converting type to outlines, the forms of individual letters can be modified. As in other programs, this converts the type to shapes and one loses the ability to edit them as type. However, because they remain vector forms, you can use the vector program's sophisticated and precise editing tools

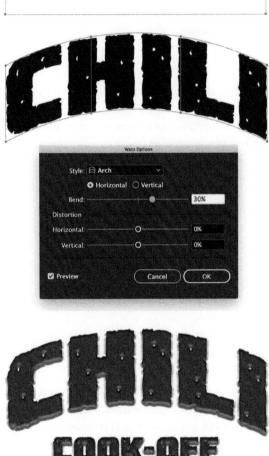

9.9
Imaginative logos are often created with illustration software and then embellished with image editing

to manipulate their curves and outlines. When complete, the transformations will retain a clarity and geometrical nature that is superior to those in bitmapped ones. This is why many designers prefer illustration software for creating logos (see Figure 9.9).

Today, some of the more powerful image-editing and painting programs also include some vector typography tools. Still, dedicated vector illustration software packages remain the designer's choice,

offering the most powerful options for quickly and easily editing, manipulating, and customizing the look of display type, whether as editable letterforms or as converted vector forms.

Painting and Color

Color can be applied to a vector object's stroke and fill once the object is selected. In most illustration programs, there are a variety of ways to choose colors similar to those in bitmap programs. There are panels where you can mix colors. The eyedropper tool can select a color instantly from any place already in your picture. There is also a panel with a collection of color swatches. This assortment of standard colors can be supplemented with selections from color libraries, like Pantone, or with new ones that you create. As in layout and design software, tints of any color can be made by adjusting the percentage of a color.

New colors can be mixed by any of the standard digital media approaches: CMYK, RGB, or HLS (see Chapter 7 for explanation of these color models). Whatever color model you choose, you can either adjust a color's components with sliders (for example, ones for red, green, and blue) or by simply picking a color by clicking in a circle or rectangle filled with the wide spectrum of colors and values. After a new color is created, it can be added to the swatches panel and even given a unique name, like "nacho yellow."

Current colors may be found in the bottom of the toolbar and in the color panels. The outlined square shows the path's color. The solid one is the fill's color. Quick changes can be made by clicking on those rectangles.

Drawing With the Pen Tool

As powerful as the many tools included in a vector illustration program may be, the heart of it will always be the pen tool (sometimes called the *Bezier* tool). The precise control you have when creating paths and editing them are beyond any of the alternative line and shape creation tools found in other software. This may be why more and more other kinds of digital media programs are now including the pen tool. Still, because of the way lines are generated and then edited, it takes most artists and designers some practice to become comfortable with using it. Drawing with the pen is the essence of vector graphics, but also its most challenging skill to master.

Clicking down and placing one end point, moving the mouse and then clicking down again will create a simple straight line. The path must then be ended or the pen tool will automatically connect a new line to the old one when you begin using it again. Many beginners find this difficult to remember and end up with unexpected results (often resembling a tangle of hairs). One way to end a path is to connect it up to its beginning—thereby finishing a shape and making a **closed path**. Open paths are ended by either clicking on the pen tool's button in the toolbar or by deselecting the path. You can always continue an open path later by clicking on an endpoint with the pen tool and drawing.

Vector curves are also called *Bezier* curves. To create them, you click down with the pen tool to place a starting point and drag to make it the first curve anchor point. The first click places the point, the drag draws its attached direction line or handle. The curve will not become visible until you place the second curve anchor point (again by clicking and dragging). The direction in which you drag will determine two things—if the curve will be upward or downward and the angle of its slope (see Figure 9.10). How far you drag before releasing the mouse button will determine the height of

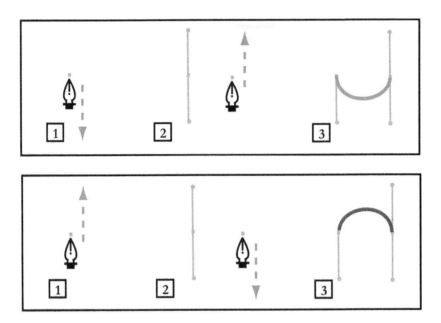

9.10
Drawing a simple curve with the pen tool

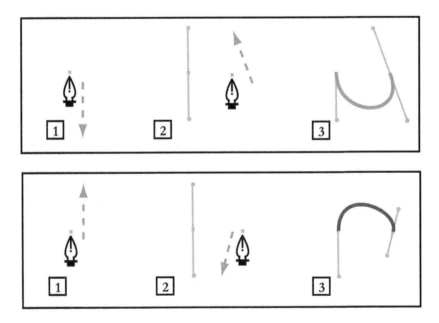

9.11
The effect of different dragging movements with the pen tool on curves

the curve (see Figure 9.11). As with all lines made with the pen tool, the path will continue to be added to until you decide to end it.

As discussed earlier, once you've created curves, you can reshape them with the direct selection arrow. You can drag anchor points or the handles at the end of direction lines. For example, by changing the angle of a direction line, you can increase its inward curve. When a curve becomes too complex,

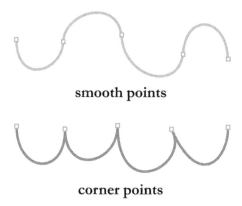

smooth points

corner points

9.12
Curves with smooth and corner points

it can be simplified by deleting some of its points. Special pen tools are used to add points or delete them (a white arrow with "+" or "-").

As you draw a line, the pen tool creates two kinds of anchor points. **Smooth points** are for drawing continuous curves, as in rolling hills. **Corner points** are where the direction of a curve changes direction, as in a collection of waves (see Figure 9.12). You can also convert smooth points (points within continuous curves) to corner points with a special tool or the pen tool and a keystroke. This will change the direction of the next curves to make it the opposite of the earlier one (for example, upward to downward).

To prevent a just completed segment from turning around when you change direction, first hold down the Option (Mac) or Alt (Windows) key on the keyboard. This pins down the old segment before you begin a new one, thus preventing it from moving accidentally before you complete a closed shape.

It will take awhile to feel comfortable using the pen tool. Dragging and clicking to make curving paths is not like drawing with a pencil. If you are using a mouse, rather than a digitizing tablet, it's easy to make a less than smooth movement and create a new point accidentally. But the hours of practice will be time well spent. There is no better tool to create smooth, curving forms. And once you've mastered the pen tool in a vector illustration program, you will be able to use it in any software package that includes it, even bitmap ones.

Brushes

The more powerful illustration programs have evolved over the years to include more tools that imitate natural media. A variety of brushes from the painterly to the calligraphic can create more "artistic" effects but retain the benefits of the vector format, including smaller file sizes. Because of the underlying geometry, even with brushes that splatter, results tend to be less rough edged and smoother—helping to create a more polished look.

Patterns and Gradients

In addition to colors, vector objects, including type, can be filled with patterns and gradients. A selection of standard patterns can be found in the Swatch palette. New ones can also be created, which can later be saved to and named in the Swatch palette.

Any of the standard patterns can be modified and then applied as a new fill. In the fill panel, you can scale the size of the pattern, change its colors, vary the angle, or set it to tile. Some illustration programs allow you to create a pattern from scratch. You simply draw the shapes you would like to use as a pattern, fit a rectangle around them, and either save it as a pattern in the appropriate menu or just drag it into the swatches palette.

In the Gradient panel, you can either redesign preset gradients to transform them or make entirely new ones. Basic variations include choosing between the two categories of gradients (linear and radial) and adjusting the angle of any gradient. Simple gradients are created by selecting two colors for either end of a linear gradient or for the center and circular edge of a radial one. The program immediately calculates the smooth color transition between the two colors. By adding more colors and adjusting their relative positions, more complex multi-color gradients can be created.

Gradient Meshes

Gradient meshes are a unique feature of Adobe Illustrator, which, by smoothly combining multicolored gradients, allow you to create a 3-D look for your forms. A mesh looks like a net applied over your object (see Figure 9.13). Any object can be converted to a mesh one through the *object* menu or by selecting the gradient mesh tool from the toolbar and clicking on the form. Whatever color is current is then combined with the object's original color to form a gradient across it. To add an additional color to the gradient mesh, simply choose one and click on another spot in the object. Simultaneously with adding the color, new mesh lines appear. The more colors you add, the more mesh lines crisscross the form.

With the direct selection tool, you can grab mesh points at the intersection of each mesh line and drag them to reshape the mesh and its gradients. Mesh points, like anchor points, have direction lines that can also be used to reshape the curves of the mesh. By using lighter and darker colors carefully and manipulating the lines of a mesh, you can use gradient meshes almost like a sculptor. For example, an apple can be modeled into a pepper by adding colors and reshaping the curving mesh lines.

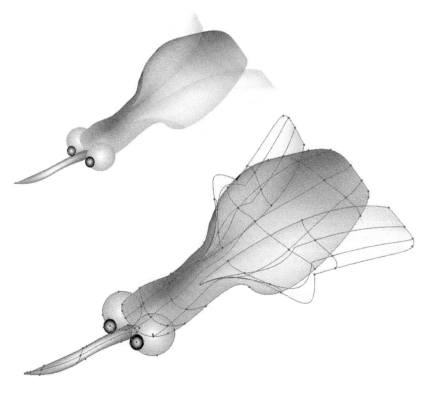

9.13
The gradient mesh: hidden wireframe and wireframe views

Artist Profile: David Sossella

The Italian illustrator David Sossella is an imaginative illustrator and painter who has used his energy to find many avenues to sell his work. He was born in Venice and graduated from his hometown's Accademia di Belle Art. After graduating, he worked first as an illustrator and graphic designer, then in an animation studio. In 2010, he founded *Manifactory* with three other artists— a communication firm that specializes in illustration, logo design, and videos, with clients like Ray-Ban (see Figure 9.14).

9.14
David Sossella, *Never Hide*, Ray-Ban advertisement, 2010

9.15
David Sossella, *Ideas (Noah)* for Boston Globe, 2016

Four years later, he also started *Gusto Robusto* to sell limited-edition prints in vector graphics by him and about 20 other fellow artists. In addition to his work with these two companies, he also is represented by several illustration agencies in the U.S. and Europe and has a Behance page (see Figure 9.15).

Sossella is always drawing and has many ideas—"only a small portion of them become a finished work." No matter what the project, Sossella begins each project with a pencil drawing that he then imports and traces into his illustration program. These are typically very complicated images. "I love details. I love studying how things are made and then I try to represent them with precision and detail." The complexity and liveliness of his work has made it popular with digital media software companies. They like to show a Sossella being made on screen to demonstrate the power of their new apps (see Figure 9.18).

Layers and Stacking

Like many other digital media programs, vector illustration software allows you to divide an image into layers, a collection of transparent and independent overlays. Layers can be hidden or locked, added, deleted, and merged. The locking function is particularly useful when working with the pen tool. Because of its propensity for adding unwanted points or segments, it is wise to lock all but the layer you are working on.

You can rearrange the position of the layer itself just by clicking and dragging it to a new position in the layer menu. In addition, individual objects on a layer are stacked as they are created. They can be rearranged with commands like "bring forward" or "send to back."

The most valuable attribute of layers is their independence. As in bitmap programs, special effects and other transformations can be applied to the forms on just one layer without affecting objects on any other one.

Good layer management is an essential part of working in digital illustration and all the digital media. It is easy to end up with many layers quickly so take the time to label each layer clearly as you create them. This will make sure you don't waste time later looking for one you want to work on. To make layer navigation quicker, many programs allow you to assign a different color to a layer; in illustration software this color can also be seen on the edges of a layer's objects when you select them.

To make tracing scanned drawings or photographs easier, Adobe Illustrator has a special layer called the *template*. Any imported image placed in a template layer will be displayed with a low opacity and will not print. It is there only as a guide, making starting a new work much easier.

Combining Forms to Make Complex Shapes

One of the special features in vector illustration programs is their ability to make a **compound path**: a new, more complex shape made from two or more overlapping shapes. A whole new object can be made from a group of closed paths in a variety of ways (see Box 9.2). They can be combined or *united* and become one form sharing the same overall outline. Or the new form could be made of where the forms *intersect* only, eliminating all other parts. *Exclude* does just the opposite, eliminating the areas where the shapes overlap.

Other possible transformations of a group of shapes vary depending on the particular program. *Merge* will combine only the overlapping shapes that share the same fill color. *Crop* removes any parts below the top shape. *Punch* or *minus front* cuts away the topmost shape from the group. The command *divide* increases the number of sections by splitting the shapes into smaller ones wherever they overlap. As you get more familiar with the potential of complex paths, you will be able to plan ahead and save time when making complicated shapes (see Figure 9.16).

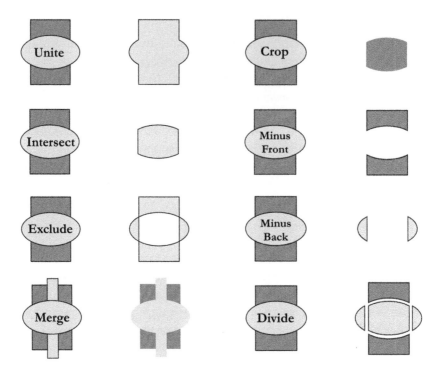

9.16
Compound path effects

Box 9.2 Making a Gear With Compound Paths

While the effect of compound path commands may be difficult to visualize for the beginner, they are well worth exploring. Applied with creativity, they can save you a great deal of time in drawing complex forms. For example, creating a simple gear with the pen tool could mean hours spent trying to get the teeth along its rim even. However, if you plan with the Punch or minus front command in mind, the process is much simpler.

First, make a filled circle, and then place a smaller circle in the center. Next, evenly place a series of small ellipses that pass over the circle's outer edge. Finally, click the *transformation* command. All the ellipses in front of the circle will vanish as they remove the parts of the original circle they overlapped like a cookie cutter (see Figure 9.17).

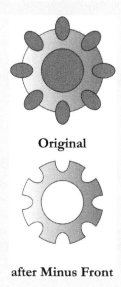

Original

after Minus Front

9.17
Making a gear with minus front

Printing

When you are ready to print your image, you'll generally be pleased to see how quickly a file in vector format prints. However, there are some illustration techniques that can slow down the process. Among them are using an excessive number of patterns, gradients, complex paths, or special effects. Gradient meshes and other gradient blends are known culprits for increasing file size and slowing the printing process. Before you print an image, it makes sense to look closely at it and make sure which of these elements are truly necessary and whether some simplification will improve the image.

Because printers print in dots, all vector images have to be translated in the process of printing. As might be expected, the higher the resolution of the printer, the smoother the ultimate appearance of the vector graphics. High-resolution PostScript printers are generally the best choice for printing vector images. It is a page description language that is especially designed for the graphics professional and includes support for many of the special effects used by digital illustrators.

If your final image is to be printed by a professional printer, as with layout and design programs, you can also produce color separations, a separate page for each color plate, rather than using the *composite* setting, which produces full-color images. You can also have your image print in specific lines per inch settings. You should rely on a printing professional to tell you what settings need to be used.

Vector Illustration and the Web

Because vector images are resolution independent and are usually much smaller than their bitmapped counterparts, they should be ideal choices for images on web pages. Unfortunately, the native formats of vector programs are not the standard ones universally understood by web browsers. Therefore, it is necessary to export the vector images into other formats.

Luckily, most vector software makes it easy to export images in formats that work well on web pages and keep file sizes small. In fact some have a special "Save for the Web" choice under the File menu. Exporting in the GIF format will make the most sense if your image has many flat, colored areas and sharp edges (as many vector images do) or type. If you have used many gradients and blends in your image, saving it as JPEG will produce more faithful results. While the flat, colored areas and edges may blur a bit,

JPEG is a format designed to display the continuous tones of gradients and photographic images. Whether you choose GIF or JPEG, most software today includes tools to optimize an image file; in other words, reduce its size for faster downloading. Chapter 12 discusses how to optimize your images for the Web.

Another option is the *SVG* (Scalable Vector Graphic) image format developed by Adobe in conjunction with the World Wide Web Consortium specifically for vector graphics. These files are resolution independent and work well when your images will be seen on many different types of displays, including mobile phones.

If, instead of one image, you want viewers to see one or more pages that you have designed in your illustration program, you can export the pages as a PDF file. This will retain your layout just as you originally designed it. Your audience will need to use the Acrobat Reader, which is free and easily downloaded, to see these files. Most current browsers will support the Reader inside the browser itself.

Another way vector illustration is used on the Web is for making elements to be used in vector animation programs like Adobe's Animate or Toon Boom (see Chapter 10). This approach makes sense particularly when you want to create complex backgrounds or forms that are more easily created with the sophisticated drawing tools of an illustration program. To make the process even easier, most illustration programs now include a module to export images in the vector animation software's native format.

Vector Illustration Applications for Tablets

Adobe Illustrator has dominated vector illustration for many years. However, like so many other digital media applications, the arrival of tablet computing has led to new competitors offering fresh software designed to take advantage of this new platform. Apps like Affinity Designer (see Figure 9.18) include

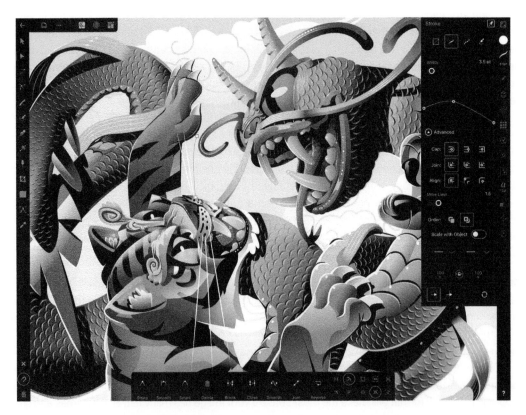

9.18
Affinity Designer for the iPad Pro (David Sossella, *Tiger and Dragon*)

most of the basics you might need to make professional illustrations. One may not find every illustration tool that a full-fledged illustration package has, but tablet apps have a surprising number of features and tools at a fraction of the cost. Another benefit is that tablets allow you to draw directly on the screen with a stylus. That's why beginners may find tablet vector illustration software easier to learn than standard packages that require a powerful desktop system.

Conclusion: Choosing Software for Two-Dimensional Imaging

Artists and designers use vector illustration in many ways. Illustrations can be used for a fine art image, a page design for an ad, a whole brochure, or parts of a larger project, such as elements for a layout, animation, or webpage. It is quite easy to import vector graphics into a page layout program. They can also be exported to any pixel-based software.

While some of the tools are not very intuitive and can be frustrating to learn, for creating strong, colorful, and graphic imagery with precise control, digital illustration has few competitors. Combine that with its flexibility in handling typography and it is easy to see why some artists and designers use this kind of software exclusively.

On the other hand, natural media or bitmap painting puts tools in your hand that will feel comfortable and enable you to create images that have the texture and complexity of traditional paintings. Combined with a digitizing tablet, your strokes will respond to subtle nuances of pressure and angle. For creating images with a hand-drawn look, painting software has few competitors.

To complicate matters, there are many artists who have built very successful careers using only image-editing software. The strengths of image-editing were outlined thoroughly in Chapter 7. It has been for many years the most popular of all the digital media.

With all these choices, you may wonder which kind of program you should choose for 2-D imagery. In some ways, this is the wrong question to ask. For most artists the real issue is to understand the nature of the project they are working on and the strengths and weaknesses of each kind of software. Digital artists who work in only one program tend to find themselves spending a lot of time trying to find a way to make the program do what it wasn't designed to do. While the most powerful programs now include tools from other types of programs, these added tools are limited versions of more sophisticated ones. When you know the real strengths of each kind of digital media program and use them intelligently, you will spend less time trying to work around a problem and more time simply solving it. Just like building a house, nothing can replace having the best tools at hand.

Projects in Vector Drawing and Illustration

1. Design a logo for a chain of hair-cutting stores that are located in malls. You may use black and white and one other color. The logo should include a strong graphic symbol and dramatic typography to make sure the store is easily identifiable at a distance and can attract customers in the visual competition for attention inside a crowded mall. Scale the symbol and typography in various sizes for the various purposes of a logo (signage, letterhead, clothing, etc.) and label them.

2. Design a 14″ x 7″ menu cover for an imaginary restaurant that serves your favorite food. Choose a name for the restaurant and create a sense of its ambience by your style of drawing and choice of type. Include patterns in your design.

3. Create a full-color, full-page (8″ x 10″) illustration for a magazine article called "Helping Grandma use her first Computer." Your illustration should express the confusion that some senior citizens feel when first confronted with computing.

10 Two-Dimensional Animation: Up and Running

10.1
Thomas Edison, scenes from his *The Enchanted Drawing*, 1900

INTRODUCTION

Animation is a magical process that has enchanted generations of audiences around the world. Few are immune to the fascination of seeing drawings come alive and move. The illusion animation depends on is a visual phenomenon called **the persistence of vision**. Because we see images for a split second longer than they are actually in front of us, a series of pictures drawn in sequence appear to be one continuous picture in motion. The illusion is a powerful one. Even the knowledge that we are seeing only a collection of drawings changing quickly cannot prevent us from feeling that what we are seeing is real.

Today, we are in the midst of an animation renaissance, with digital techniques leading the way. Commercials, cartoons, videos, full-length films, interactive media, websites, and video games all make extensive use of digital animation. Beyond the entertainment industry, animations are being used to

enhance corporate presentations, evidence in court (for example, recreations of car accidents), and for scientific visualizations.

In this chapter, we will enter the exciting world of animation. "World" is not an overstatement because once you've added the element of time to 2-D art, there is a whole new vocabulary to learn and a different way of seeing. For many experienced 2-D artists and designers shifting to this new world is quite a challenge. Unlike other 2-D art forms, it doesn't make sense to carefully build a single image for days or months since images will fly by at 24 a second or faster. Animation requires a different approach and philosophy. It even has its own laws of physics. As disconcerting as these differences may be at first, animation's unique methods and principles are well worth studying, since your art truly comes alive when you make pictures that move.

In the Beginning

Our fascination with animation has a long history. It was not long after Thomas Edison's invention of motion pictures that animation made its debut. His *The Enchanted Drawing* from 1900 (see Figure 10.1) combines both live action and animation. In it, a gentleman makes a drawing of a man's head on an easel. When the artist pulls the man's hat out of the drawing and puts it on himself, the drawing starts to frown. When he returns the hat, the face smiles again. Being given a cigar increases the drawing's pleasure; he appears to puff contentedly.

Even before the first films, the magic of animated pictures had already fascinated both young and old. In the nineteenth century, toys that created animated effects were popular. The **thaumatrope** is the earliest known toy that played with persistence of vision. It was a round disk with different pictures on each side. A child would hold both ends of a string threaded through the disk with both hands and spin it as fast as he or she could. The thaumatrope's most famous subject was a bird on one side and a cage on the other. When twirled quickly, the pictures would blend visually and the bird would magically appear to be in the cage.

The **zoetrope** (see Figure 10.2) created a more truly animated effect. The toy was an open metal cylinder with evenly spaced slits, which would spin on a pedestal. To make it work, a strip of paper with drawings was placed inside and the cylinder spun rapidly. By looking through the slits as they sped around, a child could see the drawings come to life and move in sequence. At toyshops, children could buy drawings strips to put in their zoetropes with many different subjects, from elephants to acrobats.

As quaint as the thaumatrope and zoetrope seem today, one antique animated toy continues to enchant—the hand-drawn flipbook. With one drawing quickly superimposed on the next, it is a simple

10.2
Zoetrope

and low-cost method to animate that even a child can create. Yet it remains an excellent introduction to the basic principles of creating animation.

PIONEERS OF TRADITIONAL ANIMATION

Winsor McCay

Seeing one of his son's flipbooks inspired Winsor McCay to make what he called "modern cartoon movies." In the early 1900s, McCay was already one of America's favorite cartoonists. His most famous comic strip, "Little Nemo in Slumberland," depicted the fantastic dreams of a little boy. Based on his son, the scenes were beautifully drawn hallucinations, like Nemo sliding down a never-ending banister in a mansion that ultimately flings him off into outer space or Nemo finding himself in a world where everyone is made of glass. In the last panel, the little boy always woke up.

McCay's "Gertie the Dinosaurus" (see Figure 10.3) was one of the most influential films in the history of animation. In the film, a combination of live action and animation, McCay is with a group of friends at a natural history museum and bets that he can make a dinosaur come alive. Six months later, they reconvene for dinner at a gentleman's club and McCay begins sketching on a pad on the wall. The pad fills the screen and we have our first look at Gertie, sticking her head out of a cave. When she emerges,

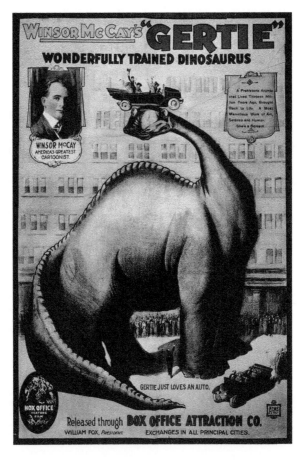

10.3
Poster for Winsor McCay's "Gertie the Dinosaurus"

we see she is a huge brontosaurus. More a gigantic dog than fearsome creature, she responds to McCay's commands (but is not always well behaved).

First completed in 1914 after two years of work, McCay drew 16 drawings for every second of animation, matching the film speed of that era. Live-action segments were added two years later including one showing the animating process. In a slapstick moment, an assistant falls down the stairs as a huge stack of drawings goes flying in all directions.

A showman in addition to a cartoonist, McCay took the first version, which included only the animated sequence with Gertie, on tour around the country. Standing next to the screen with a whip, like a lion tamer in a suit, he'd "attempt" to control the dinosaur's actions. The crowning moment of his act was when Gertie would stick her head down and McCay appeared to get on it and be carried into the film.

It was the sight of Gertie in vaudeville shows that inspired many of the pioneers of animation. Among those young people whose lives were changed by seeing a dinosaur come to life were Otto Messmer and Pat Sullivan, the creators of Felix the Cat; Max and Dave Fleischer, the creators of Betty Boop; and Walter Lantz, the creator of Woody Woodpecker.

Otto Messmer

By the 1920s, cartoons had already become a regular part of an afternoon at the motion pictures. The king of cartoons was Felix the Cat, a mischievous creature whose fantastic silent film adven-

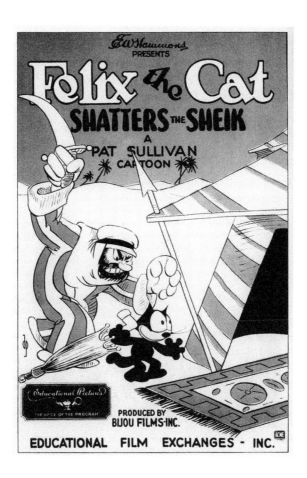

10.4
Poster for "Felix the Cat"

tures were more like Little Nemo's than his later tamer incarnation on television (see Figure 10.4). For example, in one cartoon Felix travels to Mars by shooting an arrow that is attached to his waist with a rope and then wins the presidency by convincing all cats to join him there for a better life. A product of Otto Messmer's fertile visual imagination, Felix might be grabbed by a robot, squished into a nail and hammered into the ground one moment, then take his tail off and use it as a cane in another. Produced at the Pat Sullivan Studios, he was the first animated character to have marketed merchandise. There were Felix toys, handkerchiefs, and china. Felix even had popular songs and classical music written about him.

Many of the basic techniques of early animation can be seen in the first Felix silents. Messmer designed Felix to have a clear, strong silhouette, which made his actions easily understood. Felix's arms and legs were completely flexible—like rubber hoses. In fact, his whole universe sometimes seems as if it is made of rubber; most objects stretch as they move and squash when they bang into something else. Messmer also made constant use of repeated actions or **cycles**, which saved him time when animating. One character bicycling would usually be joined by hundreds of identical bicyclists; a jumping and cheering cat would be repeated to form a crowd.

The Fleischer Brothers

As with Messmer, the animated films of Max and Dave Fleischer emphasized visual invention more than the story. To this day, very few animators have ever exploited the imaginative possibilities of the medium more fully. Their first successes utilized an original Fleischer invention, the **roto-scope** (see page 255). Dave was filmed moving while in a black clown suit against a white sheet. After tracing the frames onto paper, his drawn silhouette was transformed into the cartoon character *Koko the Clown*. Koko starred in a series of shorts called *Out of the Inkwell* begun in 1919. Each short began as live action, with Max working at his drawing table. Koko would climb out the inkwell and find ways to torture Max.

Another innovation of the Fleischers was the "Car-tunes" series, which put the words of popular music on the screen and encouraged the audience to sing along by following the bouncing ball. However, it was the entrance into a Koko cartoon by a floppy-eared female dog with a suggestive dance-style that led to the greatest Fleischer success.

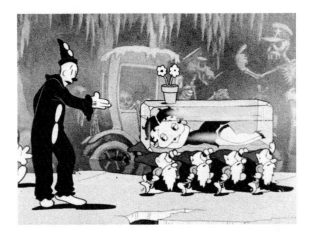

10.5
Betty Boop and Koko the Clown in Max Fleischer's *Snow White*, 1933

With the sweet voice of Mae Questel, a singer and comedienne, the fascinating dog captured the audience's imagination. The Fleischers transformed her character into Betty Boop, a 1920s flapper in a revealing dress and visible garter. Her adventures rarely made sense, but were opportunities for the Fleischers to demonstrate their extraordinarily creative approach to animation. Logic was not important and anything could happen. One moment in their *Snow White*, a masterpiece of visual imagination, exemplifies the richness of their work (see Figure 10.5). After the jealous Stepmother yells "Off with her head" she points at Snow White (Betty), and to make the point, one of her fingers curls around, becomes saw-edged, and cuts off her own thumb.

Among the many animators influenced by the Fleischer's approach is John Kricfalusi, the creator of *Ren and Stimpy*, who said their films "best illustrate the purest essence of what Cartoons are about."

Walt Disney

Kricfalusi also sees the emergence of Walt Disney as the beginning of a sad decline of animation from its early wildly imaginative years. Nonetheless, there are millions who would disagree. Disney's name has become synonymous with cartoon animation, and his company's methods defined the standard process for animation production (see Figure 10.6).

Walt Disney created his first animation company, "Laugh-O-Gram Films," in Kansas City during the early 1920s. But success did not come easily. In 1923, close to bankruptcy, he left for Hollywood with a one-way ticket and $50. There Disney made a series of increasingly popular cartoons about a rabbit named Oswald. But in 1928, just as he was enjoying his first successes, Universal Pictures (the distributor of his films) took control of the rights to Oswald and hired away most of Disney's animators.

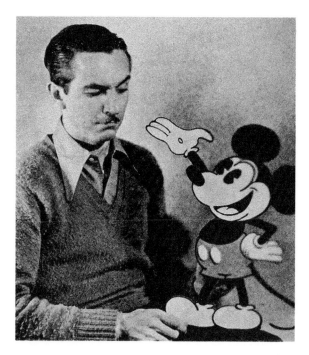

10.6
Walt Disney and friend in 1931

To recover from this disaster, Disney decided to create another character, which he copyrighted. It was a mouse, whom he first called "Mortimer." His wife didn't like the name and suggested the world-famous name "Mickey." Designed by Ub Iwerks, one of the few animators who had stuck with Disney after the Universal fiasco, Mickey was drawn with simple circular shapes, traced from quarters and half-dollars. For long shots, the animators used nickels and dimes.

Like Felix, Mickey was black and white with a strong silhouette. But Disney's overall approach to cartoons was fundamentally different. Even in his earliest films, Disney insisted that his staff tell a story. Unlike Messmer's and Fleischer's cartoons, his characters inhabited a pleasant country environment. While Mickey could be mischievous, it was always just gentle fun.

The first two cartoons featuring Mickey Mouse didn't attract any distributors. The third, *Steamboat Willie*, like the others, was initially released as a silent cartoon and was equally unsuccessful. But in 1928, with the arrival of sound in motion pictures, Disney decided to redo the film with sound, using a washboard, slide whistle, harmonica, and pots and pans banged together. It cost $15,000 to add a soundtrack and his brother Roy, the business manager, protested. Walt wrote to him and said, "I think this is Old Man opportunity rapping at our door. Let's not let the jingle of a few pennies drown out his knock."

The re-release of *Steamboat Willie* was a landmark in cartoon history (see Figure 10.7). Reportedly Max Fleischer and Pat Sullivan were at the premiere but were unimpressed by Disney's new work. Soon they would be struggling to compete with him. Adding sound to cartoons became the new standard and was even called "Mickey Mousing."

As the Disney Studios grew over the next decades, their understanding of animation principles evolved. The careful planning procedures that are the standard process today, with detailed storyboards, model sheets, and pencil tests, were Disney innovations (see Box 10.1). Different teams were responsible for different characters. Walt also made sure his company led in technology, for example being the first to use a multiplane camera, which could vary the focus on different layers of a scene as it zoomed in. A tough taskmaster, Disney constantly pushed his animators to greater challenges. In order to ensure quality, he hired drawing instructors who worked with his staff at nightly model sessions.

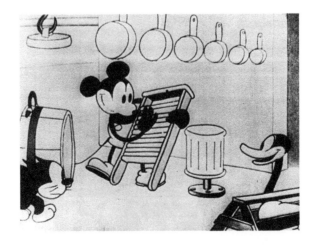

10.7
Adding sounds made *Steamboat Willie* a landmark animation in 1928

The first full-length animated film, *Snow White and the Seven Dwarfs*, released in 1937, took nearly three years to complete. Known during those years as "Disney's Folly," it cost $1.5 million, an unheard-of amount for a cartoon. What he aimed for was nothing less than art. In Technicolor with a fully orchestrated soundtrack, each scene was more complex and beautiful than had ever been seen on the screen. In the years since its release, it has earned more than $1 billion and will continue to earn profits for years to come.

Box 10.1 How Traditional Animation Was Made at the Big Studios

As anyone who has watched the credits after a full-length animated film knows, the production process in a professional studio is a huge enterprise. In filmed animation, 24 frames are used for every second of action. Tens of thousands of drawings will be needed for a typical seven-minute cartoon. Teamwork and coordination among many different staff members are essential for success (see Figure 10.8). Since the 1920s, a basic structure for organizing work has evolved in the large studios, outlines which are still followed whether working digitally or not. An understanding of these approaches is also important because much of the vocabulary used by digital software refers to the older techniques.

After the concept, script, and storyboards (see page 222) are approved, it is actually the soundtrack that typically comes next. Prepared from the script, the sounds and action heard will be important inspirations to the animators designated to work on individual sequences.

Once the soundtrack is completed, a very detailed work schedule, sometimes called the **Exposure Sheet**, is made. In this chart, every frame of the film and every piece of art is described in terms of the general action (such as "man walking in field"), detail of action ("five frame walking cycle"), if there are any special effects, and sound (crunching with sound of airplane in distance). Tweeners working from this schedule, the storyboard, and model sheets created by the lead animator or director (see page 227) begin making pencil sketches of each frame on **onion skin** (semi-transparent) pages, which allow one to see earlier drawings. These are then given to the Clean-up Artists who correct lines and make sure the work of various animators conforms to the

10.8
Working on a scene at MotionWorks, a German animation studio

10.9
Elaborate background art from *Brave*, 2012

Director's model sheets. After the pencil sketches are cleaned up, they are photographed and made into a film called the *Pencil Test*.

Meanwhile, the backgrounds are being created and will later be compared to the action (see Figure 10.9). Once the pencil tests are accepted, they are scanned and printed or photocopied to cels. In many studios even today, Inkers then paint colors and shadows on the back of each cel. These painted cels are placed on top of the backgrounds and photographed, frame by frame.

The film is then carefully synchronized with the soundtrack. The Director and Film Editor preview the film and make the final editing decisions. Copies of the film are made for distribution. After that, it is up to publicity and marketing departments to bring the film to the public.

Chuck Jones

Chuck Jones was the leading figure of the second generation of pioneer animators. He grew up around Hollywood and, as a child, regularly peeked over a fence to see Charlie Chaplin making his movies. He worked for Ub Iwerks and Walter Lantz, and even had a short stint at Disney Studios. In the depths of the Great Depression, he was hired at Warner Brothers to wash animation cels. He moved up to being a tweener, and then became a lead animator in 1938. Along with his older colleagues Tex Avery and Fritz Freleng, Jones was the guiding spirit of the animation division of Warner Brothers known as "Termite Terrace," the dilapidated home of Bugs Bunny, Daffy Duck, Elmer Fudd, and Porky Pig (see Figure 10.10).

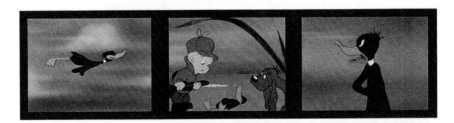

10.10
Stills from "To Duck or Not to Duck" by Chuck Jones, 1943

In a long career at Warner Brothers, MGM, and as an independent director, Jones worked on over 300 cartoons. He believed in the fundamental importance of each and every frame being carefully drawn and designed. The backgrounds of his cartoons are just as carefully planned as Disney's but far more modern and geometric, his characters more ridiculous and wittier. His original creations include Pepe LePew, Marvin the Martian, Wile E. Coyote, and Roadrunner. The winner of many Academy Awards, his most acclaimed cartoons include *What's Opera, Doc?* and *Duck Dodgers in the 24 ½ Century*. His longer films from the late 1960s include *How the Grinch Stole Christmas* and *The Phantom Tollbooth*.

Tezuka and Anime

Anime (pronounced "annie-may") is the Japanese style of animation. Compared to cartoons made in the United States, anime has much greater variety in subject matter. In fact, anime is enjoyed by all age groups in Japan, from children to adults.

The sources of anime go back to the nineteenth-century artist Hokusai and what he called *manga*. Hokusai is best known for his woodcut prints, like "The Great Wave," which inspired the French Impressionists. His manga (meaning "easy, silly pictures") were sketchbooks (see Figure 10.11) that caricatured all sorts of activities in Japan, some real, some pure fantasy. For example, one page shows overweight men taking baths. Another imagines games people with very long noses might play, like tossing rings from nose to nose.

In the twentieth century, manga came to mean comic books. Japanese comics were strongly influenced by those from the United States, particularly Walt Disney's. During World War II, manga were suppressed by the dictatorial regime, but in the war's aftermath they flourished as one of the few low-cost entertainments available in poverty-stricken Japan.

Anime's founding father was a former medical student, Osamu Tezuka, known in Japan as "the god of manga." He brought a more sophisticated, cinematic style to the manga, using close-ups and "camera" angles. He also expanded the subject matter. "The potential of manga was more than humor," Tezuka said, "using the themes of tears, sorrow, anger, and hatred, I made stories that do not always have happy endings."

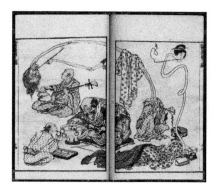

10.11
Page from Hokusai's *Manga: Spirits with Long Necks*

Ironically, he is most famous for his manga created for children, particularly *Tetsuwan Atomu* ("Mighty Atom"), a robot boy who fought crime (see Figure 10.12). In 1958, Tezuka founded his own animation company and turned "Mighty Atom" into an animated cartoon for television. In the 1960s, the robot boy came to the U.S. with another name—"Astro Boy" (his original name might have reminded Americans of Hiroshima). The anime industry had begun.

Tezuka's influence on anime is far-reaching. In his cartoons all humans and animals have big, expressive eyes and simple, rounded features. One can see Tezuka's style in the faces of today's Sailor Moon and *Pokemon*'s Ash Ketchum. The action in most anime reflects his method of using rapidly changing close-up stills rather than smooth animation to show a character's reaction. The success of his Astro Boy created an international interest in Japanese anime. In the 1960s, new programs came to the U.S. such as *Mach GoGoGo*, or *Speed Racer*. Another show, *Gigantor*, created the genre of giant robots controlled by humans, like the very popular *Gundam*.

The most influential anime director of the past 20 years is Hayao Miyazaki, the director of *Princess Mononoke*, *My Neighbor Totoro*, and other classic films. In 2001's *Spirited Away* (see Figure 10.13), a girl whose family is moving finds herself alone in a mysterious town. There are ghosts, gods, and monsters, and she must try to figure out which ones to trust and what to do in order to save her parents. The fairy-tale atmosphere is enhanced by lovely, subtle colors, beautiful hand-drawn characters, and elaborate, decorative computer-animated backgrounds.

Spirited Away was not only the most successful film in Japanese cinema history, but it also won many awards, including the Oscar for Best Animated Film. Behind its success is Miyazaki's extraor-

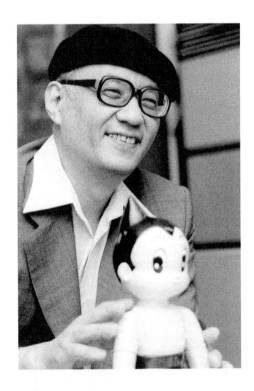

10.12
Osamu Tezuka and Astro Boy

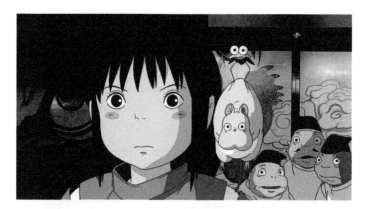

10.13
Still from Hiyao Miyazaki, *Spirited Away*, 2001

dinary meticulousness. At Studio Ghibli, the company he founded, he was known for checking every drawing and redrawing ones not to his satisfaction. While he at first resisted digital technologies, he has said more recently, "I think talent decides everything. More than the method, what's important is the talent using it. There's nothing inherently wrong or right about a method, whether it be pencil drawings or 3-D CG."

Animation Goes Digital: John Lasseter and Pixar

New technologies have affected the shape of animation since its beginning. The arrival of sound added a new arena for the animator's imagination. The multiplane cameras in the 1930s led to new ways to create a sense of depth. In the 1960s, copier techniques, which used Xerox cameras to create cels, sped up the animation process and allowed a more hand-drawn look throughout.

Like many young people interested in animation in the early 1980s, John Lasseter began experimenting with computer animation, although his career had already had an auspicious beginning. After interning there, Lasseter was hired by Disney Studios straight out of college in 1979, where he worked on *The Fox and the Hound*, among other films. However, because he became so insistent in his requests to make an animation on a computer, Disney ultimately fired him from every animator's dream job in 1984.

Lasseter joined the new computer graphics division of Lucasfilm, which focused on special effects for motion pictures like *Return of the Jedi*. The division was soon sold to Steve Jobs, one of the founders of Apple (see Chapter 5), and renamed *Pixar*. Jobs poured millions into his new company, allowing it to develop the latest technologies, among them **RenderMan**, still regarded as one of the finest 3-D rendering software systems. In this fresh environment, and with the assistance of some of the best available digital tools, Lasseter created his own totally computer-animated short film.

Luxo Jr. (1986) (see Figure 10.14) was the story of a parent desk-lamp, a child lamp, and an ill-fated bouncing ball. It became the first 3-D computer-animated film to be nominated for an Academy Award. Two years later with *Tin Drummer*, the story of a metal toy chased by a baby, Lasseter brought home his first Oscar.

These successes led to the ironic situation of the once disinterested Disney Studios hiring Pixar to develop their first full-length computer-animated film. Taking four years to complete, *Toy Story* became the highest-grossing film of 1995. A completely digital production, each character's design was the

10.14
Scene from Pixar's "Luxo Jr."

result of some of the most extraordinarily complex 3-D models ever created. For example, Woody had more than a thousand control points. A room full of workstations, stacked like pizza boxes, handled the chore of rendering the complicated models, scenes, and action. *Toy Story* won a Special Achievement Academy Award in 1996. Success continued to follow Lasseter. After the merger of Disney/Pixar in 2006, Lasseter became Chief Creative Officer for both companies and also oversaw the design of attractions in Disney theme parks.

While the technical achievement of Lasseter's films *is* impressive (Chapter 11 discusses the complex and specialized techniques of 3-D modeling and animation), underlying his great success is a mastery of traditional animation techniques. This is what gives them life. Lasseter's approach is the product of what is now a century-long development in the art of animated films. All animators, whether traditional or digital, need to understand basic principles and techniques to be effective, in order to have success creating, as Thomas Edison did in 1900, enchanted drawings.

TRADITIONAL ANIMATION TECHNIQUES AND PRODUCTION

Working in Time

One of the challenges visual artists face when planning an animation is moving from carefully developing a single image to working on a series of images which will be seen for no more than a split second. Working in the fourth dimension, time, requires a very different approach. Over the decades, since the first hand-drawn film animations were created, a unique visual language has evolved with its own rules of design.

Animation's language and laws are known intuitively to anyone who has spent hours watching cartoons on television. Compare in one's mind, a punch to the face in an action movie to one in an animated one. In one, a head jerks back sharply, sweat flying. In the other, the head flies back several feet, the neck stretches like a rubber-band, and the shape of the fist becomes imprinted on the victim's face. The normal rules of physics do not apply in an animation and in fact, appear abnormal.

The "Natural" World of Animation

The first rule of animation is that it is an artificial world. The more naturalistic the forms used, the more unnatural they will appear. This is why *exaggeration appears normal* in an animation. In the language of animation, action is communicated by overstatement. Winds are rarely gentle zephyrs; they bend trees. Animators use the technique of *squashing* to represent the power of an impact and also give a sense of an object's material. Therefore, when a rubber ball hits a wall, it squashes and expands as it hits a barrier (see Figure 10.15). A Ping-Pong ball wouldn't squash as much and would spring up quicker.

Sympathetic movement or *stretching* is utilized to better convey action, too. For instance, a fast-moving object will change its form to accentuate its path. A superhero will stretch out as she sweeps across the sky.

It is important to understand when one plans an animation that *reality is much too slow to remain interesting*. This is something all filmmakers know. While the pop artist Andy Warhol thought it would be an interesting statement to film six hours at the Empire State Building uncut and with one camera angle, a successful animator will only include the essential moments necessary to tell a story. Filmmakers know a character that is waiting a long time for a friend can convey that by checking his watch two or three times. The viewer does not also have to join him in waiting 20 minutes. Successful animators utilize other conventions of film, such as fade-outs, close-ups, and changing angles, to hold the interest of the viewer.

Finally, remember that **animation** *is fundamentally a visual medium*. Whatever your story, it should be understandable simply from the images you create. While sound can make important contributions to your film, it should never be the main focus. It should enrich the images. If you find yourself creating a great deal of dialog to explain your story, then animation might be the wrong medium for your project. Your animation should be a work of visual imagination.

10.15
Bouncing ball sequence

Cinematic Techniques

Understanding basic film techniques can enhance even the simplest animation. Over the past century, directors have developed a language for cinema that viewers have come to understand intuitively. Animators use these concepts, too. Effective use of these techniques provides variety for viewers and retains their interest.

The *close-up* is one of the most powerful film techniques. A close-up not only adds variety; it also forces the audience to pay attention to what the director wants viewers to look at.

The earliest films followed the conventions of plays and did not use close-ups. Viewers watched the entire scene as if they were watching live theater. When the director focused on one character, they were shown from head to toe. One of the first directors to use close-ups was D.W. Griffith, and they are reputed to have been terribly startling. Screams from audiences were heard, as if a character had just been decapitated. Charlie Chaplin was another early director who used close-ups. By focusing on his tramp's face, viewers were drawn into sympathy with his character and felt they understood what he was feeling.

Generally, new subjects are not first seen in close-up but whole, in what is called an **establishing shot**. The camera then *zooms in* or slowly moves in closer. Zooming in intensifies the action or emotion of a scene while *zooming out* tends to have a calming effect. Imagine the difference in impact of a fight seen close-up versus off in the distance. **Panning** is another form of camera movement, usually used at a distance from the main subjects (see Figure 10.16). It is a slow movement across a wide scene, which feels as if the viewer's head is turning with the camera.

In conclusion, every animator should consider carefully the *point of view* of each scene. Viewers' feelings are strongly affected by whether a camera is tilted or straight on or how far from a subject someone is seen. For example, a character seen with a camera placed low to the ground will seem huge and menacing. If that same character is shot from high above, looking down at them in a pit, they will seem small and pitiful.

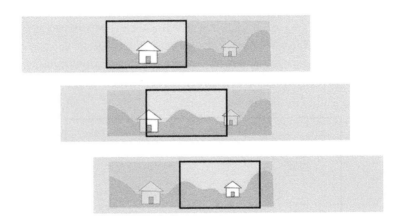

10.16
Panning sequence

Transitions

Transitions between scenes play a crucial role in helping retain the interest of the audience. Each kind of transition not only moves the action along, but means something different to viewers. *Cuts*, or quick shifts of view, are the most common transitions. They allow the filmmaker to radically compress time, so the events of an hour can be shown in a few minutes. Rapid cuts create a feeling of intense energy.

Another common transition is a *fade*. Fading in or out indicates to viewers that there has been a complete change in time between the two scenes. A **dissolve** is when one scene fades in as the other fades out. This implies a logical connection between the two scenes. A dissolve might be used when the first scene shows the main character as a baby and the second as a young girl (see Figure 10.17).

One of the earliest transitions used in films was the **wipe**, where one scene is cleared off the screen at an angle by the next scene. Wipes are rarely used in live-action movies today unless the

10.17
Dissolve sequence

director wants to give the film an old-fashioned look. However, animations still use wipes to tell the viewer that a change in location is happening.

THE IMPORTANCE OF PLANNING

Even with the assistance of computers, animation is an extremely time-consuming, labor-intensive medium. All professional animators know the importance of careful and thorough planning. Each artist and company may have their own approach but all generally follow a standard series of steps.

Concept

Animations begin with the *concept*, the idea behind the film. It should be able to be expressed in no more than a sentence or two. Examples of a concept are "young mermaid falls in love with a human prince" or "a strange substance turns four young turtles into teenage ninjas." A good concept suggests something interesting and full of possibilities. In the professional world, it is called the *high concept* and is what is *pitched* (presented) to possible financial backers.

Treatment

Once a good concept is settled on, it is then developed into a **treatment**. Like the concept, this is written rather than drawn. The story is outlined from beginning to end and each of the characters is described. A good treatment will be one that boils the story down to its essentials and manages to keep the interest of the audience every step of the way. It will limit the number of scenes and make sure everything shown has meaning and importance. Ham Luske, who worked for many years at Disney Studios, wrote a very clear explanation of the challenge facing story writers:

> Our first job is to tell a story that isn't known to the audience. Then we have to tell a story that may cover several days or several years . . . so we have to tell things faster than they happen in real life. Also we want to make things more interesting than ordinary life. Our actors must be more interesting and more

unusual than you or I. Their thought process must be quicker than ours, their uninteresting progressions from one situation to another must be skipped. . . . Is that not what drama is anyway, life with the dull parts cut out?

While it is written, the treatment forms the foundation for the next step—the artist's *visualization* of the film—the first sketches of scenes and characters.

Storyboard

The storyboard (see Figure 10.18) shows the key moments of an animation in a series of small boxes with written notes below. Each major change of action should be illustrated. The notes below the pictures should include any sounds or dialog. The storyboard is used to plan changes in camera angles and transitions between scenes. At a major film company, this can mean a detailed storyboard of more than 10,000 panels. A smaller company might make storyboards with quick black and white sketches.

Storyboarding is a creative process during which new ideas will be generated. This is when the flow of the story is determined and fundamental editing decisions are being made. When preparing a storyboard, one should think like a director. The sequence of "shots" needs to be decided upon. Is there enough variety in the camera angles? Will the viewer be confused? Is there too little or too much information? Is the pace right? The shifts of scene should appear natural but, ultimately, you are responsible for what viewers see and what they don't. Viewers should feel that what they are seeing is what they would want to see—unaware that the director is actually in control.

While new animators might be inclined to plunge into animating once the treatment is approved, experienced ones agree that the storyboard is the most crucial part of the planning process. It is while the storyboard is being made that the animator truly visualizes the look of the film. Sketches are made over and over again so that each frame of a storyboard has a strong composition. Most importantly, an animator wants to limit the number of scenes that are animated but have to be cut later on. Both the emotional and financial cost of cutting a scene is much less during storyboarding than after weeks of work on an ultimately nonessential sequence.

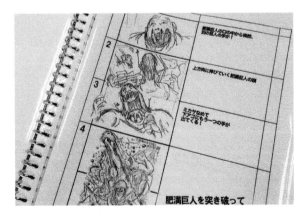

10.18
A storyboard by director Shinji Higuchi for *Attack on Titan* (Toho Studios, 2014)

Model Sheets and Character Design

After a good story, the success of an animated film probably depends most on strong character design. In professional animation companies, the lead animator creates **model sheets** (see Figure 10.19) as a

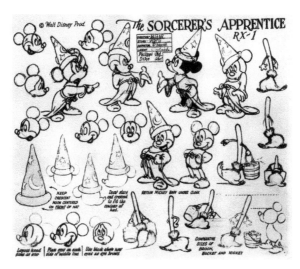

10.19
Model sheet for Mickey Mouse in *The Sorcerer's Apprentice*

guide for the other animators. Each character is drawn at various angles, colors and costumes are carefully detailed, and any notes the animator thinks would be helpful to colleagues are added.

Because each image of an animation flies by faster than anyone can see it, it is best to use easily drawn, simple shapes with clear structures. The silhouette of each character should be easily recognizable. Characters with clear outlines communicate best with viewers. This is a good thing for the artist, because these kinds of shapes are also the easiest to recreate over and over again during the length of a film. This is not a small consideration, since even a short cartoon for the Web will require a minimum of 240 separate images for a length of just two minutes. One designed for film would need almost 6,000. It is important to make sure they are easily drawn from every angle.

The most famous and successful character in animation history, Mickey Mouse, illustrates this principle. As mentioned earlier, he was first drawn as a series of circles by tracing quarters and half-dollars. Open, round shapes like his strike viewers as likable and appealing. Long shapes with sharp angles usually signal an evil and dangerous character.

Backgrounds

In the larger studios, while the main actions are being animated, other artists are at work creating backgrounds for the film (see Figure 10.9). They provide a stage for the characters and help set the mood of each scene. Because they are seen by viewers for longer periods of time than any one image of a character, they are generally more complex and developed than the character drawings.

However, it is important that a background not be a finished composition in itself. It should always seem a bit empty, as if it is missing something. Then when a background is shown without any characters, viewers will have a sense of anticipation that some action is about to begin. The arrival of your actors will seem natural as they complete your composition.

Soundtrack

The soundtrack plays an important supporting role in an animated film. Used imaginatively, it helps amplify the action. The sound of the sea will give depth and weight to the simplest pictures of waves.

Sounds can also be important time-savers for animators because they help "draw" scenes that are never actually seen. If we hear a car crash after a car has driven across the screen, our imagination completes the picture.

A soundtrack should be chosen carefully with your themes in mind. Viewers will make associations between the images they see and the sounds they hear. Sounds can set the mood of a scene, such as a moonlit night with a wolf howling. Sounds can also create a sense of anticipation because viewers listen for clues to the action ahead. A young woman swimming is a pleasant image until ominous music begins to play. Add a quick image of a shark's fin and a beach party has been transformed into a horror film.

Most animation programs include simple tools for synching the images with the soundtrack. Modest editing of sounds is sometimes possible. However, before sounds are added to an animation, it is best to edit them first with dedicated sound software (see Box 10.2). Sound-editing programs have sophisticated editing tools and filters, which can produce a variety of sound effects.

Box 10.2 Orchestrating Sounds

From the silliest sound effects to lush orchestrations, sound and animation have gone together for more than 90 years. Even in the era of "silent pictures," cartoons were usually shown in theaters accompanied by a piano with a prepared score. That's because every image, from the slap of a face to the start of a car, is made more vivid by the addition of a sound. As the masters of radio drama knew, sound can create a world in the listener's imagination, even when that world is never seen.

On the other hand, a poor soundtrack can make even the most professional animation appear amateurish. Care and effort need to be taken when adding sounds. Luckily, there are many sound-editing programs available to manipulate and transform sounds in the digital environment.

Sounds are composed of waves. In sound-editing software, each recorded sound is pictured as a **sound wavegraph** (see Figure 10.20). The graph shows the wave itself, the length of the sound over time, and the wave's **amplitude**. Amplitude is technically how much change in pressure a

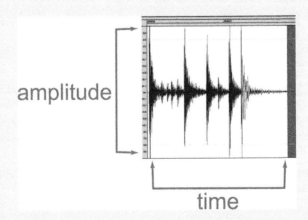

10.20
Sound wavegraph

sound creates. While we don't usually think of sound as pressure, anyone who has entered a loud concert has experienced it. One can feel the huge sounds against your body; the pressure even hurts your ears. The taller a wavegraph's amplitude, the louder the sound.

Digitized sound comes in two formats: *synthesized* and *sampled*. Synthesized sound is computer generated from formulas. Its most common format is MIDI. Like another mathematical format, vector graphics, synthesized music even with an orchestra full of instruments can often come from files of surprisingly small sizes.

Sampled sound is made with digital recording equipment, for example, speaking into a microphone connected to your sound card. Among the standard sampling file formats are WAV (for PCs), AIFF (Apple), PCM (used on CDs), and MP3. Like a scanned bitmap image, a sampled sound can result in a very large file size depending on the quality of the recording. In fact, if you zoom into a sampled sound closely, you will see the same "jaggies" as you would in a bitmapped image.

That's because digitized recording is made in steps that are known as "sound samples." The number of samples per second is called the *playback rate*. The higher the number of samples, the truer the sound (just as an image with higher dpi will appear more realistic). Average sampling rates for digitized recordings are 8,000 to 44,100 per second.

CD-quality sound is not necessary for many digital productions. In fact, in order to limit your overall file size, it's wise to keep sound files as small as possible. One common method to eliminate the need for a lengthy sound file for background music is to use a *loop*, a short sequence of music that can be repeated over and over again.

Most sound software allows you to add several audio streams or **tracks**, like layers in graphics programs. These can be *mixed* (layered on top of one another). Sounds can also be cut and pasted. You can use cutting to clean up a sound file, such as eliminating the sound of the narrator's breath before speaking into a microphone. Once it has been located on the wavegraph, it can be quickly edited out. Sounds can be altered or *processed* with filters, for example adding echoes, changing the pitch of an actor's voice, or creating the illusion that the sounds are being heard in a cathedral.

Simple sounds can have big effects, like the "whoop" of a slide whistle as a character slips and falls. That's why sound effects have always been popular with animators. More complex ones can add to the excitement of a scene, like footsteps coming closer and closer as sinister music gets louder and louder. "Foley sounds" are sound illusions created in the studio, like snapping a piece of celery to sound like a bone breaking, frying bacon to simulate rain, or banging coconuts to mimic horses walking.

Any animator will tell you that the time and effort spent in developing a soundtrack is well worth it. You'll know it the first time you put a sound in one of your animations.

TWO-DIMENSIONAL ANIMATION

Cel or Key-frame Animation: Traditional and Digital

What most of us think of as animation is **cel** or *key-frame animation*. In the traditional process, cel animation is a time-consuming product of filming drawings made on sheets of clear acetate or cels. One

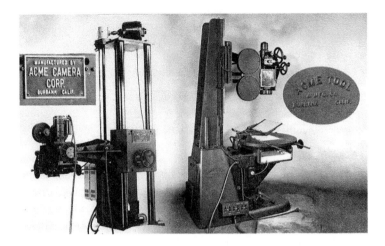

10.21
The Acme animation stand

frame of action might require several cels stacked on top of one another (for example, a background, middle-ground, and character) which are then photographed. Careful registration is ensured by placing cels on a fixed platform with pegs that match punched holes in the cels. The most common peg and camera system is the *Acme*, a name immortalized in cartoons as the manufacturer of all incredible and improbable machines (see Figure 10.21).

In cel animation, whether you are working traditionally or digitally, a series of drawings is made that show a subject's changes of position. For example, in a traditional animation, a boat moving across the screen from left to right might require ten drawings with the boat's position changing an inch to the right in each one. In digital animation, the process is a bit simpler. Ten blank frames are created. The boat is drawn, copied and then pasted to a new position in each frame. Most digital software provides an **onion skin** function that allows the animator to see pale versions of previous drawings as if they were on semi-transparent pages.

Traditional animators draw and paint on clear cels and then lay them over any elements that do not change (like a background). The background can be seen below and used for several frames. In the moving boat example, one drawing of a lake and shoreline can be used in all ten frames. If animating a head talking, a drawing of a character's head without a mouth could also be used for several frames while only the mouth is animated on another layer of cels.

In digital animation, the equivalent of the stacking of pages of clear cels is the use of **layers**. In each layer, any part of the frame that is not drawn on remains transparent. So a background with no animation simply is drawn once on a layer and left on screen for the necessary number of frames. It will be seen behind the other layers that contain characters and other elements.

The Timeline

The timeline is the backbone of all animation software. This is where one works with the frames and layers that make up an animation. Individual frames or entire segments can be shifted in time by cutting and pasting. Layers can be repositioned so that, for example, a fish passes behind a rock, not in front of it. The stacking of multiple layers, therefore, is an important aid in creating a sense of depth. The timeline is also where soundtracks are synchronized with images; with each track of sound appearing as a separate layer.

Tweening

Most traditional animation studios have a division of labor where lead animators create **keyframes**, or moments of important changes in action, and **tweeners** have the more tedious responsibility of drawing the in-between frames. Digital animation software automates this time-consuming process. After one has drawn an element on the first keyframe, a specific number of frames are created for the tweening sequence. Changes are then made to that element in the last frame. The program will calculate the differences between the first and last frame and *tween* them, in other words, create the in-between frames, making a smooth transition over time. Tweens can be used for changes in shape and size (usually called *morphs*) (see Figure 10.22), position, rotation, color, and transparency. Since the tween will be absolutely smooth and mathematical, most animators edit tweened sequences to make them appear more natural.

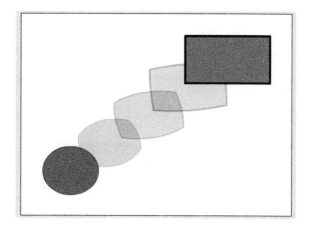

10.22
Tweening of two shapes

Cycles

Because of the tedious nature of creating animated action, all animators have looked for shortcuts to simplify the process. One of the most time-honored is the **cycle**, where a short sequence is repeated several times to form a longer action. For example, to make a bird flap its wings only three changes are necessary (see Figure 10.23). The wings should be drawn in the up, horizontal, and down positions. This sequence of three drawings can then be traced over and over again and simply moved to different positions across the screen to create the illusion of a bird flying around. The key to success in a cycle is to create an end frame that leads naturally to the first.

In digital animation, these repeating cycles are sometimes known as **animated symbols**. They are saved with a project's file and can be reused over and over again in different places. A shuffling walk, clocks with moving hands, fishes with swishing tails, and spinning car wheels are all typical examples of animated cycles.

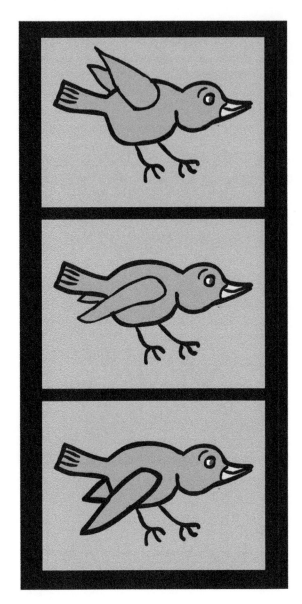

10.23
Simple cycle of a flying bird

Creating and Importing Elements

Most animation software contains basic painting, text, and selection tools that are familiar to anyone who has worked with image-editing, drawing, and painting programs. Elements can be created that can be resized, rotated, or grouped. However, the main purpose of animation software is the complex task of creating movement and combining the various parts in a timeline. As in all digital projects, it is best to make use of a variety of programs, utilizing each software package's unique strengths. Complex and detailed shapes are often best created in programs dedicated to that purpose and then imported into animation software.

Many digital animators actually begin by drawing their elements by hand with traditional tools like pencil or pen. They then scan their drawings. Most animation software has a function that will import these drawings and allow them to be used directly as animatable forms or permit the animator to convert them into animatable forms by tracing.

The Web: GIF Animations

Animation has had an important role since the earliest days of the World Wide Web. However, because of the large size of bitmapped images and the resulting slow download time, special software was developed to keep the file sizes of animations with multiple images relatively small. One of the earliest answers to small Web-sized animations was **GIF animation** also known as the **GIF 89A** format, which continues to remain popular particularly on social media.

In a GIF animation, several bitmapped pictures are linked together and appear animated as they play sequentially. The critical issue in GIF animation is achieving a significant impact while keeping the overall file size small. No matter how interesting your sequence is, Web users will not wait patiently while an animation takes minutes to download.

For the Web and Beyond: Vector Animation

A more sophisticated method of creating animations for the Web utilizes vector forms rather than bit-mapped ones. Two of the most popular vector animation programs are Adobe Animator (formerly Flash) and Toon Boom. As discussed in Chapter 9, because vector graphics define forms by mathematical equations, they result in much smaller file sizes than bitmapped images.

Another way vector animation software keeps file sizes low is by re-using single versions of an object in a library rather than saving multiple copies of it. When an object appears again, only a new reference to it, not the object itself, is added to the file. Imported sounds are stored the same way, so, for example, one explosion can be used many times over the course of an animation. Even animated cycles, like a character walking, can be stored as animated symbols and reused over and over again with little increase in overall file size. Because of their relatively small file sizes, complex, long vector animations can be created that download quickly.

With relatively low-cost software, new and professional animators have embraced vector animation (see Figure 10.24) and use it to create not just short sequences, but classic length, seven-minute

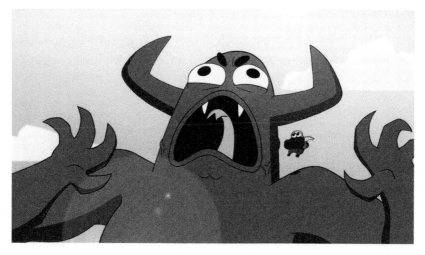

10.24
Scenes from a vector animated cartoon by Alexandre Pelletier, *Gnome the Barbarian*, 2019

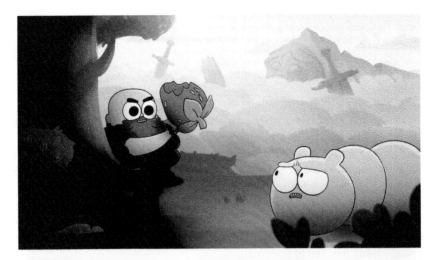

10.24
(Continued)

cartoons. These are not just for the Web. Nickelodeon and Cartoon Network regular broadcast cartoon-length vector animations that are also available on their websites. Even feature-length animations for distribution to theaters have been produced by creative and independent animators (see Artist Profile).

Artist Profile: Nina Paley

One great result of the digital age is that powerful but fairly low-cost tools have been put in the hands of individual artists. Nina Paley was a comic strip artist when she moved to India after her husband took a job there. While on a short visit to New York, her husband emailed Paley not to return because their marriage was finished. In "grief, agony, and shock," Paley, over the next three years, turned her anguish into a feature-length animated film as a one-woman production company.

10.25
Scenes from Nina Paley, *Sita Sings the Blues*, 2008

Sita Sings the Blues (see Figure 10.25) was done on one computer mixing many animation techniques and styles. Some sequences were made from scanned-in collaged cut-outs, photographs, and hand-painted backgrounds. Others are pure 2-D vector computer animation. Specifically, the episodes that tell the story of her failing marriage are drawn in Paley's jittery comic strip style. These are interspersed with sequences that convey the 3,000-year-old Indian Ramayana epic in a style reminiscent of Betty Boop cartoons. Mixed in is commentary by three contemporary Indians (portrayed as shadow puppets) who struggle to remember the story of the myth they learned as children.

In the ancient Hindu legend, the god Rama betrays his faithful wife Sita after she is kidnapped by a demon king. Paley was attracted to the story because it seemed to be a mirror of her own. "Why did Rama reject Sita? Why did my husband reject me? We don't know why, and we didn't know 3,000 years ago. I like that there's really no way to answer the question that you have to accept that this is something that happens to a lot of humans."

According to Paley, the film is "a tale of truth, justice, and a woman's cry for equal treatment." When the film premiered in 2008, critics were amazed at Paley's accomplishment, particularly because her longest animation before *Sita* was only four minutes long.

The film's soundtrack is an unusual blend of traditional Indian music and early Jazz Age recordings like "Mean to Me." Unfortunately for Paley, while the songs gave her inspiration, the jazz ones were still under copyright protection. After learning of Paley's success, the owners demanded $220,000 in payment for the rights. At that point, Paley, who had financed the film herself, was already in debt for more than $20,000. It seemed that three years' work was about to be silenced.

Instead, Paley responded by releasing her high definition film for free on the Web. Because of a special clause in copyright rules, she was also able to broadcast the film on public television.

A year after the film was finished, the copyright owners finally agreed to let Paley make a limited-edition DVD after she paid them $50,000. She did that but because of her miserable experience with copyright law, Paley is now a firm believer in a copyright-free society and a strong supporter of Creative Commons (see box in Chapter 7). On her website, she encourages her audience to "Please distribute, copy, share, archive, and show *Sita Sings the Blues*. From the shared culture it came, and back into the shared culture it goes."

CONCLUSION

Animation is in the midst of a renaissance. Commercially, the impact of animation can be seen in commercials, hugely successful feature films, and entire television networks devoted to showing cartoons. Animation has also found a new world-wide theater on the Web. In the hands of a skilled designer, it can also become an integral part of the design of a website. But it is no longer the exclusive domain of specially trained professionals. Animation can now be a mode of expression for any digital artist who has access to relatively inexpensive hardware and software.

Nevertheless, as seen in this chapter, even with the aid of digital techniques, animation remains a time-consuming process. Effective animation requires the study of time-honored animation principles and procedures. It has its own visual vocabulary and physical principles. For success, nothing can replace diligent study and practice. With them, you can move beyond concepts, techniques, tips and tricks into fluency in the language of animation.

Projects in Two-Dimensional Animation

1. Make a flipbook animation using 25 3″ x 5″ index cards. Drawing in pencil on the cards, show a simple boat moving right to left, hitting an iceberg and sinking.

2. Create your own version of a short digital animation of a ball bouncing (see Figure 10.15). In 15 frames, have a ball enter from the left, hit bottom and spring up and out of the frame at the right. To make your animation more convincing, draw the ball when it hits the bottom as a flattened ellipse. To show the effect of gravity, increase the distance the ball travels in each frame as it moves downward. After it springs upward, slowly shorten the distance between frames. By the fifteenth frame, the ball should be beyond the edge of the frame. Set your animation software to play your film as a loop and the ball should smoothly repeat its bounce over and over again.

3. Using layers, create an animation of an aquarium. Show a variety of fish moving in different directions. Make a background with typical home aquarium items. Put plants in different layers, so the fish can pass in front of and behind some. If your software has this capability, a semi-transparent blue gradient can be located in the front layer to increase the sense of looking through water to see your characters moving.

11 Three-Dimensional Modeling and Animation

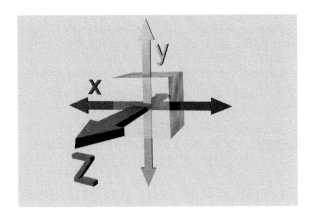

11.1
Imaginary box of space with X, Y, and Z-axes

INTRODUCTION

Because of the popularity of computer games and motion pictures like *Jurassic Park* and *Toy Story*, *3-D modeling* (the construction of digital objects that can be viewed at any angle) and *3-D animation* (the movement of such objects in virtual space) have become the best known of the digital media. Their basic procedures have been demonstrated in numerous "The Making of . . ." videos. Digital artists are usually featured in these promotional films as people creating convincing representations of incredible creatures with the ease of a magician. By adding color, texture, and lighting to wire-framed forms, they conjure up a fully rounded world of their imagination with a few clicks of the mouse.

Of course, in reality the process is quite complex and demanding, as demonstrated by the lengthy credits following any film featuring 3-D animation. The many professionals who create these marvels spend years learning their skills. Thick books have been written on the most powerful software. Professionals know their success depends on continually learning and improving their skills. The power and capability of software is constantly increasing. Yet the effort is well worth it. Beyond the opportunities for 3-D modelers and animators in television, film, and games, 3-D artists are also in demand for print, advertising, medical illustration, product design, and architectural visualization.

This chapter is designed only as an introduction to this marvelous arena for imagination and its unique vocabulary. The range of techniques and approaches is probably more than any one person can learn in a lifetime.

For beginning digital animators, simply visualizing a group of objects in three dimensions and simultaneously moving them over a period of time is in itself quite a challenge. For those with experience in 2-D software, a few of the tools in 3-D programs will be familiar. Typically, there are pencil and pen tools, selection tools like a lasso, and simple geometric shape tools like a circle and rectangle. As in 2-D programs, objects may be grouped so they move together or combined to create more complex shapes. But there are many more tools and techniques that are unique to 3-D modeling and animation.

The basic steps of modeling and animating in three dimensions can be seen as the digital version of traditional clay, or stop-action, animation. First, as in the older form, the objects are constructed, in this case from virtual wire that is wrapped in color and textures in 3-D after texture maps and shaders are applied. Then lights are positioned. Cameras are placed that will "film" the scene. Finally, the animators control the action as the entire scene is recorded or, in 3-D animation terms, *rendered*. The process is time-consuming (movie studios use rooms full of linked computers), but because it is done entirely on computers, you can with time and effort create nearly anything you can imagine.

Before anyone begins learning the specialized techniques of 3-D modeling and animation, he or she must first understand the unique qualities of the stage where their creations will perform. Compared to the world of 2-D art, it is a very different kind of space.

The View in Three Dimensions: The Z-axis

Since our lives are lived in a 3-D world where there is constant movement, why should creating and animating in that kind of world be so difficult? First, we are not required to create very much of what we experience in our world. The sun, the sky, and the mountains are already there. Most of us have not built our houses or our cars. We buy dishes and televisions. But in 3-D modeling and animation, everything that is seen has to be created from scratch.

Second, we will be working in a virtual world. And even though both 3-D and 2-D space on a computer are an illusion, there is a profound difference between them. Mathematically, this is explained by saying that the width and height of the X- and Y-axes are now joined by depth, or the Z-axis. Artistically,

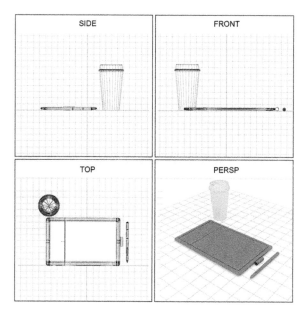

11.2

Multiple views of the same objects in three-dimensional software

this means that those experienced in 2-D techniques like imaging or illustration are forced to make a significant shift in what has to be considered. Instead of working on a flat surface, the computer modeler works in an imaginary box of space (see Figure 11.1).

To do this effectively, the modeler has to see an object from more than one angle. Most 3-D programs provide **viewports** (see Figure 11.2), different views of the object for creating and editing forms. There are usually four viewports, with an image of the object inside a 3-D grid from the front, top, bottom, and either left or right side. As you work, you can zoom in and out in each of the viewports, moving quickly from being close to the object to being almost infinitely distant from it.

However, the almost god-like view of the modeler is not the same as the audience who watches the finished animation. Generally, only one angle will be seen at one time and much will be cut off at the edges of the screen. Hence, it is important as you work to keep in mind what will ultimately be in the **viewing plane**—what the audience will see on screen in the final version.

Viewing Modes

In addition to the viewports, modelers need to choose the kind of *viewing mode* they will work in. **Shaded** mode shows each sculptural form in color as well as how it is lit; in terms of details, it is very close to how it will be ultimately seen by viewers. While it is the most helpful for the modeler, this mode is more demanding on the computer. Even with the great increase in computing power of today's processors, with a particularly complex model each change to a scene may take a few seconds to be *rendered* or redrawn slowly. Waiting for the screen to redraw while manipulating a form can become very frustrating.

This is why today modelers sometimes choose to work back and forth on a complex model in both shaded and **wireframe mode**. In wireframe mode, the *topology* of objects is displayed like a mesh sculpture wrapped in netting. Each line and vertice is represented and the overall form can be seen. Seeing these details also makes it easier for the modeler to make fine adjustments to the topology.

Flat shader is an even less demanding display mode that enables the modeler to see only the silhouette of the object, an important consideration for both 2-D and 3-D animators.

From time to time, most modelers will choose to check their progress by closing their multiple viewports and looking instead at the camera's view of the scene, in order to better gauge its effect on the audience. By rotating the object in *perspective mode*, the modeler can also check to see if there are any unplanned distortions of the 3-D object in any of the viewing angles (see Figure 11.3).

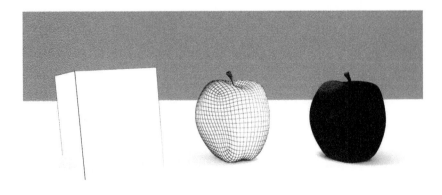

11.3
Three viewing modes: bounding box, wireframe, and simple shaded

MODELING: DIGITAL SCULPTING

Every element in 3-D animations has to be built or *modeled*. The construction of convincing 3-D forms in virtual space is an art in itself. While most beginners assume that animation is the most time-consuming part of the process, experienced 3-D animators know about two-thirds of their time on any project will be spent creating the models. Many professionals make this their specialty, leaving animating to others.

Each 3-D shape must be planned carefully. The first step is to analyze the shape you ultimately desire and break it down into its simpler components. Generally, each part is created separately and then assembled later. The collection of parts of a complex 3-D object (like a jet fighter before it is assembled) is not unlike what you might see when you first open a modeling kit sold in toy stores.

In 3-D modeling, objects are constructed out of a series of connected polygons, called a **polygon mesh**. Even a form as simple as a cube has six interconnected squares or **faces**. More complex objects will be made from thousands of small polygons. A closer look at the smooth surface of a sphere, for example, will reveal something more like a disco ball covered with many facets (see Figure 11.4). The modeler digitally sculpts by adding and subtracting from objects. Like an artist working with clay, the modeler stretches and pushes the forms by dragging the polygons to new locations (see Figure 11.5).

11.4
A close-up of a sphere shows its facets

11.5
Dragging a sphere's polygons will create new forms

Hard Surface vs. Organic Modeling

Modelers often divide their projects into either *hard surface* or *organic* modeling. Hard surface gener-ally refers to building static objects like a street sign, gun, statue, building, or other man-made forms. Organic models are ones that will deform or be animated, like characters, creatures, or a flag blowing in the breeze. However, the most important criterion is how the object will ultimately be used. A steel girder is almost always a hard surface model. But if a superhero will ultimately bend it, the girder's model will need to be designed organically.

Another way models are described is as either *stylized* or *photo-real*. Stylized models are abstracted and simplified, like a cartoon character. Photo-real models are extremely detailed, whether it is a kitten or a dragon. Modelers, even if creating imaginary creatures, use reference materials. The movements and textures of a dragon will seem much more convincing if they are based on study of a lizard's skin.

Working With Primitives

Whatever the type, most 3-D modeling begins with **primitives**, basic geometrical shapes supplied by the animation program. Typically, these shapes include cubes, spheres, cylinders, and cones. Primitives can be repositioned, resized, and rotated in all three dimensions. Altering or combining these simple shapes can create a surprisingly wide array of forms.

For example, by stretching a cube along the X-axis, it can be transformed into a shoebox. By com-pressing or *squashing* the height of a cylinder, it will take on the shape of a can of tuna. These kinds of changes are called **deformations**. Other kinds of deformations include bending, twisting, or skewing the object in one direction (see Figure 11.6).

11.6
Primitive shapes (cube, box, sphere, cylinder, and cone) and simple deformations of them

Techniques for Modifying Two-Dimensional Forms

An even simpler approach to modeling in three dimensions is to start with a 2-D form. One can begin by drawing with the pen tool to create a shape made up of Bézier curves. Like all vector drawings, points can be added and subtracted.

Once the flat shape is right, the modeler can use a variety of techniques to transform it into three dimensions. The most commonly used method is *extruding* or *lofting*, which gives the shape depth by pulling it out into 3-D space. Extruding gives a flat shape volume by adding a Z-axis to the flat shape

and extending the shape along it. For example, by extruding a circle vertically upward, you can make a column. The process is much like the children's toy that forces clay through a cutout shape to make long, snake-like forms. The outer edge of the extruded form is determined by the outline of the cutout shape. Like those toys, extrusion is generally used for fairly simple solid forms that will later be edited. In essence, it is a technique to use 2-D shapes to create your own 3-D primitives.

Beveling is the simplest and most well-known type of extrusion, often used to give text a 3-D look. Also called *face extrusion*, the process pushes forward a flat shape and adds angled edges along its sides, so the original shape becomes the front face of the new 3-D object. This technique first caught the public's eye when "flying logos" began to appear at the beginning of sports telecasts in the late 1980s (see Figure 11.7).

In **sweeping**, sometimes called **lathing**, a simple shape is spun around its center to create a new object with volume. The classic example is the sweeping of a wineglass (see Figure 11.8). The profile of the glass is drawn as a thin, flat shape. It is then spun by the program along its center to make a 3-D glass with its open cupped top, thin stem, and rounded base. This process can be used to create basic shapes (for example, a swept right triangle would create a cone) or many complex 3-D forms, like elaborate chair legs, with relative ease.

11.7
Extrusion of a shape without and with bevel

11.8
Sweeping a wineglass

Boolean Operations

To create even more complicated solid forms, modelers overlap solid shapes and combine them in a variety of ways. These methods are called **Boolean operations** and the various techniques used are similar to the ways compound forms are created in vector illustration (see Chapter 9).

In a Boolean **union**, the outer forms of two volumes are adding together and whatever intersects internally is eliminated. For example, the rough form of a derby hat could be made from a half sphere unified with a dish-shaped disc. One of the most useful Boolean operations is **subtraction**, where one form is cut away from the other. If the grouping of sphere and dish was done as a subtraction rather than an addition, the dish-shaped disc would end up with a circular opening. Another kind of Boolean operation is the **intersection**, where only the overlapping parts of the two shapes are preserved and every other part is eliminated. In this case the combination of the half sphere and the dish would result in a smaller dish (see Figure 11.9).

Spline-based modeling applies more subtle changes to solids. Rather than moving and pushing whole polygons in a wireframe, the curved **splines** that make them up are individually edited. Splines are similar to the Bézier curves found in vector illustration programs (see Chapter 9). Each curve has control points that can be pulled and dragged to reshape curves.

NURBS (non-uniform rational b-splines) are a special kind of spline designed for modeling organic forms. In most splines, each control point has an equal impact on a curve. But a NURBS spline has adjustable weights attached to each control point so you can increase or reduce the impact of any change by individual control points. Weighting control points permits the finer modifications to a spline curve necessary to make the more subtle, complex curves found in natural forms.

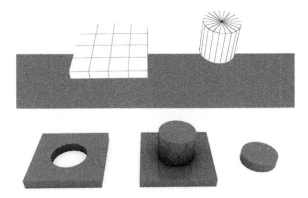

11.9
Boolean operations: subtraction, union, and intersection

Digital Sculpting

All of these techniques are designed to create fundamentally geometric forms that are quite far from the more free-form shapes that amaze viewers of films like *Avatar*. Unless you are creating an architectural scene or machinery, these basic volumes are usually just a starting point. Like a traditional sculptor's block of wood or lump of clay, their geometry will then be digitally sculpted by hand to realize more remarkable visions. This can be called *organic modeling*, **free-form modeling**, or, simply, *digital sculpting*.

Most modeling software, like Maya or 3-D Studio, allows you to shift and pull the vertices and polygons that make up the wireframe mesh that covers all 3-D objects. This can be a very effective technique to create modeled forms. However, advanced modeling software is required to sculpt 3-D objects in finer detail.

In **direct-point** or **surface modeling**, individual vertices in the wireframe mesh can be dragged and stretched to reshape the surface of a form. By clicking and pulling many points, a sphere can become a head or a cone can take on the appearance of a mountain.

Since the arrival of Pixologic's Zbrush in 1999 (and subsequently Autodesk's Mudbox) most professional digital sculpting today is brush based, allowing lots of freedom and the ability to create models with millions of polygons. Manipulating a mesh with digital brushes results in models with a much higher level of detail than other methods. As in the past, the modeler will start with a primitive such as a sphere, but brushes can pull on forms to stretch them out. A thin shape can be inflated to give it more body. A smoother brush can be used to polish any rough edges. Brushes with texture can apply it by hand (see Figure 11.10).

Highly detailed models are not necessary for every project and make most sense for projects in film or toy modeling (see Artist Profile). No matter the method, like any good sculptor, digital sculptors should rotate the model often to make sure it makes sense from all angles. Fine surface details should be added near the end of the process.

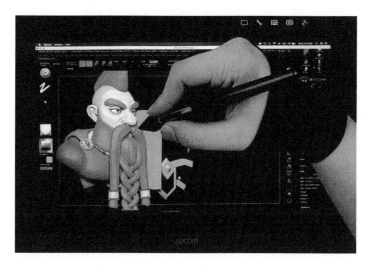

11.10
Direct-point modeling with Wacom Cintiq and Zbrush

Scanning in Three Dimensions

Three-dimensional scanning is another method to create digital models and can be a useful shortcut in complex projects. As part of the production process, Pixar's character designers, for example, will create clay models based on character sketches. These will then be 3-D scanned and handed to 3-D modelers for editing. Scanners can range in size from small ones that easily fit on a desk to those large enough to scan an entire person. They generally come in two types: one has an arm that touches the subject to create its data, whereas non-contact scanners use light or radiation to collect their information. These can create much more detailed models but have trouble with transparent or shiny objects. (See more on scanning 3-D movement on page 255.)

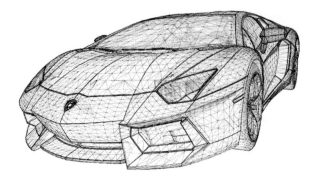

11.11
Complex wireframe of Lamborghini

If these many modeling processes seem far too complex at first, it may be reassuring to know that you can purchase mesh models from many companies who sell libraries of all kinds of forms to animators. Some of these are quite expensive and made by using sophisticated 3-D scanners that are far beyond the finances of most artists, but many free mesh objects are also available on the Internet. Some programs come with libraries of start-up models—useful elements like trees and ponds for a modeler's use. Rather than spending hours to painstakingly recreate a sports car with its many elaborate shapes, you can download a wireframe model of a Lamborghini and spend your time in the next important steps: coloring and adding textures (see Figure 11.11).

Texture Mapping

Once a wireframe model is finished, the next step is to add a surface or skin to it. This is called *texture* **mapping**, and includes the addition of colors, patterns, materials, and textures, as well as properties like shininess and transparency. Mapping is an almost magical process; one wireframe shape can take on many skins and become the parent of many different and equally convincing objects. A wireframe of a simple sphere, for example, can become a rubber ball, a marble, or a ball bearing depending on how it is mapped (see Figure 11.12).

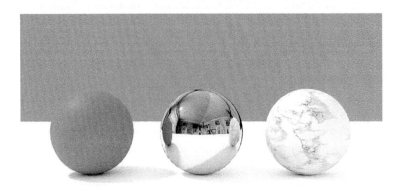

11.12
Spheres mapped with three different textures

Modeling programs include a large collection of preset textures to make this process easier. Among the categories you can choose from are plastics, woods, metals, and glass. Applying the preset texture automatically adds the special qualities of that material, such as its colors, whether it is transparent, or how it reflects light.

Texture mapping (sometimes called just *texturing*) is one of a modeler's essential skills and most important time-saving tools. In this process, a bitmap image is wrapped around a wireframe form. By choosing a picture of a texture, a primitive shape can appear to have a very complex, modeled surface— without a modeler having to go through detailed point-to-point editing of the wireframe mesh. It also eliminates the long processing time necessary to render such complicated forms. For example, instead of the time-consuming effort to reproduce the rough texture of a brick in a wireframe model, a convincing brick can be made by simply wrapping a picture of a brick's texture around a basic rectangular box shape. A column can become a complexly textured tree trunk with just an image of tree bark. In the more precise *UV mapping* (see Figure 11.13), the flattened 2-D textures are overlaid with a grid and point coordinates that correspond to specific points on the 3-D model. ("U" and "V" refer to the horizontal and vertical axes of the 2-D image, since X and Y are already in use by the 3-D model.)

Textures for mapping can be created from scratch using paint or image-editing programs. Some modelers will simply grab their digital camera and take a photograph of a surface, like the bark of a tree in their backyard. Or they'll search through thousands of texture images available in online stock libraries.

Texture mapping is a technique that is often utilized in video games, to ensure that scenes are rapidly rendered. If a vehicle is going to speed by a brick wall, it doesn't make sense to do more than create a flat wall shape with a bitmapped picture of brick on it. Experienced modelers know that in many parts of any scene, it is only necessary to create an impression, not a literal representation. Complex models are reserved for important objects that audiences will study extensively and appreciate, like the vehicle the gamer is driving or a weapon.

What many call texture mapping is not limited to creating the illusion of textures. In a raceway scene, the modelers will wrap images or *decals* of numbers and company logos across cars

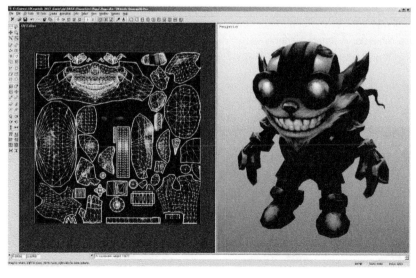

11.13
UV Map for three-dimensional model

and use bitmaps of a small collection of faces, for example, to create crowd scenes from simple wireframe forms.

Bump maps are a step beyond texture mapping in realism. This technique alters the way light reflects off a surface, simulating the way an actual textured surface would reflect the light, without actually changing the geometry of the outside of the model. The illusion of the texture's depth is based on the contrast between the bright and dark parts of the image. For example, the dark areas of a wood grain bitmap would appear indented while the light ones would be raised. By embossing a bitmap of an orange's dimples to a sphere as a bump map, you can create the illusion of an orange's texture without tedious modeling.

With modeling and texture techniques, you can create objects with complex and remarkable surfaces. However, for a 3-D scene to be truly effective, it has to be more than a collection of objects, as marvelously realistic as they may be. To bring an entire scene together and unify it, artists use the power of light.

Lighting

Lighting a 3-D scene is an art in itself. It can mean the difference between ordinary and dramatic expression. A single candle, a fireplace, or a child's innocent face transformed into something quite different by applying a flashlight just below the chin are all examples of the impact of lighting. Just like on a stage, the 3-D modeler will place lights to establish the appropriate mood and focus the audience's attention. Well-placed lighting will enhance the objects in an image and the theme of the picture.

There are three basic kinds of lights: **ambient**, **fill**, and *spot* or *key light*. **Ambient lighting** is not focused, spreading light across an entire scene. The objects in a scene lit by ambient lighting alone are easily seen but tend to appear flat and dull. Fill lighting (sometimes called **omnidirectional**) is somewhat more focused, spreading light from one general direction, but does not cast strong shadows or make highlights. **Spotlighting** (sometimes called *key lighting*) is the most focused. It is emitted from one point and directed at another, usually as a cone of light. Spotlights create concentrated lighting with high contrast shadows. Changing their angles can dramatically change the effect of a scene. The most effective lighting combines at least two of these types (see Figure 11.14).

For example, the harshness of a spotlight can be moderated by adding ambient or *global illumination*, which will add light to the shadows, so the contrast between light and dark is not as harsh and appears more realistic. A flatly lit scene with ambient lighting can be given more drama by lowering the ambient light and adding a spotlight on the main subject in the scene to emphasize its importance.

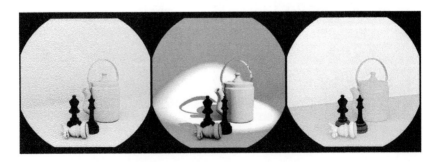

11.14
A scene lit by three lighting types: Ambient, Spot, and Fill

Most 3-D modeling programs provide many more options beyond choosing among the three types of lights and adjusting their angles. The brightness and distance from the scene or target can also be adjusted. This allows the modeler to distinguish between the light cast by a lamp on a desk and the broad power of the sun on a summer's day.

Pure white light is rare in the natural world; most lighting has a *cast* to it or a tendency towards one color. One of the most important choices a modeler makes when lighting is adjusting the colors of the lights. The color of interior lighting will have a significant impact on a scene. It can determine whether a room can seem cool and forbidding or warm and inviting. For example, the blue cast of fluorescent lighting will seem more appropriate in a large department store than in the warm study of a home. Colored lights are also an excellent way to depict the time of day in exterior scenes. Morning light has a red cast, while the light at noon tends to be more yellow.

As important as lighting is, it should be used carefully and not excessively. If you create a scene with many lights and shadows, it will not only appear unnatural but also will greatly increase the scene's complexity and considerably increase its rendering time.

The Camera and the Audience

As discussed at the beginning of this chapter, most 3-D programs provide four viewports, different views of the object for creating and editing forms. The viewport is usually a 3-D grid with a wireframe version of the object or objects seen from the top, bottom, and sides.

But this is not the point of view of the audience. The viewer can only see what is in the frame of the finished image. To be successful, the 3-D modeler should never lose sight of this. As in photography or any of the other fine arts, choosing what will be in a frame, how a scene will be cropped and presented, is decisive. A table setting of beautiful objects, lit dramatically, can lose all its impact if seen from too great a distance. A happy couple dancing in a garden turns nightmarish if all we see is a close-up of their teeth. The placement of the viewing plane can determine not only what the audience sees in a scene but how they understand it.

In order to set the edges of the frame, the modeler first places the camera **target**—a marker that shows where the camera is focused—on the wireframe drawing. Surrounding that marker is the **viewing plane**, the rectangular field that contains the only section that the viewer sees in the frame. This widens or shrinks depending on how distant the camera is located from the scene. It is important to take the time to set the camera and the ultimate viewing plane carefully. Rotate and adjust them until the scene is framed in a strong, meaningful composition.

Focus

Another way to influence what the viewer is focusing on is by adjusting the camera's *focal length*. This is a term borrowed from conventional cameras, where changing the lens on a camera will result in different effects by shifting what is seen in focus. The focal length controls both the **depth of field** and **field of view**. Depth of field is how far back things can be seen in focus. Field of view is how wide or narrow is the area seen in focus. The shorter the focal length, the wider the view. Among the choices that 3-D software recreates are wide angle (for distant scenes), macro (for extreme close-ups), and telephoto or zoom lenses (see Figure 11.15). Creative use of focus is another important technique for 3-D artists to direct the view of the audience and affect how they perceive a scene's meaning. For example, in a churchyard, depending on your use of the depth and field of view, your audience will see either a sharply focused hand reaching for another, with vague stonework in the background, or a shadowy couple at the entrance of an old medieval church, covered with beautifully carved figures.

11.15
Using different camera lenses for different effects: normal, wide angle, and telephoto

RENDERING AND SHADING

After the models have been created, the lights set, and the camera positioned, the moment of truth for a 3-D image has arrived—**rendering**. Rendering is the computer generation of the finished scene from the viewer's point of view. A bitmapped image is created from the polygons of the wire meshes, the mapped colors, and textures, along with the lights, shadows, and reflections. If special effects like smoke and fire have been added, their impact not only on the atmosphere but on every surface needs to be calculated by the computer, too.

Even in an age of ever faster and more powerful computers, this is usually a lengthy process that requires the patience of the visual effects artist. As with much of digital media, just as the hardware has increased in capacity, so has the software increased in complexity. Modeling procedures, which recently were only possible on mainframes, are now commonly available on a digital artist's desktop. Rendering intricate models with many textures and effects remains a demanding, highly intensive processing operation. For many scenes, the old 3-D artist's joke remains true—after you enter the command for rendering, it's time to go make dinner. In some cases, it's also time to eat dinner and go to bed.

Before rendering begins, there remain some important choices for the modeler that will affect the quality of the final image. What resolution should it be? What should be its color depth or number of colors? Your decisions should be based on your ultimate goal. What kind of output is planned? Is the image going to be high-resolution print or a resin model? Is it going to be featured on a website? (Chapter 7 provides a discussion of resolution, color depth, and output.) Another decisive factor in the ultimate quality of the image is what method of **shading** will be used to render the 3-D image.

Shading Options

Shading transforms the geometrical net of polygons in a wireframe model into an object whose surfaces have color and tone. With more complex **shaders**, objects can become shiny and have highlights and reflections.

There are several standard ways to shade surfaces. **Flat shading** (sometimes called *facet surface shading*) is a simple approach that applies one tone and color to each facet or polygon on the surface of the model. Because of its simplicity, it renders faster than other methods but results in very geometric-, almost cubist-looking 3-D forms. Surfaces tend to be flat and dull and edges often have the "jaggies." The first 3-D video games were dominated by this method. Today, few final images are made with this method, but most modelers will make "quick renders" with it during the modeling process to check on their progress.

Gouraud shading (or *smooth shading*) was developed by Henri Gouraud while a graduate student at the University of Utah in 1971 (see Chapter 3). This rendering mode results in much smoother tonal blends, by mathematically interpolating and, hence, smoothing the edges of the polygons. It approaches shading as a series of colored lines. A model rendered with the Gouraud shader will have a surface that appears to be shaded with gradients.

Another graduate student at the University of Utah, Bui Tuong-Phong, developed an even more complex form of shading, known as **Phong shading** (or *specular shading*) in 1975 (see Chapter 3). His approach smooths the polygons of a wireframe pixel by pixel, rather than line by line. This made it possible to add shiny highlights and reflections to 3-D models but also results in much more time-consuming renders.

Ray Tracing

Ray tracing is one of the most realistic rendering approaches. This setting recreates the reflections of light and color that we use to see objects in the real world. A line of light is traced

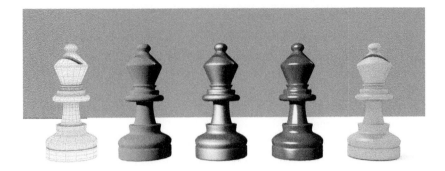

11.16
Rendering a wireframe model with different shading options: Flat shading, Gouraud shading, Phong shading, and Ray Tracing

from the light source to every pixel of an object and then bounced to the camera as a light ray. Depending on the nature of the model's surface, the light will bounce in different ways. For example, a brick and a metal pipe reflect light differently. A transparent glass filled with colored water will bend the light rays. Ray tracing calculates these differences as it renders the scene. This mode of rendering is used for many of the special effects we are familiar with in movies, like fog and smoke.

As might be expected, the more complex the reflections or the bends of light, the more computer intensive are the renders. Still, the convincing photorealism of ray traced images is well worth the extra time (see Figure 11.16).

Rendering for Production: How Much Detail Should Be Used?
While a highly detailed model can be impressive, professionals try to keep their polygon count (also called *polycount*) as low as possible. A model is not finished until all unnecessary geometry is removed. This is particularly important if the model will be used in a game where its complexity could bog down movement and prevent "real-time rendering." Any unnecessarily detailed models will have to be modified in a process known as "retopology," which lowers the polygon count so an object can be redrawn quickly by the game engine.

One should also consider how the model is going to be seen. An up-close object (also called a "hero-object") requires much more detail than something seen only at a distance. In general, professional modelers admire "clean topology" or ones that are easy to work with and edit.

Once all models are cleaned up, the rendering of a scene begins. Colors and shading are applied, materials and bitmapped textures are wrapped around surfaces, the amount of light on any surface and how it bounces is determined, and highlights, shadows, and reflections appear. When these calculations are finished, special effects like motion blur or fog are applied and much of the earlier work is recalculated and reapplied. Then the long hours of work and waiting are over and a finished image is created (see Figure 11.17).

Rendering can be handled in real-time or off-line. Most models for games and short animations can be handled on a powerful desktop computer. Higher quality models like ones to be used in feature films or toy manufacturing will be sent to *render farms*, companies with many computers linked together to share complex, highly intensive processing chores.

11.17
Complex rendered image

Three-Dimensional Printing

Of course, a 3-D model can also result in an actual object. The arrival of relatively low-cost 3-D printing has revolutionized 3-D modeling in much the same way that laser printing changed graphic design forever. 3-D prints can be used as prototypes for any product manufactured, from action figures to furniture. They can help visualize architecture or a character design. As in 2-D, there is still a significant demand for service bureaus to handle large-scale, complex renders.

Three-dimensional printing is usually an additive process. Models are built up layer by layer, each layer stacked on top of the last one and fused together. Three-dimensional printers have special software that can translate a 3-D model into layers, as well as rescale the original model. Additional software can be used to prepare the model for printing in parts that will ultimately fit together and fix design issues.

Home 3-D printers use a kind of glue-gun approach. Thin filaments pass through an extruder that heats them until they melt and can form a layer on the print bed below. The filaments are usually either PLA (polylactic acid), a biodegradable plastic made from natural materials like cornstarch or ABS (acrylonitrile butadiene styrene), a stronger plastic with a higher melting point. ABS is commonly used in children's toys.

Factors like cost, time, materials, and purpose go into choosing what kind of printer is needed for a project. Higher resolution or production printers will use better, but more costly quality resins for finer details and smooth surfaces. Expensive ones can handle details at the micron level and blend thousands of colors. Printers that fabricate in plastic are used for models that require more strength and thickness or greater size. Milling machines go beyond additive building in plastic or resin and can cut complicated shapes out of metal and wood. Metal "sintering" printers can now combine laser burning with powdered metals, like gold, silver, chrome, titanium, steel, and aluminum to create metal prototypes or even usable parts. Sometimes a 3-D printer is used to create only the molds for a limited run model like an imaginative toy for collectors. (See Artist Profile.)

We are still in an early era of 3-D printing with more detailed, stronger, and larger scale 3-D prints coming in the near future. Already, small 3-D printed houses are being made out of components that mix biopolymers and powdered volcanic rock. These prototypes may well become the standard approach to emergency housing after disasters or the way the first settlements on Mars will be constructed.

Artist Profile: Michael Milano—Making limited-edition models for collectors

Michael Milano is a professional 3-D modeler who has loved character design since he was a teenager. After graduating in 2008 from Savannah College of Art and Design with an MFA in Animation, he has specialized in creating characters for animations, commercials, games, and even jewelry for a variety of companies. But his passion is to create limited-edition models, like "Venom" (see Figure 11.18), that are popular with collectors around the world.

While his impressive skills in character modeling using Zbrush and Maya are easily seen, what is not so apparent is the amount of planning necessary to prepare these models for 3-D printing and assembly.

Each file has to be sliced apart into "fitted pieces" that can be easily assembled later (see Figure 11.19). Even more challenging is making sure each fitted piece is designed to make sure it can be cast and duplicated in order to create limited editions. This took much trial and error when he first began.

According to Milano,

> The hard part was learning the best places to slice up the model for molding, which took some trial and error. Fitting the pieces can also be challenging, and sometimes [I] have to get creative for the smaller and more delicate parts.

The precision of his designs cannot be replicated with the low-cost 3-D printers that consumers can afford. That's why Milano uses online printer services with the resources for the latest and best equipment. While much more costly, he's always impressed with how today's 3-D printing companies can output "a near duplicate" of his digital files (see Figure 11.20) and "capture every detail."

Obviously, many hours of work go into his designs. But for Milano, the rewards of the results are very satisfying.

> It has been fantastic speaking with clients from all over the world. Many people are avid collectors and gamers, and typically enjoy assembling and painting model kits.

11.18
Michael Milano, Venom (external view), 2017. Three-dimensional view in Zbrush of 2.9" model

11.19
Michael Milano, Venom (internal view), 2017. Three-dimensional view in Zbrush of 2.9″ model

11.20
Michael Milano, Venom, 2017. 2.9″ acrylic model

I absolutely love getting back images of purchased models they've painted and really made it their own.

He is looking forward to what the future holds for modelers like himself. While he sees more precision and affordability in the years ahead, in the meantime he's pretty happy being able "to transform my digital creations into physical models."

For some artists, a fully rendered 3-D model, like a mountain landscape in the Alps or the interior of the living quarters on a distant planet, is the finished work. However, for many others, modeling forms, placing the lights and the camera are only preliminary steps in a longer process—in essence, they just set the stage for *action*.

THREE-DIMENSIONAL ANIMATION

Movement in Three-Dimensional Space: The Z-axis

While most of the basic techniques and concepts used in 2-D animation apply to all animation, the world 3-D animation moves in is quite different. Two-dimensional animation is based only on the X- and Y-axes, but each element is fundamentally flat. One has to create the illusion of changes in depth. The addition of the Z-axis in 3-D animation not only provides a much more convincing sense of depth and solidity, but a whole other dimension for movement. The camera can soar over and under objects. When a boat roars past we can see its bow; when a dragster's front end rears up, we zoom in on its undercarriage to see the dripping fuel. Because of sophisticated 3-D modeling software, these movements can be combined with photo-realistic objects and create remarkably convincing effects.

Keyframes and Motion Paths in Three Dimensions

As in 2-D software, 3-D animators create movement by positioning objects in keyframes and utilize timelines to keep track of the animation. Markers indicate the keyframe on the timeline. The software *tweens* the frames in between keyframes. The main difference between 2-D and 3-D animation in this regard is that the position of objects can vary on three axes, rather than two, so an object can move across the screen, under, and away from the viewer. More powerful software and hardware are needed to calculate these kinds of changes. Once the animator has taken the time to draw an object in three dimensions, the software will take care of redrawing the object as it changes its position.

Motion paths can be drawn to guide an object's movement. These, too, are seen along three different axes. In 3-D wireframe mode, one can see the relation of an object to its surroundings over time by studying its path. Having objects follow paths makes more fluid movements possible. The paths can be drawn with either free-form or geometric tools. Editing the path is done by *curve editing*, clicking, and moving points on the curves or **splines** (see Chapter 9). New spline points can also be added to create more complicated movement.

Motion paths can be used to control more than objects. Just about anything can be moved with motion paths, including lighting and the camera. In a very active sequence, an animator will even use a motion path to create a sense of the observer moving, along with the action in the scene.

Point of View and Camera Movement

As mentioned earlier in the chapter, the camera represents the eye of the viewer taking in the scene. Intelligent use of point of view is important in any animation. However, it is even more of a challenge in a 3-D-animated environment because of the variety of possibilities. Like a play's director controlling which actors are on stage or off stage, the animator chooses what is in the viewing plane at any moment in time.

The movement of the camera can be an extremely dramatic element in an animation. Three-dimensional software recreates and utilizes the vocabulary of traditional film camera movement to create imaginative effects. For example, when a **dolly**, or moving platform, is attached to a track in a

11.21
The same scene from three different points of view

film studio, the camera can follow the subjects as they walk down a hallway. In 3-D programs, tracking will keep the camera dolly at a set distance from an object as it moves along a scene. **Dollying** moves the camera towards or away from objects to zoom in or out on subjects.

Unlike 2-D animation, **panning** in 3-D animation follows a curved motion, similar to a head turning to take in different parts of a scene. Cameras can also be *rolled* and *banked* to create effects like riding on roller coasters or spinning an airplane. Today, 3-D animation software provides the animator with an almost unlimited range of interesting, wild, and even strange uses for positioning and moving the camera. As exciting they may be, animators should first think about the purpose of the animated sequence before positioning their cameras. Ultimately, camera angles should be chosen for their dramatic effect only if they support the story (see Figure 11.21).

The Search for Realism

In stark contrast with 2-D animation, the history of 3-D modeling and animation software continues to be largely a search for more and more realistic and impressive effects (see Chapter 3). More convincing shading, lighting, and motion have been placed in the hands of artists because of innovations in software and more powerful processors and video cards. As these effects become ever more sophisticated, so do the challenges.

Physics and Gravity

To calculate the impact of the physical forces of the real world, like gravity and wind, on 3-D models in motion is an extremely complex enterprise. Luckily, most 3-D animation software has built-in tools to simulate these effects for you. Once an object's characteristics or **attributes** are set, realistic animations can be created that take into account the rigidity of an object, its weight and how friction and inertia might affect its movements. Without the addition of attributes, a character's feet might just pass through a floor as she walks.

Procedural Processes and Special Effects

External software or add-on packages, also called *third-party* **plug-ins**, can also be purchased to handle even more complex issues in physics. The software relies upon elaborate formulas that take into account the randomness of natural phenomena. For example, how would soft objects like a flag react to a stiff wind? What would a car's headlights illuminate on a foggy road at night? Many

companies have created advanced **particle systems**, which generate realistic special effects like smoke, fire, fog, clouds, and explosions, eliminating the need to describe and control thousands of elements at once.

Other kinds of plug-ins create special lighting effects, like realistic neon lights, or provide special tools, like shaping tools that act like they are carving wood. Texture plug-ins might cover an object with fur or add a veneer of rust to metallic surfaces. Post-production plug-ins can change the whole look of an animation in 3-D to the style of Japanese anime or look as if it is an old 1950s style black and white television show.

Rigging and Linked Motion

Besides physics, 3-D modelers and animators often have to master anatomy, too, when designing models with parts that move together. **Rigging** creates the underlying mechanics that make a machine or character functional. An animated character will require more complex rigging (sometimes called *skeletal animation*), where parts of the mesh are attached or "skinned" to underlying bones in the rig.

Whether you are designing a rudimentary catapult or a racing cheetah, the underlying structures of rigs share some basic attributes.

Parent-child relationships, where moving one part causes a second to move, are made by establishing *links* between the two parts. These links should be established in the model before animating. An example of a parent-child connection is a hinge, whether on a machine or a knee.

More complicated links are needed in objects like an arm where a *chain* is established so that when an upper arm is moved, the elbow, forearm, wrist, and hand move with it. In this case, **constraints** are added to limit the range of motion to create more natural motion (see Figure 11.22).

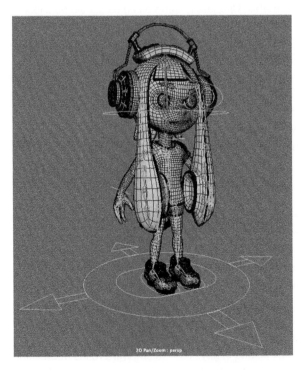

11.22
Model with three-dimensional skeletal rigging

Forward and Inverse Kinematics

A chain of parent-child links works best when describing the movement of machinery. One mechanical part initiates the movement of other parts in a process called **forward kinematics** (**FK**). The movement works only in one direction—for example, in the case of an arm, the upper arm must initiate the action. In order to move a finger, the animator must start first at the shoulder and move down through the chain of links.

Inverse kinematics (*IK*), one of the most sophisticated animation tools, allows one to initiate actions at either end of the links. Once one has established the basic skeleton, one can move a finger and thereby create the normal chain of reactions in the hand, wrist, and forearm.

Rigging is an art that requires technical knowledge. If you just stroll around a room and pay attention to all the movements and linked joints needed to just accomplish a basic walk, you'll understand not only why skilled riggers are in demand, but also why toddlers spend a great deal of time falling. It is easy to see why building your rig or skeleton first will save you time and effort in modeling moving forms.

Constant communication and coordination between the Modeler and Animator is vital while any rigged model is being developed. An unexpected facial expression can cause grotesque deformations of the model if not planned for in the rigging's original design.

Motion-Capture and Rotoscoping

Because facial expressions and the movements of human beings are extraordinarily complex, they have frustrated animators since the beginning of animation. Kinematics creates very smooth movements, but much of the subtle nature of natural movement is lost. An important alternative approach to create convincing natural body movement is **motion-capture**.

Early animators used a form called *rotoscoping*, where a live person was filmed while moving. The filmed frames were made into a series of large photographs which the animators used as references or even traced. The results can be spectacular; a famous example is the dance sequences of Walt Disney's *Snow White*, which were based on rotoscoping the dancer Marge Champion.

Today, movement can be recorded digitally and then interpreted with computer software. The subject wears a dark, skin-tight bodysuit. Little white spots or reflective balls are attached to the person at key juncture points and act as targets. When subjects move, an optical tracking system follows their movements. Strobe lights are flashed over 200 times a second while cameras record their actions from several angles and feed the information into a computer (see Figure 11.23).

After the movement is captured, custom software translates the information into standard 3-D animation formats. Initially, what is seen on the screen is a cloud of white dots, like a swarm of bees. Animators translate these dots into fluid, natural movement. The higher the number of recorded points, the smoother and more convincing the final animation.

Not all motion-captures result in photo-realistic action. In Riverbed Studio's *Ghostcatching*, an animation based on the movements of the dancer and choreographer Bill T. Jones, the forms are hand-drawn and gestural (see Figure 11.24). The stylized, luminescent lines move across the dark screen gracefully, like a 3-D dance of pastel figure drawings.

By placing dots along the critical muscles of a face, a person can be the model for very convincing facial animations. When combined with motion-capture for body movement, virtual actors can be created. The first applications for these virtual actors were for animal characters and aliens, but today virtual human actors regularly appear in feature-length films. While still beyond the capabilities of personal computers, as with most technologies, it is only a matter of time before these tools are placed in the hands of most digital artists. We are already seeing phone apps that capture facial expressions in order to create talking avatars.

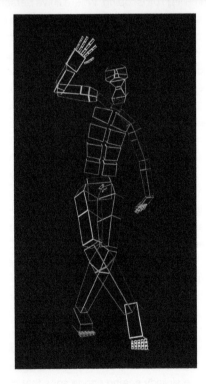

11.23
Three steps in the process of motion-capturing the dancer Bill T. Jones

11.24
Two frames from the finished film, *Ghostcatching*

Previewing, Rendering, and Output

While 3-D animators spend most of their long hours of work in a wireframe environment with grids and multiple perspectives, they have to remain aware that when rendered, the wireframes and grids will disappear. Their creation will become a smooth, lit world of movement and color with only one camera angle seen at any one time.

While making editing quick and efficient, working in a 3-D world of wireframes has its limitations. From time to time, to truly understand what effects are being created, it is important to preview the animation. Most software has *preview modes* to allow the animator to see at least a simplified version of the animation with the colors applied. A higher-level preview will show more detail using Flat or Gouraud shading (see page 247). Ideally, an animation should be seen in 'real time' (displayed in less than one-fifth of a second) to see the effect of any changes. Unfortunately, complex animations or even a highly detailed still can take too long to be created on personal computers and are therefore unsuitable as a preview in the midst of animating.

Nevertheless, once the 3-D animation is complete, it is time to fully *render* it. Rendering an animation goes beyond the complicated application of all colors, textures, lighting, and reflections to wireframe models to computing their movements (and the camera's) in time. This is why rendering a 3-D animation is an even more time-consuming process, usually taking many hours, sometimes days or more. For truly complex and detail-rich animations, animators, like modelers, can submit their files online to *render farms*—companies that divide the rendering chores among a warehouse full of linked computers.

Preparing for final rendering of an animation is the time for final choices. What will be the quality of the render? How detailed will the images be? If using a render farm, what file types does the company accept? As discussed earlier in the chapter, there are many ways to render a 3-D model, like ray tracing and Phong shading. With animation, there are new questions—like how many frames per second will the animation be (television and film, for example, have different frame rates)? What animated special effects are truly necessary?

Conclusion: Animation Today and its Future

Today, 3-D modelers and animators are in demand. Their creativity and skills are needed in feature films, television, commercials, training videos, accident recreations, architectural and industrial visualization, toy design, graphics for magazines, books, and advertising, and all types of games, be it console, computer, or mobile apps.

The expansion of these media seems to be moving at warp speed. In less than 20 years, 3-D animation went from slow-moving boxy shapes "dancing" to disco music to lunging velociraptors convincingly attacking live-action actors. With rapid increases in capabilities and power of both hardware and software in the 1990s, long format 3-D animations created entirely digitally soon appeared on television and in motion pictures. Today, it is increasingly common to see virtual human actors in commercials and movies, placing new challenges for the real actors as they perform as motion-capture subjects. News programs are already being located in lively virtual environments. Many of the cars you see in commercials are actually animated 3-D models, so they can stay clean and perfect as they race around hair-raising curves. What will be next? Virtual newscasters? Stories on wildlife with virtual elephants roaming the set?

One can be confident that today's rendering tools and others processes will soon seem antiquated. There are startling new software capabilities ahead, more powerful video cards, and the arrival of even more robust broadband networks with the ability to quickly deliver 3-D animated films. To be successful, professional animators must be committed to constantly learning new techniques and updating their knowledge of new software and hardware.

But is it possible for the tools of animators to become too powerful and complex? Even with the incredible capabilities of the technology to come, an animation's quality will ultimately rely on the talent and vision of its team of artists. The challenges of interesting story lines and drama will remain just as they have for more than a century. In fact, the greatest challenge for animators may not be how to learn to use the latest version of a complex piece of software. Rather, it will probably be to have the discipline to avoid the temptation to spend hours exploring new, complicated tools and, instead, keep one's focus on the creative issues that have always been central to successful animation.

Projects in Three-Dimensional Modeling and Animation

1. Using a predefined solid primitive like the box, complete six variations using texture mapping and lighting to create six objects that appear very different.

2. By overlapping three different solid primitives, create three very different forms using the Boolean operations of union, subtraction, and intersection.

3. With primitives, simple colors, and by applying plastic surface materials, model a child's toy boat. With camera movement alone, create a 25-frame fly-over of the toy.

4. Animate a 30-frame bouncing ball sequence with three different 3-D balls. By changing their appearance and how they bounce, make them appear as if they are made of three different materials with different attributes: a rubber ball, a Ping-Pong ball, and a bowling ball.

5. Create a short, 50-frame animation of a dancing cylinder. Bend, squash, and twist the cylinder. Vary the camera position and viewing plane to add to the energy of the dancing. Move the lighting to create a dance club atmosphere. Add appropriate music.

12 The Evolution of the World Wide Web/Designing for the Web

INTRODUCTION

There have been only a few times in history when something has come along that has so revolutionized a culture and redefined the way in which average people interact with the world as much as the Internet, yet it is not without precedent. Beginning in the nineteenth century, we witnessed the arrival of new communication systems, each having a part in making the world a smaller and more accessible place by offering a once unheard-of immediacy to mass communication. First, the telegraph made almost instantaneous communication possible over wires strung across the continent. Yet, the telegraph, for all its speed, was essentially communication from one user to another, interpreted and delivered by a third party. Telephones soon followed and interpersonal communication took a major leap forward as written communication was augmented by a more human and direct contact. The radio moved mass communication beyond the physical wires necessary for telegraph and telephone communication and touched millions of lives simultaneously.

Each of these technologies was a revolution in its own right, still none of them compares to the Internet as a worldwide medium with the ability to broadcast information and allow for immediate interaction between individuals separated by vast distances. The implications of this new technology are still unfolding. This chapter will first provide a brief overview of how the Web evolved with a focus on some of the key technologies that affect web designers. It will then review the nature of creating content for the Web.

HOW DID THE INTERNET HAPPEN?

The Origins of the Internet

While it may seem as though the Internet and what we now know as the World Wide Web came into being almost overnight, most Internet users have only been able to access its features since 1994 (of course for those born after 1994, the Internet has always been present). But there was a time without the Internet and as with most inventions, what at first appears to be an overnight success actually took a long time to develop.

The Internet is the child of the Cold War and fears of nuclear war. As a direct response to the Soviet Union's launching of *Sputnik*, the first artificial satellite to orbit the Earth, in 1957, and the fears it caused, the United States Department of Defense formed the **Advanced Research Projects Agency** (ARPA). Its goal was to re-establish America's lead in the development of science and technology applicable to the military, along with finding a way to maintain command and control over our nuclear arsenal and armed forces after a nuclear attack. To achieve this, a way was needed to connect or network the government and military's many massive computers—even though their systems were often incompatible.

The Basic Technology

In June 1969, the first network, ARPANET (Advanced Research Projects Agency—NET) was launched by the Department of Defense. It was rather primitive and functioned more like a vast bulletin board than the Internet we know today, and was limited to military use only.

The technology behind this centered on the concept of **packet switching**, a unique method of sending messages still in use today. In packet switching, **protocols** (standardized formats) divide data into *packets* or pieces before they are sent to another computer. Separate packets, each with only part of a complete message, can be transmitted individually and even follow different routes before arriving at their final destination. Each individual packet contains a header, much like a zip code for the postal service, which provides information about the source, destination, and how the packets are sequenced. Because they follow a particular protocol they can be reassembled back into a complete message at their destination. Should a single packet get lost or damaged, that individual packet can be resent.

Today, the most widely used protocol in use is TCP/IP. Any information that requires flexibility in speed of transmission or that often experiences delays (like real-time audio, video, email, etc.) benefits from the technology of packet switching. The development of networks using a packet-switched technology revolutionized the way in which computers shared information.

The genesis for this system had come a few years earlier. Bob Taylor, formerly of NASA and now an ARPANET researcher, realized he had three different terminals on his office desk, each of which was connected to a different computer system by a telephone. He asked himself the question—why three? Why not one interconnected system? In one of the most successful meetings in history, Taylor met with the head of ARPA to outline the problem. Twenty minutes later he was given a million dollars to explore networking solutions. New ARPA researchers were assembled, many of them still graduate students, at a conference in Ann Arbor, Michigan to discuss the issues facing them. At the end of the meeting, Wesley Clark suggested the use of interconnected **interface message processors** (IMP, known today as routers) to manage the network.

A Honeywell minicomputer was selected as the foundation upon which to build the IMP, selected after an unusual demonstration of its durability. Suspended from the ceiling while running, the Honeywell computer was beaten with a sledgehammer—and still worked.

In 1969 the actual network was constructed. It linked four **nodes** or processing locations—the University of California at Los Angeles, Stanford Research Institute (SRI), the University of California at Santa Barbara, and the University of Utah. The network capability at that time was only 50 Kbps, very slow by today's standards, but the ARPANET had become a reality. Each of the nodes had a unique address that would identify it to other computers.

UCLA became the first functional node on the ARPANET. A month later, Douglas Engelbart's (already the inventor of the first computer mouse—see Chapter 5) at the Stanford Research Center became the second node. With the addition of a second node, the first host-to-host message ever sent on the Internet was initiated from the computer at UCLA. Kleinrock and one of his programmers attempted to "logon" to the Stanford Host. Programmers at both ends wore telephone headsets so they could respond to the logon procedure by voice. Once the programmer typed in "log," the computer at Stanford would add the "in" to create the word command "login." Checking by voice as each letter was typed in, they got to the letter "g" and the system crashed. However, the second try was successful. The system worked.

Even though this first Internet was a simple text-only system, research into visual communication played a role from the early days of the ARPANET. The third and fourth sites were at research universities working on visualization application projects. The University of California at Santa Barbara set up a node to investigate methods for the display of mathematical functions, while the University of Utah set up a

node to investigate 3-D imaging. During the next several years the number of computers connected to the ARPANET increased and by 1970, a new node was being added each month.

This rate continued to grow faster and faster due to the first public demonstration of the ARPANET in 1972 plus the introduction of something most of us take for granted today—electronic mail. Written originally to allow ARPANET scientists to coordinate their efforts, electronic mail caught the eye of other research scientists and quickly became the network's largest application.

THE WORLD WIDE WEB

As the Internet developed from its ARPANET roots to the decentralized series of interconnected networks we have today, one thing has remained constant—the expansion of access to an ever-broadening body of users. As cheaper, more powerful computers have become accessible to the public, use of the Internet has grown. This was, in large part, the direct result of a new kind of software designed to take advantage of the Internet's capacity to deliver images as well as text (and later, audio and video streams)—**hypertext markup language** (HTML). This is the software that created point and click **browsers** that made it far easier for the average user to navigate through a network in order to access information.

INVENTING THE WEB

Tim Berners-Lee and CERN
Located in Geneva, Switzerland, CERN (European Laboratory for Particle Physics) is one of the world's oldest and largest scientific laboratories dedicated to research into the field of particle physics. Since no single European country can afford the extensive and costly facilities this type of research requires, CERN, along with several satellite sites, is a collaborative venture and a center for researchers from more than 80 countries. While much of the research takes place at one of the CERN sites, researchers also work at their own universities or government laboratories. They collaborate in research teams that may include hundreds of physicists, engineers and other highly trained colleagues spread out all over the world. In order for the experiments to proceed smoothly, constant contact must be maintained as data is shared.

In 1989, CERN connected their computers to the Internet so their researchers throughout the world could exchange information quickly over their network. In addition to email, communicating over the Internet allowed scientists to analyze data in their own labs, and this in turn allowed them to continue teaching at their own universities. Throughout the 1980s however, even as the Internet was evolving at dizzying speed, the system was increasingly frustrating. The types of computer, operating, and network systems being used throughout the academic community varied widely. Common features were rare and users needed to be conversant with more than their own system in order to share information.

At that time, in order to share information and research data, researchers had to find the file they wanted by name, from a list of files without any description, on either a local or remote computer, connect to that computer using the current TCP/IP protocol and then download the file they wanted. If they were working on different types of computers, they would also have to translate the information in order for it to work on their native platform. It became clear that this unwieldy system needed to be replaced by a common user interface that could bring information across a network without the need to translate it before it could be read by differing operating systems.

Tim Berners-Lee (see box), a young programmer at CERN, had already written a program in 1980 called *Enquire*, that organized information through open-ended relationships between documents by

using links. In 1989 he proposed a hypertext system based on his earlier work with Enquire. Using prior experiences with developing multitasking operating systems and typesetting software, he wrote the prototype software for a server and client for what later came to be known as the World Wide Web. His program could connect a collection of hyperlinked pages at different locations on the Internet by using a network protocol called HTTP (hypertext transfer protocol).

From December of 1990 through 1993 Berners-Lee's system was refined. In addition, in 1993 the ISO (International Standards Organization) established a standard for hypertext markup language (HTML), that involved marking up text files with standard codes in order to format it. This was initially done with a basic text editor. In the early 1990s, researchers at CERN were using Berners-Lee's early web browsers to access information on the Web and a variety of newsgroups in order to share information. Soon these simple browsers spread to other research and scientific communities and interfaces were added to provide additional access to other protocols with names like WAIS, Telnet, FTP, and Gopher.

In 1992, CERN published the source code for their Web servers and browsers and began to promote the Web beyond the research and academic communities. It immediately became evident that the Web was providing a communication medium for users from all walks of life. Web pages began to appear everywhere—not just on academic topics, but on all sorts of subjects. Soon, software developers were evolving second generation web browsers with more powerful tools and simpler interfaces for PC and Mac systems.

In two years, the World Wide Web had evolved to 10,000 servers and 10 million users. By 1997, the number of servers had exceeded 650,000 with approximately 1,000 new servers coming online every day. By the Web's twentieth birthday, the number of servers had already grown to 75 million, with nearly 1 billion websites.

WHAT MAKES THE WEB WORK?

As astonishing as it may seem, the World Wide Web has only been available to the general public since 1994. During that time, the ability of web browsers to deliver complex information, including graphics, animations, streaming video and audio, has grown dramatically. The growth of broadband access to the Web, in the form of cable connections, DSL, and satellite access, has opened new horizons for web content.

What we refer to as the Internet is not a single network but rather a worldwide web of individual networks that are tied together. They are joined by modems connected through a variety of higher speed options such as ISDN, DSL, cable, and other broadband connections (see Chapter 4 for more information). Early in the development of the Internet, an accurate picture of just how many networks were connected to the Internet was possible. Today, the number of networks that are connected throughout the world is so vast, and increasing so quickly, that it is impossible to keep track of them all.

Who's In Charge?

No one really. As strange as it may sound for something so expansive and powerful, the Internet is like a vast cooperative, with many different organizations and even countries supporting it with money, hardware, and technical expertise. Certainly there are "thicker" networks supporting the "thinner" ones. For example, the National Science Foundation (NSF) started the NSFNET, which was a nationwide network that connected universities, colleges, and other organizations—one of the first "Information Superhighways." By 1995 this federally funded network changed to a new architecture and was replaced by the kinds of commercially operated networks we know today. Larger networks connect smaller and smaller networks until one of them eventually connects to your house or workplace. Internet technology has made the independence of individually connected networks guaranteed.

While the technology has made it possible for individual networks to communicate seamlessly with one another, content and structure are another matter. There is no official, governing Internet agency. There is no set of absolute rules everyone must follow (outside of the communication protocols that allow the net to function). However, there are organizations that provide guidance on the way in which the Web comes together. The World Wide Web Consortium (W3C), founded by Tim Berners-Lee, is made up of many organizations that work together to set the standards, in the form of recommendations, for the World Wide Web. This is especially important to the organization of the protocols that make web pages work consistently throughout the world.

As the Internet becomes ever larger, its content changing and serving ever growing needs, it can still be a chaotic place.

NEW CONSIDERATIONS

Forces in Play: IoD (Internet of Documents)

The first phase in the evolution of the Internet was essentially technological. Systems were being developed and employed to share information and connect users with one another no matter what type of computer they were using. New digital technologies were developed to make this easier and faster. By the end of the twentieth century there were approximately 1 billion users in this first wave of Internet use. This first era can be referred to as the "Internet of Documents."

IoC (Internet of Commerce)

As the twenty-first century began, Internet use had risen to approximately 3 billion users and had evolved beyond viewing documents, into a vast shopping network. While Amazon.com and eBay are just two of the most famous success stories, today every business, large and small, must have a presence on the Web to survive. This "Internet of Commerce" (IoC) has expanded the user base dramatically. Just about anything you can purchase in a brick and mortar store is also available on the Web. This has also increased the quantity of data available on the Web and access to that data. Businesses have developed to "mine" that data, not only to create product, but also redefine the way in which they connect to their customers.

IoP (Internet of People)

As commerce was maturing on the Web, social media also began to explode. Services like Facebook, Pinterest and LinkedIn became powerful forces in allowing a more personal and intimate connection on the Internet. Everyone in this new "Internet of People" was suddenly "present" on the Web and available for contact. But the IoP encompasses more than just social contact. It also includes personal electronics connected to the Internet (smartphones and watches for example). Soon, wearable technology, incorporated into fabrics and other products, will enable tracking of fitness, treatment of some diseases, global positioning, and more. With over 10 billion devices now connected to the Web, the amount of data being collected and used to drive technology is staggering. This interaction between personal technology and humans is closely connected to the Internet of Things (IoT), which is evolving simultaneously.

IoT (Internet of Things)

Sometimes considered the "third wave" of Internet development, or the "Industrial Revolution of the 21st Century," the IoT has become a powerful force in the implementation of technology in our lives.

Sanjay Kumar Pal wrote in 2008 the following statement, which illustrates the increase of computer function in the "Internet of things."

> The computing power in the few microprocessors that are now in a Ford Motor Car is much more than all the computing power that was put in the space vehicle that landed the first men on the moon and brought them back.

Computer-related technologies have been spilling beyond our PCs and into our lives in a variety of ways. One only has to pick up their cellphone to understand how interconnected we are. Houses can be linked to our smartphones so we can check our locks, see what's in our refrigerators, monitor who is at our door and more. Data sensors allow us to embed feedback devices in almost anything. This will allow us to pull into a parking lot and know just where the open parking spaces are because the sensor implanted in the cement or blacktop of the space is transmitting the information directly to our car. The same can apply to road conditions, structural integrity of buildings, and just about anything else you can imagine.

PLANNING A WEBSITE

Thinking It Over

There are many things that all come together on a website, but even if you learn all the code, and different ways of preparing images, and perhaps even some JavaScript, the most important considerations come before you even sit down at the computer. A website usually contains a series of inter-linked pages, each of which covers a portion of the particular content you wish to present. The first questions asked should not deal with HTML or CSS (cascading style sheets, explained later in this chapter) code, but with the nature of the site itself.

As in any multimedia production, before you begin, you should ask several important questions. Who is your audience? What do you wish to convey? What ideas do you have for the "look" of the page—the format and basic design? While the Web does have its own special properties (many of which we will introduce during this chapter), you are still designing space and your design must not only make sense and be visually appealing, it must also convey the content clearly and coherently with a minimum of distractions. A site for "John Smith: Home Heating" would not have the same look and feel as one for "Jane Smith: Corporate Law." All of the skills that a graphic designer brings to print publication—selection, size and spacing of type, use of graphics and photographs, sophisticated use of color, and so on—apply to designing for the Web. Too many students interested in web design as a career think they should spend most of their time learning the latest in HTML code, CSS, JavaScript, and other web languages. However, even the best coding skills will be wasted if the underlying design is poor and navigational elements are difficult to use. Strong design skills are still very important to the success of a website, and for art and design students, are absolutely the best preparation for web design.

That said, what about content? Who is actually going to write the information that will appear on the website. Clear, cogent writing that gets to the point quickly and without obvious errors in the use of language says something about the professionalism of the site you prepare. If you don't think of yourself as a writer, find someone who does. Many websites are the result of a collaboration between visual artists, writers, photographers, and technology experts.

UX and UI Design

The concepts of *UX* (user experience design) and *UI* (user interface design) are sometimes confused. UX design refers to the entire user experience that someone has with a site, product, and how well a user's needs are met. UX deals with understanding the total scope of your user's goals and takes into consideration everything from ease of use to post-site interaction. The user will not see the wonderful, behind-the-scenes code that makes things sparkle on your site. The end user will only see what does or does not work.

The UX designer makes sure that everything on a site works together in harmony to create a user experience that is smooth and effortless. Did the user find what they were looking for? Was it easy and enjoyable? Was the synthesis of your coding and design successful?

UI design is, of course, part of UX and the concept of user interface is a bit harder to define. While UX design refers to the entire, overall experience a user has with a company's website, products, and services, UI design refers to the specific things on a website that the user interacts with in order to accomplish their goals. UX might be akin to an overall strategy while UI is more like the tactics used to accomplish it. UX evolves far beyond the website to a user's overall experience while UI is a part of that experience that makes it possible.

The Website Interface

Once your content is clearly delineated, it makes sense to plan various ways in which that information can be presented within the website. This is often referred to as *wireframing* and can be completed with dedicated software applications, Photoshop or simply pencil and paper. As already mentioned, a website is usually composed of inter-linked pages, each of which conveys some portion of the information you wish to present. Based on the content of the page, how should the information be accessed? Usually there is a home or opening page, typically referred to as the *Index page*, which introduces the site and offers links to additional information or pages on the site. The design of the homepage itself will require decisions about the use of display type (the larger, more visually prominent lettering used for headlines or introductions). It should not only be related to the content of the site but also readable in order to be effective and successful. Is it large enough? Is the letter spacing coherent and thought out? How does it relate to other design elements? Should it be serif or sans-serif?

UNDER THE HOOD

Hypertext Markup Language (HTML): A Quick Look at the Basics

Hidden behind every web page is a universal language—hypertext markup language or HTML. Clicking "view source" in any browser will reveal this secret language. While HTML web pages can become quite complex as items are added to a page and "marked up" with various tags (codes), a basic starting page, however, is quite simple. The sample template that follows indicates all that is necessary for a simple, functional web page.

Sample HTML Template

Every HTML command, or tag, is placed in a set of bracket (< >) symbols. HTML tags can range from a single letter to several lines of detailed information. Each tag contains instructions that change the nature of an item on the page. Most tags work very much like switches, with one tag turning a setting on and another tag turning a setting off. The off commands are preceded by a slash. For example,

<TITLE> indicates that what follows is the document's title and **</TITLE>** indicates the title is complete. **** indicates that the type following this element is going to be bold and **** indicates that the bolding of type should end here. Tags are not displayed when seen in a browser.

All HTML documents start with the <HTML> tag that lets older browsers know that it is reading a document coded in HTML. After the HTML tag, the <HEAD> tag tells the browser that what follows in the header should either be applied to the entire document (as in the case of style sheets discussed later in this chapter) or, if bracketed by <TITLE> tags, displayed in your browser's title bar. It is within the <TITLE> . . . </TITLE> tags that you name or "title" your document. If your page is **bookmarked** or saved to be revisited, the title is what will appear on a bookmark list, so it is important to choose something short and descriptive of the page's contents. Titles also identify your page for search engines. After ending the title tags, end the header element </HEAD> to let the browser know that the information that follows does not belong in the title.

After the header comes the content of the web page, which is announced by the <BODY>tag. At this point, content (for example, text and images) is added. If this is the beginning or "index" page, then it will contain links to other parts of the site. After the body of the document is complete, it will end with the </BODY> tag. The document is completed with the "ending" HTML tag </HTML>.

Box: 12.1 Basic HTML Document

<!DOCTYPE html>	Used today, without this doctype declaration, which indicates you are using the current standard of HTML 5, future browsers might assume you are using a different version of HTML and so interpret your coding differently.
<HTML>	Starts the HTML document.
<HEAD>	Starts the header element.
<TITLE>title of page</TITLE>	Name or "title" of document. (Note the /title which says the title ends here.)
</HEAD>	Next, end the header element. This lets the browser know that the information that follows belongs in the body of the page.
<BODY>	Starts the body element. Begin to enter the content of web page right after this tag.
</BODY>	After the page content is complete, end the body element.
</HTML>	End the HTML document.

All of the information thus described could be typed in a simple text editor and saved with an .htm or .html file name extension. Once done, a basic web page is created that any browser can read. Of course this doesn't contain hyperlinks, or images, or any of the things which can make web pages interesting, but it is a web page nonetheless. Although there are far more sophisticated means to expand upon it, the fundamental template for an HTML document has not really changed since 1995.

ADDING IMAGES AND LINKS

Preparing Images

As you design and test web documents, you will most likely want to add images. If these are prepared before you begin, you will be able to apply them as you design your page.

Each of the image file formats (GIF, JPEG, and PNG) that can be displayed on the Web has their own strengths and weaknesses. Choosing the right image type format to use is important. GIFs are best for solid color graphics with sharp-edged transitions between colors, such as charts. Another strength of a GIF file is that you can define colors in the image that will appear transparent, allowing the background of the web page the image is placed on to show through those areas. However, GIF files are limited to 256 colors (8 bit), which makes them unsuitable for sophisticated color photographs, which look best in millions of colors. In addition, image files for the Web are usually compressed in order to load fast without frustrating delays. GIF files, for example, due to their limited color range use a **lossless** compression scheme, which means that after the image is compressed and opened up, it will not lose any of the information it originally had.

JPEGs reproduce a photograph's subtle tonal gradation much better than GIF files and are generally much smaller in terms of file size. However, JPEG files use a **Lossy compression** scheme that discards or loses information as the file is compressed. After the image is compressed, that information cannot be regained. There is always a tradeoff between the amount of compression that takes place and the amount of information that is lost in the compression.

Another file format that can be used on the Web is PNG (pronounced "ping"). It is similar to a GIF, using a lossless compression scheme and working best on graphics, line drawings, and text, but uses a larger palette. Like GIFs, certain colors may be defined that will appear transparent on your webpage. Most importantly, there are two versions of PNG—an 8-bit (256 color) file format and a 24-bit file format that will reproduce color similar to JPEG files. PNG also allows for differing degrees of transparency.

Adding Images to Your Pages

Once you have determined which image format to use, including the image can be completed with a simple code. To place an inline image on your website, add the code in the body of your document. By adding this tag, whatever image you include after "<IMG SRC=" will be included on your page (e.g.,).

Links

Using a dedicated web design program makes linking images and documents very straight forward and allows you to use a visual interface to search for images, link files, and create all the code your document will need. Understanding the basics of code, though, will help you untangle issues as they arise and make it easier to troubleshoot your documents.

If you want to have an icon or word linked to the image so that the image will appear when it is clicked, then you need to have the image in the folder containing your web files. For example, if you wish to include an image called "statue.jpg" on a webpage, you can simply add the code (in the Body section of the document) and the image will appear on the page. If you are using a web design program, it may also add information about the size of the image, for example style="width:600px;height:800px;"> This will be included with the image code to read:

Box 12.2 Basic Coding for Links

To link an icon (castle_icon.gif) to a Web page:	
` `	Note: When there is a space between words (english and castle), for example, use an under-score in place of a blank space. This will make things go easier when it is time to FTP (file trans-port protocol) your site to a server. This is similar to the sample code outlined, ex-cept that we are referencing (<A HREF) a particu-lar HTML file ("english_castle.htm") by clicking on an icon ("castle_icon.gif") to launch us there.
To link text to a website:	
`<A HREF "www.yourchoice. com">choice `	Note: Once again, <A starts the anchor tag and HREF indicates the referenced site (www.your-choice.com). The url being referenced starts and ends with quotes. The word used, "choice," will show up as a blue, underlined link. When you click on it your browser will take you to the website you desig-nated (www.yourchoice.com).
To link an icon (image) to a website:	
`<A HREF "www. yourchoice. com"> `	This will take you to the same site as noted, but instead of a word, you will be clicking on an icon ("icon.gif") instead to take you there.

Hyperlinks (or hypertext) can be added to your Web page to allow the viewer to jump from informa-tion on one page to view new information on another page within your website, on another website entirely, or even to a new spot on the same webpage. Almost anything can serve as the source of the link, but usually it is a word or an image. For example, small thumbnail images can be clicked to open a larger version of the image or a new HTML page containing the image with information about it.

If you want the image to appear on screen with a color background, then you need to prepare a separate HTML document to hold the image. That document can be very simple: just the basic HTML template with the included.

While all of the items introduced can be entered manually, there are many programs that make it easier to build a working website. In the examples that follow we are using samples from

Adobe Dreamweaver as part of the Adobe suite of programs that makes both simple and more sophisticated elements of web design more easily applied. However, there are many dedicated web design programs that can be used in much the same way. Even for simple items like placing an image on a page, it is easy to click on Insert>Image to browse to an image and click on it for insertion (see Figure 12.1). When you do this, the application will insert the necessary code (as outlined) for you. This will hold true for many of the elements we will be discussing next. While it is good to know the manual version of inserting code, a dedicated web design program can make things much easier.

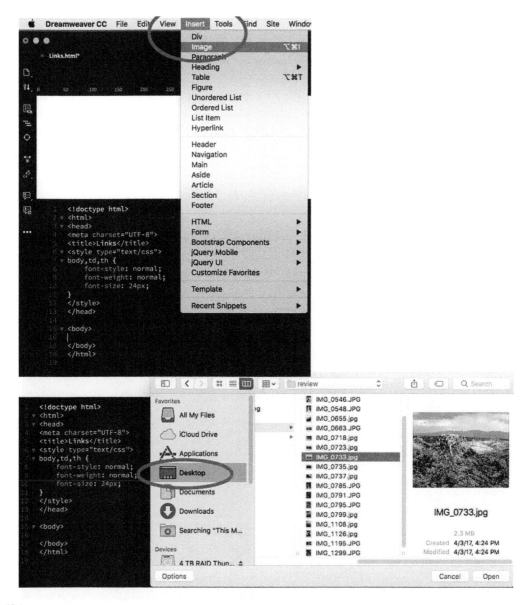

12.1
Using an "Insert" menu to browse for an image to place on your webpage is simple, and once you select it, a web design program will install all necessary code for viewing the image

Defining a Site

In designing any website, it makes sense to keep things organized and in one place. Most web design programs make this easier by allowing you to "define" a site and designate how certain program features will operate when creating the site (see Figure 12.2).

Once the site has been created, all further pages, images, and so on will be saved to the location specified. This site can also be edited later to change the location if necessary.

Basic Layout Features

First, to set up your workspace, make sure you have chosen a standard template to begin. This will automatically allow you to elect to see just the code. Experienced users sometimes prefer this. You can also choose to see the code and a visual representation of the page (Split), or just the Live View of the page itself without the code. The Split view gives you the best sense of how code and page go together. In a web design program, Dreamweaver for example, by clicking on File and then Page Properties, a dialog box will open that allows you to set the basic, overall parameters of your page (see Figure 12.3a). In this box you will be able to select the overall appearance of the font to use, its size and color. In addition, you can choose the overall background color for the page or set an image to be used as a background instead. Your choice for this will be either Appearance (CSS) or Appearance (HTML). (A discussion of cascading style sheets will follow.)

12.2
Creates a site (specific location for your files and assets) where all new items are saved

12.3
Page Properties allows you to establish the basic parameters of a web page

Once you have set the overall definition of the page in terms of basic text and background, by selecting Links (CSS) you can also choose how links should be defined and appear on your site (see Figure 12.3). What color should the links be? What color should they change to when "moused" over? You can even select what color they will turn once clicked, along with whether or not a link should be underlined or not.

As you continue to work, you may want to modify the initial properties you have established or change a single word, sentence, or paragraph to a different typeface or color. When you click on Window on the Menu bar at the top of the page, you will see a long list of different features that can be opened within their own dialog box to allow you to use shortcuts to introduce new items or technologies to your website. One of those is simply called Properties.

12.4
The Properties box gives you a quick way to modify and set the placement of text using CSS or HTML controls. Changing to HTML mode also allows you to set links

The Properties box (see Figure 12.4) allows you to change the font, font color, and placement of selected text. This is best used where the changes are only applied to the selected area (an "inline" style). When used in HTML mode, it also allows you to select text or an image and then browse for an item (such as an image or HTML file) in order to create a link to that item. As an alternative, you can also drag the target to an item to create the link. While many design features can be controlled in the Properties menu, cascading style sheets offer a far more sophisticated way to modify and define text and images.

Today's Design: Cascading Style Sheets (CSS)

Most web design programs today offer technology that far exceeds the simple local HTML tags used in the past. Instead, CSS (cascading style sheets), either embedded into an individual page or as a separate CSS document, will define all of the key elements of the page instead of defining information element by element. Whereas HTML provides the structure for your webpage, CSS is the language used to describe the style (appearance and formatting) of your HTML page. The term cascading is used because there can be more than one style sheet that can apply formatting within your document. If you want only one paragraph on a page to be in blue text, you can apply a style to just that one block of text. Combining standard HTML with cascading style sheets allows for flexible and powerful design.

A CSS file for a particular HTML file is saved as a separate document and is given a suffix of .css. This distinguishes it from the HTML document that contains much of the content of your web page. You can apply formatting to HTML elements by simply referencing the items prepared in the CSS document. You can also use your CSS files on more than one HTML file, which can save time in preparing other web pages.

Internal CSS

Using Internal (Inline) CSS is much closer to traditional HTML coding compared to using CSS as a separate document. For example, you can change the color of a word with the following code:

Blue words are great.
Will result in: Blue words are great.

In order for this to work, the style needs to be defined within the heading area of your web page (see Figure 12.5). You can place as many style definitions as you wish in the header of your document

12.5
This is how the coding and result would appear in a web design program. The circled area shows the "inline style" defined in the *header* of the document

so that you can use them whenever you wish. However, every time you want to make a word blue, you would need to use the style you have defined. If you want to change the color, you would need to change the style in the header or add an additional style element. However, with a CSS file as an addendum to your HTML file (external CSS), you can make major changes by simply changing items within the CSS file itself.

EXTERNAL CSS

Most web authoring programs allow you to create a CSS page as a separate document (see Figure 12.6) that can set definitions for text colors, size, background color, and far more. The CSS document can then be attached (linked) to your HTML page(s) and so make design easier and more consistent from page to page.

In order to attach the HTML file to the CSS file, you will need to place a link tag in the heading area of the HTML file. The link needs to define three characteristics; a *type attribute* which is related specifically to text ("text/css"), a *rel attribute* ("stylesheet") that specifies the relationship between the current (HTML) document and the linked (CSS) document, and an *href attribute* that points to your CSS document. An example would be:

< type="text/css" link rel="stylesheet" href="docname.css"> (where docname is whatever you name your .css document).

While this can easily be coded manually, dedicated web design programs can make the task easier. When you have your HTML file open, click on *File, Attach Style Sheet*. This allows you to

CSS as first created

```
 Dreamweaver CC   File   Edit   View

× Test adding CSS.html   × Test.css
1   @charset "UTF-8";
2   /* CSS Document */
3
4
```

CSS with basic text definitions

```
 Dreamweaver CC   File   Edit   View   Insert   T

× Test adding CSS.html   × Test.css
1    @charset "UTF-8";
2    /* CSS Document */
3 ▼  body {
4        background-color: antiquewhite;
5        color: blue;
6        font-size: 1.2em;
7    }
8 ▼  h1 {
9        color: red;
10   }
11 ▼ #intro {
12       font-size: 2em;
13   }
14 ▼ .colorful {
15       color: darkred;
16       font-size: 1.5em;
17   }
18
```

HTML document with attached CSS code to define text

```
<!doctype html>
<html>
<head>
<meta charset="UTF-8">
<title>Test adding External CSS</title>

<link href="Test.css" rel="stylesheet" type="text/css">
</head>

<body>The background was defined in the attached style sheet as antique white.
<h1>This text is h1 (heading 1) and so, according to the attached CSS file will <br>
be large and red</h1>
    <p id="intro">This intro text will be in a 2 em size and be blue</p>
    <p class="colorful">This text is applied using a class and
    as defined in the external CSS will <br>be a darkred color
    and 1.5 em in size.</p>

    Regular text will be blue and 1.2 em.
</body>
</html>
```

body ▼ ckground was defined in the attached style sheet as antique white.

This text is h1 (heading 1) and so, according to the attached CSS file will be large and red

This intro text will be in a 2 em size and be blue

This text is applied using a class and as defined in the external CSS will
be a darkred color and 1.5 em in size.

Regular text will be blue and 1.2 em.

12.6
Basic CSS documents and an HTML document (bottom) based on them. The initially created document is on the top left and the document with code definitions is on the top right

browse for the CSS file you wish to attach (see Figure 12.7). Once you find the file and click on it, your web design program will attach the file and create the code for the link. Or you can add the code manually.

12.7
Using a web design program, in this case Dreamweaver, to attach the file provides all the necessary coding for you

SS3 MODULES

As new technologies emerge (for example, smartphones and tablets), new adaptations of existing HTML and CSS must be modified in order to keep up. Like earlier versions of CSS, the most recent version (CSS3) has been divided into many "modules" that contain both older CSS specifications and new modules specific to CSS3. While there is a long and ever-increasing list of elements that can be defined in CSS, much of this will be beyond the introductory nature of a beginning class. Still, it is important to be aware of how they impact more advanced web design. A few of the more important modules are outlined next.

CSS in Action: An Animation
CSS offers an alternative to dedicated animation software that is both fluid and powerful. By using keyframes to define the stages and styles of an animation and *animation properties* to connect the keyframes to a particular CSS element, you can define how you want an item to be animated. The use of CSS Transform, which is still experimental, allows you to rotate, scale, and skew a particular element. In its most fundamental state, CSS animations are more akin to PowerPoint animations than Adobe Animate (or its earlier form—Flash), although far more sophisticated animation tools are available in CSS as well.

In order to get a feel for the powerful capabilities of CSS, let's look at its ability to create animations without the aid of a secondary animation program. With the predominance of high-speed Internet connections today, animations have become far more practical as a web design element than they used to be. Making something move has its conceptual basis in traditional animation techniques reviewed in Chapter 10, and for animations used on the Web there are still more options. But it is important to

consider your goals, whether you need a simple icon that expands when clicked upon or a full-scale animation that introduces an entire website.

CSS Animation Classes, that specify different classnames for an element in CSS, are quite direct. Something can slide in from the top, bottom, left, right, and so on. Opacity can change, as can size. Spinning an object is also quite straight forward. For example, if we were to animate the text "This text slides in," we first need to define it in our CSS document (see Figure 12.8).

```
1   @charset "UTF-8";
2   /* CSS Document */
3 ▼ p {
4       animation-duration: 8s;
5       animation-name: slidein;
6   }
7
8 ▼ @keyframes slidein {
9 ▼    from {
10          margin-left: 100%;
11          width: 300%;
12      }
13
14 ▼    to {
15          margin-left: 0%;
16          width: 100%;
17      }
18  }
19
20
```

12.8
CSS file for animation slider

We can then designate the animation in our HTML file. Note the headings in the accompanying HTML file to control the size of the text are not capitalized and they are outside the "p" designation. In Figure 12.9 an image is included (terad.png) that will move across the screen with the text.

```
1   <!doctype html>
2 ▼ <html>
3 ▼ <head>
4   <meta charset="UTF-8">
5   <title>Trial Animation</title>
6   <link href="anim.css" rel="stylesheet" type="text/css">
7   </head>
8       <h1><p>This text slides in.</p></h1><br>
9       <h3><p><img src="terad.png" width="360" height="287" alt=""/>This too.</p></h3>
10 ▼ <body>
11
12  </body>
13  </html>
14
```

12.9
HTML code designates what will be affected by the CSS code in Figure 12.8

This text slides in.

This too.

12.10
Sliding text and image by using CSS animation

When we open the HTML file, we see the text and the pterodactyl image move from right to left across the screen. Since the duration of the animation is set for 8 seconds in the CSS file, it moves slowly and easily across the screen (see Figure 12.10).

As there are many differing ways of coding CSS for animations, it is important to form a basic understanding of how CSS works in your classes and then experiment with different CSS functions and samples that are available in books and online. You will find there are many shortcuts to make coding faster and easier. Once you understand the basics of how things work, you might find it easier to modify and incorporate existing CSS to fit your needs—especially if web design is not your primary discipline. However, if you are working with a dedicated web design program, you will find that many different animation features are available to you without the difficulty of knowing the code from the ground up.

Responsive Web Design: Site Flexibility

As a concept, responsive web design is addressed by a number of elements in CSS. The ability to view websites on a variety of different devices and sizes of displays makes traditional web design difficult. An approach to addressing the many different size and types of displays web pages are viewed upon is termed responsive web design (RWD). RWD uses a flexible grid, text, media, and images so that a website can adjust to multiple device sizes. This allows websites designed for desktop viewers to also be viewed on smaller devices like phones and tablets. The ability to adapt a layout to changing viewing sizes uses fluid grids, flexible images, and CSS3 media queries allowing page element sizing to change in percentages rather than set units like pixels. This holds true for images as well. Part of this is the Media Query module of CSS3 that allows a page to incorporate varied CSS rules in order to determine the characteristics of the device being used to view the website.

With RWD, there is no change to the HTML being sent to devices, or the CSS that controls the layout of the page. Instead of separate documents for differently sized devices, a single codebase can resolve the issue of different viewing devices. As the size of the device changes, larger or smaller, the page elements reshuffle in order to adapt to the new viewing environment. Due to the reshuffling of elements, designers need to work closely with technical staff in order to make sure that elements not only fit into different viewing spaces, but work in terms of usability as well.

Media Query

Given the number of different platforms (computer monitors, iPads, smartphones) for displaying web pages, Media Query is a key element of web design today. Media Query checks the capability of the device that will be displaying a web page and then formulates a series of rules that will determine how visual information will be rendered on that device. It allows a photograph or graphic to be sized relative to the device displaying it. Media Query will also indicate whether different scripting languages are going to be supported on a particular device. In addition, you can use Media Query to determine whether your device has access to a mouse for navigation using a "pointer" media feature. If you don't have a mouse (as on phones and tablets) then the specification can make buttons and boxes larger. It does add a relatively complex layer to coding a page, but the results are worth the effort. As with many facets of web design, a dedicated web design program often has built-in capabilities for applying this feature. Sometimes it is as simple as clicking on a symbol (see Figure 12.11) in order to add a media query to your file.

12.11
One simple method of adding a media query to your document. This will change depending on the web design program you choose to use

Bootstrap: Mobile First Design

Some web designers focus on designing for mobile phones and tablets rather than PCs and laptops. Bootstrap is a very popular HTML, CSS, and JavaScript framework and is used for developing websites that are geared towards mobile first applications. While Bootstrap can be downloaded and used for free, it is also integrated into most web design programs.

A Quick Note About JavaScript and jQuery

JavaScript is a relatively simple programming language that can be embedded in an HTML document to open the range of possible interactive features. It allows you to embed special effects, open new message windows, perform calculations, write interactive games, and more. The JavaScript we tend to see most often is for cause and effect activities like *mouseovers* (also called rollovers). This can also be extended so that any object can change as the mouse rolls over it.

[Note: JavaScript has no relation to the powerful and complex Java programming language.]

Box 12.3 Create a Simple JavaScript Mouseover

In order to create a mouseover, two images of the same size are created. One of the images will be visible when the page initially loads. The second image—changed to whatever form the

designer wishes—will become the *rollover* image that will result when the mouse action triggers it. Even though your browser will assume the script language you are using is JavaScript, many designers suggest adding a set of tags in the header of your document to define the script language in the event other scripting languages are introduced.

In the *body* of your HTML document, you can insert the JavaScript that will trigger the mouseover event.

<a href="Florence.htm"	References the html document that will be opened when the mouse click actually takes place on the mouseover. This is a page with an image of Florence, Italy.
onMouseOver = "document.sample.src='iFlorence.jpg';return false;"	When the mouse moves over the icon, it changes to this.
onMouseOut = "document.sample.src='iFlorenceb.jpg';return false;">	When the mouse is not over the icon, it looks like this.
****	This is the image (icon) that first shows up when you see the page with the rollover.
****	Ends the anchor tag.

Note: for a series of mouseovers, the "sample label" must be unique. This is often accomplished by adding successive numbers for each of the mouseovers after sample. (Example: document. sample2.src)]

While JavaScript can be very powerful and helpful in designing web pages, it is also more difficult for the beginner to learn and apply. Luckily, there are many programs that have the most often used functions ready to click or drag and drop in your application.

For example, **jQuery UI** (User Interface) is a library of pre-scripted features that make it easier to apply interactive JavaScript elements to your webpage. Built on the more powerful and complex jQuery, it allows a user to apply various *interactions* (for example, make something draggable, droppable, or resizable), *widgets* (for example, to create buttons, containers, and menus), *effects* to create various forms of animations, and *utilities* that can set an item's position relative to other elements on your webpage. This is accomplished by adding another type of stylesheet (called *script.js*) that contains information about what will happen to elements defined within it. In various web design programs, menus list the possibilities for both jQuery and JavaScript (see Figure 12.12).

12.12
A sample of a menu for using jQuery UI and JavaScript

Social Media and the Web Designer

The incorporation of social media (such as Facebook, Instagram, Twitter, YouTube, Pinterest, LinkedIn, and a host of others) as part of website design has accelerated as businesses have realized that moving beyond the isolation of a single web presence can reap dividends.

By providing an option for users to link your website to their social media connections, you can extend the reach of any website. Adding buttons for social media sites on your index page, so that users can join to discuss and comment on your site and product, is an excellent strategy for growing brand recognition. It also makes sense to allow users to log in to their account with "social sign in" using their existing social networking identification. Most users appear to prefer this to setting up new accounts with still more passwords to remember.

There are many other strategies one might employ to integrate social networks and websites. Sharing relevant blog sites, customer testimonials, customized pages for social media customers to enter (instead of the standard home page) with specialized information, or offers along with links to your normal website will create a sense of special access.

Embedding Audio and Video

If you intend to play an element with extended sound—such as music or video—then you should also incorporate controls that will allow a user to elect to start and stop the media. Audio that immediately starts playing when the web page loads can be an unwelcome, even startling intrusion if it is not in some way part of what the site is about or is featuring.

Luckily, there are many control options to choose from. Figure 12.13 depicts a simple HTML addition of a media player that allows users to play and/or stop a sound file and can be placed anywhere in the body of a webpage.

[Note: Ogg is a container (or wrapper) that holds any type of data but is used primarily for streaming audio and sometimes video files.]

```
1    <!doctype html>
2  ▼ <html>
3  ▼ <head>
4    <title>Audio Player</title>
5    </head>
6  ▼ <body><audio controls>
7        <source src="your choice here.ogg" type="audio/ogg">
8        <source src=" your choice here.mp3" type="audio/mpeg">
9    Your browser does not support the audio element.
10   </audio>
11       <h3>Title of audio if you wish</h3>h3>
12   </body>
13   </html>
14   |
```

12.13
Adding an audio player with basic HTML code

Embedding video works in much the same way and with HTML5, it has become much easier (see Figure 12.14). In the past, a viewer needed a special plug-in (for example, Flash Player) in their browser in order to play a video. With HTML5, the *video element* provides a standard for embedding video on a

```
1    <!doctype html>
2  ▼ <html>
3  ▼ <head>
4    <title>Video Player</title>
5    </head>
6  ▼ <body><video width="320" height="240" controls>
7        <source src="your movie here.mp4" type="video/mp4">
8        <source src="your movie here.ogg" type="video/ogg">
9    Your browser does not support the video tag.
10   </video> |
11   </body>
12   </html>
13
14
```

12.14
Incorporating a video player works in much the same manner as the sound player

12.15
Basic movie viewer with simple video control

website. Here is an example of that video element in practice (see Figure 12.15). As you can see, this is very similar to embedding audio. The key difference is specifying *video*, *dimensions*, and especially *controls*. With the controls attribute, play, pause, and volume are automatically included. If you substitute autoplay (not recommended) for controls, the video will play whether someone wants it to or not.

WHAT IF IT DOESN'T WORK?

During the process of creating web pages with HTML and CSS, most designers expect some errors to creep in. HTML and CSS, like all programming languages, are very literal. Most pages with elements that don't work can be traced to a spelling error or a missing tag or even a missing bracket from a tag. It takes a lot of time to work out a complete site without frustrating errors. Certainly, in the beginning, the best approach is to keep it simple. Cascading stylesheets usually take a bit of time to get to know well, and many of the problems even experienced web designers encounter have to do with code that will work in one browser and not in another. The more complex your code, the greater the likelihood there is of this happening.

Test Your Site

The most important rule is to test and test often. Test your site on as many browsers as you can. Click all the links and make sure the linked documents appear the way in which you want them to. Check the photos on the page to be sure they are the ones you want to appear. In addition, include information about who to contact about the site. There are many users who will provide both good and bad feedback on a site.

Testing takes on an even greater importance if you're designing for multiple devices like phones and tablets as well as desktop computers and notebooks. Testing on all of them will confirm that your CSS is working to display your website properly across the spectrum of users.

Once your website checks out thoroughly, the next step is to decide where to publish your site. There are many hosts that will carry your website free of charge. If you are a student, most colleges and universities provide free space for student websites. Most Internet service providers, including local telephone and cable companies, will also provide free space for subscribers' websites. If you are producing a commercial site, then there are thousands of companies that will host your site for a monthly fee (or example, iPage, Bluehost, HostMonster, and others).

Domain Names

The Domain Name System (DNS) is how websites are commonly addressed. Domain names have a categorical hierarchy that groups different types of sites together. There are commercial sites (.com), educational sites (.edu), government sites (.gov), military sites (.mil), organizations (.org), and more. Organizations register for domain names based on the type of site they will maintain. It has become fairly easy to purchase a domain name though it usually requires a monthly or yearly fee. Having your own domain name makes it easier for users to find and remember your site.

FTP: Uploading Your Site to a Server

Once you have a website, domain, and have chosen a host, the next step is to upload your pages and content to the host. There are many file transfer protocol (FTP) programs available both commercially and as freeware and shareware. FTP is a client-server protocol that allows a user to upload, download, rename, delete, move, and copy files on a server. Whether using Cyberduck, Filezilla, or WS_FTP, you will be using a graphical interface that will work by clicking and dragging files from one computer to another over the Internet. This will allow you to quickly copy your site to a new domain.

Box 12.4 Copyright and Creative Commons

It is frequently thought that anything on the Web is available for anyone to use. But finding something already on the Web does not mean that it is copyright-free and can be copied for inclusion on your own site. There are an enormous number of misapprehensions concerning copyright infringements on the World Wide Web. It should be obvious that any copyrighted material that you wish to use on your site must have the permission of the copyright holder. However, it is sometimes difficult to determine just what is copyrighted material and what is not. Generally, if material is more than 75 years old, chances are good that it is no longer covered by copyright unless the owner of the material has specifically taken steps to extend their copyright. Material that is less than 75 years old, that has not specifically been placed in the public domain, is protected by copyright. More specifically, work by a single author remains protected by copyright until 70 years after the author's (or artist's) death. If a work has more than one author, an anonymous author, or if the work is owned by an organization, it is protected for 95 years. Of course, there are always exceptions, but these guidelines should help in determining what you can and cannot use. Further, copyright exists from the moment a work is published. It does not have to be formally registered with the copyright office and it is not even important whether or not the copyright symbol appears on the work.

Unless work on a site specifically states that the material is copyright-free—and this applies to text, images, music, multimedia, and anything else you can think of—it is best to consider it under copyright protection. Even if you receive permission to use a work, there may still be problems. Often there are separate copyrights on items. If you receive permission to use a piece of music by the author, the performance you choose to use may still be copyrighted by the artist performing it. In fact, there may be many copyrights by various artists and recording companies on the same piece of music. Film or video is even more complex with copyrights extending throughout the world. Researching copyright has become a growing business in the multimedia production profession.

Fair use is a limited use free of copyright restrictions, and is often misunderstood. Outside of education, the only fair use applications that are relevant apply to small selections of an original

work when used for news reporting, criticism, and parody. Going beyond these strict limitations could make you liable for copyright infringement.

Creative Commons

Creative Commons is a new approach to copyright which its founders believe is more in the spirit of the Web. It is sometimes defined as a "copyleft" movement that seeks to bring more work into the public domain with simple, easy to understand licenses that are free to the public. As a non-profit, American company, Creative Commons seeks to make a variety of creative work available for others to expand upon or use as originally intended.

The licenses available cover a wide range of possibilities. In its simplest form it allows the creators of the work to retain copyright while allowing the work to be copied, modified, and used in any one of a variety of ways. These derivative works can also be shared with others. The licenses range from simple *Attribution* where the work can be used freely as long as the original artist is credited for the original creation. *Attribution-ShareAlike* allows for the same freedom that allows others to build upon an artist's work, even for commercial use. *Attribution-NoDerivs* allows for the redistribution of creative work as long as the work is not modified in any way. *Attribution-NonCommercial* is similar to the first two licenses outlined but restricts the work from being used commercially and the original artist must be acknowledged. *Attribution-NonCommercial-NoDerivs* restricts the use of work to allow others to download and share work, with credit to the artist but with no changes to the work and no permission to use the work commercially.

Alternatives to HTML and CSS Coding

Despite the help that web design programs can provide, many people have found web programs like Wordpress and Wix to be very useful in designing pages. Wordpress for example provides numerous templates that can be modified successfully by the user.

Once you have registered and have chosen a template (which can be changed later) you can simply edit the template to reflect your interest, adding images and text as needed. This a very intuitive way to prepare a website and no knowledge of HTML is necessary. In addition, programs like Wordpress provide domain name choices for free if wordpress.com is used (your website.wordpress.com).

Wix works in a very similar fashion and also provides an option for presenting videos in a variety of different ways on your site. It also features 360 degree and 3-D images, an Instagram feed, social media connections, and more apps to update your site.

Both Wordpress and WIX, as well as other similar sites, offer the opportunity for sophisticated sites. While not for web design professionals, it does have its place for non–web designers in need of a web page that can be created fairly quickly.

Artist Profile: Clement Valla, Postcards from the Edge

Clement Valla is essentially a collector—a collector of images found on Google Maps that represent the world in a moment of representation that is not a glitch or error but the result of the way in which the Google Earth software actually functions.

12.16
Clement Valla

12.17
Clement Valla, Postcard from Google Earth (48.408737, -122.64598)

Is simply recognizing and then taking screen grabs of the found images actually art? This has been debated on websites presenting his work, but one must ask, how is this any different from what photographers do when making a photograph? The photographer deals with a moment of

12.18
Clement Valla, Postcard from Google Earth (43.108994, -79.05813)

12.19
Clement Valla, Postcard from Google Earth (46.51286, 6.909127)

recognition (of something of value) and then makes an image of it (not usually a screen grab but with a more sophisticated instrument) and then presents what he or she has made for a viewer to experience.

The interpretation of the images is left to the viewer.

Valla notes:

> I discovered strange moments where the illusion of a seamless representation of the Earth's surface seems to break down. At first, I thought they were glitches, or errors in the algorithm, but looking closer I realized the situation was actually more interesting—these images are not glitches. They are the absolute logical result of the system. They are an edge condition—an anomaly within the system, a nonstandard, an outlier, even, but not an error. These jarring moments expose how Google Earth works, focusing our attention on the software. They reveal a new model of representation: not through indexical photographs but through automated data collection from a myriad of different sources constantly updated and endlessly combined to create a seamless illusion; Google Earth is a database disguised as a photographic representation.

Valla's work has been exhibited in numerous galleries around the world and has been cited in numerous publications.

CONCLUSION

This brief introduction to preparing for entry to the Web has only touched on the highlights and basic items necessary to getting started. You will find thick books in most bookstores with detailed HTML code, CSS, and JavaScript to help you get the most out of your web developing experience. The Web also has extensive information on both HTML and CSS along with tutorials, samples, and excellent background information. But remember, all the code in the world cannot take the place of good design and a well-planned and organized page.

Only a handful of visionaries were able to see the usefulness of the Web for communicating information and none could foresee its impact. In the last few decades we have seen incredible changes in digital technologies and the tools available to those in the arts. In the digital world, new information and ways of doing things are a constant. Bringing together your visual thinking and design skills along with the technical ability necessary to express them in a web design might at first seem overwhelming, but with enough time and effort can produce a very satisfying result.

Projects: Designing for the Web

1. BASIC WEB PAGE
 Create a basic introductory web page (index page) about yourself or your family, including two links to other pages and one link to a website. Make the background a color.

2A. MAKING JPEGs AND ICONS (NOTE: PROJECT 2 IS A THREE-PART PROJECT)
 Make JPEGs of six individual images you have scanned. For this project, be sure they are no larger than 400 × 550 pixels in size. Try to keep their file size under 50K. In addition, create icons for each of the images no larger than 100 pixels in their longest dimension.

2B. IMAGE PAGES
 Create six individual web pages featuring one of the JPEG images you created. Save them with simple names (i.e., image1.htm, image2.htm, and so on). Make sure you have a color background and center the image on the page.

2C. ICONS AND LINKS PAGE
 Create a web page with an introduction to your images and a series of icons with a link to the page holding the larger image it represents.

13 Game Art and Design

13.1
Oscilloscope with Higinbotham's Tennis for Two

The attraction of creative people to the game industry is not difficult to understand. Financially, it has eclipsed movies and music, with estimates of its revenue ranging from $20 billion to $90 billion per year. Its impact culturally is equally significant. For those born after 1990, games are their common connection, much like movies for the generation before WWII or television for the Baby Boomers.

Creating games requires the ability to understand and utilize the game tools and systems available in order to create an environment that is both engaging and challenging. In addition to using the digital tools available—especially in 3-D modeling and animation programs—designers need to be aware of the theater of game design and game play. What is generally thought of as game design is a complex collaboration of team members with a wide variety of skills. This chapter will not only look at the nature of game design itself but will focus on the parts that are handled by artists and designers. We will see that the digital media discussed in the preceding chapters play key roles in a career in the gaming industry.

WHERE DID IT ALL BEGIN?

The history of computer-based game design began long before the introduction of desktop computers for consumers. In 1958, at the Brookhaven National Laboratory, William A. Higinbotham hosted a public tour of his laboratory. Brookhaven was a nuclear research lab and the public was invited to tour the facility each year to let them see for themselves just how safe the facility was. As Higinbotham's lab was not a terribly exciting part of the tour, he wanted to find some way to make it more interesting. Using what was considered then a small computer in his lab to control the trajectory of a bright moving point (which he called a "ball") on an oscilloscope, he had the visual foundation for a more interesting and interactive experience for the public tour. Along with Robert V. Dvorack they assembled an interface for their "game." It included a horizontal line at the bottom of the oscilloscope, a short vertical line coming up from the center (the net) and two paddles. Each paddle was a box with a dial that controlled the angle of the ball's movement and a button that allowed a player to "hit" the ball from their side of the screen to the other. The result was essentially a side view of a tennis court on the round oscilloscope screen, with the ball bouncing over or into the net when struck with a paddle on one side or the other.

Thus the history of video games began as one of the first peacetime applications of military technology. Rather than plotting missile trajectories, a program was repurposed into what they called *Tennis for Two* (see Figure 13.1).

While this game may seem incredibly primitive today, people stood in line for hours for a chance to play on a 5"-diameter screen in 1958. A year later the screen size was larger and Higinbotham programed changeable gravity into the system to show competitors what it might be like to play tennis on other planets. Unfortunately for Higinbotham, soon after the laboratory tour in 1959 the device was dismantled and the parts used for other purposes. He never pursued a copyright.

SPACEWAR! (WEDGE AND NEEDLE)

During the late 1950s, the computer labs of the Massachusetts Institute of Technology (MIT) were open to almost anyone at the university interested in gaining expertise in writing programs and exploring the capabilities of computer programming. After MIT acquired a new PDP-1 (Programmed Data Processor-1) computer in 1961 (with 9 kilobytes of RAM), Martin Graetz, Steve Russell, and Wayne Wiitanen created the game *Spacewar!*

In this game (see Figure 13.2), each of the players controls a spaceship. Using relatively primitive controls, each player can control the motion (propulsion rockets), rotation, and the firing of up to 31 space torpedoes to destroy the opponent's ship. To add to the complexity of the game, each torpedo could have either a proximity fuse (explodes when it comes near another object) or a timed fuse (causing the torpedo to explode after a set time). A heavy star in the center of the screen provided a strong gravitational force drawing both ships inward toward the center of the screen. Without the thrust of the propulsion rockets, ships are drawn to collide with the star and are destroyed. In addition, the use of a hyperspace emergency drive (limited to three uses) allowed ships to disappear to avoid destruction and appear somewhere else on the screen.

As you can see, the game, even in this simple environment, was relatively complex and interesting to play. This was also an excellent way to demonstrate the capabilities of the new PDP-1 computer. Unfortunately, only 55 PDP-1 computers were ever sold and not all were sold with monitors (see Figure 13.3). This limited the original *Spacewar!* from reaching more than a very narrow audience of computer academics. However, it did inspire many to begin to consider gaming as a legitimate activity for programmers.

With the creation of BASIC (Beginner's All-purpose Symbolic Instruction Code) (see Chapter 2), one of the first programming languages that could run on a variety of hardware types, programs written for

13.2
Spacewar! on original monitor for PDP-1 computer

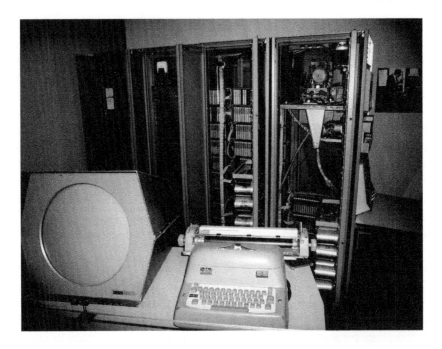

13.3
PDP-1 computer complete with monitor

one type of machine were able to run on others. This allowed games to spread to more users within the programming community and inspired others to program still more applications. However, the goal remained to expand programming skills and to take advantage of newer and faster computers, rather than developing games for the public. This was not surprising since computers were rare, enormous in size and cost in comparison with today's computers, and required a graduate school level of programming knowledge. Something else needed to happen to bring computer gaming to the rest of us.

AN INDUSTRY BEGINS

In 1971, inspired by MIT's *Spacewar!*, Bill Pitts and Hugh Tuck, two programmers at Stanford University, made the first attempt to bring computer games to the public and create the first commercial, coin-operated arcade video game—*Galaxy*. At the time, most coin-operated, mechanical arcade games (like pinball) cost about $1,000 each to manufacture. Unfortunately, just the computer for *Galaxy* cost $20,000, so the game was never commercially viable. Still, after installing their arcade game in Stanford's student union, they did earn back their $60,000 investment in six years. Nonetheless, after producing a few prototypes, *Galaxy* was abandoned.

As in most industries, once an idea has taken hold, additional creative ideas move the concept forward. Nolan Bushnell was an engineer and computer science student during the late 1960s, and played *Spacewar!* on a DEC (Digital Equipment Corporation) computer at the University of Utah. He and a colleague, Ted Dabney, thought that the game would be a success as a coin-operated unit in much the same way pinball machines were at that time. Wanting to create a less costly game based on *Spacewar!* (the coin box in this game was a paint-thinner can), they worked to build a coin-operated game that could be easily manufactured and distributed. In their game, *Computer Space* (see Figure 13.4), a rocket ship

13.4
Computer Space console

controlled by the player would try to shoot down two flying saucers that were also shooting at the rocket ship. With four buttons to control the rocket ship—two rotation buttons, one for thrust (movement in the direction the rocket faced) and one for firing a missile—the goal was to shoot down the saucers before they could shoot you down. After initially trying an expensive computer to run their model, they discovered they could substitute a simple video control board to control the game's moving video elements. This solution brought the cost of producing the game to about $100 each.

The game was a relative success and sold between 1,300–1,500 units. After unsuccessfully negotiating with their manufacturer for their next game idea, Bushnell and Dabney took their small profits—a total of $500—and founded a new company called Syzygy. However, since a roofing company had already registered that name, they changed it to *Atari*. Bushnell later said Atari was a move in the ancient Japanese game Go: "what you said to your opponent if you put their stones in jeopardy. . . . I just thought it was a cool word." After hiring another engineer, Al Alcorn, to help build the next game, they decided to start with a simple tennis game. This was a fully electronic game with all solid state parts and hard wired to play what became known as. . . *Pong* (see Figure 13.5). After resolving the paddle control, a prototype—and history—was made. Almost.

After being turned down by Bally Pinball to build and distribute the game, Bushnell decided that Atari would build and distribute the game itself. Renting an abandoned roller skating rink, he hired local labor and began to build the systems. Each *Pong* game quickly began to bring in over $100 a week. After selling 8,500 machines at $1,200 each, with a building cost of $500 each, their profit for the first year was over $3 million.

The computer game industry had been born and Atari went on to become one of the largest and earliest manufacturers of computer-based games.

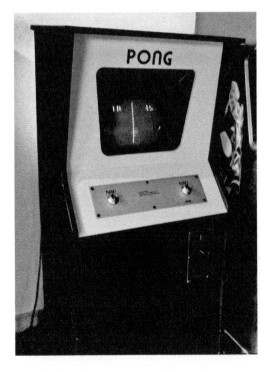

13.5
Commercial *Pong* console for arcade gaming locations

GAME GENRES

As gaming has matured, it has evolved into distinct types or *genres*. While detailed descriptions of these and their sub-genres is beyond the scope of this text, every Game Designer needs to first consider what kind of game they would like to develop. Broad categories are only a place to start and many successful games are a hybrid of these types.

The earliest games from more than 50 years ago, like the arcade games *Space Invaders* or *Asteroids*, involved rapidly firing at targets, and were called *shmups* as in "shoot-'em ups." In most cases, the shooter was in a fixed position or at best could only move side to side along a rail.

First-Person Shooter

Shmups would ultimately develop into one of the most successful types of video games—the *first-person shooter*. With the release of *Wolfenstein 3D* in 1992, the shooter was able to move freely through a 3-D space (see Figure 13.6) and meet targets on the run. Players moved through the game with the viewpoint of their characters or *avatars*—heightening the drama as dangers came towards them. Soundtracks added to the intensity, for example with heavy breathing that grew louder as the threats grew.

The success of the first-person shooter genre (with landmark titles like *Doom*, *Quake*, *GoldenEye 007*, and *Call of Duty*) was due not just to its excitement but the arsenal of imaginative weaponry. These remain among the most violent types of games.

Early in their history, first-person shooter games also introduced another crucial development in game design—the *multi-player* game. Players could compete with and against each other, cementing one of the most important qualities of gaming—its social aspect. *Respawning* allowed killed players to come back to life and increased the pleasure of these games. In today's multi-player games, thousands of players can play together at one time.

Just as importantly, game companies provided tools that allowed gamers to supplement a game's original landscapes with their own "maps" that could be shared with other players.

13.6
Scene from *Wolfenstein 3D*, 1992

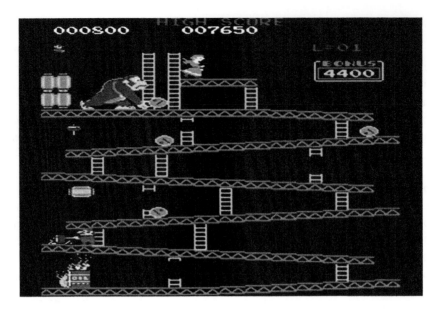

13.7
Donkey Kong, 1981

Linear Adventures and Role Playing

A linear game is one that requires the player to complete a series of specific challenges. The earliest ones were text adventures, where players typed simple commands like "open window" as they discovered the unfolding story.

The first visual linear adventures were arcade games, like *PacMan* and *Donkey Kong* (see Figure 13.7). Players scrolled left to right or up and down as they avoided obstacles and defeated enemies. After a series of challenges were met, the player was taken to a new level with a higher degree of difficulty. Many of the most successful video games have used a linear approach, including one-on-one fighting, survival horror, vehicle simulations, and dance challenges.

Linear adventures can have either a first-person perspective or *third person* (also known as a *role-playing game—RPG*), where the player controls a character he or she can see as in the *Tomb Raider* and *Legend of Zelda* series (see Artist Profile on Nintendo's Shigeru Miyamoto in Chapter 3). Many games today allow players to choose among multiple characters or even to design their own.

Sandbox Adventures

In a *sandbox adventure*, the protagonist has much more freedom to roam and explore. While players usually have a mission, they can take as much time as they want to see the sights in an environment. The *Grand Theft Auto* series is a good example of a sandbox adventure and even allows players to choose among missions. One reason for the series' success is the richness of its environments and the opportunities for exciting, unusual action and exploration.

Real-Time Strategy (RTS)

In *real-time strategy* games, players typically command armies, gather resources, and build empires. You can make and break alliances with other players and the view is an aerial perspective from above a large map. Normally set in a specific time period, they can range from ancient Rome to World War II or far into the future on fantasy alien planets. Successful titles, like *Age of Empires*, have been released in series and also include game specific *expansion packs* that add to the storyline or include new maps.

Puzzle Games

Puzzle games are much simpler but are also the most widely played of all computer-based games. Part of their success is their combination of low cost and availability on all kinds of platforms—from home computers to mobile phones. Often designed for a single player, their historical precedents are among the most popular games in history, like crossword puzzles, mazes, and solitaire. Future Game Designers are often encouraged to begin with a puzzle game to develop their skills and imagination.

The most famous computer puzzle game is *Tetris*, originally designed by Alexis Pajitnov, a Russian researcher at the Soviet Academy of Sciences, to test computer hardware. When this falling blocks game was released in 1985 for the IBM PC, it became a world-wide sensation.

The addictive quality of Tetris is a hallmark of all successful puzzle games. Today's *Candy Crush Saga*, played more than a trillion times, is just the latest manifestation of this perennial favorite game genre.

PLATFORMS

Today, games are played almost anywhere and on many kinds of equipment. Gamers can be found at play in video arcades, living rooms, or on a train (but, luckily, never in a classroom). As a result, game companies not only have to decide what type of game to design, but also what kind of platform they want the game to be played on. Each platform has its unique requirements.

Arcades

Arcade games have a long history, beginning with games of chance and skill at amusement parks. Coin-operated mechanical pinball machines arrived in taverns in the 1930s and cost a penny to play. As mentioned, in the early 1970s, Nolan Bushnell founded Atari and created the first successful coin-operated video arcade game—*Pong*—and established the quarter as the price of play. Soon followed by *Space Invaders* and *Pac-Man*, video game arcades were a multibillion-dollar industry by decade's end (see Figure 13.8).

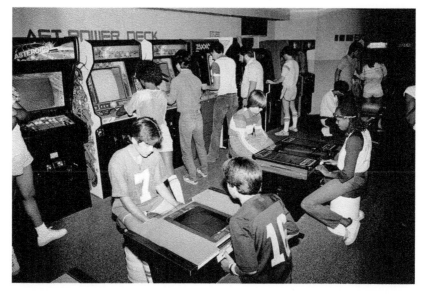

13.8
Video arcade in early 1980s

While arcades in the U.S. are no longer as popular, they remain a thriving market in other places like Japan (where there were five times as many *Space Invaders* machines as in the U.S., reputedly causing a temporary coin shortage in Tokyo in the 1970s). Arcade games do continue to succeed worldwide when they offer specialized game controllers and other hardware not available in the home—like the dance platform of *Dance Dance Revolution*.

"Entertainment Systems"—Consoles

The most technologically sophisticated games are played on dedicated consoles like Xboxes and Sony PlayStations, each with its own proprietary programming optimized for game play. Their origins are in the first home video game players of the 1970s, like the Magnavox Odyssey and the Atari 2600, which consumers plugged into their television sets. As the hardware and software for graphics improved (especially with the arrival of 3-D animation), the heightened realism of this game platform became more and more cinematic.

Since consoles are fixed, dedicated systems, games can be designed specifically for them and take full advantage of the console's hardware, proprietary software system, and controllers. However, because of their sophistication and the intense competition between console makers, these games are also the most expensive to develop. Before beginning, developers must get approval from the console maker, a license, and purchase a special, expensive development kit. When completed, the game has to undergo rigorous testing by the manufacturer before final approval. Production and marketing costs are closer to those in the movie industry, with development teams numbering in the hundreds. But there is also the potential for movie-size profits, too.

Dedicated Portable Devices

Around 1990, Nintendo released the first successful handheld game device, the Game Boy (see Figure 13.9). Like consoles, handheld portable game players can take advantage of dedicated programming, but designers also have to take into account the hardware limitations of these

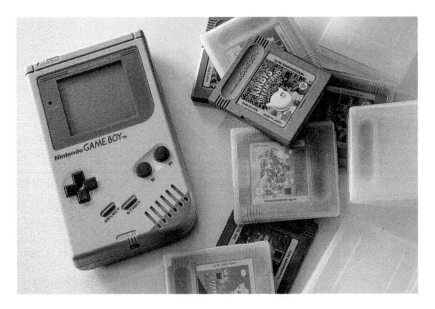

13.9
Original Game Boy and cartridge, 1989

devices. The original Game Boy used the Intel 8080—the same processor found in early calculators (see Chapter 2).

All handheld game devices have a built-in screen, game controls, speakers, and a battery system. Because these also contain proprietary software, the approval process and requirements for developing handheld device games are the same as with dedicated consoles.

Hybrid Systems

Recent advances are blurring the division between home and portable game play. A *hybrid console* combines console and portable use. For example, Nintendo Switch, introduced in 2017, is meant to be used predominantly as a game system but has a controller that can be removed from a docking station and used as a stand-alone game player. Pulling out the controller's two sides reveals a small touch screen. Players can use the mobile controller to play online through the Internet or by connecting to another nearby Switch console.

Mobile Phones

The arrival of cellphones in the 1990s soon meant there was a new portable device for games. Like the first Game Boys, early phone games tended to be simple puzzles. The genre took off first in Japan with virtual pet games (which led to Bandai's hugely popular *Tamagotchi* handheld pet game toys).

Today, low-cost, addictive smartphone games have audiences in the millions. Successful mobile games, like *Angry Birds* and *Candy Crush* (see Figure 13.10), are easy to play and have much shorter levels to complete than typical video games. Many games connect to other players through social media, which increases involvement and provides free publicity. To offset a mobile game's minimal or free initial cost, companies will sell add-on features or include ads. These end up being crucial parts of a business plan. While their screen size is small, the cost of developing a mobile game is not.

Designers first need to choose what types of phones they are targeting. This usually means a choice between developing with the native coding languages for either the Android or iOS (iPhone)

13.10
Candy Crush for mobile phones, 2012

operating systems, deciding to have two parallel developing teams, or using a cross-platform develop-ment kit that may be easier to work with but loses some of the native coding benefits (like access to the camera). As it was with the early Game Boy developers, visual elements have to engage users but also take into account the smaller screen and relatively limited resources for loading graphics. Designers need to strike a balance between exciting imagery and quick gameplay.

Home Computer

Many arcade and console games are ultimately "ported" to home computers. While offering a very large market, designing for this game platform has its own unique challenges. Programmers have to take into account the conflicting demands of a home computer (word processing, spreadsheets, web browsing). They also need to manage a wide range of computer types. As a result, many compromises must be made while redesigning games originally designed for dedicated game machines.

However, computer games reach a broader audience and generally require smaller development teams than those for consoles. Because personal computers are open systems, the costs do not include the strict and expensive requirements that console makers demand. The home computer also allows for a wider range of game types, from simple puzzles and card games, to complex first-person shooters.

FROM IDEA TO RELEASE: THE GAME DEVELOPMENT PROCESS

No matter what the genre or platform, every game begins with an idea. What game player hasn't asked themselves, "wouldn't it be great if I could. . .?" That's a fine place to start. Still, every good idea is going to need a producer and team if it has any chance of becoming an actual game.

The High Concept and Pitch

As in movies, producers are going to want to know your *high concept*—an easy way to understand and explain the game to others in a sentence or two. One way to communicate a concept easily is to compare your game to other popular games. For example, our new *Return from Troy* is *Grand Theft Auto* meets *Call of Duty* as told by Homer. Make sure you know what made the earlier games successful and how that applies to what you are proposing. Remember whomever you are talking to will need to explain your concept to others in the company. Once a producer is interested in your high concept it is time to make your Pitch.

The *Pitch* (a term borrowed from Hollywood) is a prepared presentation that first describes the concept of the game and then provides a thorough overview of the game design itself. A description of characters, the nature of gameplay, and the technology required outline the full potential of the game. For example, can expansion packages be added to the game to encourage continued play? Is there a multi-player option? Can you play against friends? Whatever elements that might contribute to the financial success of the game are reviewed.

The nature of gameplay is covered, often with a walk through of the interface and a playable pro-totype of a portion of the game. Preliminary conceptual artwork is also reviewed in order to help the client visualize the game and its look. Once you've attracted a producer and some initial funding, it is time to begin the phase called pre-production.

Pre-Production: The Design Document

The design document outlines a complete development plan for a new game. The development plan consists not only of how the game will play, look, and sound, but how it will be made. It will

include a list of all personnel required for the completion of the game—for instance, a designer, chief programmer, junior programmers, art directors, artists, illustrators, sound effects person, and so on. The timeline for delivery of the game is also set, along with a more detailed outline of characters and animations.

Pre-Production: Prototype

Because game development today can cost millions of dollars, no producer is going to commit to a project solely on a good plan. That's why most development teams are required to make a limited prototype of the proposed game. Sometimes called a *demo*, the prototype demonstrates that the game is not only playable and enjoyable, but that it can work technically. Does the game require new programming or an unusual interface? Outside testers will be brought in to identify problems.

Building a prototype also will prove to the producer that your team is capable of completing a project. Could you handle technical difficulties or changes in concept? Did you meet deadlines?

In addition to the design document and prototype, more work on concept drawings, character design, some preliminary 3-D modeling, and backgrounds will need to get underway. All of this work is necessary before a game producer will have the confidence to give the OK to begin full production.

Artist Profile: teamLab—Game? Art? Both?

"Transcending boundaries" is not just part of an artwork's title but the goal of teamLab, a group of several hundred international artists, designers, animators, programmers, sound engineers, and mathematicians. When visitors enter the darkened room of *Universe of Water Particles: Transcending Boundaries* (see Figure 13.11), they are transported into a world where reality and imagination co-exist. After they enter, they first hear the sounds of water and electronic music. On the far wall, a projected waterfall flows. The waters run across the floor towards the visitors, but seem to sense where they stand because the streams move around them. Their feet trail flowers, which bloom in their wake. A touch on the wall sets off an explosion of butterflies and cherry blossoms.

Is this a game or a work of art? Or both? There are no winners or losers. Each visitor is a participant in the creation of the experience that is generated in real-time. As in a game, the experiences are based on the interactions of you and your fellow visitors. What happens inside the room constantly changes. Programmers' algorithms ensure that nothing ever is repeated.

teamLab has created 3-D works for flat screens, as well as wall-size interactive works, smart hangers for stores, and projected environments in ancient forests (see Figures 13.12 and 13.13). Calling themselves "ultra-technologists," their projects combine programming, sensors, projectors, screens, animations, lighting, and digital sounds.

As futuristic as it appears, the creators of teamLab see their work as part of a long tradition that links their work to Nintendo games like Super Mario Brothers. They believe that the way Super Mario scrolls across screens is no accident but follows the trail of how traditional Japanese

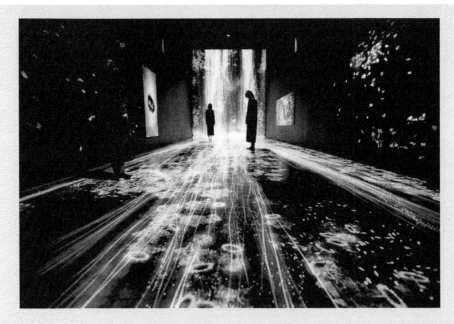

13.11
Universe of Water Particles, Transcending Boundaries, teamLab, 2017, Interactive Digital Installation, Sound: Hideaki Takahashi © teamLab

13.12
Ever Blossoming Life Rock, teamLab, 2017, Digitized Nature, Sound: Hideaki Takahashi © teamLab

13.13
Drawing on the Water Surface Created by the Dance of Koi and Boats—Mifuneyama Rakuen Pond, teamLab, 2015, Interactive Digitized Nature, 13min 24sec, Sound: Hideaki Takahashi © teamLab

scroll paintings told stories as they were unrolled. The ritual movements of the tea ceremony, Nintendo game play, and teamLab works are all logical developments of Japanese culture and philosophy. "When an action has a purpose, that action becomes independent from the purpose." Eventually, the action becomes independent from the purpose, but it still remains valuable in a spiritual sense. [Thus], "we see spirituality in the action and we play and enjoy the action, and this has from ancient times to the present day been unconsciously handed down through generations."

Game Development: The Team

Congratulations! You've satisfied the game producer that your project has potential and you've gotten the green light to begin full production. Now that you have the funding you need, it's time to hire your complete team and begin work. This can include artists, designers, animators, coding specialists, engineers, 3-D modelers, writers, storyboarders, sound editors, musicians, asset managers, and more. Just like the credits that roll at the end of a major motion picture, the list of individuals contributing to the production can be very long.

Game Designer

The lead Game Designer is responsible for developing the overall concept and structure of the game (layout, concept, and gameplay), the rules of the game and how they will be implemented, and has the overall responsibility for bringing the many steps that lead toward a successful game together. The Game Designer determines what a game is and does and defines each of the core elements of the game including the setting for the game, the flow of the story, characters and how they may interact with various objects and environments, what vehicles may be present and their characteristics, and

the interface design. Equally important is the ability to communicate with the entire development team responsible for creating the code that makes things run and the assets that make the game visually appealing. In most game design there will be a large multi-disciplinary team. The ability to communicate concepts is of paramount importance.

In communicating a vision to the team, the designer also needs to be able to listen to team members and accept the insights of others that might positively impact the game. In this way, the game developers can become, at moments, Game Designers. In short, the designer's ability to communicate in an open and direct manner should help to identify issues that others may have greater skills at solving.

While the Game Designer seems to be the paramount position in terms of determining the overall concept of a game, it is important to realize that many others will contribute to how the game is developed. So, while one person may have the title of Game Designer, and be primarily responsible for the overall game, many individuals engaged in creating content for the game will contribute to the ultimate game design.

Game Programmer

Programmers are essential members of any game development team. Without them there is no game. They create the medium that all the other asset producers build into and who the asset producers will come to with technical problems.

Game Programmers will write and modify game software, as well as test and debug it. A lead Game Programmer will coordinate the work of programming specialists in graphics, sound, user-interfaces, and networking.

Game Level Editor

A Level Editor constructs the interactive environment for a game as it progresses, including everything that will appear in the game. How the game is played out, the nature of the graphics, and the integration of game play as it relates to the environment are all determined by the Level Editor after consultation with the Game Designer.

The overall gameplay for a specific level of a game is determined by the Level Editor. While the Game Designer creates the specifications for a level, the Level Editor determines the nature of the space, the lighting and textures that should appear, where certain objects should be stationed, the specific challenges a player will encounter, and what the player must do to move forward. Movement through the space, including hiding places, obstacles, and various tasks, trials, and encounters are determined by the Level Editor.

Audio: Sound and Music

From the music that sets the stage for various elements of gameplay to the sound effects created by various game experiences, sound can make or break a gaming experience. A composer writing music for a game will find that it is fundamentally different from writing music for other parts of the entertainment industry because it is often non-linear. The composer has no idea exactly when a part of the composed music will be triggered. Soft music playing as a character sits by a slowly moving stream will need to suddenly transition as a life-threatening attack occurs or a gamer forces the character to leap in the water.

A sound designer is responsible for creating the many different sound effects we have come to expect in a game. If a rock falls or a cannon fires, someone must create the sound to accompany it. An

audio designer makes sure that the music and sound elements all come together, along with the work from voiceover directors who are responsible for character vocals. The audio programmer uses audio software to edit and enhance the results for effective implementation into the game. After the sound assets are in place, it is important that they are effectivity used as players trigger different elements of game play.

Game Tester

The role of a Game Tester is to go through a game from beginning to end, checking that all menu items work correctly, and that navigation works without issues. They play the entire game in each mode of play (from beginner to more advanced) and try and find problems or errors. If there is more than one choice of character in the game, the Game Tester must play the game as each character from start to finish. Every possible move or choice a player might make must be explored throughout the game.

If an error if found, the tester must document what happened and how to recreate the problem. Once the issues are reported, the tester will review updated versions of the game to verify the problem has been fixed.

Even before a game is completed, testing begins. Each part is tested as soon as it is playable. Even art objects and animations need to be tested as they are finished to make sure they work with the software and fit into the overall look.

Of course, the final test process is the biggest and most important. *Beta testing* takes place once every level, every asset (interface, characters, weapons, vehicles), and all programming is complete. Some publishers will open up beta testing to the public to ensure that as many contingencies have been checked and no unforeseen bugs emerge. Only after all bugs are cleared up and the game plays without errors, will the game by produced and distributed.

GAME ARTISTS

The largest group in any game development team is the artists. Game Artists are responsible for the visual elements of a game that determine the overall look and feel of the gaming environment. Whether working in 2-D or 3-D design, Game Artists create everything from the characters to the scenery surrounding them. The props, vehicles, objects a character engages with—all must be designed to fit the overall sensibility of the game. Strong design and drawing skills are a must, in addition to the specialized skills game art and design requires. You will see that these essential roles in game production involve nearly all of the digital media covered in this book's previous chapters.

There are many types of Game Artists and most work under the guidance of a lead artist. Each has a specialty, from creating paper sketches to modeling those sketches into computer graphics. Some will work designing characters while others will work on buildings and backgrounds. Textures must be applied to 3-D models. What follows are just some of the typical jobs that require the skills of a Game Artist.

The Concept Artist

After Concept Artists have helped sell the game to a producer, their work has just begun. Concept Artists shape the overall look and feel of the game by sketching key elements of the game world includ-

ing the characters that inhabit it and the details of their environments (see Figure 13.14). This ensures a consistent look to the game elements as other artists use the Concept Artist's work as a guide.

13.14
Sample of concept art

Storyboard Artist

Like in animation (see Chapter 10), Storyboard Artists show the key moments in any game and help the other artists in the team to visualize the action. However, these storyboards are even more complex since they have to take into account the multiple possibilities of gameplay.

Two-Dimensional Artist

While many games today are seen in three dimensions, much of what goes into a game's visuals are 2-D. While interfaces may appear as 3-D, menus and icons are typically flat images with shading. Maps, text displays, dashboards, and more are the work of a 2-D artist. Backgrounds that are seen only as players' cars whip by need not be truly 3-D. Creative 2-D artists can create a sense of a full scene without building a complex environment. This work is critical to a game's success. When the size of visual elements is kept as small as possible, quick gameplay is much more achievable.

Two-Dimensional Texture Artist

Two-Dimensional Texture Artists are specialists primarily involved with bringing surfaces to life by adding textures to almost everything appearing in the game. With an awareness of lighting and perspective

13.15
Flattened texture for three-dimensional figure

and how various materials respond, they can change a flat plane to a tile floor or a stone wall. They have the special ability to understand how to create a flat image that when wrapped around a 3-D wireframe seems completely natural (see Figure 13.15). Imagine what the flat texture map for a kitten looks like before it wraps around the mesh designed by a 3-D modeler.

Three-Dimensional Modeling Artist

Artists who specialize in 3-D modeling (see Artist Profile in Chapter 11) build the characters and objects that appear in a game. They create furniture, vehicles, weapons, planets, forests, and other scenes. This underlying structure is important to gameplay and also allows the environmental artists to build the actual world by creating the interiors and exteriors of various spaces, roads, caves, and whatever special elements the world requires.

If something is going to have to move, the 3-D modeler has to build that capability into its structure and work closely with the animators. Surprises can be unfortunate. If a character is going to wink, the modeler better build that in first or it might end up looking grotesque.

Animation Artist

Within a game, characters will hop or crawl, walk, run, or fly. Whenever something moves, an artist responsible for animation is involved. This particular skillset is what often engages the player and brings the game to life. Due to the more sophisticated nature of professional games, the Animation Artist will often need to understand a particular game engine's technology as well as the platform on which the game will run. In addition, working with programmers and other artists will allow the animator to find the best balance between sophisticated movement and optimizing movement for the platform being used.

Special Effects Artist

If fog obscures a boat or a dangling wire is shooting sparks or water is leaking from the ceiling, an Effects Artist is at work. Whether creating a weapon's puff of smoke after it fires or a light that buzzes on and off, an Effects Artist makes the world a more believable place for the player.

Lighting Artist

Essentially a director of photography, the Lighting Artist controls the lighting color, intensity and placement in a game level in order to control the mood and realism of a particular environment.

There are many other definitions and sub-categories of Game Artists but hopefully this brief introduction gives you a glimpse of the roles artists can play in game development and provide a hint of where your own interests may be.

Virtual Reality—Gaming's Final Frontier?

As a growing, competitive multibillion-dollar industry, games continue to drive technological innovation. Yet, in regard to *VR*—computer-generated locations that can be experienced by users separately from their natural environment—this continues to be more promise than reality. VR has been "the next big thing" for more than half a century. Research into its special equipment and software began with Ivan Sutherland's headset known as the Sword of Damocles (see Figure 3.8) in the 1960s. Jason Lanier's PowerGlove for Nintendo arrived in 1990 (see Figure 3.19), and VRML (virtual reality marking language) was first proposed in 1995, only a year after the World Wide Web was born.

Yet, aside from the increasingly common online "virtual tours," widespread experience of VR has simply not arrived as first imagined and continues to present challenges to researchers. Balancing believable imagery with the equipment's weight and cost remain the biggest stumbling blocks.

All VR experiences require tracking hardware—so that your body's movements (head turns, hand gestures) can be mirrored by your virtual one. The tracking hardware is usually encased in some kind of equipment for your head and hands. The sense of touch can be provided by devices attached to fingertips.

Gaming *has* helped realize the promise of **augmented reality** (**AR**), where computer information is layered over our visible world. Its first popular use came in 2016, with the introduction of *Pokémon Go*. Rather than depending on digitally enhanced eyeglasses (like the unsuccessful Google Glasses) or headsets, Pokémon Go is a mobile game app that utilizes a smartphone's GPS mapping technology to "see" and capture Pokémon discovered while walking.

13.16
Laurie Anderson and Hsin-Chien Huang, *Chalkroom*, 2017. Virtual reality installation. MASSMoCA, North Adams, MA

Japan's *teamLab* (see Artist Profile) take another approach to AR systems by using projectors, sound systems, and sensors to add a digital overlay to reality and create immersive environments. Inside such spaces, visitors can interact with and share in the creation of new experiences of "digitized nature."

Today, there is reason to be hopeful that the VR train is about to arrive in the station. Hundreds of companies are working on products designed to make VR available to consumers. Progress has been made on lighter, lower cost headsets, like the *Oculus Rift* especially designed for gaming. VR first-person shooters and RPGs have begun to be released. New genres are emerging, as in a game where you are a wizard and your disembodied hands can cast spells and fire thunderbolts.

Artists are also creating VR artworks. In Laurie Anderson and Hsin-Chien Huang's *Chalkroom* (see Figure 13.16), visitors feel as if they glide through gigantic spaces filled with words and images. While VR remains largely a private experience so far, multi-player VR games are in development.

The strongest evidence that VR is moving to the mainstream may be that the venerable *New York Times* has distributed free Google cardboard viewers to its subscribers. Meant to be used with their VR videos and VR app on smartphones, the *Times'* goal is to truly take readers "inside" stories. The untethered 3-ounce box, while low-tech, is certainly a long way from the wired headgear that Ivan Sutherland pioneered in 1968. His Sword of Damocles had to be suspended from the ceiling so it didn't crush its user.

The Future Is Arriving and the Past Is Always With Us

The gaming industry's impact and size is already hard to measure. But there is no question that playing video games is the universal cultural activity for anyone born after 1990, much like television was for their parents. Like any new medium, it will take time to understand its unique qualities and potential. Early photography imitated painting; early movies were filmed like plays. Though much time and effort has gone into creating cinematic effects, games are not movies. Ever higher levels of realism may not be the future at all (how realistic is *Candy Crush*?) but new approaches like augmented and virtual reality. AR and VR may even end up being new mediums, too, and require their own chapter in the next edition of this book.

The game industry has been around long enough to evoke a powerful sense of nostalgia. Gamers talk about classic games, like film buffs discuss classic films. Witness the success of the best-selling *Atari Flashback*. This game console can deliver more than 100 historic, early video games to any TV and sells about 300,000 units each year. Anyone interested in developing games is expected to be conversant in its history, like painters who traditionally study the history of art.

Can games become something greater? Will a future game be considered art? The director Steven Spielberg told college students that will happen "when somebody confesses that they cried at Level 17." But already the immersive experiences created by Japan's teamLab have entered museum collections and are sold by galleries. Exhibitions on the "Art of Gaming" have been shown at many museums, including the Smithsonian Institute.

It will not be long before most of the world leaders will not only have grown up in the computer age but playing video games. Will that affect how they govern? One can hope that games have taught them flexible thinking—since there is more than one way to win a game. Gamers are used to solving seemingly intractable problems by attacking them with persistence. Perhaps our world will evolve from being ruled by powerful leaders and nationalism to a team approach, since the world's citizens will have spent years playing multi-player global online games.

These are all questions that can't be answered yet. But we can be confident that games, like all the digital media, will require designs by talented, skilled, and creative individuals in the years ahead. It will be exciting to be a part of what comes next.

Projects in Game Art and Design

1. Select two different games of a similar type (for example: first-person shooter) and play each for at least 30 minutes. Compare and contrast each game. How are they similar? What differentiates one from the other? Are the goals different? How does the game provide opportunities for the player to succeed?

2. Using only a pencil and paper, sketch a character whose target audience is six-year-old children. Bring that character into your favorite digital program and create a model sheet—a page that shows the character from various angles and how it might move.

3. Organize a simple interior in order to convey a strong emotion. Take several photographs from different positions and bring one into your favorite digital editing program. Create an illustration from one of the photographs that might be used as a game background. Be sure to establish mood through the use of color and lighting.

4. Create a landscape that has a strong emotional context and represents a world that no one has ever seen. This work can be either highly stylized or a realistic, dreamlike image. Include a figure that fits the psychological nature of the landscape you have created.

Glossary

Abacus The first calculator. This calculating system, invented between 3,000 and 5,000 years ago by traveling traders in ancient China and Babylonia, has beads that slide along several strings in a frame. Each string represents ones, tens, hundreds, and so on.

Additive color model See **RGB mode**

Advanced Research Projects Agency (ARPA) Organization founded in 1957 to re-establish America's lead in military development of science and technology, particularly after Russian scientists succeeded in putting a satellite into orbit before the United States.

Alpha channel A stored selection or mask.

Ambient lighting Light spread across an entire scene without a focus, which illuminates all objects equally.

Amplitude The height of a sound as seen in a **sound wavegraph**. Technically how much change in pressure a sound creates. The taller a wavegraph's amplitude, the louder the sound.

Analytical Engine Early computing machine designed by Charles Babbage in the early 1800s, controlled by a set of punch cards that interacted with pins on metal wheels. Although never completed, it was an important forerunner of modern computers. This machine was larger than his earlier **Difference Engine**.

Anchor Tag that starts and ends links.

Anchor points In vector illustration, anchor points are found on either end of a **path**. When selected with the **direct selection** tool, control handles appear that can be used to modify the curve and direction of the path.

Animated symbol In digital animation, a short sequence, like a cycle, that can repeat several times to form a longer action. It can be saved with the file and reused again in different places in the animation without increasing the overall file size. Also known as a **sprite**.

Anime (pronounced "annie-may") The Japanese style of animation. Compared to cartoons in the United States, anime has much greater variety in subject matter and is enjoyed by all age groups.

Anti-aliasing Process that smooths the edge of a selection but will not soften it as extensively as **feathering** has the capability of doing. Curved selections will benefit the most from anti-aliasing.

ARPANET The first wide area network, created by the United States Defense Advanced Research Project Agency (ARPA) in 1969 in order to link universities and research centers. This precursor to the Internet was originally created by linking computers at UCLA, Stanford Research Institute, the University of Utah, and the University of California at Santa Barbara.

ASCII (American Standard Code for Information Interchange) Standard, universal text set of 96 characters.

AT (attention command) Invented by Hayes Corporation during the late 1970s to begin each modem command.

Attributes In 3-D animation, an object's characteristics, such as its rigidity and weight.

Augmented reality (AR) Interactive, computer-generated information that enhances what is seen in the real world via a device (like a smartphone, eyewear, or a head-mounted display).

Baseline shifting Allows you to select and then move individual letters above or below their *base-lines*, the imaginary line upon which all letters would normally sit.

BASIC (Beginners All-purpose Symbolic Instruction Code) A relatively easy-to-use programming language of the 1960s and 1970s.

Beveling A simple and very common variation of **extrusion** by pushing forward a flat shape and adding angled edges along its sides, so the original shape becomes the front face of the new 3-D object. Sometimes called *face extrusion*.

Bézier curve Another name for a vector curve, which is typically created with the pen or **Bézier tool.**

Bézier tool Another name for the pen tool, used for creating vector graphics.

Binary code Basic computer code composed entirely of zeroes and ones.

Bit The smallest unit of data in computing, with a value of either zero or one.

Bit depth The maximum number of colors or shades in each pixel. The greater the bit depth, the more subtle and realistic color and grayscale images will appear.

Bitmap Images created by a series of dots. Bitmap type can lose quality as it is enlarged and pixels moved further apart.

Bitmap painting software Programs that create digital pictures that have the look and range of traditional painting, as well as other artist materials. Also called **natural media software**.

Bookmark Saved website to be revisited.

Boolean operations In 3-D modeling, a method of creating more complex solid forms by overlapping solid shapes and combining them in a variety of ways by adding or subtracting an object from another. Examples are **Boolean union, subtraction**, and **intersection**.

Boolean union In 3-D modeling, where the outer forms of two volumes are added together and whatever intersects internally is eliminated.

Boot The loading of the operating system into a computer and starting of initial processes.

Bounding box In 3-D programs, a quick-rendering viewing mode where only a simple box, large enough to contain the object, is seen rather than its wire mesh.

Broadband Internet access at speeds in the range of 1 MHz or more is considered broadband access. For example, optical fiber and cable modem access.

Browser A software program that allows users to navigate through a network in order to access information.

Brushes Tools that imitate **natural media** ones, like chalk or pencils.

Bump maps In 3-D modeling, an advanced form of **texture mapping**. This technique simulates how a textured surface would reflect light naturally, without actually changing the geometry of the model. The illusion of the texture's depth is based on the contrast between the bright and dark parts of the image.

Bus A data pathway that connects a processor to memory and to other "peripheral" buses like SCSI, AGP, PCI, and PCIe.

Byte 8 **bits** of data.

Cable modem A device that connects a computer to the coaxial cable provided by a cable television (CATV) network. Cable modems are always online and are capable of multimegabit data transfer.

CAD (computer-aided design) A special kind of vector-based 3-D modeling used by industrial and fashion designers, engineers, and architects to create models for manufacturing and architecture. Sometimes called a *drafting* program.

Camera dolly In 3-D animation, a camera that follows subjects as they move, based on a moving platform attached to a track in a traditional film studio.

Camera target In 3-D modeling, a marker on the wireframe drawing that shows where the camera is focused.

Camera-ready art Mechanical, photographic, or other art prepared to be photographed in order to create a plate for printing on an offset lithography press. See **paste-up** and **mechanical**.

Canvas The work area in digital painting software where the new image is created.

CCD (charged-coupled device) Converts light into analog electrical current. Flatbed scanners use linear arrays of CCDs.

CD-R (compact disc recordable) Instead of creating pits and lands in a disc, the CD-R heats (burns) special chemicals on the disc causing them to reflect less light than areas not burned. The burned areas reflecting less light work in a similar fashion as a "pit" on a conventional CD-ROM, with unburned, more highly reflective areas becoming the land. Due to the chemical composition of their coating, CD-R discs can be written only once.

Cel animation In traditional animation, a series of drawings made on sheets of clear acetate or **cels**. Registration is ensured by placing cels on a fixed platform with pegs that match punched holes in the cels. In digital animation, the drawings are made on a series of transparent keyframes. Also known as keyframe animation.

Centered Centers text between the left and right edges of a text block.

CERN (Conseil Europeen pour la Recherche Nucleaire) Located in Geneva, Switzerland, this is the founding organization of the World Wide Web. One of the world's oldest and largest scientific laboratories, it is dedicated to research into the field of particle physics.

Channels Separate 8-bit images that the computer mixes together to create a full-color, 24-bit image. Each of these independent 8-bit images represent the tonal values for red, green, and blue RGB and cyan, yellow, magenta, and black in CMYK.

Chipset Microcircuits that control the flow of information from one part of the computer to another and determine the way in which the processor will access memory, the way it will communicate with peripheral devices, the type of RAM memory that can be used, and so on.

Clock tick The speed with which the CPU can execute instructions.

Clones Computers that utilize functionally identical computer systems. Generally, these are Windows-compatible computers.

Cloning A method of painting with part of another picture or another location of the current picture.

Closed path In vector illustration, a path that begins and ends at the same point and describes a shape. A rectangle and circle are both examples of closed paths.

CMYK color model Format for images designed for printing on a press. Cyan, magenta, yellow, and black inks are printed one after the other to create full-color images. Unlike **RGB**, CMYK utilizes a subtractive model based on the reflected light of inks rather than projected light. As light strikes the ink, a portion of that light is absorbed.

COBOL (Common Business Oriented Language) A hardware-independent programming language for government and business use developed by Grace Hopper in 1959. Unlike **FORTRAN**, it uses words rather than numbers.

Color separation A method to transform color artwork into cyan, magenta, yellow, and black components, from which most colors can be reproduced. See also **CMYK color model**.

Compound path In vector illustration programs, a complex shape made from two or more overlapping shapes. Shapes can be combined or *united* and become one form sharing the same overall outline, or made of where the forms *intersect* only, eliminating all other parts. *Exclude* eliminates only the areas where the shapes overlap. *Merge* combines only the overlapping shapes that share the same fill color. *Crop* removes any parts below the top shape. *Punch* or *minus front* cuts away the topmost shape from the group. *Divide* increases the number of sections by splitting the shapes into smaller ones wherever they overlap.

Computer Graphics Research Group (CGRG) Group founded at Ohio State University in 1969 by Charles Csuri to advance research in computer animation. In 1987, the group was renamed the Advanced Computing Center for Arts and Design (ACCAD).

Constraints In 3-D animation, a restriction added to a linked motion in order to limit the range of movement and make it appear more natural.

Copyfitting The adjustment of type to fit into a given space or number of pages.

Corner point In vector illustration, a kind of anchor point made with the pen tool that changes the direction of a curve (for example, from upward to downward), as in a collection of waves versus rolling hills.

CPU (central processing unit) The computer's brain, it processes and executes operations after taking requests from applications.

CRT (cathode ray tube) Usually used as another name for a computer monitor, it is technically the tube of a monitor in which electron rays are beamed onto a phosphorescent screen to produce images. This kind of monitor has now been replaced by **LCD** monitors.

CSS (cascading style sheets) A method for assigning properties to various elements of a Web page, which helps provide a consistent look to websites of many pages. For example, style sheets can be used to control font size, color, style, weight, and line spacing.

Curves A control in most image-editing programs that allows you to selectively raise or lower values in specific areas of an image.

Cycles A time-saver for animators, cycles are short sequences that can be repeated over and over again, like a character walking. In digital animation, they can be saved with the file and be reused again in different places. Also known as a **sprite** or **animated symbol.**

Daisy wheel An impact printing system that uses a spoked wheel with type characters positioned at the end of each spoke. A print hammer strikes the key and pushes it into an inked ribbon, which then strikes the paper to create a text character.

Dataglove Glove designed to allow users to appear to touch and manipulate objects in a virtual environment.

Deformation Modification of a simple 3-D model, such as stretching, squashing, bending, twisting, or skewing it in one direction.

Depth of field The amount of visual information that appears to be in focus. In 3-D software, how far back from the camera objects can be seen in focus.

Difference Engine Early computing machine designed by Charles Babbage in the early 1800s. Never completed but important forerunner of modern computers. Designed to do calculations for mathematical tables mechanically and to print automatically.

Digital cameras Cameras that use an array of **CCD** sensors to capture light and convert it into digital data.

Digital layout and design software The primary tool of graphic designers for laying out text and pictures in ads, magazines, newspapers, and books; once known as "desktop publishing."

Digital media The artforms created with computer technology.

Digitize Convert to analog to digital data.

Digitizing tablet A flat, pressure-sensitive input device. A pen-shaped stylus is used to draw directly on the tablet.

DIMM (dual inline memory module) A type of preassembled RAM module supporting a wider data path than SIMMS, which allows faster memory access.

Direct selection A special selection tool for vector forms (usually displayed as a white arrow); designed for making precise modifications to parts of a path and individual anchor points.

Direction lines Lines used to reshape a curve's height and slope in vector illustration. They are connected to the anchor points of a curve and are made visible after clicking on a curve with the **direct selection** tool.

Disc Optical storage media like CD-R, CD-ROM, DVD, and so on, as opposed to magnetic storage systems.

Disk Magnetic storage media like floppy disks and hard disks as opposed to optical storage systems.

Display Another name for the monitor.

Dissolve In film and animation, where one scene fades in as the other fades out. This implies a logical connection between the two scenes.

Dithering The approximation of an unavailable color by using a mixture of available colors.

Dmax The maximum density within an image as measured by a densitometer.

Dmin The minimum density within an image as measured by a densitometer.

DNS (Domain Name System) The standard method for assigning website addresses. Domain names are organized in a categorical hierarchy based on the type of group that is the host; for example, commercial sites (.com), educational sites (.edu), government sites (.gov), military sites (.mil), and general organizations (.org).

DOD (drop on demand) Printing technology in which small drops of ink, triggered by heat and controlled by a printer's software, squirt onto the paper.

Dollying In 3-D animation, moving the camera towards or away from objects to zoom in or out on subjects. In traditional film, done with a camera on a wheeled platform.

Dot matrix printers Printers that use a matrix of small hammers, instead of actual type letters, to push pins against an ink-coated ribbon, which in turn transfers ink dots onto the paper to form letters.

Download Information transferred from an ISP to a personal computer.

Downsample Resampling approach that deletes information from an image.

dpi (dots per inch) A method of calculating printer resolution, which describes the number of dots per linear inch.

Drag and drop An action performed using a mouse to move icons, text, images, etc. on the computer screen.

Drivers Software developed by individual hardware manufacturers to implement the devices they manufacture.

Drum scanner High-resolution professional scanner that uses **PMTs** (photo multiplier tubes) which have a much higher sensitivity to light and lower noise levels than CCDs found in flatbed scanners.

DSL (digital subscriber line) High-speed Internet access via installed copper telephone wires which provides speeds up to 20 times faster than older telephone (**POTS**) modems.

DVD (digital versatile disc) While visually similar in appearance to CD-ROM discs, higher capacity optical discs able to store up to 4.7 GB of data on a single side. Used for computer applications and full-length movies. Double-sided DVDs can store from 8.5 to 17 GB of information.

Dye-sublimation printers Printers designed to produce prints by vaporizing inks. They turn solid colors into a gas which then solidifies or *sublimates* on the paper, thus producing prints indistinguishable from those produced in a conventional photographic darkroom.

Dynamic range Measure of a scanner's ability to differentiate differences in tones from light to dark.

E.A.T. (Experiments in Art and Technology) Organization founded in 1966 by the artist Robert Rauschenberg and the Bell Laboratory scientist Billy Kluver to bring together artists, choreographers, musicians, scientists, and engineers to imagine new forms of art.

EDVAC (The Electronic Discrete Variable Automatic Computer) The successor to **ENIAC**, this was the first computing machine with a central processing unit (CPU) that coordinated all operations. Also, it was the first machine with true computer memory for storing programs and data.

EEPROM (Electrically Erasable Programmable ROM) The type of **ROM** most often used in motherboards today. It allows the user to "flash" or upgrade the BIOS to take advantage of processor improvements or bugs found in earlier releases of the BIOS ROM.

Electro-photography First introduced in 1948 as a means of copying documents, it eventually evolved to *xerography* (Greek for "dry writing").

ENIAC (Electronic Numerical Integrator and Computer) Completed in 1945 at the University of Pennsylvania, ENIAC was the fastest calculating machine of its time; one thousand times faster than the previous **Mark 1**.

EPS (Encapsulated PostScript) A **PostScript** language format that can contain both vector and bitmap graphics and is supported by all page layout programs.

Establishing shot In film, an introduction to a scene, where new subjects are seen first at a distance. Typically, the camera then slowly moves in closer.

Expansion cards Printed circuit boards that connect to **expansion slots** to add to a computer's functions; also known as *expansion boards*.

Expansion slots Allow the attachments of different kinds of **expansion cards** to the computer.

Exposure sheet A very detailed chart used by teams of animators, which describes every frame of the film in terms of the general detail of action, special effects, and sounds; also known as a **work schedule**.

Extrusion In 3-D modeling, giving a 2-D shape depth by pulling it out into 3-D space (sometimes called *lofting*). For example, by extruding a circle vertically upward, you can make a column.

Face In 3-D modeling, one of the geometric planes that describes a form. For example, a cube has six interconnected square faces.

Fair use Use of copyrighted material for educational purposes. Other fair use applications apply to small sections of an original work used for news reporting, reviews, criticism, and parody.

Feathering The selection of a certain number of pixels with which to soften the edge of a selection or mask. This is helpful when selected areas need to be blended in with their surroundings at some point in the editing process.

Field of view In 3-D software, the size of the area seen by the viewer.

Fill In vector illustration, a color, gradient, or pattern applied to the open area inside a **closed path**.

Fill lighting (sometimes called omnidirectional) Light spread from one general direction, without strong cast shadows or highlights. It can also be used to fill in dark areas in shadow.

Filters Can be applied to an entire image or limited to selections or masks in order to create a special effect or modification (i.e., unsharp masking).

Firewall Enforces an access control policy between two networks, preventing unauthorized access to your computer.

Flat shading In 3-D modeling, a simple type of shading that applies one tone and color to each facet or polygon on the surface of the model without smoothing them.

Flatbed scanner A computer peripheral designed to **digitize** flat images, like photographs, prints, and drawings. The most common form of scanner, it uses linear arrays of **CCDs** to convert analog images to digital signals.

Flush left Aligns text with the left side of a text block.

Flush right Aligns text with the right side of a text block.

FM (frequency modulation) A mathematical sound synthesis approach to recreating the sound of an instrument.

Forced justification Aligns all text, including the last line (which may be shorter), with the left and right edges of a text block.

Format Method to organize a hard disk into individual storage locations called **tracks** and *sectors*.

FORTRAN (formula translation) The first hardware-independent programming language, created by a team led by John Backus in 1957.

Forward kinematics In 3-D animation, a kind of linked motion where one part initiates the movement of all other linked parts, as compared to **inverse kinematics**.

Frames A method of displaying more than one HTML document in the same browser window, with each frame capable of displaying information independently of the others.

Frameset Document used when creating **frames**, which contains instructions defining the size and orientation of each frame and which HTML document should be displayed in those frames.

Free-form modeling In 3-D modeling, shifting and pulling the polygons that make up the wireframe mesh that covers all 3-D objects.

FTP (file transfer protocol) Software that allows you to transfer files between your computer and a remote server. FTP can resume transfer, even if interrupted, from the point at which the interruption took place.

Galleys Sheets of printed type.

Gamma Refers to the midrange values in an image between black and white.

Gamut Describes the range of colors available that can be displayed on a monitor or printed. The **RGB** gamut contains the colors that can be accurately viewed on a color monitor. The **CMYK** gamut represents colors that can be printed with cyan, magenta, yellow, and black process inks. The L*A*B* color model has the largest gamut of all, containing all the colors in both the RBG and CMYK color models.

GIF (Graphics Interchange Format) An image compression format, limited to 256 colors, commonly used in Web pages. Created by CompuServe in 1987 so images could be shared easily.

GIF 89A See **GIF animation**.

GIF animation (also known as the GIF 89A format) On Web pages, several bitmapped pictures with very small file sizes linked together and appearing animated as they play sequentially.

Gigabyte One thousand megabytes.

Gigahertz One gigahertz (GHz) equals 1,000 megahertz, or 1 billion **clock ticks** per second.

Gopher The earliest of the systems available for organizing and displaying files on the World Wide Web.

Gouraud shading In 3-D modeling, a shading method that results in much smoother tonal blends than **flat shading** by mathematically interpolating a series of lines and hence smoothing the edges of the polygons. Conceived by Henri Gouraud at the University of Utah in 1971. Also known as smooth shading.

Gradient meshes In vector illustration, smooth multicolored gradients that create a 3-D look for forms. When revealed, they appear as a net of lines and points crisscrossing over an object, that can be modified to reshape a form.

Gradients A gradual blend of a range of colors, which is a common way to apply multiple colors in digital media software. Gradients can be linear or radial, and in some programs, spiral or circular.

Graphical User Interface (GUI—pronounced "gooey") Computer software that is graphical, or picture based, rather than text based. It utilizes icons to represent programs and folders for storing files. First created by Alan Kay at **Xerox PARC**.

Graphics accelerator A video card with a dedicated processor to boost performance.

Grayscale 256 shades of gray used to represent a black and white image. Pixels in a grayscale image have a value ranging from black (0) to white (255).

Gutter The space between columns of type on a printed page.

Halftone cels Groups of dots positioned closer together or further apart to create what appears to be a continuous tone.

HDCD (high definition CD) A type of compact disc that utilizes a higher frequency to read bit patterns from a disc, resulting in better detail and resolution of the master recording.

High resolution A monitor or video card that can display fine detail and millions of colors.

Histogram A visual representation of the tonal and color range of an image.

Hollerith Electric Tabulating System An early computing machine designed by Hans Hollerith in the late 1800s, for the U.S. Census, it utilized a punch card system that could be tabulated mechanically. The punch cards stored 80 variables about an individual on a single card.

HSB The color system whose variables are hue, saturation, and brightness.

HTML (hypertext markup language) The code or programming language of webpages, **hypertext** is used to create links in the text to other words, images or documents and offers the reader a non-linear way to seek information in web pages.

Hue The name of the basic color, as in "red" or "yellow."

Hypertext A non-linear approach to writing, allowing the reader to make choices about which threads of information are going to be followed in Web pages.

I/O (input/output) Refers to any operation in which data is transferred in or out of the computer.

ICC (International Color Consortium) Used in color managed applications that support the Kodak Color Management System.

ICM profiles Used in color-managed applications that support the Kodak Color Management System; Windows version of ICC.

Illustration software Another name for vector illustration software.

Image compositing The combination of separate images to create a greater imaginative whole.

Imagesetter A machine capable of printing text at high resolution to film or on long sheets of photographic paper to ensure smooth, crisp typography.

Inkjet printer A type of printer that sprays ink from nozzles as the nozzles pass over the paper to create full-color images from overlapping dots of color.

Input The information a user sends to the computer; for example, utilizing a keyboard and mouse.

Integrated circuit A circuit whose every part is made of silicon, not just the transistor itself; it makes possible mass-produced circuit boards and the miniaturization of the embedded transistors.

Intensity The chromatic purity of a color.

Interface message processors Communication equipment that manages network traffic flow. These were initially the minicomputers that connected nodes on the ARPANET to the network. They are known today as **routers**.

Interlaced (cathode ray tubes) CRTs that scan in two passes, first scanning the even lines and then the odd lines, to create a single scan. They were typically used in home television sets before the arrival of flat screens.

Interlaced GIFs This option allows a low-resolution version of an image to appear in web browser while a higher resolution image is downloading. While interlacing increases file size it can make downloading time seem shorter because an initial image appears quickly.

Interpolation Creating new pixels by comparing existing pixels. See **Resampling**.

Inverse kinematics In 3-D animation, a sophisticated kind of linked motion where a chain of actions can be initiated at either end of a chain of links.

IoC Internet of Commerce.

IoD Internet of Documents.

IoP Internet of People.

IoT Internet of Things.

IrDA (Infrared Data Association) Port for wireless infrared devices such as keyboards, mice, and printers.

IRIS printers Extremely sophisticated inkjet printers capable of producing fine art prints on any smooth material up to 35" x 47".

ISA (Industry Standard Architecture) Type of bus developed by IBM for their first PCs with an 8-bit transfer rate.

ISDN (Integrated Services Digital Networking) Service that has the ability to deliver two simultaneous connections that allow voice, data, and video to be transmitted digitally through a single conventional phone line.

ITU (International Telecommunications Union) Organization created by the United Nations to coordinate and standardize international telecommunications.

Jacquard loom Weaving machine invented in the early 1800s by Joseph-Marie Jacquard that was a forerunner of punch card computing systems. Patterns were mechanically controlled by a set of boards with punched holes.

Java A powerful programming language with the ability to create actual applications or applets for insertion into a Web page as well as stand-alone applications. It can also run the programs it creates on PC, Mac, and Unix computers.

JavaScript A programming language that can be embedded in an HTML document to open a range of possible interactive features. It allows you to embed special effects, open new message windows, perform calculations, write interactive games, and more.

JPEG (Joint Photographic Experts Group) An image compression format introduced in 1991 to compress 24-bit images. A **lossy compression** scheme with high compression capabilities, it is commonly used to prepare photographic images for Web use.

jQuery UI A library of pre-scripted features that make it easier to apply interactive **JavaScript** elements.

Justified Aligns text with the left and right sides of a text block.

Kerning Adjusts the amount of space between two type characters

Keyframe animation (see **Cel animation**)

Keyframes In animation, moments of important changes in action.

Kilobyte 1,024 bytes.

L*A*B* color An international standard for color measurement. Renamed *CIE L*A*B** in 1976. Designed to be device independent, L*A*B* color has a lightness component (L), and two chromatic A and B channels. The A channel controls the color from green to red and the B channel controls the color from blue to yellow. *CIE L*A*B** is often the internal color model used to convert images from one color model to another.

Lathing In 3-D modeling, a simple shape is spun around its center to create a new object with volume. For example, a swept right triangle would create a cone. Also called **sweeping**.

Layers Separate levels where elements of an image can be placed. Each layer is independent of other layers and can be modified separately.

LCD (Liquid Crystal Display) A monitor that utilizes liquid crystal cells and polarizing filters instead of electron beams and phosphors to create an image.

Leading (pronounced "ledding") Refers to the space between lines of type. In a word processing program, a simple form of leading might be to choose between single or double spacing.

Local bus A bus connecting a processor to memory, usually on the same circuit board, in order to speed up transfer of information. **PCIe** is one current example of a local bus.

Lossless compression Refers to an image that is compressed and can be opened with no loss of any of the information it originally possessed. Traditional GIF files are an example of a lossless compression scheme.

Lossy compression Discards or loses information as the file is compressed. When the file is opened from its compressed state, the lost information cannot be reconstructed. A JPEG file is an example of a format using lossy compression.

lpi (lines per inch) The unit in which halftone frequency is measured for reproducing continuous tone images.

Machine cycle The four steps that the CPU carries out for each instruction: fetch, decode, execute, and store.

Mapping In 3-D modeling, adding a surface or skin to a wireframe model. This can include the addition of colors, patterns, materials, and textures, as well as properties like shininess and transparency. Also known as assigning material attributes to an object.

Mark 1 The Automatic Sequence Controlled Calculator developed at Harvard with the assistance of IBM engineers in 1943. The first truly automatic computing machine, it was 51 feet long, eight feet tall, and weighed five tons. Information was fed into it with rolls of paper tape.

Mask When you make a selection within an image, the area of the image that is not selected is protected (masked) from whatever changes are about to be made to the image. Selections are often saved as masks in a new alpha channel or even converted to paths and stored for future use.

Mechanical In traditional graphic design, camera-ready paste-up of type, graphics, and other elements.

Media Query Allows a photograph or graphic to be sized relative to the device displaying it.

Megabyte 1,024 kilobytes, or approximately 1 million bytes.

Megahertz One megahertz (MHz) is equal to 1,000,000 clock ticks (cycles) per second.

Megapixel 1 million pixels.

Microprocessor A computer chip that has combined on it all the arithmetic and logic circuits necessary to do calculations. The first was originally designed for calculators by Intel engineer Ted Hoff in 1971. Also known as an **integrated circuit**.

MIDI (Musical Instrument Digital Interface) A type of sound file that uses prerecorded instrumental sounds that are resident in the memory of a sound card. It encodes data for recording and playing musical instruments digitally. In addition, it is a port for attaching a digital musical instrument such as a piano keyboard to the computer.

MILNET Internet system for military use only.

Mixing Layering sounds on top of one another.

Model sheet A guide to a character created by the lead animator for the other animators. Each character is drawn at various angles. Colors and costumes are carefully detailed.

Modem A device for communication over telephone, optical fiber, or cable lines which modulates or alternates between two different tones to represent the zeroes and ones of computer language.

Modules In 3-D software, add-on packages that handle complex tasks, such as light in fog, or provide special tools. Also known as **plug-ins**.

Moore's Law A graph drawn in 1965 by Gordon Moore, one of the founders of Intel, that showed that the capacity of memory chips would double roughly 12 months while the cost of producing them would be cut by half. He later revised this to every two years.

Morphing Tweens where one image progressively changes smoothly into another.

Mosaic The first true Web browser, which transformed the Internet from a text-based environment to one with colors and images. It was created in 1993 by a group of computer science students at the University of Illinois, led by Marc Andreessen.

Motherboard Primary circuit board where many of the most critical elements of a computer are located. It is the nerve center of the computer, connecting to the power supply and distributing electricity to all the other parts of the computer.

Motion path In animation, a line drawn to guide an object, light, or camera's movement.

Motion capturing In 3-D animation, recording live-action movement digitally and then translating it into an animated sequence with computer software.

Multiplane camera An animation camera that creates a more convincing sense of depth by varying the focus on different layers of a scene as it zooms in and out. This was first used by Disney Studios.

Multisession A CD writing system capable of writing additional data to a disk at a later time.

Natural media software A program designed to recreate traditional drawing and painting tools, like pencils, chalk, crayons, watercolor, and oil paints; another name for *digital painting software*.

Nodes Network processing locations. For example, the University of California at Los Angeles, Stanford Research Institute (SRI), the University of California at Santa Barbara, and the University of Utah were the first nodes on the **ARPANET**. Each of the nodes had a unique address that would identify it to other computers.

NSFNET Network developed by the National Science Foundation (NSF) to replace **ARPANET** as the main government network linking universities and research facilities.

NUBUS Bus developed by Apple for their Macintosh II.

NURBS Non-uniform rational b-splines. In 3-D modeling, a special kind of **spline** designed for modeling organic forms. NURBS splines have adjustable weights attached to each control point so you can increase or reduce the impact of any change by individual control points.

Object-oriented software Another name for **vector illustration** programs.

OEM Original equipment manufacturers.

Ogg A container (or wrapper) that holds any type of data but is used primarily for streaming audio and sometimes video files.

Onion skin In traditional animation, semi-transparent pages which allow one to see earlier drawings on other frames. In animation software, ghosts of images in previous frames.

Opacity The degree of transparency of a color or image.

Open architecture A computing system whose specifications are made public. It allows computer makers to utilize components purchased from other manufacturers.

Open path In vector illustration, a line with endpoints that are not connected.

Operating system Software that runs the programs and controls all the components of a computer. For PC users, it will be either Microsoft Windows or Linux. Macintosh owners use one of the versions of Mac OS.

Orphan Word or short line of text at the end of a paragraph carried to the top of a page or column.

Out-of-gamut Colors that can be approximated on a computer screen but not printed accurately using the CMYK color ink set. Preparing an image for print is the process of "correcting" out-of-gamut colors, usually by reducing their intensity or contrast.

Packet switching A method of dividing data into packets or pieces before they are sent across a network to another computer. Separate packets, each with part of a complete message, can be transmitted individually, even following different routes before arriving at their final destination. They are reassembled back into a complete message at their destination.

Panning A slow movement across a wide scene by a camera, usually used at a distance from the main subjects.

Pantone A professional standard color library with specific CMYK mixtures used for choosing **spot colors**.

Papyrus A reed found in Egypt, which was slit, then peeled and soaked in water. The flattened reeds were bonded under pressure to form a writing surface.

Parallel processing Processors that work simultaneously rather than sequentially. A method to speed computer processing.

Parent-child relationships In 3-D animation, a kind of linked motion where moving one part causes a second to move.

Particle systems In 3-D software, a kind of **procedural modeling** (either as a special feature or **plug-in**) which generates realistic special effects like smoke, fire, fog, clouds, and explosions. These systems eliminate the need to individually animate countless elements.

Pascaline Wheel calculator invented around 1640 by Blaise Pascal. Calculations are made by rotating eight metal dials linked together by gears in a box.

Paste-up In traditional graphic design, where text and images used in a design are cut up and pasted down on a piece of white mounting board.

Path (1) In vector illustration, a straight line that connects between points, creating forms that are always sharp and clear. All forms are built with **paths** composed of anchor points and the lines between them. There are two kinds of paths: **open** and **closed**. This is also known as a **stroke**. (2) In a digital layout and design program, the accumulation of line segments or curves to be filled or overwritten with text.

PCI (Peripheral Component Interconnect) A computer bus common to both PC and Macintosh computers. The PCI bus can transfer data at speeds of up to 132 MB per second and have the ability to perform certain tasks independently of the CPU.

PCIe Uses point-to-point technology and can support between one and 32 lanes of data flow. It is incompatible with earlier bus systems and can convey data at between 500 MB and 16 GB per second. This makes it considerably faster than earlier bus systems.

PCL A printer control language developed by Hewlett-Packard to support various printing tasks including graphics, scalable fonts, vector printing descriptions, and bidirectional printing.

PDF (portable document format) A **PostScript** file that has saved an entire design, including typography, fonts, layout information, graphics, and photographs.

PDL (page description language) Controls the formatting and layout of a printed page.

Persistence of vision A visual phenomenon that the illusion of animation depends on. Because we see images for a split second longer than they are actually in front of us, a series of pictures drawn in sequence appear to be one continuous picture in motion.

Phong shading In 3-D modeling, a complex form of shading conceived by Phong Bui-Toung at the University of Utah in 1974 that smoothes the polygons of a wireframe pixel by pixel and creates realistic highlights on shaded objects. It is also known as specular shading.

Picture boxes Shapes that act as placeholders for photographs or other art.

Piezoelectric A printing technology that uses a piezo crystal (a thin section of a crystal which oscillates when voltage is applied) behind the ink reservoir. When electrical current is applied to the piezo crystal, it flexes, forcing ink out of the nozzle.

Pits and lands The method of storage used in compact discs. A land represents a one and a pit represents a zero. A laser reads a CD by distinguishing a pit and a land by the shift in position of the reflected laser light that occurs when the beam hits the surface.

Pixels Picture elements; an individual point of light on the computer's monitor.

Platen A kind of pressure plate in early printing presses used to make firm and even contact between the paper and type.

Platform independent Software that runs on any computing system.

Plotters Large-format printers with moving pens that make linear images on rolls of paper.

Plug and play An automated installation process used to connect peripherals to a computer so each new component runs more or less effortlessly when plugged in.

Plug-ins Add-on packages that increase a software package's capabilities. They usually handle complex tasks, such as light in fog in 3-D software, or provide special tools. They are also known as **modules**.

PMT (photomultiplier tube) Used in **drum scanners**, these extremely sensitive tubes are capable of sensing very low levels of light and are able to amplify them into electronic signals that can be converted to digital information.

Polygon mesh In 3-D modeling, a series of connected polygons with which objects are constructed.

Ports Sockets that permit external devices to be attached to the computer.

PostScript A page description language developed by Adobe Systems, Inc. to describe the appearance of text, graphics, and images in a device-independent way.

POTS Abbreviation for Plain Old Telephone Service, a term used to describe a connection to an Internet Service Provider through a telephone modem.

ppi (pixels per inch) A method to describe screen resolution that also refers to image size in pixels.

Primitives In 3-D modeling, basic 3-D geometrical shapes supplied by the animation program; for example, cubes, spheres, cylinders, and cones.

Print to file A **PostScript** description of a designed page created as a file. It contains all color, font description, image, and layout information needed to print an accurate representation of your document.

Procedural modeling In 3-D modeling, software that utilizes formulas that take into account the randomness of natural phenomena; for example, fractal geometry.

Process colors Another name for cyan, yellow, magenta, and black.

Proofing Reviewing a document or design for errors before it is actually printed.

Proportionally spaced text Text where the space each letter occupies is different and can be adjusted for maximum readability.

Protocol Formal set of rules determining the way in which data can be transmitted across networks.

RAM (random access memory) Fast, short-term memory used by the computer for holding data and programs as you work. It sends information to the computer's CPU at high speed so there is a minimum amount of time the processor must wait for it. Unlike ROM, RAM can be read and written to.

Raster Bitmap images that use a grid of small squares known as pixels to represent images.

Ray tracing In 3-D modeling, a complex form of shading that recreates the reflections of light and color that we use to see objects in the real world. A line of light is traced from the light source to every pixel of an object and then bounced to the camera as a light ray.

Refresh rate Determines how many times each second a scan occurs on a monitor.

Remap Shifting values within an image to correct for poor contrast, or an image that is too light or dark.

Renderfarm A room full of networked workstations that share the chore of rendering the complicated models, scenes, and action of 3-D animation.

Rendering The final stage in 3-D modeling and animation—the computer generation of a finished scene from the viewer's point of view. In 3-D software, a bitmapped image or animated sequence

created from the wireframe forms, the mapped colors and textures, as well as the lights, shadows, reflections, and any special effects.

RenderMan A photo-realistic digital rendering software system created by Pixar Studios.

Resampling An approach to interpolating new data. Resampling occurs when you make an image larger or smaller by adding or deleting pixels. This changes the file size accordingly.

Resizing Allows you to move pixels further apart or closer together in order to make an image larger or smaller. This will change the effective size and dpi of an image but will not create or eliminate pixels like **resampling** does.

Resolution-independent graphics Another name for *vector graphics*. No matter how much or how many times vector images are resized, their edges will remain smooth and distinct, because the change is made mathematically.

Responsive web design (RWD) Allows a designer to code a web page that recognizes the device it is being viewed on and resize design elements to accommodate that device. This allows a single web design to be viewed on a large computer monitor, a tablet or smartphone in a coherent manner without requiring separate designs for each one.

Retina display *Retina* is an Apple marketing term with a very flexible definition. The first retina displays hosted 326 pixels per inch. Today it can refer to a screen where individual pixels cannot be seen by the human eye at a standard viewing distance for the device in question. The two equally important elements of pixel density and distance determine the application of the term retina to a device.

Reversed text Creates white text on whatever color background you are using.

RGB (red, green, and blue) The primary colors of a computer monitor; also known as additive colors.

RGB mode The default color model in most image-editing programs. In RGB mode, the visual spectrum is created by projected light, mixing the three visual primary colors to create white.

ROM (read-only memory) Relatively slow, permanent memory that can only be read but not written to (changed).

Roto-scope An animation aid invented by the Fleischer brothers, which transfers live action on film to drawn ones for animation.

Router Regardless of its physical connection (copper cables, wireless, fiber optic) a router's key job is to forward data packets from one computer network to another on the Internet.

Rubber stamp tool Designed for duplicating portions of an image from one location to another. Information from a sample point is copied to a destination point, and thus, *cloned*.

RWD Responsive web design.

SAGE (Semi-Automatic Ground Environment) Air defense system of the mid-1950s designed to visually track Soviet aircraft near U.S. airspace. The first interactive computer system with vector graphics.

Sampled sound Sound made with digital recording equipment; for example, speaking into a microphone connected to a sound card. Among the standard sampling file formats are WAV (for PCs), AIF (Macintosh), and MP3.

Sampling (1) Selecting a color already in an image by clicking on it with the eyedropper tool. (2) Selecting a portion of a sound file.

Saturation The intensity or degree of purity of a color.

Scalable architecture A concept where a family of computers all share accessories and use the same language, increasing the capacity of a company's computers without replacing the whole system.

Scaling Resizing.

Script (1) In animation, the outline of the basic story from beginning to end, along with a description of the characters; also known as a treatment. (2) In programming, a command in a computer language.

SCSI (Small Computer Systems Interface) (pronounced "scuzzy") A bus standard that used to connect peripheral devices, including hard drives, to computers. This has been replaced with the much faster PCIe bus.

Selection A determined limited area that is isolated from the rest of the image, either to limit work to that area, to protect (or **mask**) it, or to choose it for cutting, copying, or moving.

Semiconductor A material that conducts electricity only under special conditions; for example, silicon used in manufacturing **transistors**.

Shade A hue plus the addition of black to lower both value and intensity.

Shading In 3-D modeling, applying surfaces with color and tone to a wireframe model.

SIMM (single inline memory module) A preassembled unit of RAM chips on a circuit board that must be installed in pairs.

Sketchpad A drawing system created in 1962 by Ivan Sutherland, which utilized vector software and a light pen for drawing on a monitor. Conceptually, it was the foundation for all future vector drawing programs. Often called the beginning of computer graphics, because for the first time images were created by hand rather than by mathematical programs.

Skewing Shifting a form at an angle.

Slide scanners Digitizers that provide quality scans from transparent film materials.

Smooth point In vector illustration, a kind of anchor point made with the pen tool. It is used for drawing continuous curves, as in rolling hills versus a collection of waves.

Solid state An electrical device with all solid working parts.

Sound cards Special cards that convert audio input in two ways. First, they can convert input from the computer itself or from other sources into the analog format utilized by speakers. Second, they can digitize analog input, for example, from a microphone, so the sound can be edited in the computer.

Sound wavegraph In sound-editing software, how each recorded sound is pictured. The graph shows the wave itself, the length of the sound over time, and the wave's *amplitude*.

Specify type Communicating to the typesetter all of the type characteristics for a specific printing job. This is also known as "spec'ing" type.

spi (samples per inch) A measure of scan resolution based upon the number of samples taken in the scanning process.

Spline-based modeling In 3-D modeling, individually editing the curved **splines** in a wireframe.

Splines Vector-based curves in 3-D modeling; for example, **Bézier**, B-splines, and **NURBS**.

Spot colors Special premixed solid colors used in addition to the process colors or independently to emphasize or create a point of interest on the page.

Spotlighting A very focused light, emitted from one point and directed at another, usually as a cone of light. Spotlights create strong shadows and very concentrated lit areas. They are also known as *key lighting*.

Sprite See **Animated symbol.**

Stenciling A special mask that allows drawing only inside a selection.

Stored-program concept A method to speed computer processing. Instead of computers depending on instructions fed in with tapes or punch cards, programs are stored in the computer itself and only the data is fed in.

Storyboard In film, video, and animation, a storyboard shows the key moments of an animation in a series of small boxes with written notes below. Each major change of action is illustrated.

Stroke In vector illustration, the linear portion of the path and its characteristics. In an **open path**, it is the line itself. In a **closed path**, it is the outline around a shape. A line or outline's width, color, and style are all part of its stroke.

Superscalar The ability of a CPU to run two or even more pipelines that rapidly process many instructions at the same time.

Swatch A small rectangle of color, usually part of a collection found in the swatches panel in digital media programs.

Sweeping In 3-D modeling, a simple shape is spun around its center to create a new object with volume. For example, a swept right triangle would create a cone. This is also called **lathing**.

Sympathetic movement One of the laws of animated action, where a fast moving object will stretch to accentuate its path.

Synching Methods of integrating soundtracks with animated action.

Synthesized sound Sound that is computer generated from formulas. The most common format is MIDI. Like another mathematical format, vector graphics, synthesized music results in small file sizes.

System clock See **clock tick**.

T1 lines Fast Internet connection capable of handling 1.5 *Mbps* (megabytes per second).

T3 lines Very fast Internet connection capable of handling 45 *Mbps*. These lines are typically leased at a high monthly rate and serve many individual users.

Tables Early method in **HTML** of organizing the design of a Web page using rows and columns.

TCP/IP (Transmission Control Protocol/Internet Protocol) The protocol the military adopted as a "defense standard" in 1980 for transferring information over their network. Ultimately, this helped made the Internet possible.

Telnet Type of terminal emulation program for communicating with other computers connected to the Internet. The protocol also allows for interactive text between computers.

Terabyte (TB) 1 TB = 1,024 gigabytes (GB) = 1,048,576 megabytes (MB) = 1,073,741,824 kilobytes (KB) = 1,099,511,627,776 bytes. A one terabyte storage device can hold a trillion bytes.

Text block A space (typically rectangular) drawn by the user in which text can be entered.

Texture mapping In 3-D modeling, a time-saving form of mapping where a bitmap image is wrapped around a wireframe form. For example, wrapping an image of tree bark around a column to make a tree trunk.

Thaumatrope A nineteenth-century toy that created animated effects by utilizing the **persistence of vision**. It was a round disk with different pictures on each side and a string threaded through it. A child

would hold both ends of the string and spin the disk quickly. The pictures on both sides (for example, a bird and a cage) would appear together.

Three-dimensional animation The movement in virtual space of 3-D models.

Three-dimensional modeling The construction of digital objects that can be viewed at any angle.

Thunderbolt First introduced in 2011, Thunderbolt is the brand name of a hardware interface that allows the connection of external peripherals to a computer.

TIFF (tagged image file format) A file format for high-resolution bitmapped images.

Tile Small image with a small file size used to create a Web page's background. Web browsers automatically repeat a tile to form a seamless background for the whole page, eliminating the need to download a page-sized image.

Timeline In animation and some authoring software, a panel where one works with frames and layers. Frames are numbered and represented in time sequence, layers in the order of their stacking. The timeline is also where soundtracks are synchronized with images, with each track appearing as a separate layer.

Tints A hue plus the addition of white to raise the value of a color. This can also diminish its intensity.

Tracing In some software, a pale version of an image on a separate bottom layer, which appears as if it is below a sheet of tracing paper. The pale image is only for tracing; it is not part of the final image.

Trackball Input device that is essentially an upside-down mouse with a larger ball, which is rolled between your fingers or under your palm.

Tracking (1) In layout and design, tracking adjusts the amount of space between letters and words. (2) In 3-D animation, keeping the camera dolly at a set distance from an object as it moves along a scene.

Tracks On a hard or floppy disk, tracks are thin concentric bands forming a full circle. They contain the *sectors*, each of which can hold 512 bytes of data.

Transistors Devices that control the flow of electricity. They require very little electricity to operate, create much less heat, and are much smaller and longer lasting than the vacuum tubes they replaced. Invented by John Bardeen, Walter Brittain, and William Schockley at Bell Telephone Laboratories in 1947.

Trapping Safeguards against the common, small degree of misregistration in the printing process by slightly overlapping adjacent colors.

Treatment See **Script**.

Tri-color cartridge A single print cartridge holding separate cyan, yellow, and magenta inks.

Tweener In traditional animation studios, the role of creating the in-between frames for the keyframes created by lead animators.

Tweening Drawing the in-between frames between keyframes. In digital animation, software automates this time-consuming process.

Type color The overall tone of the text on the page. The size and style of the typeface, the amount of space around the characters, and the space between the lines all affect typographic color.

Type founding The mechanical production of cast type, which made the printing of books possible.

UEFI (Unified Extensible Firmware Interface) Firmware replaces earlier BIOS systems—able to address 32 and 64 bits of data instead of being limited to 16 as in a traditional BIOS.

User interface design (UI) Focuses on the user's experience of a web page—how it feels, various interface items like navigation buttons, widgets and other elements that affect the way a user responds to its presentation.

UNIVAC (Universal Automatic Computer) Manufactured by Remington Rand in the early 1950s, the most technologically advanced computer of its time and the first commercially successful mainframe. For the first time, data was stored on magnetic, rather than paper, tape.

Upload Information that is sent from a personal computer to an *ISP* (Internet Service Provider).

USB Flash Drive Far faster than old floppy drives or optical disc drives (CD-RW or DVD-RW) that required special hardware, a flash drive contains a small printed circuit board and a USB connector enclosed in a small protective case that can be carried in a pocket from device to device. It is also has far more storage space (8 to 256 GB are common with larger sizes available) and can be plugged directly into a computer's USB ports, which provide power for the device to run.

USB (Universal Serial Bus) Bus used primarily for installing devices outside the computer. External devices such as keyboards, scanners, printers, and other peripherals can be plugged directly into a USB port.

Value The lightness or darkness of a color.

Vector animation A method of creating animations, which utilizes vector forms rather than bitmapped ones. Often used for Web pages, because vector graphics result in much smaller files than bitmapped images.

Vector illustration Image making that is geometry based, rather than pixel based. Images are made up of geometric descriptions of points, lines, and shapes and their relative positions. Because a vector file is composed with mathematical equations, much less information is stored compared to a bitmap image. Images and fonts are **resolution independent**, so can also be resized without loss of quality.

Vectorscope Early computer monitor attached to a mainframe computer.

Viewing plane In 3-D programs, a rectangular field that shows what the audience will ultimately see in the frame.

Viewports In 3-D programs, the windows for creating and editing forms with views of the object at different angles. There are usually four, with views from the front, top, bottom, and either left or right side.

VRML (Virtual Reality Modeling Language) A Web browser programming language for creating interactive 3-D experiences on Web pages. Special plug-ins are usually required for Web browsers.

WAIS (Wide Area Information System) Method of supported document retrieval from Internet databases through full-text search. WAIS also supported listings of directories of servers, which could then be searched for a particular source by name or topic.

Widow Word or short line of text sitting alone at the end of a paragraph.

Wipe In film and animation, a transition where one scene is cleared off the screen by the next scene.

Wireframe mode In 3-D programs, a viewing mode where objects are displayed like a mesh sculpture wrapped in netting. Each line and vertice is represented and the overall form can be seen.

Work schedule See **Exposure sheet**.

WORM (Write Once, Read Many) Compact disc system with a chemical coating that allows areas of that coating to be rendered either reflective or nonreflective by a laser, mimicking the lands and pits of commercial CD discs.

WYSIWYG (pronounced "wizzy-wig") "What you see is what you get." Refers to programs where what one sees on the screen is quite close to the printed or final document.

Xerox PARC Xerox Corporation's Palo Alto Research Center, founded in 1970. Its research scientists pioneered much of the foundations of personal computing. Their slogan was "The easiest way to predict the future is to invent it."

Zoetrope A nineteenth-century toy that created animated effects by utilizing the **persistence of vision**. The toy was an open metal cylinder with evenly spaced slits, resting on a pedestal. A strip of paper with drawings was placed inside and the cylinder was spun rapidly. By looking through the slits as they rotated, a child could see the drawings move in sequence.

Credits

Cover image courtesy of Basel Alnashashibi.

Index

Note: Page numbers in *italics* indicate figures.